IMAGES
FROM THE
STORM

300 CIVIL WAR IMAGES
BY THE AUTHOR OF *EYE OF THE STORM*

Written and Illustrated by
PRIVATE ROBERT KNOX SNEDEN

Edited by Charles F. Bryan, Jr., James C. Kelly, and Nelson D. Lankford

THE FREE PRESS
New York London Toronto Sydney Singapore

To the Members of the Virginia Historical Society

Selections from the memoirs and art of Robert K. Sneden
were previously published in *Eye of the Storm*

THE FREE PRESS
A Division of Simon & Schuster, Inc.
1230 Avenue of the Americas
New York, NY 10020

Copyright © 2001 by the Virginia Historical Society

THE FREE PRESS and colophon are trademarks of Simon & Schuster, Inc.
Designed by Kim Llewellyn
Map on page xviii by Rice Dean Graphics
Manufactured in the United States of America

1 3 5 7 9 10 8 6 4 2

Library of Congress Cataloging-in-Publication Data
Sneden, Robert Knox, 1832–1918.
 Images from the storm : 300 Civil War images by the author of Eye of the storm /
written and illustrated by Robert K. Sneden ; edited by Charles F. Bryan, Jr., James C. Kelly,
Nelson D. Lankford.
 p. cm.
 Includes index.
 1. United States—History—Civil War, 1861–1865—Pictorial works. 2. United States—
History—Civil War, 1861–1865—Art and the war. 3. Historic sites—United States—Pictorial
works. 4. Historic buildings–United States–Pictorial works. 5. Sneden, Robert Knox,
1832–1918—Quotations. 6. United States—History—Civil War, 1861–1865—Personal narra-
tives. I. Bryan, Charles F. II. Kelly, James C. III. Lankford, Nelson D. IV. Title.
E468.7. S769 2001
973.7'022'2—dc21 2001040164
ISBN 0-7432-2630-8

CONTENTS

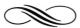

Introduction vii

Odyssey of Private Robert Knox Sneden xviii

Chronology xix

PART ONE Learning to Soldier 1

PART TWO On to Richmond! 27

PART THREE The Good Life 133

PART FOUR Captured 167

PART FIVE After the War 241

Editorial Method 253

Acknowledgments 255

Index 257

INTRODUCTION

THE RECORD OF PRIVATE ROBERT KNOX SNEDEN, which began to surface only in 1993, has proven to be one of the most remarkable Civil War collections ever uncovered. In all, it comprises some 5,000 pages of handwritten text and some 900 watercolors and maps sprinkled throughout both the surviving volumes of Sneden's memoir and his large scrapbooks of artwork, now owned by the Virginia Historical Society. It is a twin legacy of words and pictures.

Eye of the Storm, published in the fall of 2000, used relatively fewer watercolors to illustrate lengthy passages from the memoir. *Images from the Storm* reverses the perspective of its predecessor; it uses brief quotations from the memoir to illuminate a much fuller selection of the watercolors. Sneden was a skilled writer, who brought his artist's eye for details to a detached, simple, and clear prose style. He was also a skilled draftsman, who strove for accuracy over artifice in his drawings.

The process by which Sneden's legacy was uncovered was detailed in the introduction to *Eye of the Storm* and will not be repeated here. However, the facts of Sneden's life merit retelling, because they provide poignant context for anyone coming to his work for the first time.

We still know little about Sneden outside his time in uniform. A man who left such a detailed account of his experience in the Union army and in prison camps might have been expected to leave more tracks in the documentary record. He did not, but we can glean a few scraps from official records and several letters he wrote in later life about his family.

The Snedens were loyalists during the Revolution and fled north from New York in the wake of British

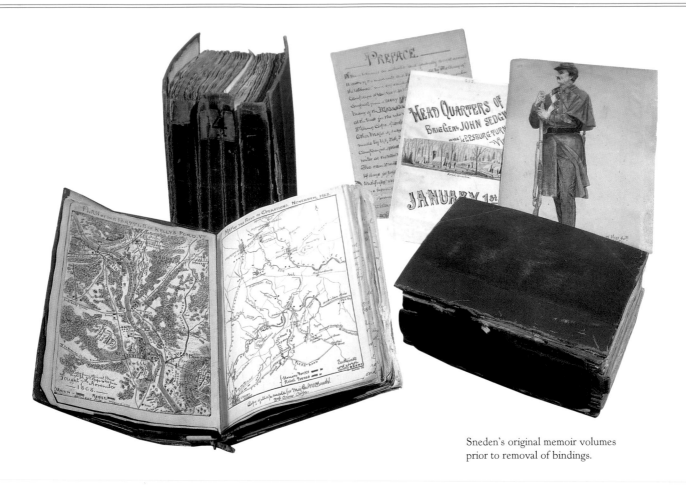

Sneden's original memoir volumes
prior to removal of bindings.

defeat. Robert Knox Sneden was born in the Canadian maritime province of Nova Scotia in 1832. Though we know nothing certain about his education, the high quality of his later writing suggests that he attended one of the province's secondary grammar schools. Despite the family's numerous middle-class and professional connections in Nova Scotia, by 1850 Robert had moved to New York with his parents and siblings. Perhaps it was the lure of opportunity that attracted them to the growing metropolis where the family had first put down roots in North America.

The father, however, struggled with only limited success as an insurance broker in the city, while the son appears to have worked as an engineering surveyor or apprentice architect. In addition to learning the more precise drafting requirements of these occupations, Robert Sneden also tried his hand at art. A handful of his surviving watercolors date from before the war. Appropriately, the earliest, painted in 1858, shows sailboats on the Hudson at Sneden's Landing, named for his pre-Revolutionary relatives.

He was working in Manhattan when the war broke out in 1861 and, in the contagious wave of patriotism that swept over the city, he joined the 40th New York Volunteers. As a private soldier during the late summer, he worked as a quartermaster in northern Virginia, where the regiment trained as part of the Army of the Potomac. His sketching caught the eye of an officer, and by early 1862 he was detached to draw maps for General Samuel P. Heintzelman, commander of III Corps.

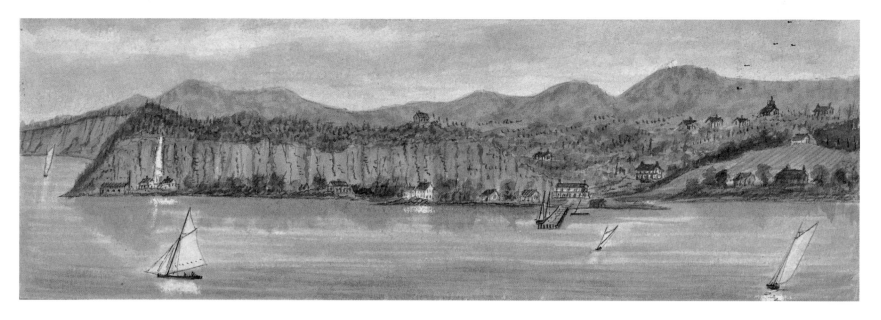

This is a pencil and watercolor view looking west across the Hudson River toward Sneden's Landing at the extreme southerly corner of Rockland County. At left are the Palisades of the Hudson. The landing takes its name from Sneden's family, which for generations in colonial New York maintained a ferry to the east bank at Dobbs Ferry in Westchester County.

Sneden's Landing, N.Y. *New York Historical Society purchase.*

With Heintzelman's headquarters staff, Sneden sailed down the Chesapeake Bay that spring to take part in General George B. McClellan's Peninsula Campaign.

He observed and drew numerous scenes of the siege of Yorktown. He was present throughout the harrowing Seven Days' battles, as the Union army made a fighting retreat in the face of the Confederates' relentless offensive that finished McClellan's attempt to take Richmond from the southeast. He was present for the second Manassas Campaign. Then, when Heintzelman was shifted to command the defenses of Washington, D.C., in September 1862, the general took his mapmaker with him. Sneden spent an idyllic time in the Union capital, attending the theater, watching baseball games and cricket matches on the White House green, listening to the latest military gossip at Willard's Hotel, and all the while sketching and writing in his diary.

In autumn 1863, he went back into the field, again

making maps for a general, again just a private. His luck ran out when Confederate soldiers under the command of partisan ranger John S. Mosby took the New York private prisoner in November at Brandy Station, Virginia. They sent him and about a dozen other captives on a wild ride, bareback on stolen mules, around the Union army and into captivity. He disappeared into the maw of the Confederate prison system and was given up for dead by his family. In Richmond during the rest of 1863 and into the first cold weeks of the new year, Sneden shivered with hundreds of other Union enlisted men in Pemberton prison, a converted tobacco warehouse.

In February the jailors packed him and several hundred others into filthy cattle cars for the jolting train ride south to a new prison, an outdoor stockade at a place in rural Georgia called Andersonville. Though he lost weight and suffered several bouts of fever during

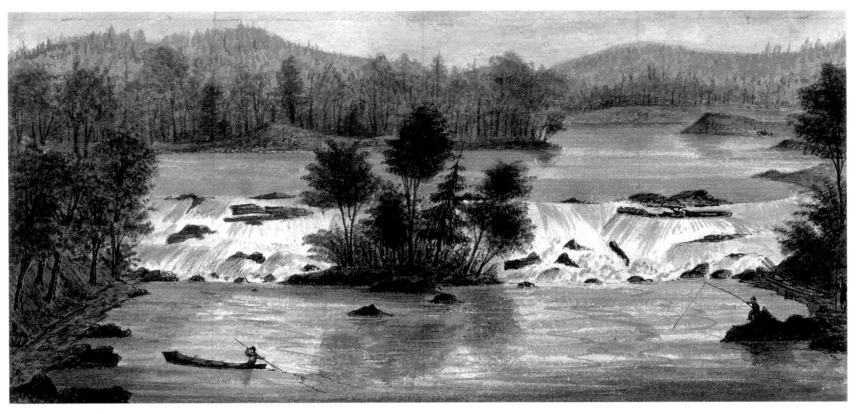

This sketch is executed in pencil, ink, gouache, and watercolor.

Glenerie Falls, Esopus Creek, near Saugerties,
N.Y. *New-York Historical Society purchase.*

the next seven months, Sneden survived Anderson-
ville and then another month in prison camps in Savan-
nah and Millen, Georgia. Shortly after arriving at Camp
Lawton, in Millen, he decided to pledge his parole and
promise not to attempt to escape. In return, he worked
as a clerk for Confederate surgeon Isaiah White. By
making this bargain, Sneden lived outside the stockade
and ate better than his comrades inside. As White's
clerk, he had considerable freedom later in Savannah
and also in Charleston and at another prison stockade
in Florence, South Carolina.

In December 1864 he was part of a mass prisoner
exchange in Charleston harbor. After sailing up the
coast to Annapolis, Maryland, where freed prisoners
of war were processed at Camp Parole, Sneden went

to Washington, D.C., for a few days and then home to
New York.

When he showed up at their house right after
Christmas 1864, a newly released prisoner of war,
his parents must have thought he had returned from
the grave. The 40th New York formally mustered
him out of the service in January, and he spent sev-
eral months convalescing. By the end of 1865, he
was working at the architectural firm of William B.
Olmsted.

Sneden identified his residence as "50 Wall Street
(top floor)." Because he also said that this was his
address at the time of his enlistment and because 50
Wall Street was Olmsted's business address, he may
have worked for the firm before the war. Though his

connection with Olmsted lasted about a dozen years, he also generated income on the side as a "Topographical Engineer and Landscape Artist," to use the wording on his business card.

He thus continued his prewar pursuits of both technical drawing and watercolor art. We might speculate that it was the former that brought in more money. Perhaps that was so, but in fact, numerous Sneden watercolors of the country estates of prosperous New Yorkers were rendered into engravings, indicating another source of income. He may have hoped the sale of his wartime sketches would bring in even more money. But aside from one image he sold to *Frank Leslie's Illustrated Newspaper* in 1865 there was no encouragement on this front. Neither did professional success reward his architectural efforts. None of the grand projects to draw "Architectural and Perspective Drawings, Plans of Hotels and Manufactories" materialized anywhere beyond Sneden's imagination or on his business card.

Instead, he spent more and more time reliving the war through the writing of his massive illustrated memoir based on his diaries and shorthand notes and sketches. He turned inward with an obsession that grew until he had compiled thousands of pages of text and hundreds of watercolors, sketches, and maps. He might have hoped to publish his work in its entirety as a history of the Civil War combining his personal story with a more general account. Certainly, portions of his account go beyond his own experience, including lengthy discussions of strategy, army movements, and analysis of army leadership. He occasionally interjected information that came from secondary sources or other published primary accounts.

Two decades after he sold the image to *Frank Leslie's*, he placed another one in the final installment of *Century* magazine's "Battles and Leaders of the Civil War" series. Several dozen more Sneden watercolors appeared in 1887 as engravings in the expanded hard-

Robert Knox Sneden

back edition of *Battles and Leaders*. Later still, *Century* used an engraving of his sketch of the gate at Andersonville in an 1890 article on prisons. The fees he received for these illustrations must have given Sneden hope that at last his art would be recognized and perhaps his words as well. But it was not to be. Nothing more of his wartime art appeared in print, and none of his words did.

The income from selling his watercolors and plans for the occasional small building, and his surveys of rural mills and farms, did not bring in enough money. Like thousands of other Union veterans, in the 1880s Sneden began a long-running campaign with bureaucrats in Washington to secure a pension. He argued that the government owed him for back pay during his thirteen months of imprisonment and for personal property that the Confederates took from him at Brandy Station, Virginia. Failing to convince his correspondents on these issues, he hoped for better luck by applying for a disability pension. The medical legacy of

Robert Knox Sneden, taken at South Beach Resort,
Staten Island, N.Y., July 11, 1911.

imprisonment was debilitating, Sneden claimed. He argued that kidney trouble and rheumatism "have unfitted me ever since to withstand changes to the weather and traveling in my profession, and I have generally to abandon all business in the winter's months, go home to the country and thereby lose work, and money."

As his commissions for surveys and building plans dwindled, his efforts for a pension intensified. One friend testifying in Sneden's behalf said he "earns a very precarious living" and echoed the artist's plaint that illnesses contracted in the service of the republic lay behind his inability to earn a decent living. The government doctors who examined Sneden found the scar inflicted by Mosby's soldier who pistol-whipped him on the night of his capture, but they detected no physical evidence to convince them of the kidney or rheumatic complaints. In fact, they pronounced him in reasonable health for a man in his seventies and finally awarded him a tiny pension of only $8 a month based on general disability.

By that time both of Sneden's parents were dead. He had moved back to stay with his mother in Greenwich, Connecticut, when his father died in 1877. She supported him, though they did not even own the house they lived in. After her death, there cannot have been much left to the $800 inheritance she had received from her husband. By the turn of the century, Sneden began to weigh the unpleasant prospect of moving to an institution for indigent veterans. With a pitiful appeal for an increase in his monthly allotment, he told the commissioner of pensions that he could "see nothing in view to help me financially but to go to the 'Soldiers Home' at Bath, N.Y. unless you grant me an increase of pension. I do not want to go to the 'Home' if I can possibly help it." But he could not help it, and in 1905 he joined two thousand other Union veterans at Bath in the Finger Lake district of western New York.

There is evidence that Sneden continued to sketch and add to his scrapbooks right up to the time he moved to Bath. A cranky, peculiar old man, heavy set and solitary in his ways, he appears to have had little contact with his siblings. He had been shot at on half a dozen battlefields and walked out of as many Confederate prison camps, unlike thousands of his comrades. He survived all of that but succumbed at last at the age of eighty-six in 1918. He was buried near the Soldiers' and Sailors' Home, at the national cemetery in Bath—section J, row 11, grave 4. He never married, but left, as he wrote a local historian interested in the Sneden family's genealogy, "a good WAR RECORD." By that he may have meant the mammoth memoir and the collection of watercolors that documented his war and that appear in these pages.

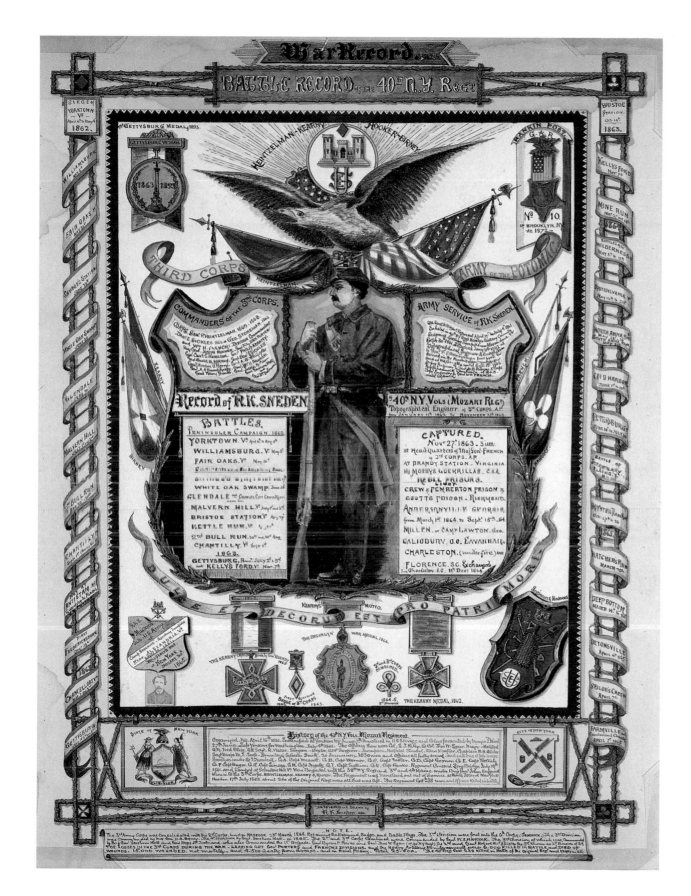

Private Robert Knox Sneden's war record.

The Civil War was the subject of three broad categories of art—works drawn for publication during the war in illustrated newspapers, soldier art done largely for personal gratification, and works executed after the war, sometimes based on wartime sketches.* The categories overlap and Sneden's works falls into all three types to varying degrees. Of his 900 watercolor scenes and maps, about half are based on wartime sketches, the rest being derivative postwar images. He also contributed to the illustrated newspapers. Although sixteen "special artists" sent into the field by those papers produced 2,625 published views, Sneden was among about 300 others, mostly service personnel, who had at least one drawing published. These men were responding to advertisements such as one from May 11, 1861, in the *New York Illustrated News*: "Any one, in any part of the country, who will send us faithful sketches or scenes connected with the war, however roughly they may draw, will be heartily thanked by the proprietors of this paper. If the sketches are used, they will be liberally paid for."

On several occasions Sneden records in his memoir having sent sketches to *Frank Leslie's Illustrated Newspaper*, but he does not give titles. What they were and whether they were published is unknown. The only Sneden image known to have been published was the view of the prison camp at Andersonville that appeared on October 21, 1865, months after the war ceased. The occasion for its appearance was the trial and eventual execution of camp commandant Henry Wirz.

The most important component of Sneden's output consists of those scenes and maps based on eyewitness experience. Before incarceration, like many mapmakers and engineers, he had ample opportunities to sketch. We know little, however, of his methods. Like the "special artists," he probably worked initially in pencil, perhaps in ink, but certainly not in watercolors. We know that as a prisoner he worked exclusively in pencil. "Specials" generally drew in haste, including detail in proportion to the available time, but often merely writing notes such as "trees here" or "two-story porch."

In October 1863, before returning to the field as a general's mapmaker, Sneden had the prescience to send his diaries and sketches home to New York. How finished they were is unknown. What is known from the work of the "specials" is that accuracy was inversely proportional to the length of time taken before the sketches were completed. For many years—apparently into the early 1890s—Sneden converted his wartime sketches into finished watercolors, apparently discarding the originals, none of which are known to remain. Depending on how finished they were when sent home, accuracy was at the mercy of memory.

Nor do we know why Sneden produced duplicate images in his memoir and his scrapbooks. It was fortunate, however, because the second volume of his memoir was burned in a fire at the Century Company while his drawings were being considered for *Battles and Leaders of the Civil War*. As a result, we lack his narrative for the important months of May and June 1862, as McClellan approached Richmond during the Peninsula Campaign. But we do have some watercolors and extended captions of the army's progress through places such as New Kent Court House because of images in the scrapbooks. Perhaps the scrapbooks were a form of insurance.

*The best general source, from which many of the quotations about artists are taken, is Harold Holzer and Mark E. Neely, Jr., *Mine Eyes Have Seen The Glory: The Civil War in Art* (New York: Orion Books, 1993). Also useful are Hermann Warner Williams, Jr., *The Civil War: The Artists' Record* (Washington, D.C., and Boston: Corcoran Gallery of Art and Museum of Fine Arts, Boston, 1961), and Doranne Jacobson, *The Civil War in Art, A Visual Odyssey* (New York: Smithmark Publications, 1996). For the role of the "specials," not dealt with in this essay, see *The Civil War, A Centennial Exhibition of Eyewitness Drawings* (Washington, D.C.: National Gallery of Art, 1961). For the *Century Collection* and *Battles and Leaders of the Civil War*, see Stephen W. Sears, ed., *The American Heritage Century Collection of Civil War Art* (New York: American Heritage Publishing Co., 1974).

Although we do not know how much time elapsed before Sneden completed his initial sketches, clearly there are inaccuracies in some of his works. His sketch of Westover on the James River shows the mansion without its prewar wings, merely flanked by two detached frame or log buildings, although both are present in an 1864 sketch by E. L. Henry. Accordingly, even sketches of places where we know he was present must be approached with caution.

Evaluating the importance of Sneden's work necessarily involves comparison to other soldier artists. There were many. Only a few, however, left bodies of work in any way comparable to Sneden's. One, Conrad Wise Chapman, a Confederate, was prolific but mostly sketched portraits of soldiers and genre scenes of military life, hardly duplicating Sneden's subject matter at all. Another southerner, William Ludwell Sheppard, romanticized the war when converting his wartime sketches to finished postwar productions, serving a different purpose than Sneden's art, which aimed at straightforward documentation.

There were some soldiers who, like Sneden, aimed for realism in their sketches. John Jacob Omenhausser, a Confederate private with no artistic training, is known as "the Point Lookout Artist" because of his 184 images of prisoner life at Point Lookout, Maryland. He produced far more prison images than did Sneden, and unlike Sneden does not seem to have redrawn them after the war, but his body of work lacks the breadth of Sneden's subject matter.

Other Confederate soldiers left only a few images each. Union soldier artists were more plentiful than their Confederate counterparts because of raw numbers and, perhaps, the greater availability of artist's supplies. Edward Lamson Henry and Julian Scott were primarily easel artists. Henry's much-admired postwar paintings were based on wartime sketches, but only from a few months in late 1864. Much of Scott's work consisted of heroic portraits or grand battle scenes to which Sneden never aspired. Xanthus Smith's sketches were primarily nautical. More similar to Sneden was Charles W. Reed, who, like Scott, enlisted at fifteen. He rose from bugler to engineering officer in the Army of the Potomac. Hundreds of his sketches are at the Library of Congress. Like Sneden, he redrew his initial pencil sketches in pen-and-ink after the war. Some were published to accompany J. D. Billings's *Hardtack and Coffee* in 1887. Others appeared in *Battles and Leaders*. Both derived from his wartime sketchbook.

Postwar art had many dimensions. Some of Winslow Homer's Civil War art was done after the war from sketches made when, before May 1862, he was a "special." In another vein, Benson J. Lossing set out sketching for his *Pictorial History of the Civil War*, which he hoped would equal the success of his prewar *Pictorial Field-Book of the Revolution*. To produce the sketches, many of which survive, he visited all theaters of the war. He drew the scenes of war after the fact, but some of Sneden's scenes—such as of the battlefield of first Bull Run—were also done after the fighting if not after the war. The main deficiency of Lossing's work in comparison to Sneden's is the absence of any activity—a landscape without a war.

Much postwar art was done by men who never experienced the war firsthand. In the 1880s the preeminent painter of Civil War scenes was Gilbert Gaul (1855–1919), who had barely turned ten when Lee surrendered. By then, a quarter century after Appomattox, those who *had* fought were ready to put down their recollections on paper and share them with others. The veterans had reached their forties, when historical consciousness seems in many to begin, and enough time had passed for passions to cool and for historical perspective to set in. Sneden and his illustrated memoir fit neatly into this context, and they coincided with a major publishing endeavor that was launched in 1884 and offered monetary rewards that prompted a flood of wartime recollections.

In an attempt to revive the fortunes of the financially troubled *Century* magazine, assistant editor Clarence Buel developed a scheme to publish accounts of Civil War battles as told by surviving officers on both sides. Beginning in November 1884 and for the next three years, each monthly issue of the magazine featured installments in a series titled "Battles and Leaders of the Civil War." A key component of the articles were scores of accompanying illustrations, many of them supplied by veterans. Within a matter of months, the series was a commercial success. Circulation of the magazine doubled. As word spread that *Century* was paying its authors and illustrators good money, veterans inundated the magazine's offices with letters to the editors, draft articles, illustrations, and even war relics.

After publication of the final installment in late 1887, the editors rushed into print a greatly expanded, four-volume hardcover compilation, also named *Battles and Leaders of the Civil War*. It featured even more illustrations than the original magazine version. In all, some 200 Union and Confederate veterans contributed their recollections, and more than 1,700 images illustrated the expanded edition. Like the magazine series, the bound *Battles and Leaders* was a commercial bonanza, earning the Century Company a million dollars, a very profitable showing for that day.

Sneden may have seen the project as an opportunity to compensate financially for a less than successful professional career. Possibly through personal connections from his old regiment, the 40th New York Volunteers, whose chaplain had been the father of *Century*'s owner, Sneden managed to have nearly three dozen of his watercolors selected for conversion into engravings, mostly for volume 2 of *Battles and Leaders*, covering the Peninsula Campaign.

How many images he submitted is unknown, but thirty were published, and at least four were redrawn by Century Company artists but not used. Because of the varied quality of submissions, it was *Century*'s practice to have all originals redrawn by its stable of illustrators. Edwin J. Meeker redrew twelve of Sneden's images from northern Virginia and of the Peninsula Campaign. Charles A. Vanderhoof redrew fourteen Sneden sketches, mostly from the Peninsula Campaign, but including four from Pope's Northern Virginia Campaign and one of "Castle Pinckney, Charleston Harbor" from the time of Sneden's exchange. Harry Edwards (1868–1922) revised two views of Savage's Station. I. Walton Taber, whose 250 reworked drawings were the most of any *Century* artist on the project, did four Sneden images—Fort Monroe; the prison at Florence, South Carolina; and two of Andersonville. Hughson Hawley (1850–1936) redrew Sneden's "Sprout's Spring Mill, Oppequon River" and "Appomattox Court House."

Century's editors published all of his submissions as "based on a wartime sketch." The two redrawn by Hughson Hawley, however, were not. Sneden never was on the Oppequon River near Winchester and certainly not in September 1864, the date on the drawing, being still incarcerated at Andersonville. Nor is Sneden known to have visited Appomattox. Because the rest of Sneden's submissions were eyewitness representations, presumably *Century* assumed these two were also.

Although Sneden contributed to *Battles and Leaders*, a number of his images are drawn *from* it. In many cases the source of Sneden's derivative images is not yet known, but a few of them can be directly traced to *Battles and Leaders*. Sneden's "Union Breast Works on Little Round Top, Gettysburg, Big Round Top in the Distance" has the identical long title of the image published by *Century*. Even more tellingly, his "View from the Position of Hazlett's Battery on Little Round Top Looking Across the Valley of Death" has the identical title of the image in *Battles and Leaders*. Sneden's caption for this image says it is taken from a photograph,

but it is probable that Sneden saw it in *Battles and Leaders*. Several other images that must be derivative seem to be taken from it also. In some cases he made slight alterations, just enough to make his work seem not to be a literal copy. His "Confederate Works on Willis's Hill" at Fredericksburg has the same vantage point as the *Battles and Leaders* image and only minor differences. Curiously, he dates it 1865. These dates generally are those of execution but do not mean that Sneden was the original artist.

Comparing Sneden's 900 documentary images to the works of easel artists such as civilian and one-time "special" Winslow Homer, or fellow soldier artist Julian Scott, is difficult. Sneden's work is not even necessarily more important than those of the prolific "specials" Edwin Forbes and Alfred Waud. Those men's works, however, have been known for more than a hundred years. The Sneden collection, apart from the approximately thirty images engraved for *Battles and Leaders* and the one published in *Leslie's*, is a fresh unpublished archive of Civil War imagery, the value of which is enhanced by the discovery of a diary/memoir that sheds light on the circumstances under which many of the scenes were first sketched.

When *Century*'s collection came to light and was acquired by American Heritage in 1973, Harold Peterson, then chief curator of the National Park Service, wrote, "I can say without reservation that these draw-

ings constitute the single most important collection of Civil War art to be discovered in this century." The Sneden trove is, to say the least, the most important discovery since then. Both collections consist of works redrawn after the war, *Century*'s by its illustrators, whose work is what survives, the originals having been returned to owners such as Sneden in the 1880s. Sneden at least redrew his own images, and if half of his work is not firsthand, neither is much of the *Century* collection.

The principal value of both collections lies in the works generated from eyewitness accounts. Although it is the case that Sneden's wartime sketches were sometimes faultily redrawn after the war, we know that the "specials" employed by the illustrated newspapers had the same problem during the war, and that most of Sneden's fellow soldier artists also redrew their work when the conflict subsided. Unlike the professional artists, however, Sneden never compromised his work for commercial motives.

We can be grateful for the relative integrity of Private Robert Knox Sneden's story and imagery. In these pages the grand project of his declining years—an illustrated history of the war—can be appreciated in its breadth and colorful magnificence.

Charles F. Bryan, Jr.
James C. Kelly
Nelson D. Lankford

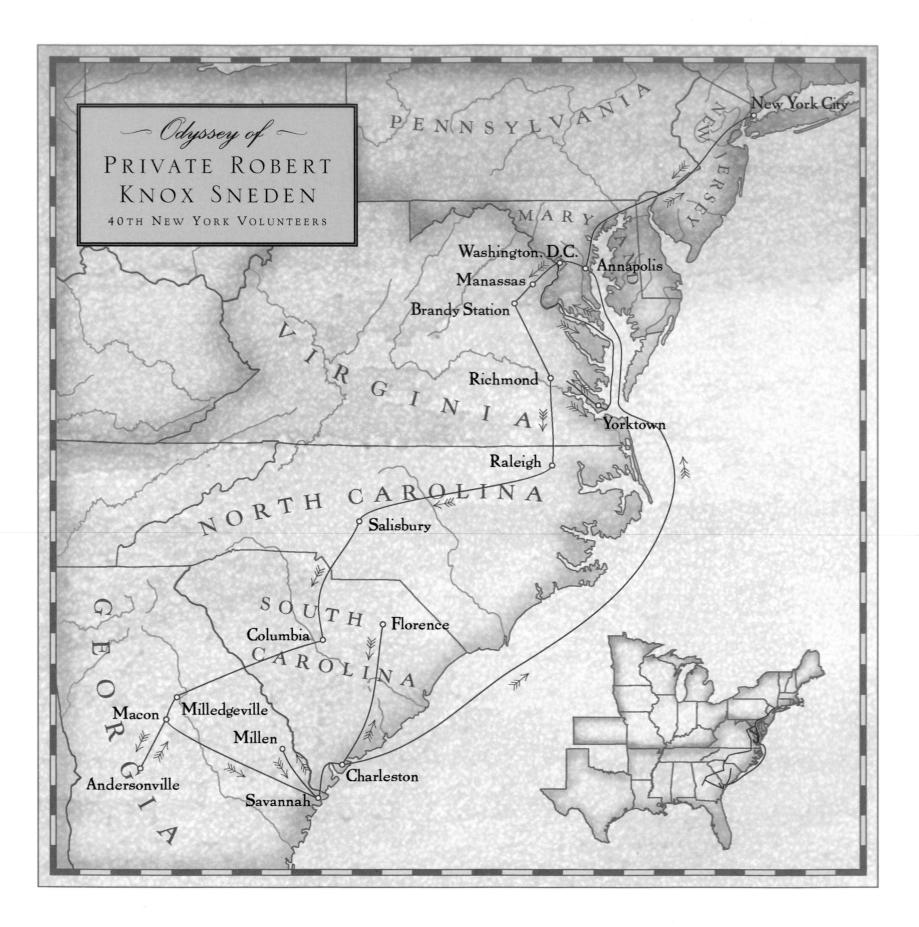

Odyssey of
PRIVATE ROBERT
KNOX SNEDEN
40TH NEW YORK VOLUNTEERS

PENNSYLVANIA

NEW YORK

New York City

MARY

NEW JERSEY

Washington, D.C.

Annapolis

Manassas

Brandy Station

VIRGINIA

Richmond

Yorktown

Raleigh

NORTH CAROLINA

Salisbury

SOUTH CAROLINA

Florence

Columbia

Macon

Milledgeville

Millen

Andersonville

Savannah

Charleston

GEORGIA

CHRONOLOGY

1831

JUNE 9 Marriage of John Anthony Sneden and Ann Knox, St. Paul's Anglican Church, Halifax, Nova Scotia.

1832

JUNE 3 Robert Knox Sneden is born in Annapolis Royal, Nova Scotia.

c.1850 Immigrates to New York with parents and siblings.

1858 Earliest known date of a Sneden water-color, *Sneden's Landing, opposite Dobbs Ferry, Hudson River, N.Y.*

1861

JUNE 14 Sneden is listed on the roster of the 40th New York Regiment as civilian assistant quartermaster; home address is listed as 50 Wall Street.

JULY 4 Stays behind to clean up encampment after the 40th New York is ordered to leave New York for Washington.

AUGUST 25 Leaves New York for Washington.

AUGUST 29 Arrives at Camp Sackett on Leesburg Turnpike, Va., where the 40th New York is camped.

SEPTEMBER 30 Enlists as a private in E Company, 40th New York.

NOVEMBER 16 Finishes a set of plans for construction of a redoubt on Leesburg Turnpike, Va.

1862

JANUARY 10 Captain William Heine, a topographical engineer for General Samuel Heintzelman, commander of III Corps, has Sneden transferred from the 40th New York to Heintzelman's staff at Fort Lyon, Va.

JANUARY 30	Sneden goes on raid near Colchester and Occoquan, Va., leading to the capture of Rebel prisoners after a firefight.
FEBRUARY 1	Observes Professor Thaddeus Lowe's hot air balloons in northern Virginia.
FEBRUARY 10	Nearly shot by a company of the 40th New York engaged in target practice.
MARCH 21	Boards steamship with Heintzelman's staff for the voyage to Fort Monroe, Va.
MARCH 24	Lands at Fort Monroe to begin Peninsula Campaign.
APRIL 7	Begins participation in the month-long siege of Yorktown, Va., making maps and coming under fire on several occasions.
MAY 4	Enters Yorktown.
MAY 4–24	Marches in pursuit of Confederate army to the outskirts of Richmond, Va.
MAY 5	Observes battle of Williamsburg, Va.
MAY 31–JUNE 1	Observes battle of Fair Oaks or Seven Pines, Va.
JUNE 25	Seven Days' battles begin.
JUNE 29	Sneden participates in battle of Savage's Station, Va.
JUNE 30	Participates in battle of Glendale, Va.
JULY 1	Participates in battle of Malvern Hill, Va.
JULY 2	Retreats to Harrison's Landing, Va., on the James River.
JULY 2– AUGUST 15	Makes several maps as the Army of the Potomac recuperates.
AUGUST 15–21	Army of the Potomac withdraws from the Peninsula and sails to Alexandria, Va.
AUGUST 25	Sneden goes south with Heintzelman to the front at Manassas, Va.
AUGUST 29–30	Participates in second battle of Bull Run or Manassas.
AUGUST 31– SEPTEMBER 1	Retreats with army to the outskirts of Washington.
SEPTEMBER	Remains at Heintzelman's headquarters in Alexandria.
OCTOBER	Remains on Heintzelman's staff, headquartered at Arlington House, Va.
DECEMBER 10	Moves from Arlington House to 15½ Street and Pennsylvania Avenue when Heintzelman is appointed to command the defenses of Washington.

1863

AUGUST 25	Colonel Thomas W. Egan of the 40th New York offers Sneden a post as engineer on his staff in the field; later Sneden moves to the staff of Generals D. B. Birney and William H. French, III Corps, Army of the Potomac.
SEPTEMBER 2–13	Sneden goes to New York on furlough.
OCTOBER 8	Leaves Washington to rejoin III Corps near Brandy Station, Va.; he mails his diaries and drawings home to New York.
NOVEMBER 18	At Miller's house, near Brandy Station, headquarters of General French, III Corps, Sneden learns the Mine Run Campaign is about to begin.
NOVEMBER 27	Just before dawn, Sneden is captured by men of Confederate irregular John Singleton Mosby at Brandy Station.
NOVEMBER 30	Arrives by prison train at Richmond, Va.; incarcerated in Crew and Pemberton Prison.

1864

JANUARY 2	Moves to Scott's building to work as prisoner-clerk helping inventory U.S. Sanitary Commission food and clothes to be distributed to prisoners.
JANUARY 16	When inventorying is nearly complete, Sneden decides to escape; steals a C.S.A. uniform coat and walks out of Scott's building past the guard but is recaptured by a patrol; is interrogated and returned to Crew and Pemberton Prison.

FEBRUARY 22	Is put on a prison train at Richmond and shipped south.
FEBRUARY 24	Arrives at Salisbury, N.C., prison camp.
FEBRUARY 28	Arrives at Andersonville, Ga., prison camp.
JULY 3	Witnesses an uprising of inmates against the Raiders in Andersonville.
SEPTEMBER 16	Leaves Andersonville for another prison camp.
NOVEMBER 12	Signs parole at Camp Lawton prison, Millen, Ga., to work for Surgeon Isaiah White, C.S.A.
NOVEMBER 23	Arrives in Savannah, Ga., to continue working for Surgeon White.
NOVEMBER 29	Leaves Savannah on train.
DECEMBER 3	Leaves Charleston, S.C., on train for the Florence, S.C., prison camp, still on parole to Surgeon White.
DECEMBER 8	Rejoins prisoners being sent from Florence to Charleston to be exchanged and sent home.
DECEMBER 9	Arrives in Charleston and is put in a temporary jail awaiting exchange.
DECEMBER 11	Is exchanged and boards the U.S. steamer "Varuna" sailing for Annapolis, Md.
DECEMBER 16	Fire on ship nearly causes disaster off Cape Hatteras.
DECEMBER 17	Steamer "Varuna" arrives at Annapolis.
DECEMBER 20	Sneden is paid off and takes train for Washington.
DECEMBER 26	Arrives in New York City.

1865

JANUARY 30	Sneden is mustered out of the 40th New York Regiment.
APRIL	Recuperates at Tarrytown, N.Y., in care of his cousin, Dr. James Thome Shaw. Sees Lincoln's funeral train.

MID-YEAR	Moves to Brooklyn, N.Y., and works with Carl Pfeiffer, architect, 4 Broad Street, for six months.
OCTOBER 21	One of Sneden's Andersonville drawings appears in *Frank Leslie's Illustrated Newspaper,* in connection with the hanging of Captain Henry Wirz, the Andersonville jailor.
END OF YEAR	Sneden begins twelve years' work as architect with William B. Olmsted.
1867	F. W. Beers's *Atlas of New York and Vicinity* includes engravings of Sneden's drawings of houses and views in Dutchess, Putnam, and Westchester counties.
1868	Sneden revises a two-volume atlas originally published by I. B. Culver & Co. in 1866.

1877

NOVEMBER 25	Sneden's father, John Anthony Sneden, dies at Greenwich, Conn., age 69, leaving all his possessions to his wife; Greenwich probate court assesses his estate at $1,006.58. Sneden moves to Greenwich.

1884

DECEMBER 10	Sneden submits his first application for a pension.
1887	Approximately 30 drawings based on Sneden watercolors appear in volume 2 of *Battles and Leaders of the Civil War,* the expanded four-volume work that first appeared in serial form in *Century* magazine during 1884–1887.
NOVEMBER 10	Sneden again applies for pension, citing typhoid fever in prison in Richmond and scurvy at Andersonville; also rheumatism in arms and legs; says his privations at Andersonville "have unfitted me ever since to withstand changes in the weather

and travelling in my profession, and I have generally to abandon all business in the winter's months, go home to the country and thereby lose work, and money." Says his work requires him to do outdoor surveys. "I have to travel very often to survey mills and farms, which takes me into New York, Pennsylvania, Massachusetts, Connecticut, Rhode Island, and elsewhere."

1888

DECEMBER 5 Henry E. Gotleb, former captain of Company E, 40th New York Regiment, certifies that he has known Sneden since 1856, and that Sneden was in the 40th New York.

1892

JANUARY 13 Sneden's mother, Ann Knox Sneden, dies at Monsey, N.Y., and is buried with her husband at Christ Church cemetery in Greenwich, Conn.

1901

AUGUST 15 Sneden now living at Monsey, N.Y., but planning to move soon to either Bath, N.Y., or Chicago, Ill.

1904

MARCH 17 Writes to commissioner of pensions in Washington: "See nothing in view to help me financially but to go to the 'Soldiers' Home' at Bath, N.Y. unless you grant me an increase of pension. I do not

want to go to the 'Home' if I can possibly help it."

1905

JUNE 22 Enters New York State Soldiers' and Sailors' Home at Bath, Steuben County, N.Y.

1909 Listed in Frederick Floyd's *History of 40th (Mozart) Regiment, New York Volunteers.*

1918

SEPTEMBER 18 Dies at New York State Soldiers' and Sailors' Home, Bath, age 86; buried at Bath national cemetery, section J, row 11, grave 4. Scrapbook albums and memoir volumes are inherited by his nephew.

c. 1930s Scrapbook albums are given to the Ash family when Sneden's nephew is unable to repay the money they loaned him.

1936 New-York Historical Society purchases five watercolors signed by Sneden, dated 1858, 1859, 1865, 1876, and 1883.

1993 Virginia Historical Society purchases the scrapbooks from Charles Ash.

1997 Virginia Historical Society purchases the memoir volumes.

2000 Publication of *Eye of the Storm.*

2001 Publication of *Images from the Storm.*

PART ONE

LEARNING TO SOLDIER

SELDOM IN AMERICAN HISTORY HAVE MEN been more eager to go to war. After Confederate forces fired on Fort Sumter on April 12, 1861, and President Lincoln called for 75,000 volunteers to put down the rebellion in the South, hundreds of thousands of Northern men streamed into recruiting stations to join newly formed regiments. Within a matter of months, New York City alone fielded sixty-six regiments, including the 40th New York Volunteers or Mozart Regiment. Probably through social contacts, Robert Sneden got himself appointed as the 40th's assistant quartermaster, a civilian post he held until joining the regiment as a soldier several months later.

Despite avoiding the initial travails of basic training, it was a busy time for Sneden. A constant supply of quartermaster and commissary goods had to be forwarded to the new troops. But his was only one part of a huge job of turning citizens into soldiers. Training camps sprang up throughout New York in almost any place fit for teaching the rudiments of warfare. After several weeks in Manhattan, the 40th New York moved ten miles upriver to Yonkers on the Hudson River, first to an old flour mill, then to a large field on the edge of town.

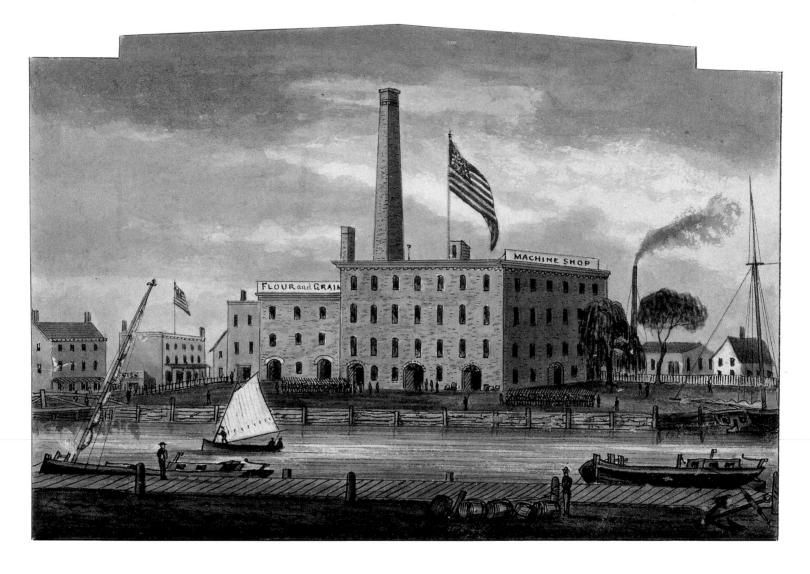

"After inspection [on] June 7, the regiment was marched to the foot of Canal Street, New York City, where it was transported in large barges towed by steam tugs to Yonkers on the Hudson River. [It was then] quartered in the large brick flour mill and machine shop (now empty) near the canal and steamboat landing. . . . The men were crowded even in this large building. Constant drilling was had on the two upper floors while the tramping shook clouds of dirt and flour dust through the board ceilings. Finally the men's quarters got so dirty that they had to be moved somewhere else."

View of barracks of the Mozart Regiment [40th New York Volunteers] at Yonkers, N.Y., June 1861.

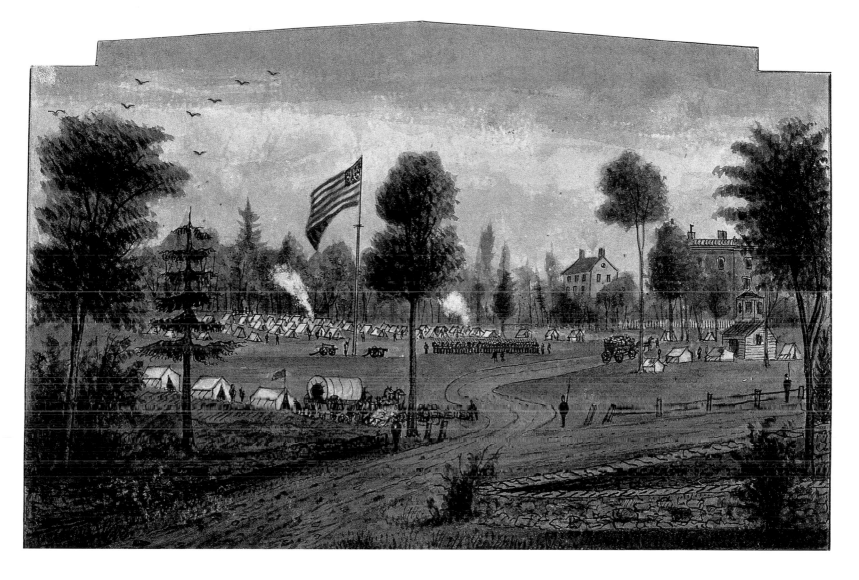

"A large field was then selected about a mile from the landing. Tents were sent up from New York, [and] the regiment went into camp [and] for the first time . . . they had ample room for all military evolutions. Guards were established . . . drilling was constant, [and] dress parades every day attracted large numbers of the inhabitants of Yonkers, while a drum corps and a 6 pounder howitzer made things look warlike. . . . The regiment soon attained a high degree of discipline."

Encampment of the Mozart Regiment at Yonkers, N.Y., known as "Camp Wood," July 3, 1861.

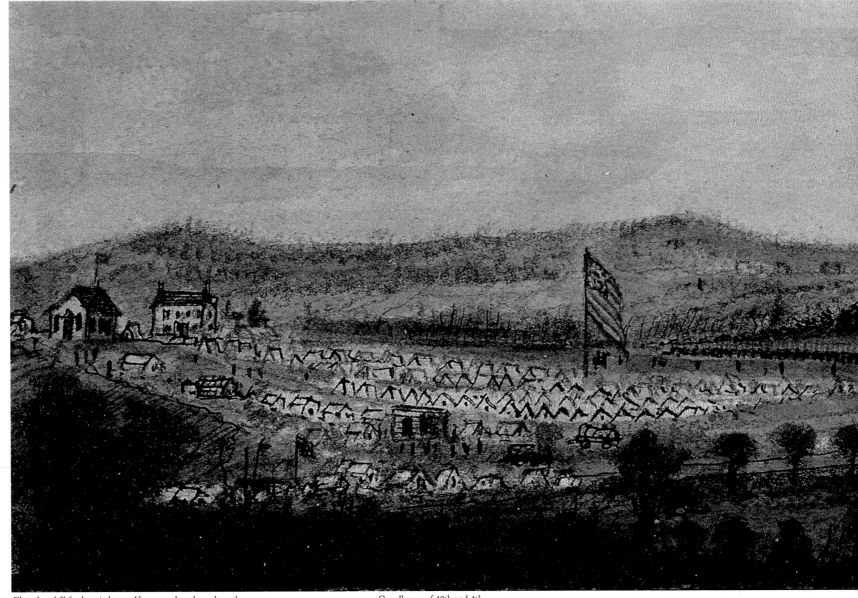

Chapel on hill for hospital, House on the telegraph road Guardhouse of 40th and 4th,
40th Regiment General John Sedgwick's headquarters

In early July the 40th New York Regiment left for Washington, and after cleaning up the camp Sneden joined them in late August as a private. This section captures his pre-battle experiences, quartermastering and mapmaking, including sketching the camps, fortifications, and earthworks going up around Washington. In addition, he began to keep his daily journal, providing insights into army life and detailed descriptions of a once-peaceful landscape that was rapidly becoming scarred by war. His journal entries and accompanying sketches vividly portray the newly christened Army of the Potomac in its infancy.

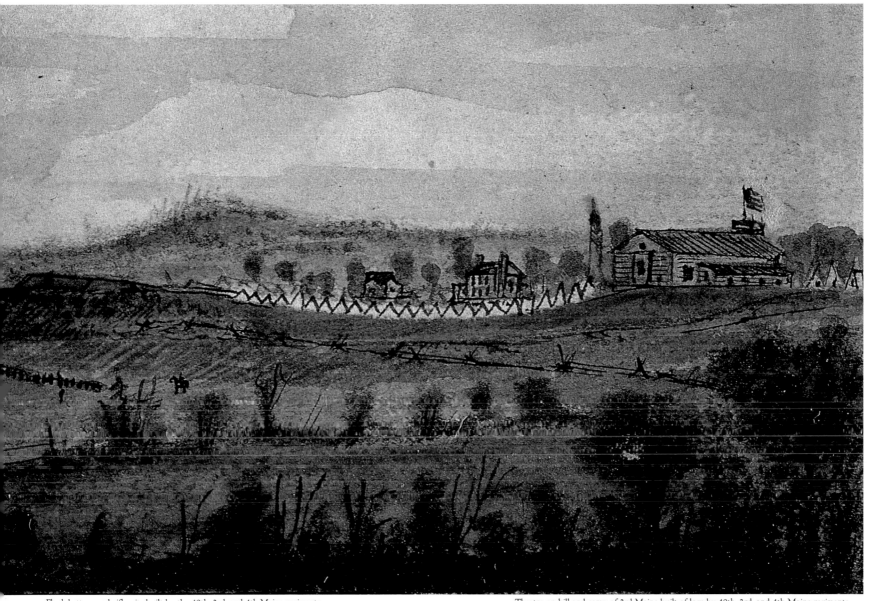

Flank battery and rifle pits built by the 40th, 3rd, and 4th Maine regiments

Theatre on hill and camp of 3rd Maine built of logs by 40th, 3rd, and 4th Maine regiments
Fowle's house on hill

September 1, 1861. "Fine weather. Most of the regiments on this side of the Potomac have daily to send large detachments of men to work on the numerous forts and rifle trenches now being made. . . . There is constant drilling going on in all the regiments, besides brigade drills every fine afternoon. Drum corps are practicing all day target shooting. . . . Fatigue duty on the forts and picket duty keep everyone very busy."

Encampment of the 40th New York Volunteers (Mozart Regiment), Leesburg Turnpike, Va.

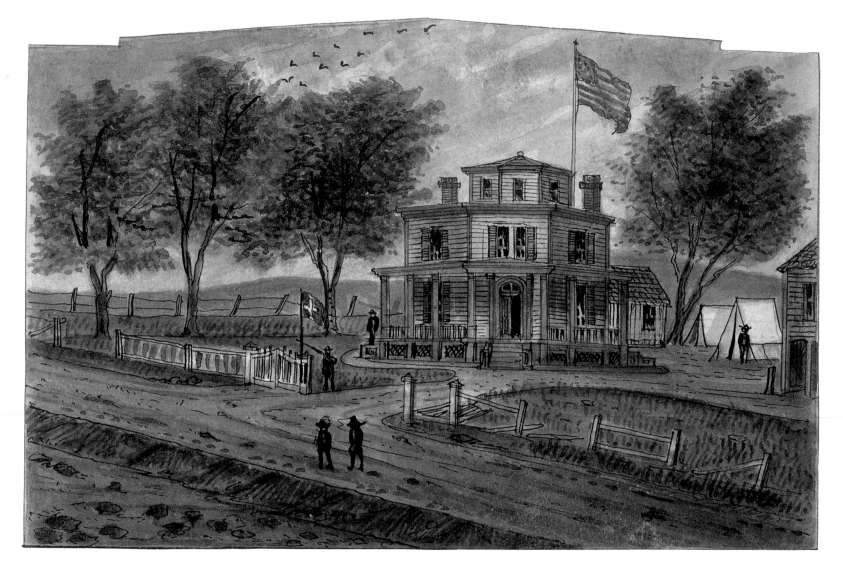

September 20, 1861. "Today the tents of the 3rd and 4th Maine, the 38th New York and 40th New York regiments were struck [and] loaded on the wagons and all moved out from the vicinity of the Octagon House two miles further on the Leesburg Turnpike beyond camps of all other regiments and encamped on Fowle's Plantation."

View of the Octagon House on the Leesburg Turnpike, Va., headquarters of Brigadier General John Sedgwick, U.S.A., November 1861.

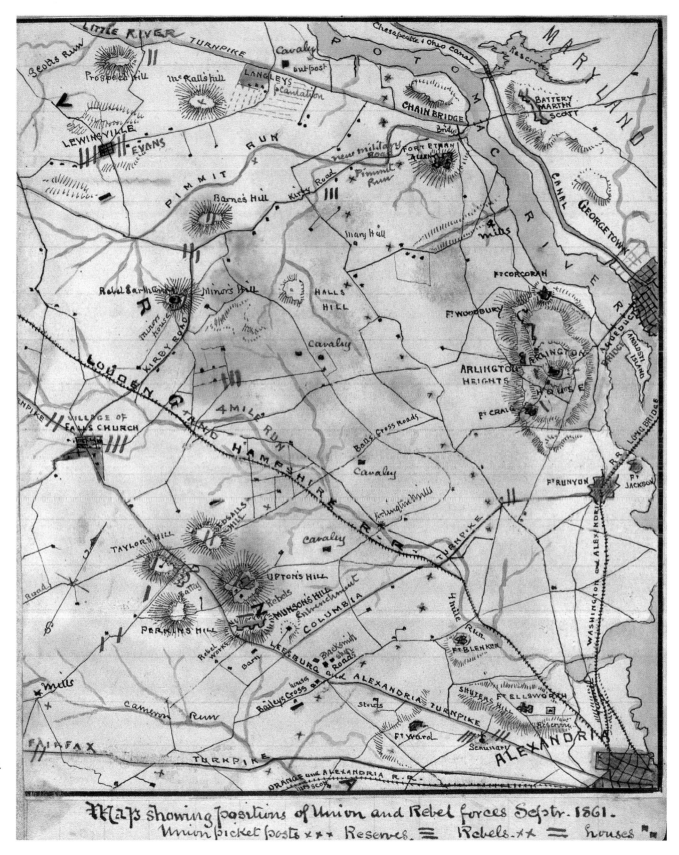

Map showing positions of Union and Rebel forces, September 1861.

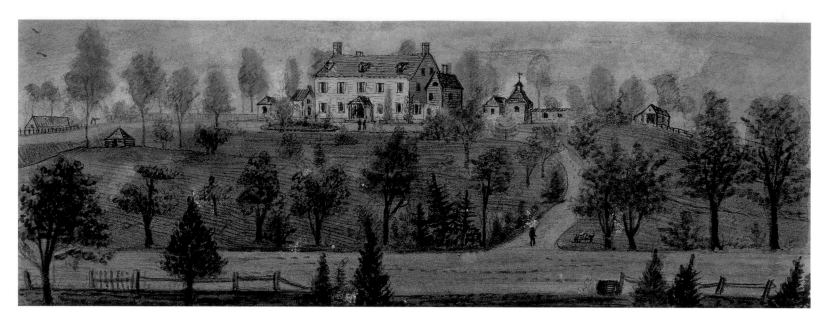

September 25, 1861. "[I] went to the residence of Commodore French Forrest, once of the U.S. Navy now in the service of the Rebels. The Forrest mansion had been a fine one, but the soldiers had torn down and burnt the inner doors and sawed up mahogany bedsteads, chairs, wardrobes, etc., which had all gone for firewood. Not an article of furniture had been left, but the piano. The keys of this had been smashed with the butt ends of muskets. All the strings and movements carried off for relics, while the box frame was outside the front door and served as an oat trough for cavalry pickets who had been here a month ago."

Residence of Commodore French Forrest, C.S.N., picket post of 38th and 40th New York Volunteers, September, 1861–March 12, 1862. The interior was completely gutted by the soldiers here on guard. The regiment built the fort on hill and and the log theatre where performances were had from now to March 1862. The land belonged to Mr. Fowle, secessionist.

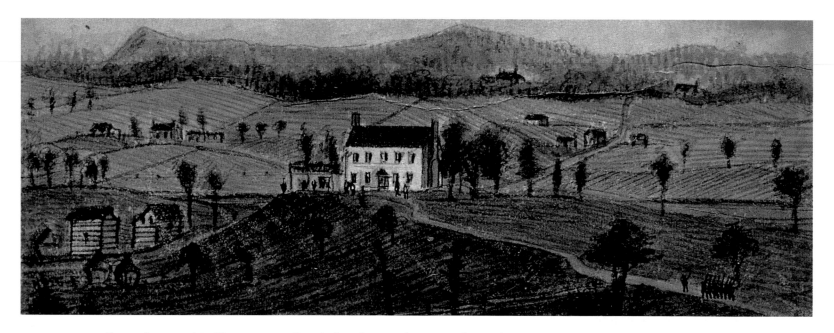

September 25, 1861. "I . . . went to Stout's farm house where our other pickets were. Mrs. Stout and her daughter [were] at the house, and though a 'Secesh' [she] was glad to get salt, tobacco or sugar from our fellows. They got bacon and corn meal in return which was a great luxury at this time. We brought our own rations when leaving camp to last two days but they were all devoured in one day. So we had to forage or buy what we could from Mrs. Stout."

Stout's Farm on the Souder & Hampshire Railroad, Va., picket post of the 40th New York Volunteers. Sketched October 25, 1861.

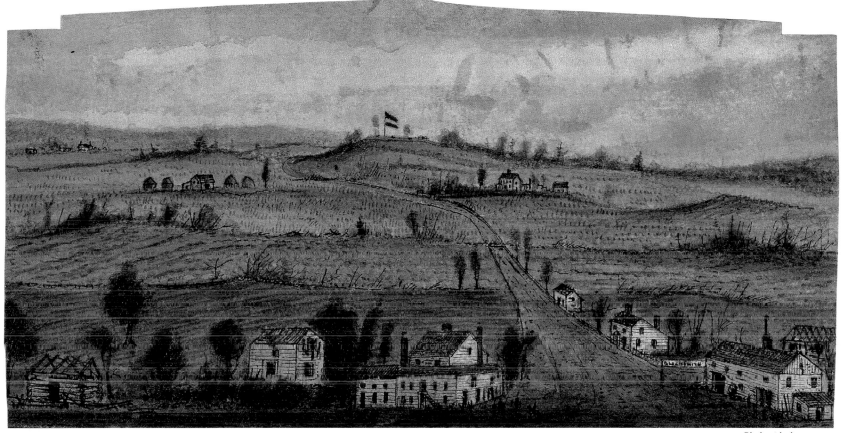

Blacksmith shop

September 27, 1861. "I went out to Bailey's Cross Roads early this morning. . . . Two or three new guns had been mounted on the low parapets of the work by the enemy, while on them stood several of the Rebels with glasses who were surveying our position. Several shots were fired by our men at them, who were concealed in the corn field at the second ridge in front, but at such a long distance none of the Rebels seemed to be hit. The enemy built a second line of obstructions across the road nearer to the works, but none of their men could be seen as they were hidden behind the well of the hills and in the corn field. Several large piles of fence rails and stones were thrown up in places below the works, which I surmised were rifle pits or shelter for their sharpshooters."

View of Munson's Hill from Bailey's Cross Roads, Va., September 1861.

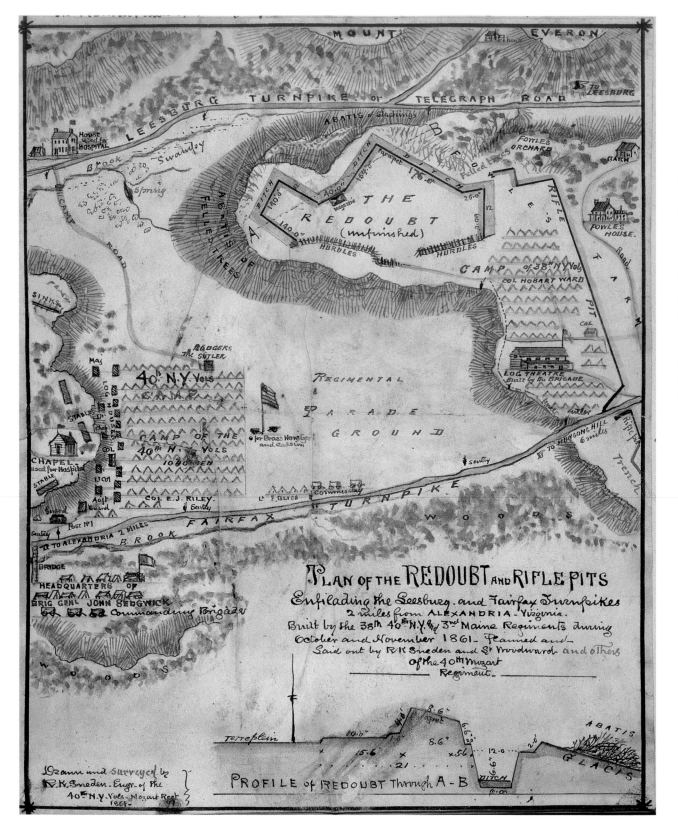

The map contains the following labels and annotations:

MOUNT EVERON

To LEESBURG

LEESBURG TURNPIKE or TELEGRAPH ROAD

ABATIS of Slashings

House used for Hospital

Brook Swamp

Spring

THE REDOUBT (unfinished)

DITCH — PARAPET — DITCH

Felled Trees

FOWLES ORCHARD

BARN

FOWLES HOUSE

ABATIS OF FELLED TREES

Magazine

HURDLES

HURDLES

CAMP of 38th N.Y. Vols

COL. HOBART WARD

RIFLE PITS

CAMP ROAD

SINKS

R. ROGERS THE SUTLER

Maj

40th N.Y. Vols

CAMP

LOG HOUSES

STABLES

CAMP OF THE 40th N.Y. VOLS

1060 MEN

COL. E. J. RILEY

CHAPEL used for Hospital

STABLE

Act Guard

Guard

Host N°1

Sentry

To ALEXANDRIA 2 MILES

BROOK

BRIDGE

REGIMENTAL PARADE GROUND

6 for Brass Howitzer and Caisson

LT F. BLISS

Commissary

Sentry

To MUNSONS HILL 6 miles

Rifle Pit Trench

LOG THEATRE Built by the Brigade

BARN

COL

FAIRFAX TURNPIKE

WOODS

HEADQUARTERS OF BRIG GENL JOHN SEDGWICK Commanding Brigade

WOODS

PLAN OF THE REDOUBT AND RIFLE PITS
Enfilading the Leesburg and Fairfax Turnpikes
2 miles from ALEXANDRIA - Virginia.
Built by the 38th 40th N.Y. and 3rd Maine Regiments during
October and November 1861. Planned and
Said out by R.K. Sneden and St Woodward and others
of the 40th Mozart
Regiment.

Drawn and surveyed by R.K. Sneden - Engr. of the 40th N.Y. Vols - Mozart Regt 1861.

PROFILE of REDOUBT Through A - B

Terreplein

DITCH

ABATIS

GLACIS

November 16, 1861. "Working detachments from the 40th New York and 38th New York regiments broke ground for a redoubt and line of trenches to stretch across the camps from [the] telegraph road on one side to across the Leesburg Turnpike on the other. . . . I furnished a set of working drawings for the work. . . . The men were put to work felling trees for abatis . . . and digging a ditch 12 feet wide and 6.6 feet deep. A whiskey ration was issued to the men both before going to work and when the day's work was done."

The redoubt built by the 40th New York Regiment at Mount Everon, Va., between the Leesburg and Fairfax turnpikes.

On his many excursions to the picket lines in northern Virginia, Sneden sketched most of the area's landmarks, including Fairfax Court House, the site of some of the Civil War's earliest fighting. Often caught between enemy lines, the building was used as a signal post and headquarters building throughout the war.

Fairfax Court House, Va., October 30, 1861.

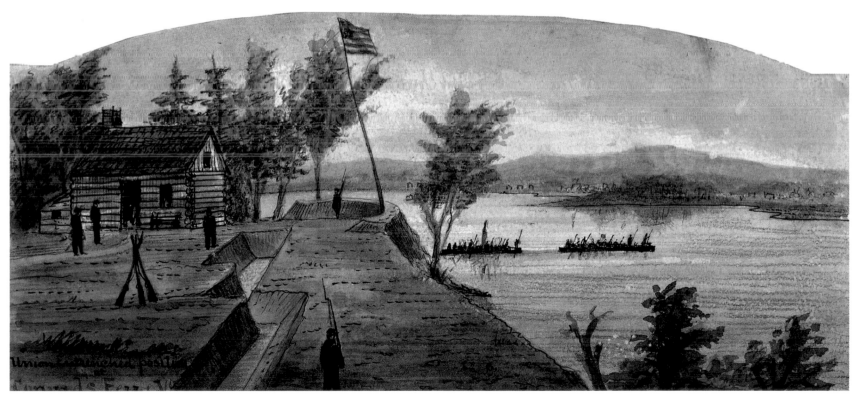

In this sketch, Sneden portrays one of the numerous Potomac River ferries between Maryland and Virginia contested by the opposing armies. Conrad's Ferry was located near the site of the disastrous Union defeat at Ball's Bluff on October 21, 1861.

Conrad's Ferry, Upper Potomac River, Md.

View of Fort Lyon, Alexandria to Fort Ellsworth, Va., from the rear of camp of the 40th New York Regiment, October 1861.

Fort Ellsworth Camp of 4th Maine volunteers on Leesburg Turnpike

November 16, 1861. "The men get on sprees while in Alexandria on a few hours' leave, and fill the guard house on their return to camp. An officer can go to Washington, see the sights and have a good time at Willard's Hotel or elsewhere. The privates must stick to the Virginia mud. Many fights take place between the men belonging to different regiments, while returning to camp in a semi-drunken condition. Sometimes a whole company in camp [has] to be turned out armed to . . . quell and arrest the rioters."

November 16, 1861. "Captain [John M.] Cooney of the 38th New York Regiment . . . started work on a log theatre* for the amusement of the men and officers in the camps of the brigade. . . . Axe men were detailed to chop down every tree on Fowle's plantation and the neighboring one to get suitable logs for a building to hold 1,500 to 2,000 men. The warehouses of Alexandria long since empty were to furnish the flooring. Sails from the vessels now rotting at the wharves were to be used inside over the logs for walls, while all the house painters and artists were to work designing scenery to be painted on ship sails for canvas."

December 3, 1861. "The brigade's theatre was completed and open for inspection today. . . . The orchestra is to be made up from some of the 3rd Maine Regiment band, while a good Negro minstrel troupe from G and H companies of the 40th will perform on the off nights. There are several amateur actors in the 38th New York, prominent of whom is Captain Cooney. Regular comedians will be hired at Washington to come out here. . . to act when all is ready. The prices are $5 for the upholstered boxes, 50¢ for gallery seats, and 25¢ for seats on the ground floor."

*See illustration, page 5.

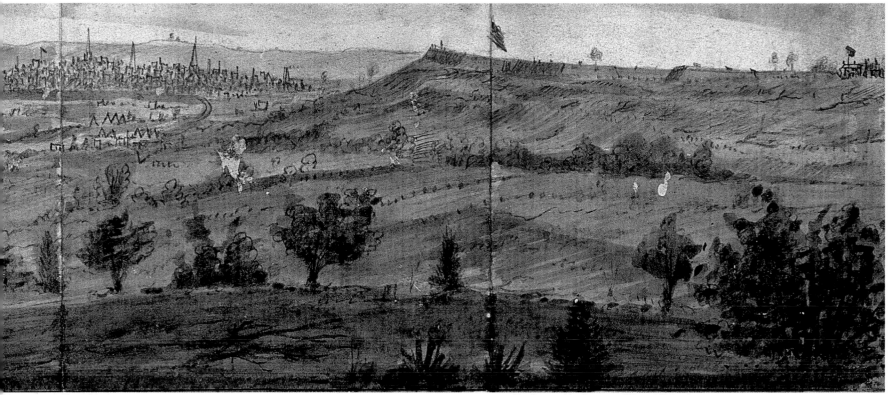

Alexandria

Fort Lyon and headquarters of General Heintzelman

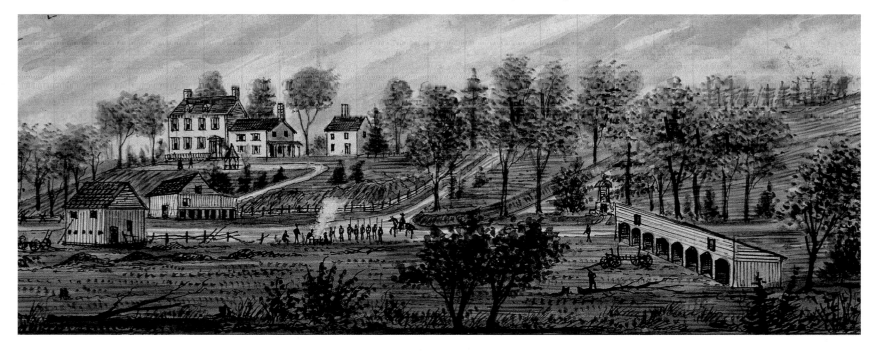

December 1, 1861. "The pickets of the 40th Regiment were fired into last night by skulkers in the woods between Mrs. Scott's and Stout's houses. None of our men were hit. One had his gun struck by a bullet which tore the cock off, just as he was about to fire."

Main picket post of the 40th New York Volunteers at Mrs. Scott's house, near the Leesburg Turnpike, Va., September and October, 1861. Here Major Scott, C.S.A., was captured.

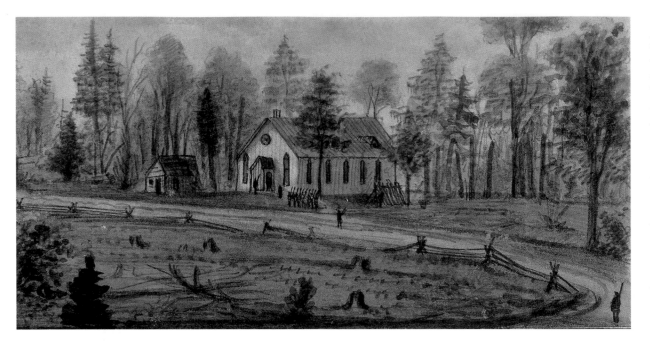

December 2, 1861. "I went out on picket duty today with part of a company of the 40th Regiment [to] . . . Olivet Church. . . . The church itself was half torn down by our men on guard. All the windows were carried off to camp . . . as well as the pews, iron work, [and] doors to make flooring for tents. One fellow had two church windows for a tent set on edge at an angle like a shelter tent."

"Olivet Chapel," Old Fairfax Road, Va., picket post of 38th and 40th New York Volunteers, September 1861..

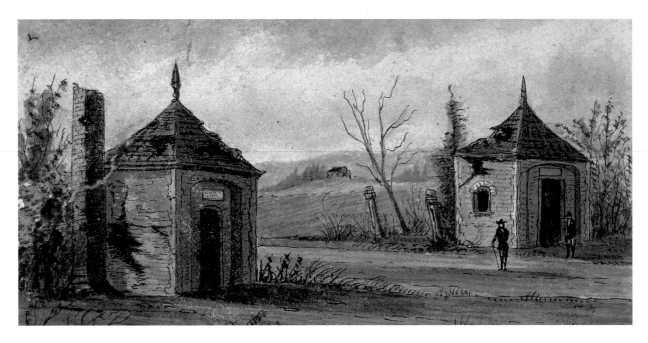

Ruins of old gate lodges, back of Mount Vernon Estates, October 1861.

December 23, 1861. "I went to Mount Vernon with three of the 40th [New York] today. At the mansion we were received by a man who has charge of the premises who showed us all over the house and grounds. The agent said that 'sometimes our fellows were there and sometimes the Rebels.' All were looking for relics to plunder, or something to eat. In one room was the harpsichord or spinet once played on by Martha Washington. One of our fellows managed to detach a brass screw from it as a relic, although the man was in the room keeping a lookout at the time. In the hall was the key of the Bastille [in] Paris, in a glass case. It was given to Washington by Lafayette. The mansion itself had a very imposing appearance, situated on a high knoll from whence a splendid view of the Potomac was had for miles up and down."

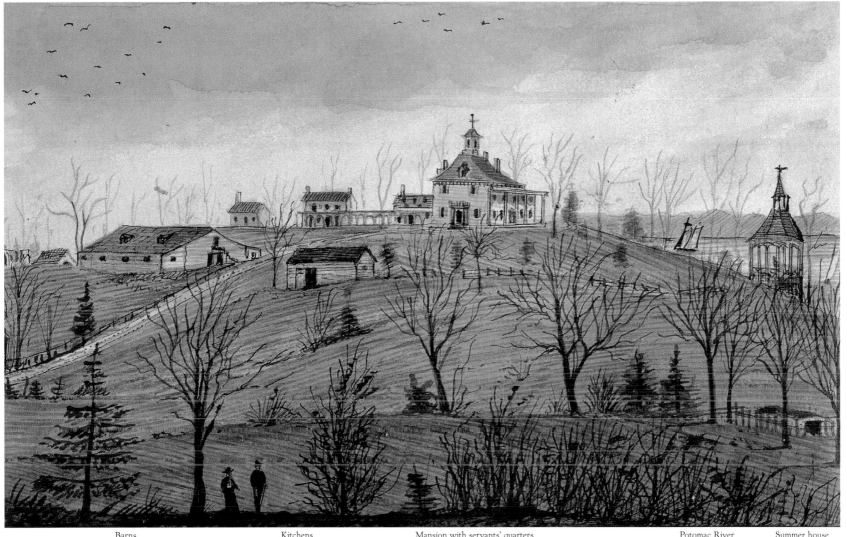

| Barns | Kitchens | Mansion with servants' quarters | Potomac River | Summer house |
| | | | | Old tomb in ruins |

December 23, 1861. "The house was much in need of repairs. . . . All the outhouses, kitchens, and barns were in a dilapidated condition. . . . We next visited the old tomb of Washington below the house, and in full view of the new tomb and river. It was in utter ruin. The door had been taken away for relics, while the entrance was blocked up with broken bricks and beams so that we could not enter. . . . We had our dinner in the summer house about 2 p.m. and opened a prime bottle of [Otard?]. . . . A fine spring on the hillside below furnished ice cold water. We gathered leaves to press and send home, and visited the old ruined wharf at the riverside. I made sketches of Fort Washington opposite and one from the tombs. . . . As it was now getting towards 4 p.m. we started back to camp."

View of Mount Vernon, Potomac River, Va. Sketched December 23, 1861.

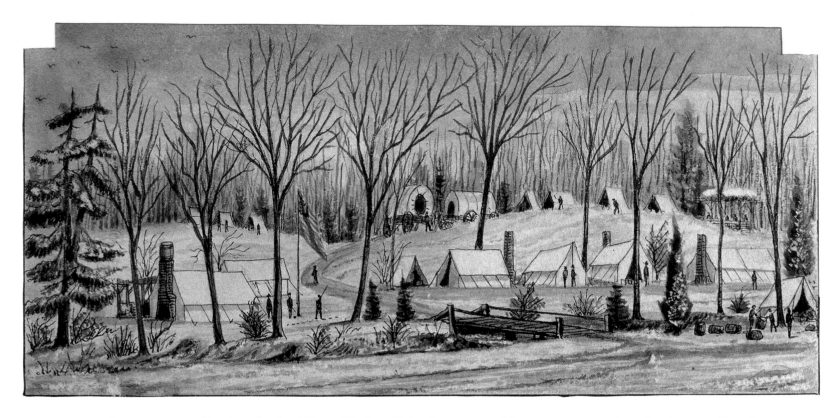

January 5, 1862. "I made a sketch of General Sedgwick's headquarters. . . . The snow is yet on the ground, about six inches deep, but the wagon wheels on the roads cut this up and churn it into filthy red paste. All the cavalry who return from picket are splashed with this filthy, vile smelling compost from head to foot. They have a hard time of it to keep themselves and accouterments clean."

View of headquarters of Brigadier General John Sedgwick, U.S.A., Leesburg Turnpike, Va., January 1862.

Sneden's drawing of General Sedgwick's headquarters was redrawn by artist Edwin J. Meeker for Century *and appeared in that magazine without Sneden's name, only the line "From a Sketch Made in January 1862."*

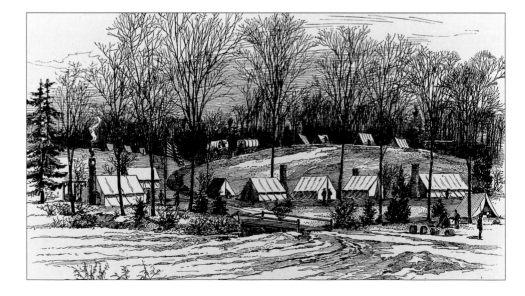

January 8, 1862. "I visited an outpost at 9:30 p.m. with the relief guard. . . . The men and officers are very slack while on picket. They look upon this duty as a sort of excursion in the woods. Plunder is the main object. And as most of the officers are tame and good natured, the men have pretty much their own way. Some officers return to camp with their detachments before others have come out to relieve the posts! . . . They thus leave . . . gaps open long enough for the Rebel farmers to pass out free."

Deserted picket post, Pohick Road, Va., January 1862.

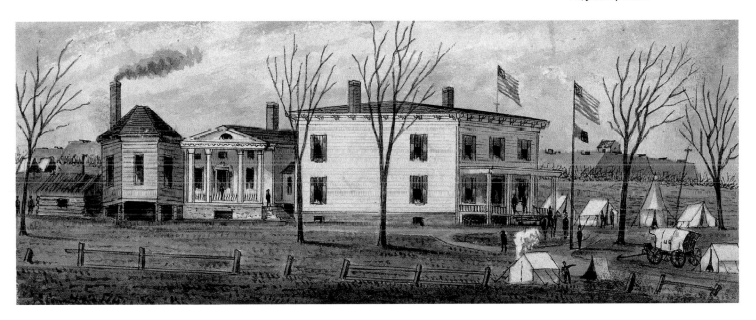

Headquarters of Major General S. P. Heintzelman, U.S.A., at Ballenger's house, Fort Lyon, Va., March 1862.

After spending several months in the field, Sneden found that his mapmaking skills were demanded at a higher level. On January 10, he received orders to report for duty at the headquarters of General Samuel P. Heintzelman, who would soon be named commander of III Corps. Two days later he made the following entry.

January 12, 1862. "These headquarters are in a house once owned by a Mr. Ballenger, now somewhere in the Rebel army. It is a large two story frame dwelling with two buildings attached, one being in octagon shape, used as a kitchen. The general has his quarters in the middle building while his staff occupy the second floor of the main house for sleeping apartments. There was no furniture left by the owner. The high earthen walls of Fort Lyon, with the tangled abatis around the ditches are only a few hundred feet away. From the front piazza a splendid view is had up and down the Potomac for many miles. I moved my sleeping quarters from the tent out in front of this house to a front room on the second floor of it. I work at my maps on the first floor where the telegraph instruments are, and the continual ticking and hammering bothers me considerably."

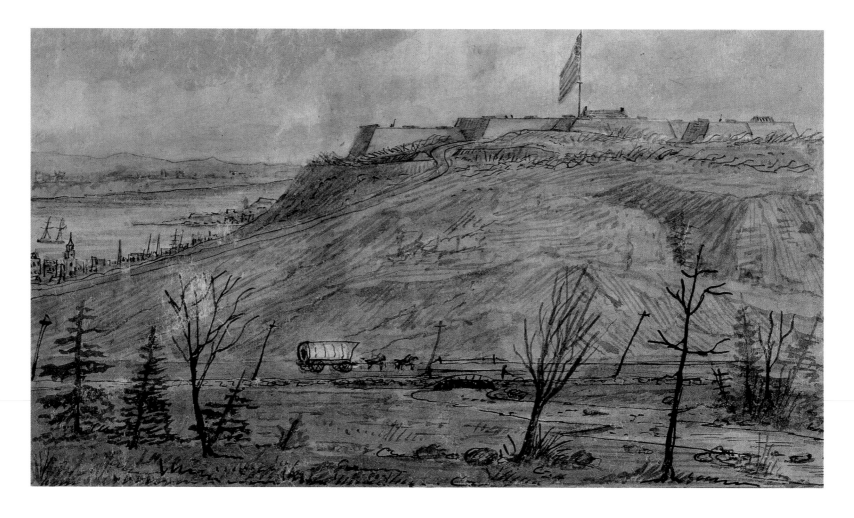

January 12, 1862. "The city of Alexandria can be seen below the hill [along with] the white tents of thousands of men encamped for miles up and down the river. On a fine moonlight night the scene is charming. Now and then the sullen boom of artillery is heard down the river for an hour at a time, showing that the enemy are alive. . . . We sit on the piazza smoking our pipes on fine nights and listen to this music for hours."

Fort Lyon on Eagle Hill, near Alexandria, Va., March 1862.

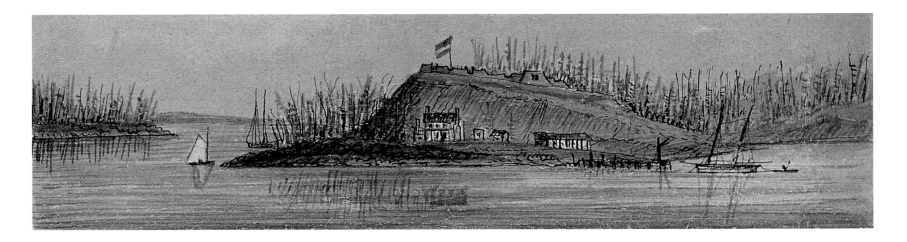

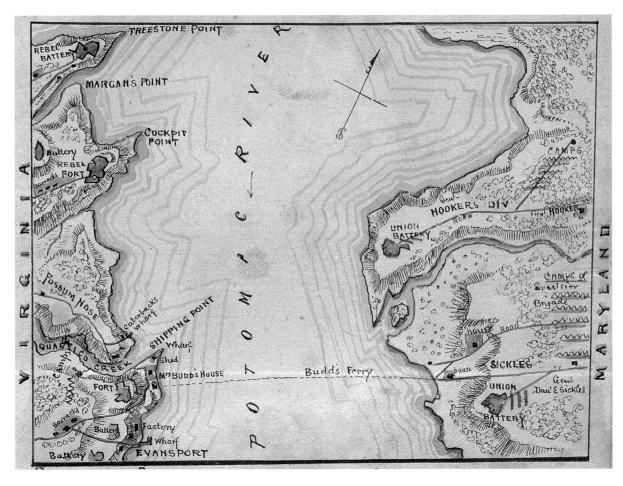

Rebel battery at Budd's Ferry, Va., Potomac River, February 1862.

Blockade of the Potomac, map showing Union and Rebel batteries, January 1862. The Rebels evacuated all their batteries night of March 9, 1862. The Rebel troops and batteries were commanded by General Holmes, C.S.A., during the blockade, which lasted from December 1861 to March 9, 1862.

January 15, 1862. "General McClellan does not make a movement to crush out the enemy at their batteries on the Lower Potomac as was anticipated. The river below Belmont Bay is completely blockaded and none of our supply vessels below Aquia Creek dare come up without the risk of capture. [General Joseph] Hooker, with [General Daniel] Sickles' troops . . . have erected batteries opposite Cockpit Point and Evansport, which shell the enemy frequently, but can effect nothing on earthworks except to dismount a gun or two. [These] are replaced by others soon after. The enemy in turn shell Hooker's batteries and camps, causing a few casualties and setting fire to the tents."

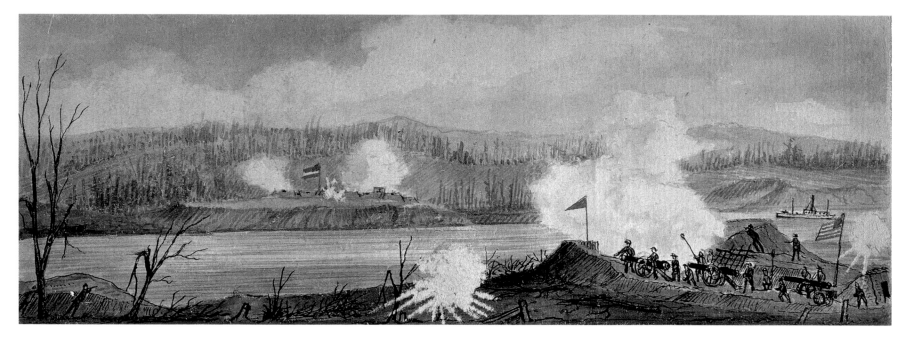

Artillery of Hooker's division shelling the Rebel battery at Cockpit Point, Va., from across the Potomac River, January 1862.

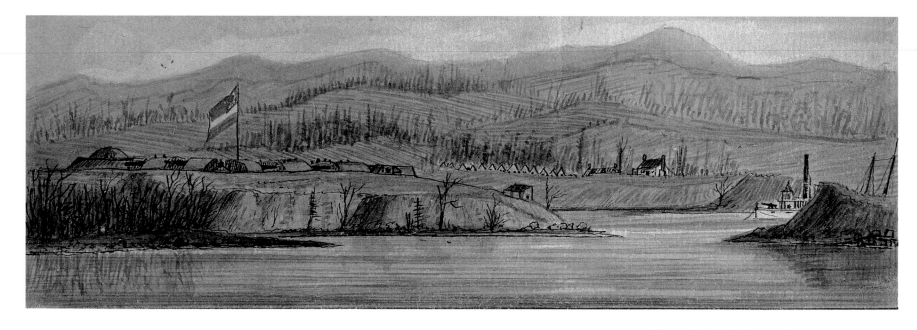

Shippen Point Rebel battery, Potomac River, February 1862.

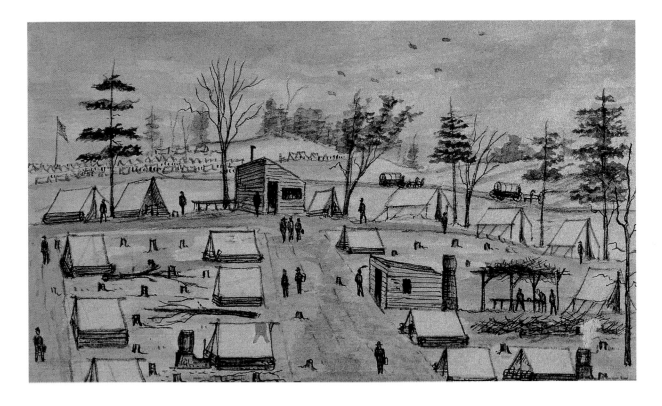

January 24, 1862. "We have had several storms since the 15th [and] about sixteen inches of snow now covers the ground, making it very uncomfortable camping out. . . . The roads and camps [are] six and eight inches deep in red mud and slush. . . . As a defense to the enemy, this Virginia mud is all as good as several regiments."

Winter camp of 5th Michigan Regiment, U.S. Volunteers, below Fort Lyon, Va., February 1862.

January 25, 1862. "We reached Pohick Church about 4 p.m. in a snow storm. [It] was a substantial two story brick structure with white marble, quoins and trimmings and old colonial gambrel roof. . . . Here Washington attended service, with all the old first families of the time. . . . Now the church was in a ruinous condition. Windows were all broken out, . . . pews nearly gone, being used for firewood by our pickets. The ceilings broken by the rain coming through the roof, walls discolored black by smoke, etc. The mahogany pulpit was half cut away and carried off for relics, while the cornerstone had been unearthed and the contents carried off. There was not much left for the relic hunters now even the sconces and door knobs and hinges were gone."

Pohick Church, Fairfax County, Va., 1862.

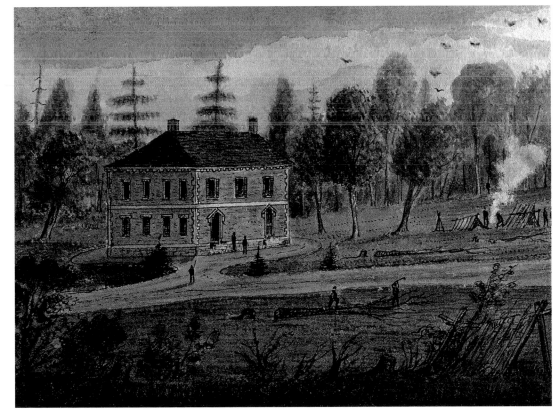

In the summer of 1861, Falls Church was the most advanced Union outpost in northern Virginia, but during the next several months, this eighteenth-century structure was caught between the lines and changed hands numerous times. Except for the placement of its chimneys, Sneden accurately sketched the structure.

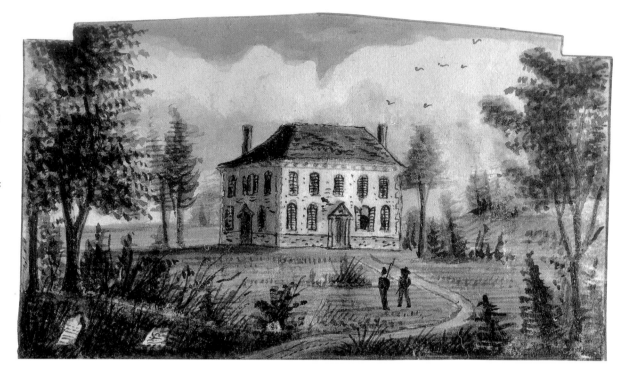

Falls Church, Va., 1862.

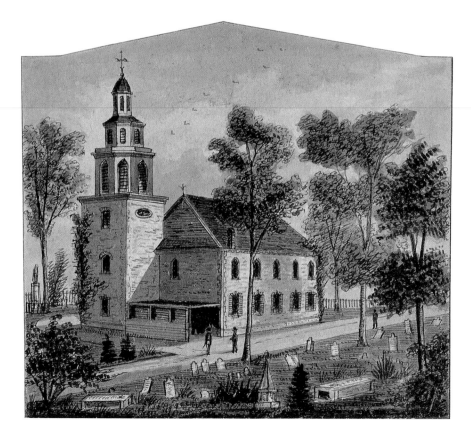

March 17, 1862. "I went to Alexandria this afternoon and made a good sketch of Christ Church, which was the first Episcopal church built there. Washington and the first families used to attend there. It was locked and I could not get inside. It seemed in good repair while the inscriptions on the tombstones were very quaint. Many stones were chiseled with armorial bearings, but the weather had obliterated all the finest executed designs. Many had sunk to only a few inches out of the ground."

View of Christ Church, Alexandria, Va. Built in 1767. Sketched March 18, 1862. The church bible was printed in 1767, the prayer book in 1795. In it was first printed the prayer for the President of the United States. Washington's double pew is in this church which he rented for $25 annually. It cost him $200. General R. E. Lee's pew is near it. Lawrence Washington, his grandnephew, belonged to this church.

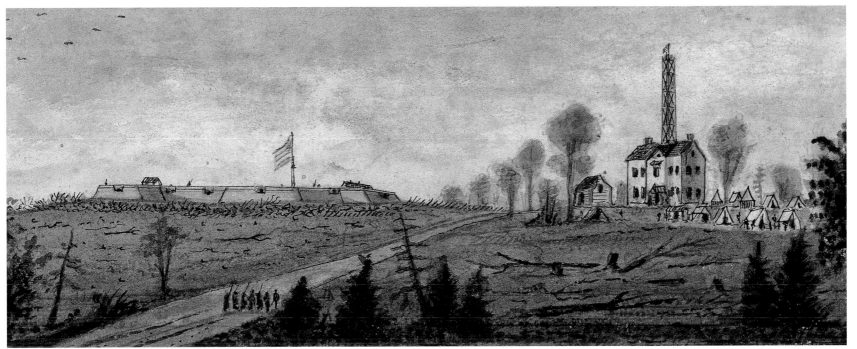

Observatory for U.S. Signal Corps at Forney's house

March 2, 1862. "I went to Ramsey at Upton's Hill . . . a very strong . . . salient . . . on the line. A very high trestle work observatory had been erected at Mrs. [Forney's] house, from whence our signal corps officers could see several miles on both sides of the Potomac."

Fort Ramsey at Upton's Hill, Va., March 2, 1862.

This engraving, which appeared after the war in volume 2 of Battles and Leaders of the Civil War, *was based on a drawing by Charles Vanderhoof, who redrew Sneden's original sketch.*

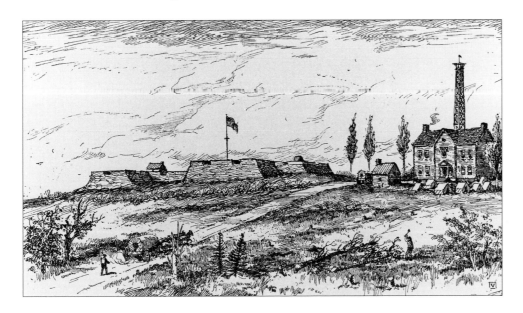

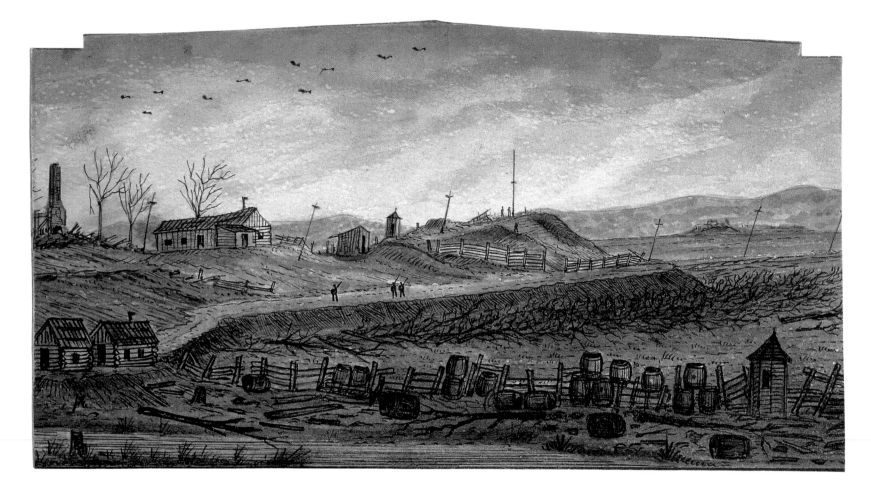

By late winter 1862, General McClellan's plans for a major offensive to capture the Confederate capital of Richmond were put on hold when Confederate forces pulled back from their fortified positions at Manassas Junction. He then developed another plan to advance on Richmond by water. He would sail his massive army down the Potomac River into the Chesapeake Bay and land on the tip of the Virginia Peninsula. From there, he would march his army seventy miles up the Peninsula to Richmond. By late March, "Little Mac" launched the largest amphibious operation the world had ever seen. Private Sneden sketched many of the events leading up to the Peninsula Campaign.

March 9, 1862. "[The Rebels] suddenly evacuated all their batteries and moved their whole army from the front of Washington, destroying their camps, burning all the bridges from Munson's Hill to Centreville, Manassas to Gordonsville. Thus doing of their own accord what McClellan thought his whole army of 80,000 fighting men was unable to make them do. So 'McClellan stock' now is very low."

Remains of Rebel fortifications at Manassas Junction, Va. Evacuated March 1862.

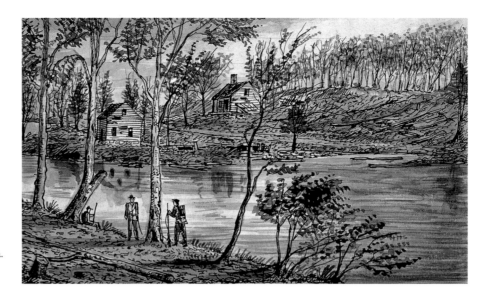

Blackburn's Ford, on Bull Run, Va.

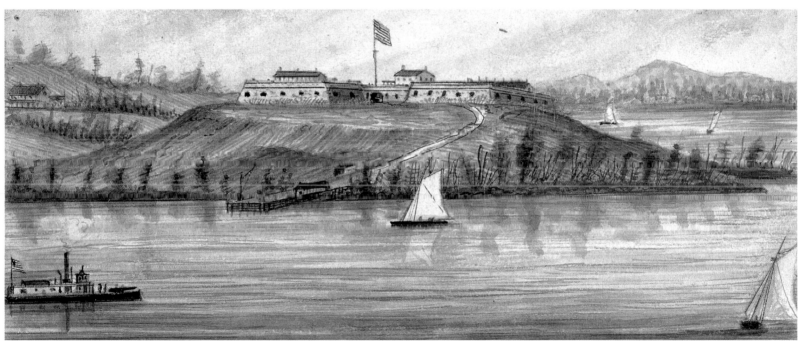

U.S. gunboat Wharf Potomac River Piscataway River

March 21, 1862. "At 2 p.m. the fleet began to slowly sail and steam down the Potomac amid the cheers of the soldiers—booming of guns in salute and the playing of several bands. The sun had now come out and shone on the white steamers crowded with blue uniforms or the red ones of the Zouaves—glistening muskets and bayonets and the white sails of the sailing vessels, while the smoke of the saluting guns from Fort Lyon gave an impressive and fine effect. The Army of the Potomac had now started on its career of glory and fame. . . . We steamed quite close to Fort Washington going slow. . . . The shouting and jokes passed by the soldiers to each other on other vessels afforded much merriment. Whiskey seemed to be plentiful on board some of them. The bands stopped playing after we had passed Fort Washington. The whole garrison were looking at us from the parapets and wharf at the foot of the high bluff on which it was built."

View of Fort Washington opposite Mt. Vernon, Potomac River, Va. Sketched from on board steamer "Kent" March 22, 1862. Army flotilla en route to Fort Monroe, Va.

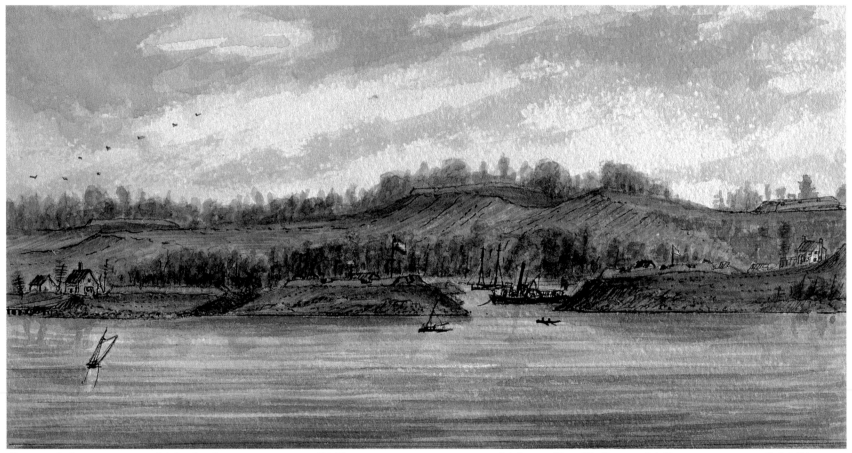

| Evansport wharf | Rebel earthworks | Rebel battery | Rebel steamer "General Page" and captured schooner "Fairfax" | Rebel battery | Cockpit Point |

March 22, 1862. "I made sketches of all the deserted Rebel batteries at Evansport, Quantico Creek, and etc. After a good supper I kept the deck until past midnight. The moon came out, making the shores and headlands plainly visible. The white sandy beach and dark black pine trees throwing deep shadows on the water made a charming picture while the churning of wheels and screws from 330 steamers made a strange noise as the echoes reverberated from the heavily wooded shore."

Quantico Creek, Potomac River, Va. Evacuated March 9, 1862.

PART TWO

ON TO RICHMOND!

BY LATE MARCH 1862, GEORGE MCCLELLAN had transported nearly ninety thousand soldiers and huge quantities of supplies, equipment, munitions, and animals to the tip of the Virginia Peninsula near Fort Monroe and Hampton. After several days of sorting everything out, he ordered his army forward, only to run into stiff resistance from a small Confederate army under John Magruder at Yorktown. Concerned that his opponent might be in greater numbers than his intelligence reports had estimated, the Union commander brought his lumbering army to a sudden halt and wasted a golden opportunity to carry a position, had he launched a coordinated attack. Instead, for the next month, the Army of the Potomac settled into formal siege operations against a foe whose numbers grew steadily as the main Confederate army under Joseph E. Johnston joined the lines at Yorktown.

For the first time in his army career, Private Robert Sneden experienced real war. Although he was a map-maker assigned to headquarters, he still endured the misery of bone-chilling rain, mud, and clogged roads, and more than once he heard the deadly whistle of enemy bullets or the sudden whoosh of heavy artillery shells flying overhead. Kept busy producing a steady supply of maps for the generals, Sneden also sketched scores of images of the landscape around him. There are more sketches from the Peninsula Campaign and subsequent Seven Days' battles than any other period of his war service, perhaps indicating that the war was still a great novelty to him.

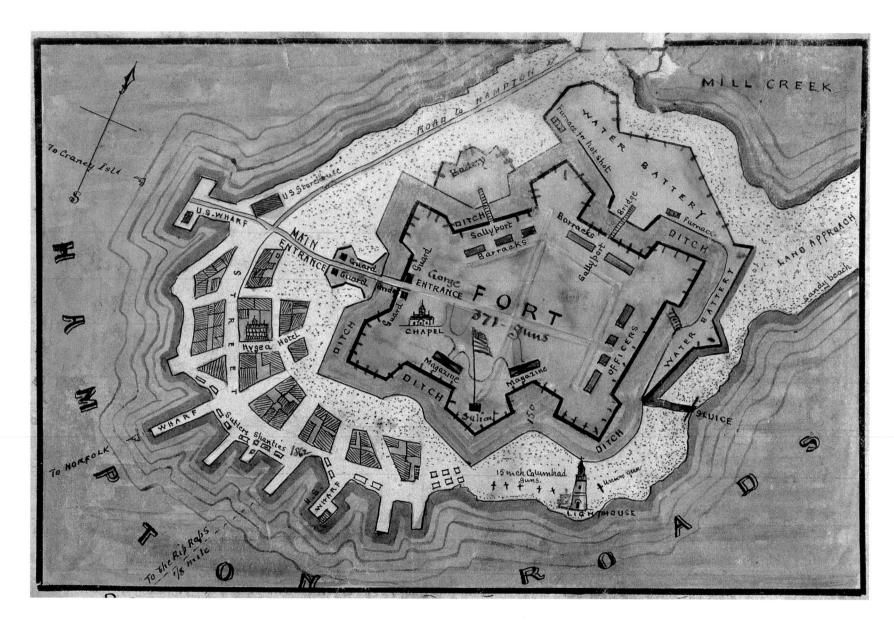

MILL CREEK

ROAD to HAMPTON

To Craney Isld

WATER BATTERY

Furnace for hot shot

U.S. Storehouse

Battery

LAND APPROACH

U.S. WHARF

MAIN ENTRANCE

DITCH

Sallyport

Barracks

Barracks

Sallyport

Bridge

Furnace

DITCH

W H A R F

S T R E E T

Guard

Guard

Guard

Gorge ENTRANCE

FORT

371 guns

Sandy beach

Hygea Hotel

Guard

CHAPEL

DITCH

OFFICERS

WATER BATTERY

WHARF

Magazine

Magazine

Sutlers Shanties 1862

DITCH

Sallyport

150

DITCH

SLUICE

To NORFOLK

U.S. WHARF

15 inch Columbiad guns

Union gun

To the Rip Raps
1/8 mile

H A M P T O N

LIGHTHOUSE

R O A D S

March 23, 1862. "About 12:30 noon we rounded the point and came into Hampton Roads, and passing the lighthouse and the frowning walls of Fort Monroe, landed at a wharf up near the [Hygeia] Hotel. . . . Hundreds of soldiers disembarked and stacked arms all along the beach for a mile, while their officers made a rush for the hotel to get something to eat and drink. All was bustle and hurry until midnight to land the troops first."

Plan of Fort Monroe, Old Point Comfort, Va. Area: 65 acres. Cost: $2,400,000.

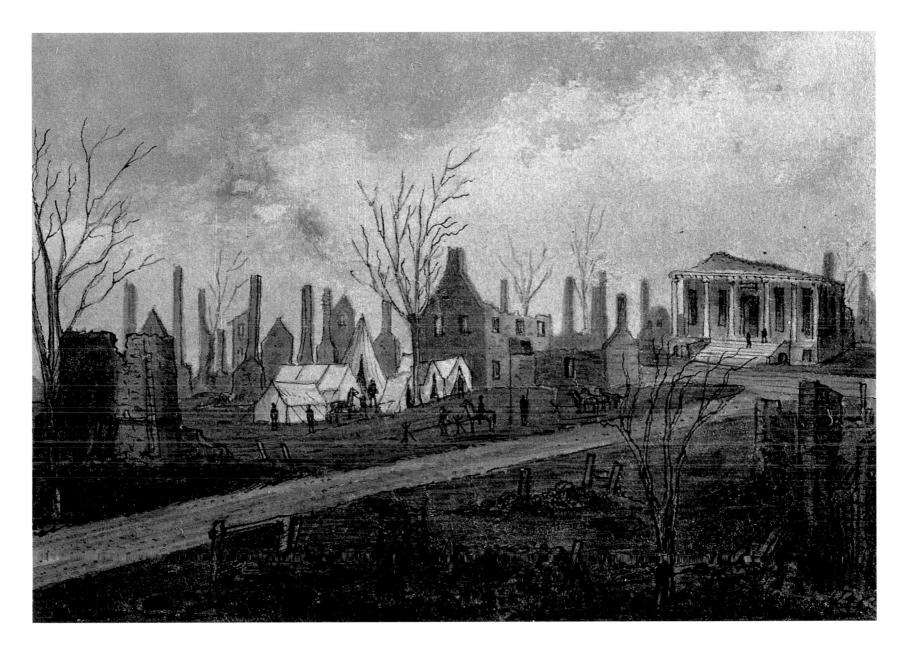

March 23, 1862. "[Heintzelman's] tent, with those of the staff, was pitched at the corner of Main Street and that [street] which led to the church, now in ruins. The court house, roofless and thoroughly gutted, adjoined the ground selected. . . . [Its] chimney served our cooks well in getting supper. The telegraph tent was soon up and the operator at work on the newly strung wires to Fort Monroe."

Headquarters of General Heintzelman's III Army Corps amid the ruins of Hampton, Va., March 24, 1862.

March 23, 1862. "I went over the ruins of the town and down to the creek. A durable trestle bridge had been built by our engineers on stumps or spiles of the former one which had been burnt. Army wagons were going over it in a steady stream and were winding away up the main street to green fields, now white with tents in all directions. . . . We found the town in utter ruin, nothing but tumble down walls and blackened chimneys, which stuck up in all directions amid charred timbers and debris of all kinds."

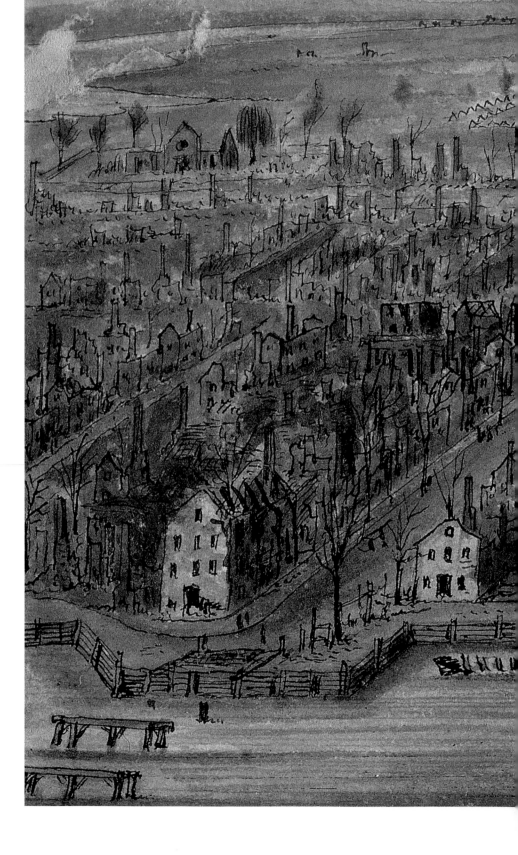

View of the ruins of Hampton, Va. Burnt by orders of General Magruder, C.S.A., August 7, 1861. Encampment of III Corps beyond the town. Pontoon bridge at right.

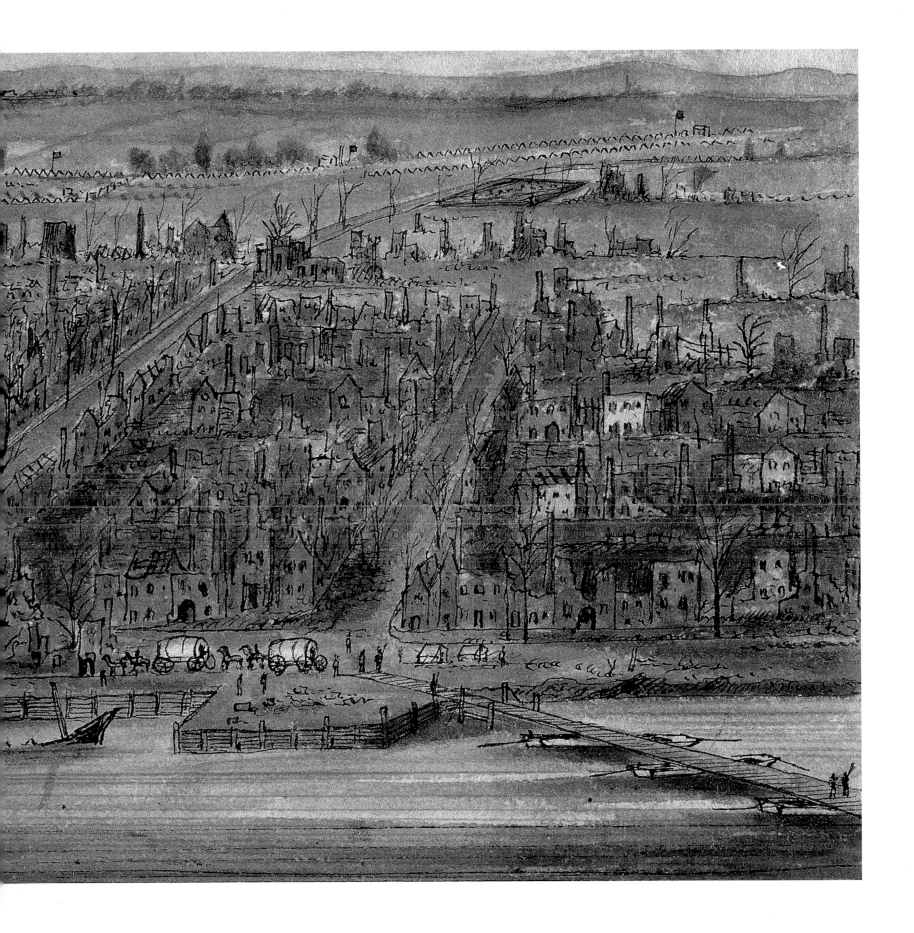

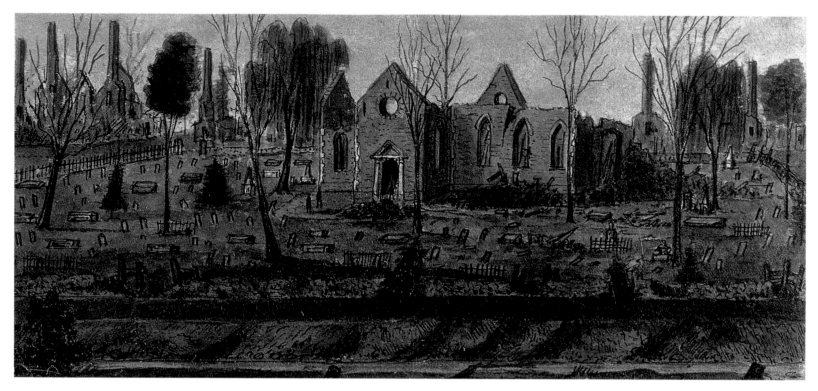

Rear view of ruins of St. John's Church at Hampton, Va., March 25, 1862, showing fortified graveyard.

March 24, 1862. "Keeping through town I came upon the ruins of St. John's Episcopal Church. The fire had gutted it completely. The tower had fallen down in a heap, roofs clean gone, and nothing but bare walls left standing. Not a piece of woodwork of any kind could be seen but a few ends of timber sticking up out of piles of burnt bricks, some of the fine trees around the graveyard were scorched black and dead, others were in full leaf. Notable [was] a large willow tree whose trunk must have been eight or nine feet at the base."

March 24, 1862. "Many of the marble monuments had been thrown down and smashed. Most of these were fine monuments of white marble erected to officers of the old army and navy of the United States for years back. Other tombs of brick with sandstone or slate slabs were everywhere, some surrounded with wooden fences, others with handsome iron fences. Most of the wooden fences had been used as firewood by [Benjamin] Butler's troops when here."

A tombstone in St. John's Churchyard. "In hope of a blessed Resurrection, here lyes the body of Thomas Garte, Gent., who was born November 24, 1640, in the parish of St. Michael in Lewis in the county of Sussex in England and dyed May 30, 1700. When in few yearre are come then I shall goe the way where I shall not return, Job 16–22."

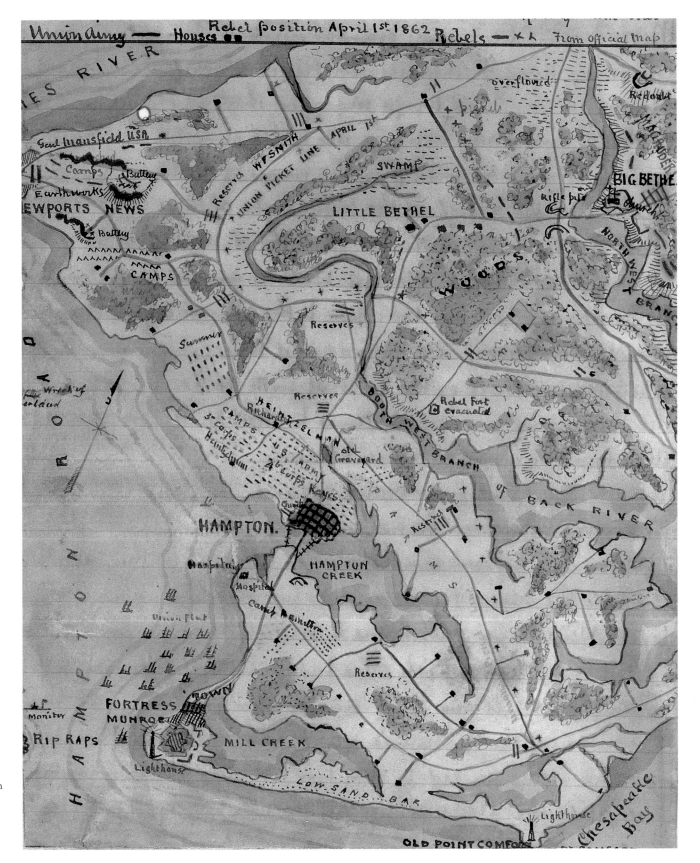

Plan from Fort Monroe to Big Bethel, Va., showing Union and Rebel position April 1, 1862. From official map.

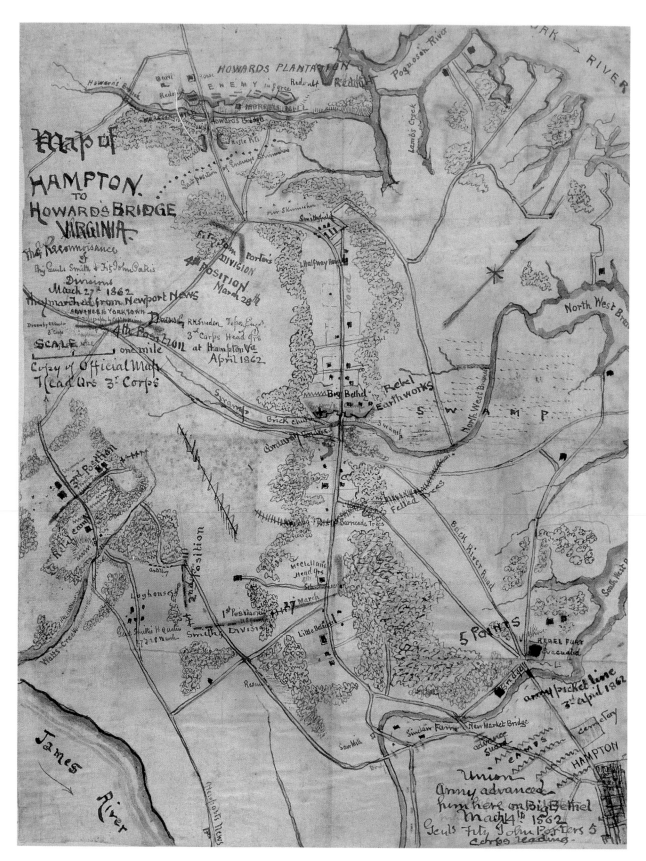

Advance of the army from Hampton to Big Bethel and Howard's Bridge, Va., March 27, 1862.

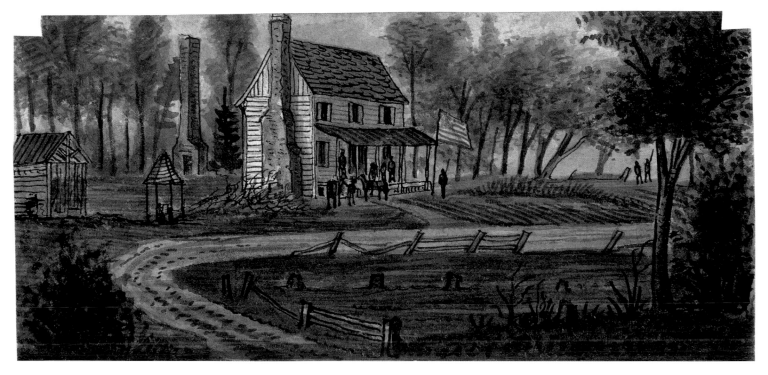

April 4, 1862. "The army is advancing [on Yorktown] in two columns. . . . All went forward with fine order, the wagon trains keeping on the road . . . while the troops marched in column on both sides . . . and across the fields or clearings at the route step. . . . Our [wagon] train came up to Little Bethel about noon time. It was little enough as there were but three houses to be seen with a few old rickety slab barns surrounded with broken fences. General McClellan had his headquarters at one of the houses. . . . As the wagon trains halted for half an hour here, I made a sketch while the troops filed past."

Headquarters of General McClellan, Little Bethel, Va., during the army advance of April 4, 1862.

April 4, 1862. "I went ahead of our train some distance and seeing a crowd of soldiers in a field went there and saw a mound of earth about ten feet long, shaded by a solitary pine tree. A pine slab was stuck up at one end on which was lettered with writing on it. Here laid the remains of some of our soldiers who were killed just before the battle [of Big Bethel] in June 1861. . . . They were probably buried in one trench at the time and some had been exhumed to send home by their friends or comrades afterwards when the Rebels reburied them and set up the slab."

Grave of Union soldiers who were killed at battle of Big Bethel, June 10, 1861. "Here are the graves of our enemies. Let no vandal disturb them again."

35

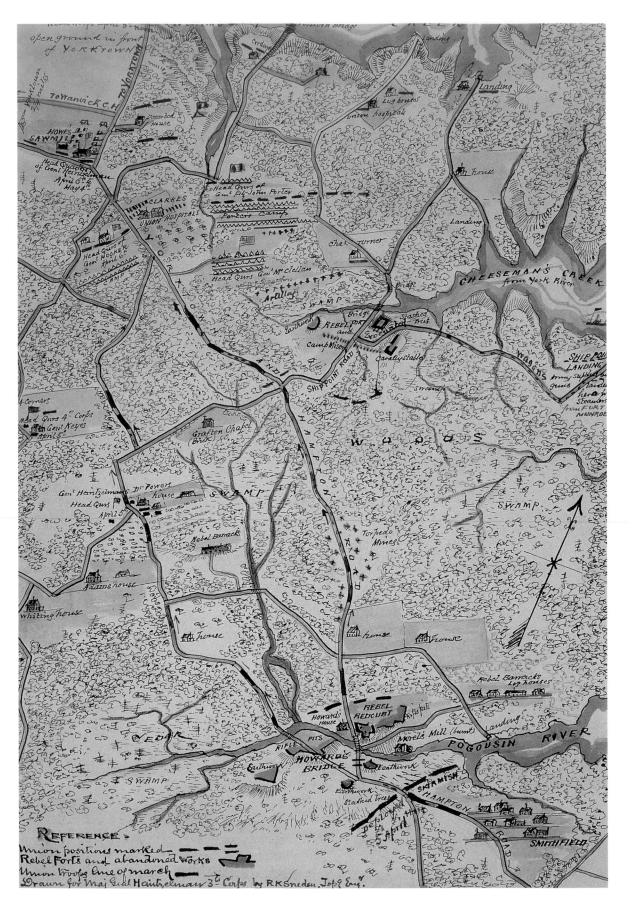

Map showing route of the III Army Corps, A.P., from Howard's Bridge to the sawmill, April 5 and 6, 1862.

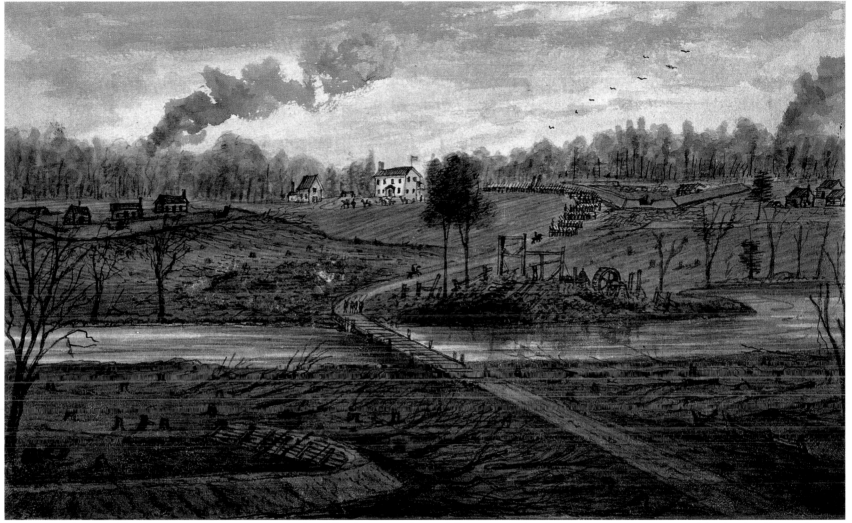

| Rifle pits and earthworks on hill | General McClellan's headquarters at house on hill | Morrel's Mill | Rebel earthworks and log barracks |

April 5, 1862. "It rained hard from 5 a.m. to 10 a.m., when it cleared off quite hot. At 5:30 a.m., all had resumed the march on Howard's Bridge. General McClellan [and staff] passed from the rear up towards the head of the marching columns amidst great cheering from the troops. Their gorgeous uniforms were splashed all over with the beautiful red mud of Virginia. . . . The roads were in a horrible state, but we had to plunge through it as best we could. . . . Everyone enjoyed this march despite the oceans of mud which we had waded through as [if it] would have been a huge picnic."

Howard's Bridge and ruins of Morrel's Mill, Poquoson River, Va., April 4, 1862. Advance of the Union army up the Peninsula.

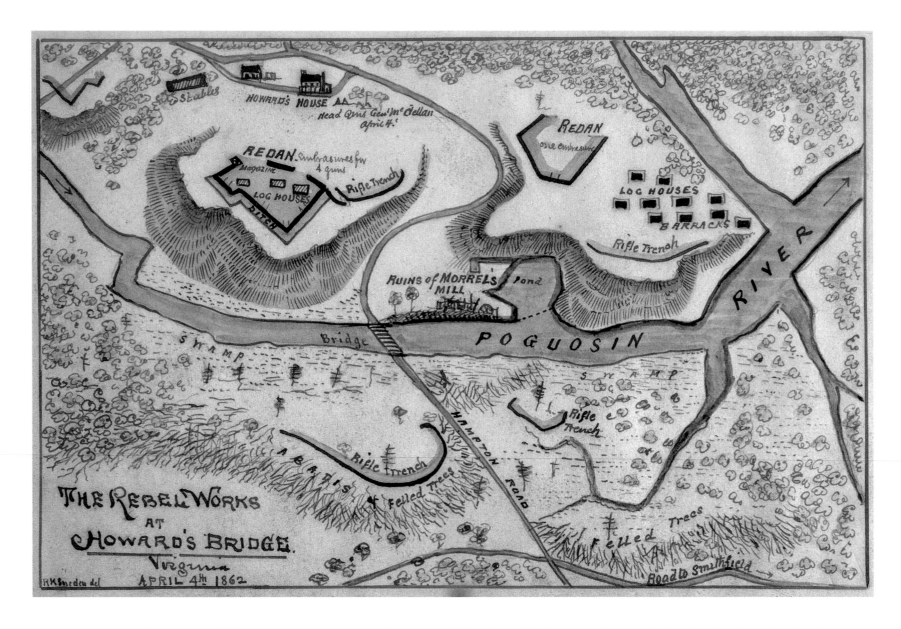

Labels within the map image:
Stables
HOWARD'S HOUSE
Head Qrts Genl McClellan April 4.
REDAN Embrasures for 4 guns
Magazine
LOG HOUSES
Rifle Trench
DITCH
REDAN one embrasure
LOG HOUSES
BARRACKS
Rifle Trench
RUINS of MORRELS MILL
Pond
SWAMP
Bridge
POGUOSIN
RIVER
SWAMP
HAMPTON ROAD
Rifle Trench
ABATIS Rifle Trench
Felled Trees
Felled Trees
Road to Smithfield
THE REBEL WORKS AT HOWARD'S BRIDGE. Virginia
R.K.Sneden del
APRIL 4th 1862

April 6, 1862. "[Howard's Bridge] was situated very [much] like that of Big Bethel with a narrow river crossed by a bridge over a long straight causeway defended on hills opposite by earthworks and rifle trenches. . . . We camped off the road while the troops kept march-ing past until near midnight. Some regiments were camped on the hills across the stream and thousands of campfires lit up the tall trunks of the pine trees while the frogs croaked in the marsh all night."

The Rebel works at Howard's Bridge, Va., April 4, 1862.

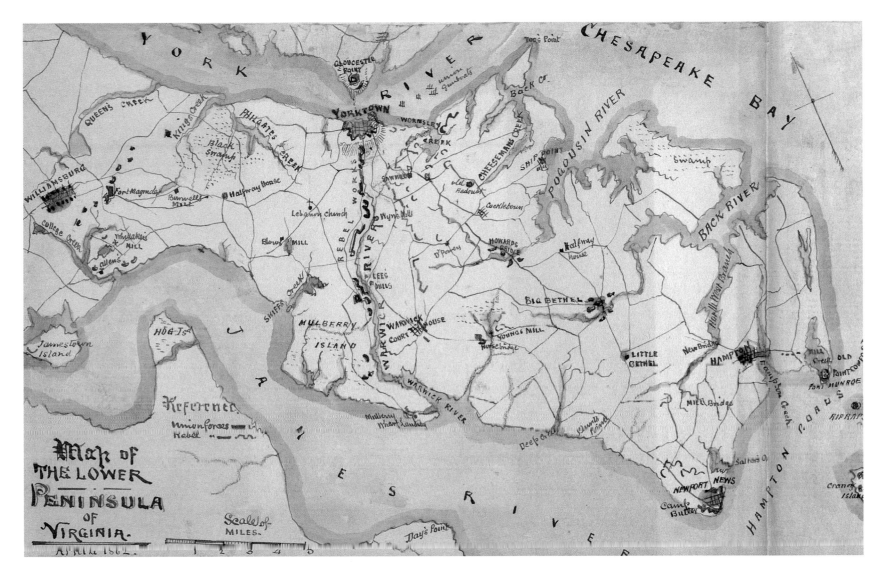

Map of the lower Peninsula of Virginia, April 1862.

April 6, 1862. "We broke bivouac at 5:30 a.m., hitched teams and crossed over to the high ground and slowly went on towards Yorktown. . . . All the infantry marched in the fields and woods which bordered it, the wagons and artillery using the road. No straggling was allowed to the houses which were seen in the distance. . . . The roads were very much cut up by the wagons and artillery away ahead of us and frequent and long halts were made caused by wagons breaking down and the balking of the mule teams. At such times the teamsters would soon build small fires and boil coffee. We came to a cross roads and turned our headquarter teams off to the left where we got mired up to the axles several times, while fence rails were freely used under the wheels. I rode on the tongue of one of our wagons, and we plunged through the pools of liquid red mud like a ship in a chop sea. We were all spattered with the vile stuff."

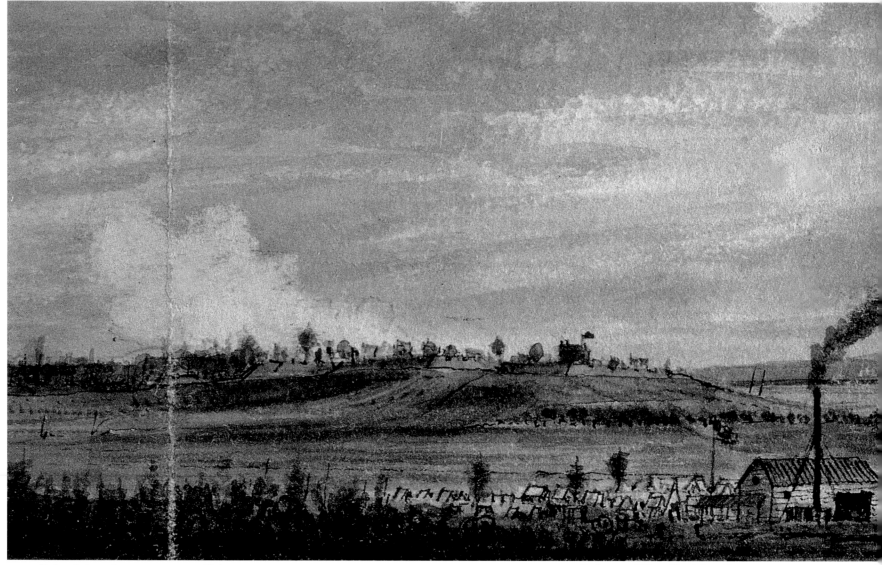

Earthworks in woods

Yorktown
Peach orchard below hill

Headquarters, III Corps, Howe's Sawmill

April 6, 1862. "Fine and warm at dawn. The bugles sounded 'pack up' and by fours all resumed the march toward Yorktown. . . . [Later] the troops took ground at the edge of [a] large open plateau in front of the enemy works and went into camp in the woods and ravines which border it. . . . The generals rode along the line and selected their headquarters. . . . General Heintzelman selected Howe's Sawmill for his headquarters on the right center of the line. . . . The steam sawmill was a rough frame building . . . and new machinery will be sent here . . . to put it in running order. It comes in very handy to us as all the gun platforms [for the siege] can be sawn when it is put in repair."

View of Yorktown, Va., from rear of Howe's Sawmill.

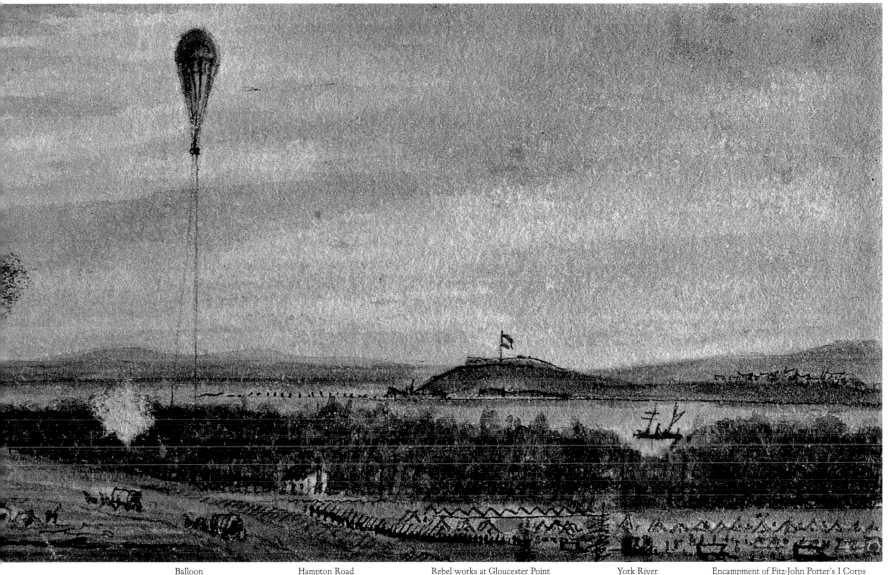

| Balloon | Hampton Road | Rebel works at Gloucester Point | York River | Encampment of Fitz-John Porter's I Corps |

April 9, 1862. "[Professor Lowe's] balloon went up for the first time this forenoon. Thousands of soldiers swarmed out from their camps in the woods to see it. It ascended from the strip of woods just across the road from these headquarters and was held by two ropes attached to the basket car. It was only partially inflated and rose like a bird to an elevation of 900 feet. It was made of yellow colored cloth varnished on the outside and glistened in the bright sunshine. On it was painted in colors an immense head portrait of General McClellan. The ramparts of Yorktown soon swarmed with the enemy to see it, but all at once they disappeared as if by orders. The balloon remained up three hours. Lowe and two officers were in it, who kept their glasses on the enemy's line of earthworks constantly. They could see, of course, the inside of the enemy's works, sketch the outlines of parapets, and count the guns already mounted, and note their bearings. From this, the draughtsman can make the maps and plans which they are waiting for. . . . The balloon came down at 5 p.m."

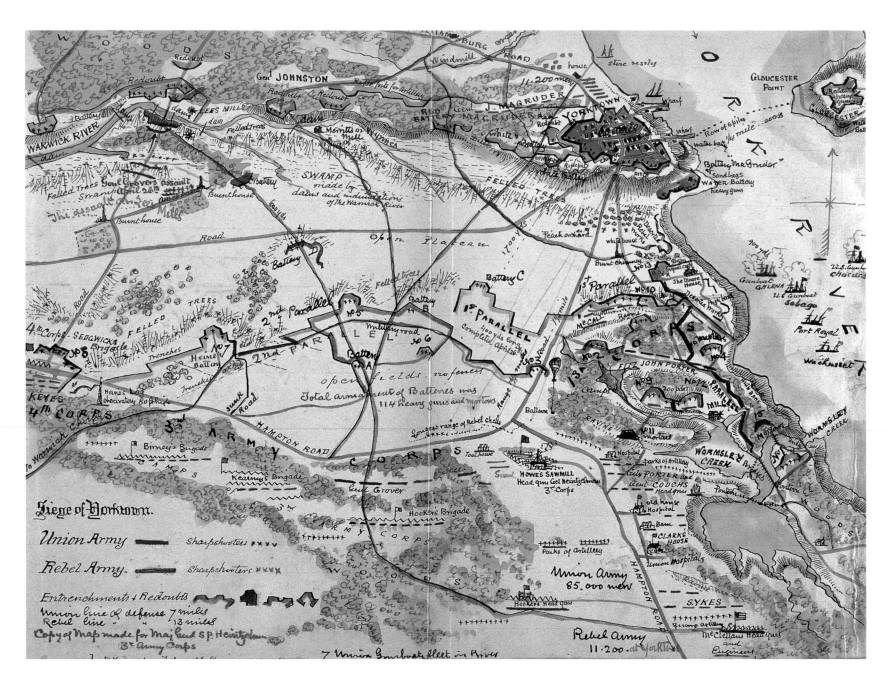

Map of siege of Yorktown, Va. Copy of map made for Major General S. P. Heintzelman, III Army Corps.

Entrance to Wormsley Creek, Va., April 1862.

Union hospitals

Fish weirs at upper end

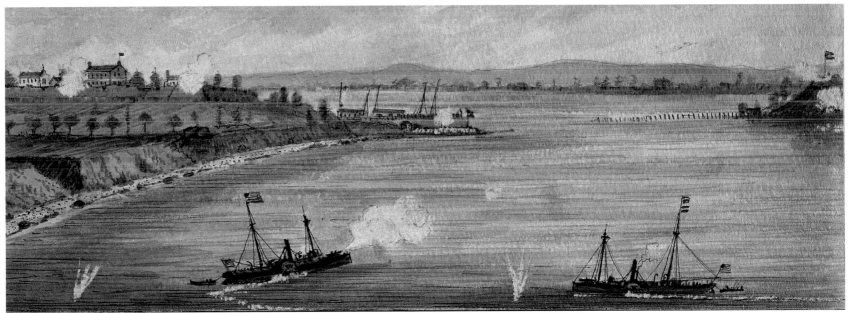

Yorktown and water battery

Gloucester Point

April 13, 1862. "I went on a tour of observation today along the Wormsley Creek shores and up river along the high bluffs. While here . . . [I] saw a lively contest between two of our side wheel gunboats and the Rebel batteries at Yorktown and those at Gloucester Point. It was a charming sight to see the gunboats move in circles and fire from their heavy bow guns. Slow, and with precision, their shells struck the parapets of the water battery . . . knocking the sandbags up in the air and dismounting a gun. . . . The enemy's shot struck the water very close to the vessels while shells burst in mid air. None struck the steamers, however, which kept moving all the while. Being on a bluff seventy feet above the York River, I had a fine view of the action."

Yorktown, Va., on the York River. Union gunboats shelling Gloucester Point water batteries.

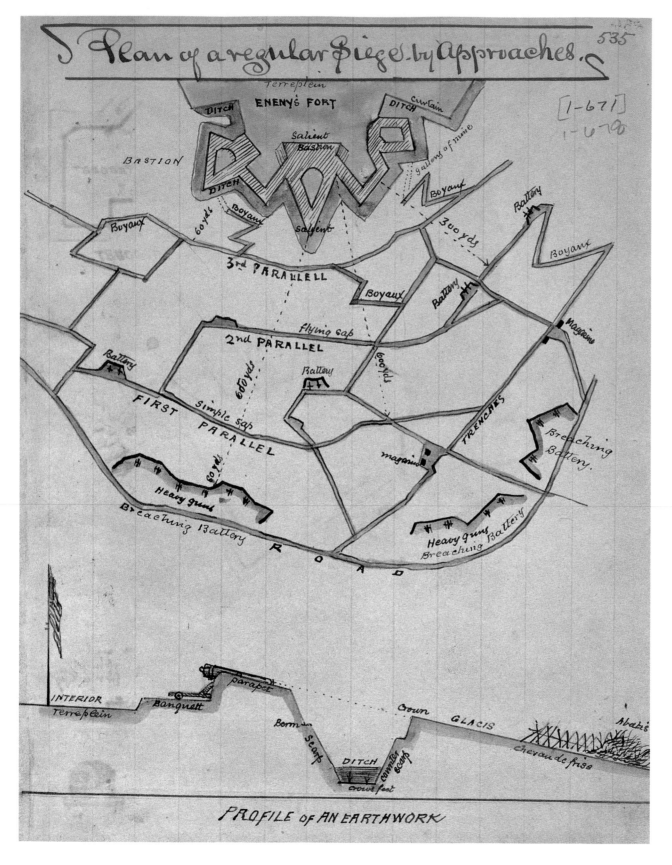

Plan of a regular siege by approaches.
Bottom: Profile of an earthwork.

April 15, 1862. "Hundreds of new picks and shovels were dumped down this morning at these headquarters, and the III Corps will now have to do more digging than fighting by the way things look. Standing in the trenches ankle deep in mud and water shoveling mud is no easy thing in the hot sun under fire from the enemy day and night. Batteries of artillery are placed along the first parallel line to shell the enemy and keep his musketry fire down until the trench is deep enough to shelter the workmen."

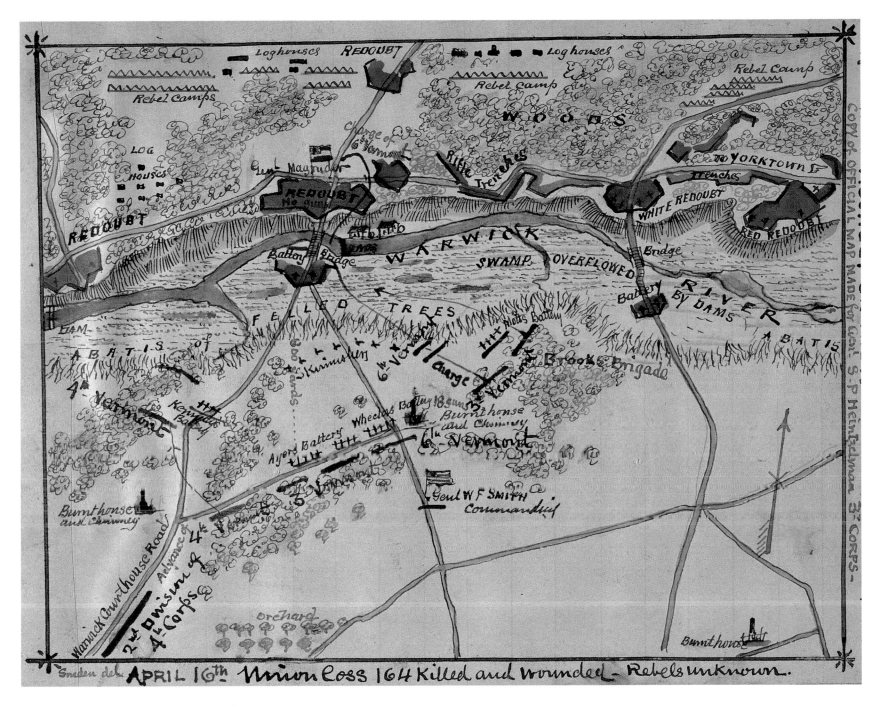

Within the map, the following labels appear:

Loghouses REDOUBT Log houses Rebel Camp
Rebel Camps Rebel Camp WOODS
LOG HOUSES Charge of 6 Vermont TO YORKTOWN
Gent Magruder Rifle Trenches Trenches
REDOUBT No guns WHITE REDOUBT
REDOUBT RED REDOUBT
Battery Bridge WARWICK SWAMP OVERFLOWED Bridge
FELLED TREES RIVER BY DAMS Battery
ABATIS of Skirmishers Motts Battery ABATIS
DAM 6 Vermont Charge 6 Vermont Brooks Brigade
4th Vermont Wheelds Battery 18 guns
Kennedy Battery Ayers Battery Burnt house and Chimney
3 Vermont 6th Vermont
Burnt house and Chimney Gent W F SMITH Commanding
Advance of 4th 2d Division of 4 Corps
Warwick Courthouse Road
orchard Burnt house

Sneden del. APRIL 16th Union Loss 164 Killed and wounded — Rebels unknown.

COPY OF OFFICIAL MAP MADE for Genl. S. P. Heintzelman. 3d CORPS —

April 16, 1862. "An assault was made this morning on a new battery constructed by the enemy . . . about one mile above Lee's Mill, which ended in a repulse with loss, all because the assaulting line was not reinforced. . . . [The 3rd, 4th, and 6th Vermont] approached . . . the enemy with marsh mud and water above the knees when they were received by the enemy with a crashing fire, which drove them back in some disorder. . . . They had to wade through the swamp and water again under a telling musketry fire with a loss of 164 men killed and wounded, many of whom were left in the enemy's hands."

The Union assault on the Rebel works, Lee's Mills, Va. Copy of official map made for General S. P. Heintzelman, III Corps, April 16, 1862. Union loss: 164 killed and wounded. Rebels: unknown.

April 17, 1862. "The balloon went up from a new position in the strip of woods near these headquarters. A telegraph operator went up in it with an instrument and a wire leading to another instrument on the ground below. The enemy began to shell the balloon, when it had to be hauled down. As shells burst uncomfortably near, it was then carried back 200 feet or so and went up again. All the enemy's shot now fell short."

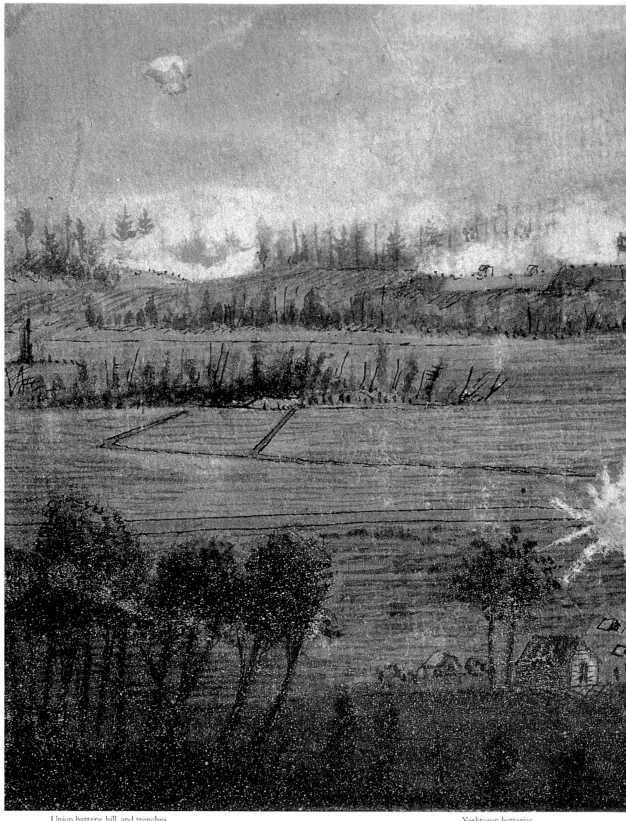

View of Yorktown, Va. Rebel batteries shelling balloon and headquarters of the III Corps.

Union battery, hill, and trenches

Yorktown batteries

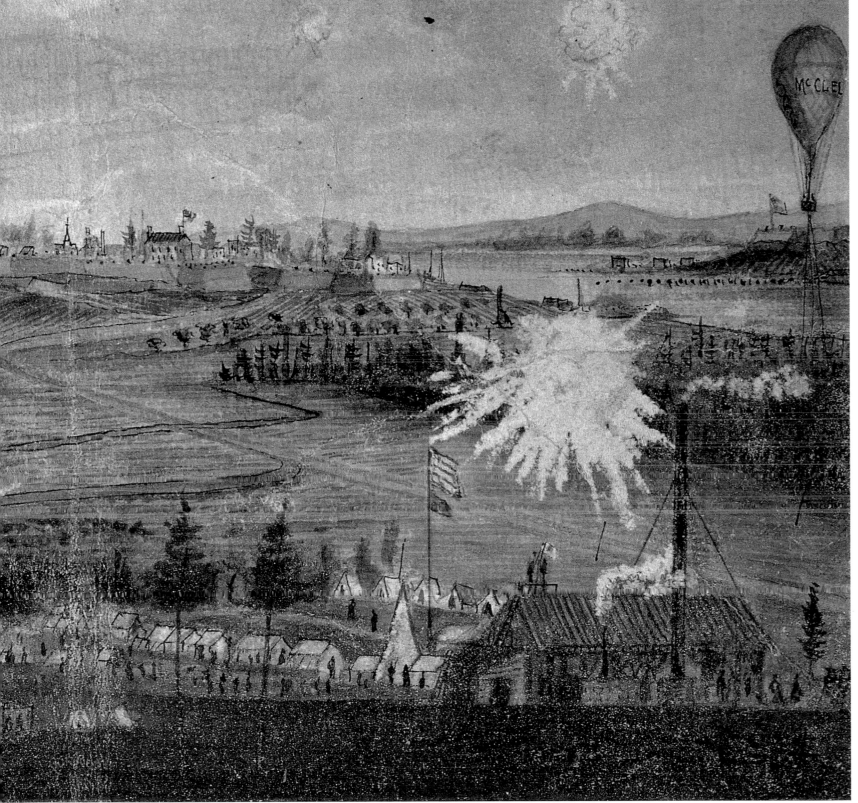

Yorktown Sawmill and headquarters III Corps Peach orchard and Gloucester Point

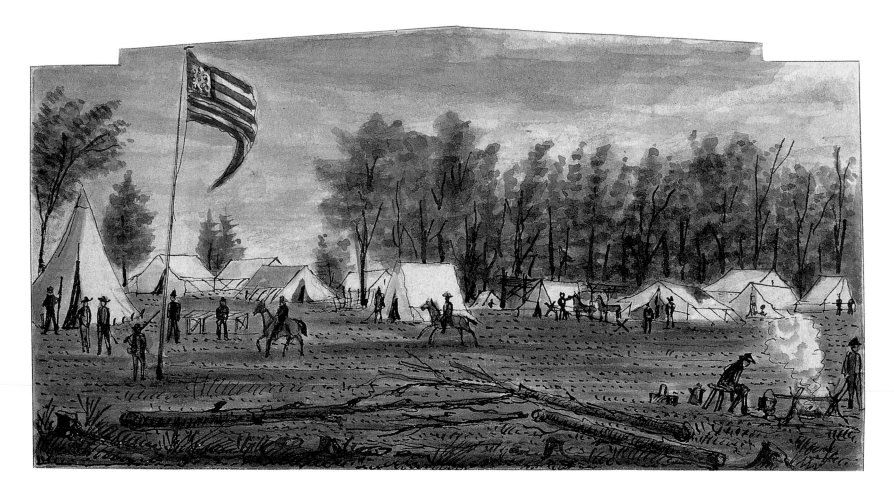

April 18, 1862. "I went over to General McClellan's headquarters today. . . . The camp was on a fine green level sward [with] about twenty tents in quadrangular form. I had much difficulty to find a Lieutenant Perkins, a topographical engineer to whom I had lent some instruments. There were fifteen or more draughtsmen at work on maps and plans . . . all old soldiers of the regular army in a large hospital wall tent. None of them knew Perkins. . . . At last an officer asked me if [Perkins] was in the volunteers. I said yes. [Then] his tent was pointed out to me at once. Regular army officers in this camp did not know any other officer unless of the regular army. I had a joke on Perkins and got what I went after, first opening a bottle of prime brandy, and [then] returned to headquarters."

Headquarters of Major General George B. McClellan, Yorktown, Va., April 1862.

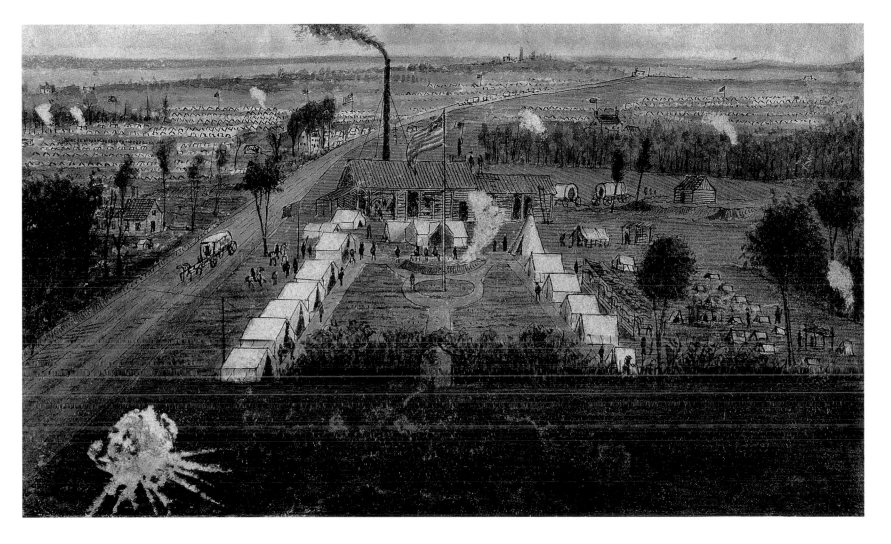

April 18, 1862. "A new [enemy] gun opened from the Yorktown parapets which threw round shot much nearer our headquarters than ever before. One came within 100 feet of my tent. . . . As the sawmill has been hither working day and night, orders were given to shut down at dark, as the lights used here help to give the enemy true range. More trees were cut and planted around our tents to act as a blind at night. All lights were ordered out at 8:30 p.m. I had to put up army blankets inside my tent so light cannot shine through the canvas, as I have to work often until 11 p.m., on maps and plans."

Headquarters of Major General S. P. Heintzelman, commanding III Army Corps A. P. at Howe's Sawmill before Yorktown, Va., April 1862. Enemy's shells bursting in front.

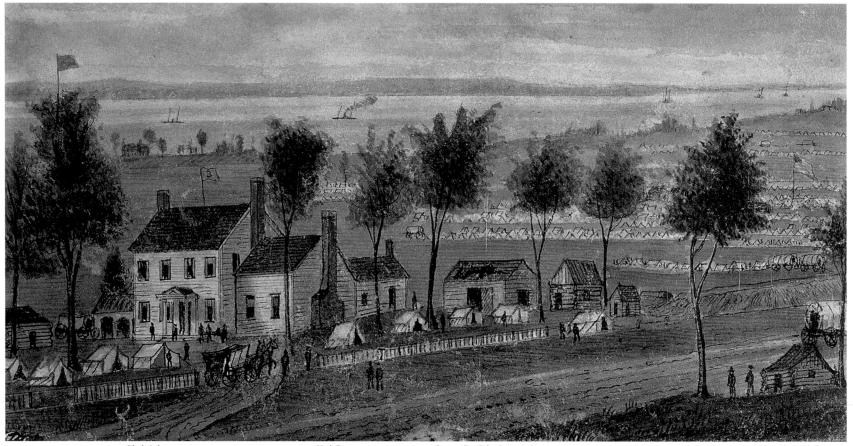

| Clarke's house | York River | Camps, Fitz-John Porter's division | Headquarters of General McClellan |

April 19, 1862. "The hospitals in the III Corps are quite full of sick soldiers caused by over-work in the trenches in the mud and water half the time. The officers all go to Clarke's house, which is used for hospital for them only. There are fine hospitals erected and covered with boughs and trees to keep them cool."

By early May, General McClellan was satisfied that he had enough heavy artillery in place to blast the Confederates out of their trenches. He planned to follow the barrage with a massive assault of infantry. But on May 4, before McClellan could begin the mighty bombardment, Rebel commander Joseph E. Johnston slipped his army out of the lines during the night and retreated up the Peninsula toward Richmond. The anticlimactic end of the siege disappointed almost everyone in the Union ranks, including Sneden. Nevertheless, the mapmaker entered historic Yorktown with sketchbook in hand, ever curious and observant.

The Union hospitals at Clarke's house near the sawmill at Yorktown, Va., April 1862.

May 2, 1862. "All the batteries nearly are in good fighting condition. . . . The question now is 'Will the enemy be fools enough to wait where they are until we open fire from all the batteries?' Many, including myself, think they will 'git out!'. . . The heaviest guns placed in the trenches at Sebastopol during the Crimean War were 68 pounder guns weighing 10,640 pounds each. . . . The guns now in the batteries before Yorktown exceed in weight fifty percent of any guns ever before placed in battery."

No. 7 Union Battery before Yorktown, Va. Six 20 pounder guns, smoothbores.

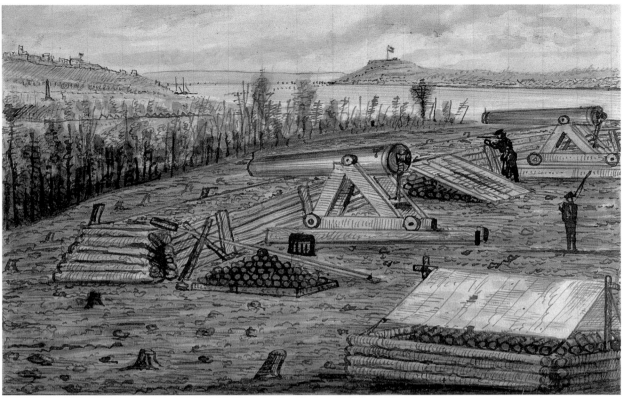

Yorktown Gloucester Point

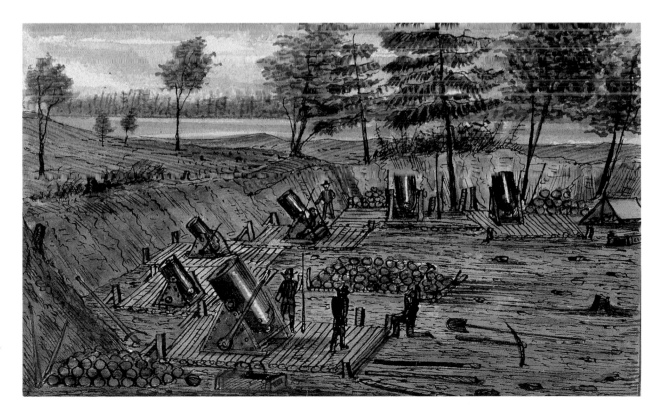

Interior of Mortar Battery No. 4, Yorktown, Va. Ten thirteen-inch mortars.

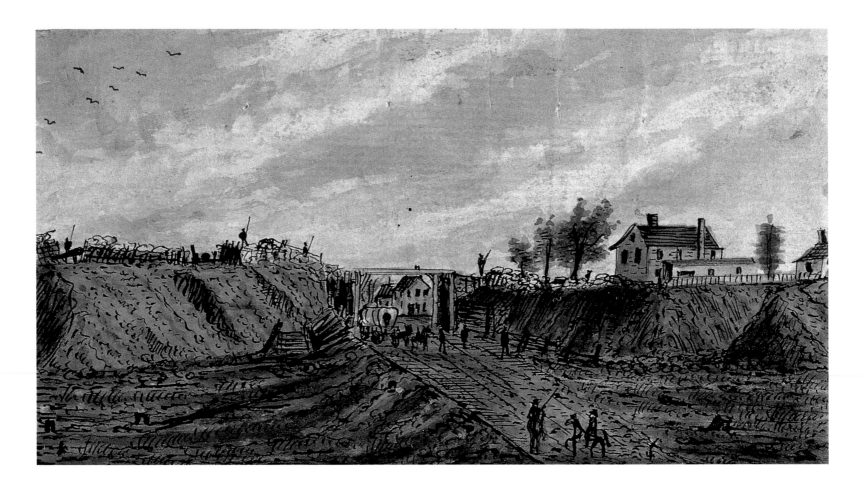

May 4, 1862. "We were all astir at 4:30 this morning while the bugles sounded through all the various encampments and shortly after to 'pack up.' . . . There was no doubt now but that the enemy were getting away as fast as they could. . . . We made a hurried breakfast at headquarters while all of our clerks were hard at work cooking rations for the expected for- ward march. . . . At 2 p.m. all our tents were struck and packed in the wagons, while the general and staff being mounted, we all moved over the plain to Yorktown."

Sally Port—or, the entrance to Yorktown, Va., April 1862.

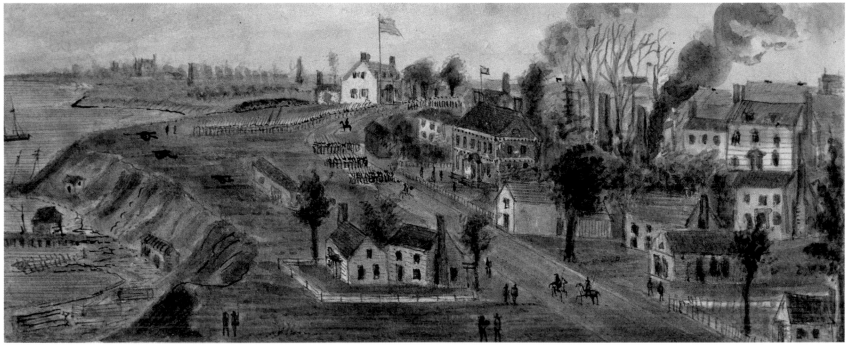

Wharf McClellan's headquarters Army marching in

May 4, 1862. "At 11 a.m. [the army] moved across the plateau to Yorktown from which clouds of smoke were still rising. The bands were now once more in full blast, while the colors flying and bright uniforms with the polished arms glistening in the morning sun looked grand and imposing. . . . General McClellan [made his] headquarters . . . in a white house at the head of the main street and nearly opposite the Nelson house. A large national flag floated from a tall pole [was] put up this forenoon. As the troops marched through I made a sketch."

This is how Edwin J. Meeker, an artist for the Century Company, redrew Sneden's watercolor sketch for volume 2 of Battles and Leaders of the Civil War.

View on Main Street, Yorktown, Va., May 4, 1862, Union troops marching in.

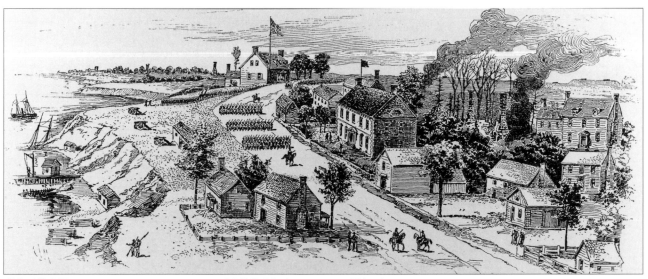

Wharf, York River McClellan's headquarters Nelson house

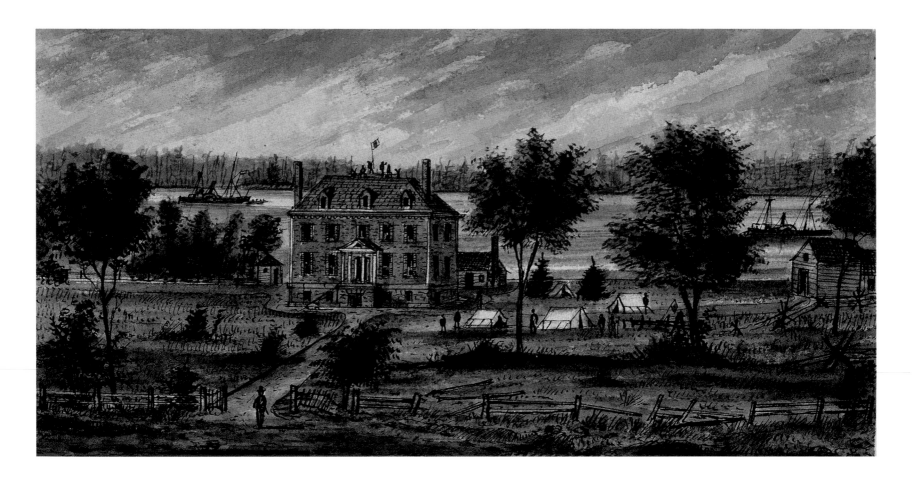

May 4, 1862. "Our headquarters train came to a halt, and I went over the town and ramparts making notes and sketching as rapidly as possible. . . . Yorktown contained only about forty houses. Many were of brick, unpainted and weather worn."

Farnhold's house near the Moore house, Yorktown, Va. Used by the U.S. Signal Corps, April 1862 (signaling to gunboats in York River).

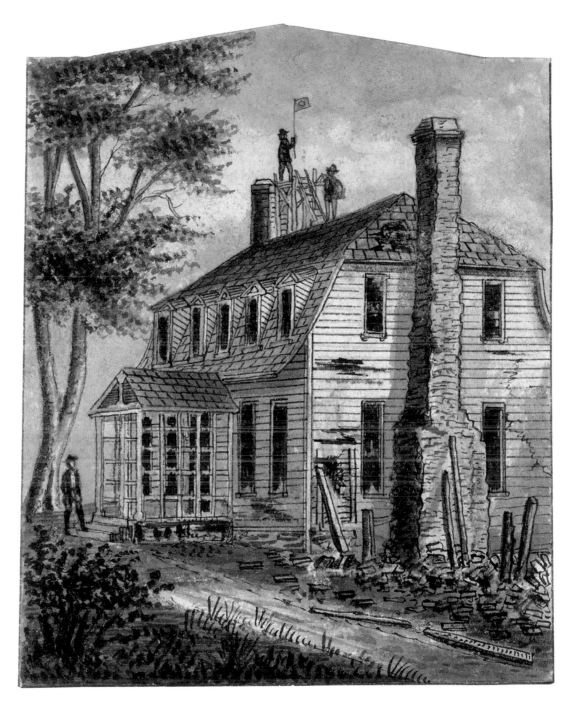

The Moore house,
near Yorktown, Va.

"This house was used as [a] U.S. signal station to gunboats in the York River and to headquarters of General Fitz-John Porter near McClellan. General Washington met General Lord Cornwallis here to make terms of the surrender of Yorktown in 1781."

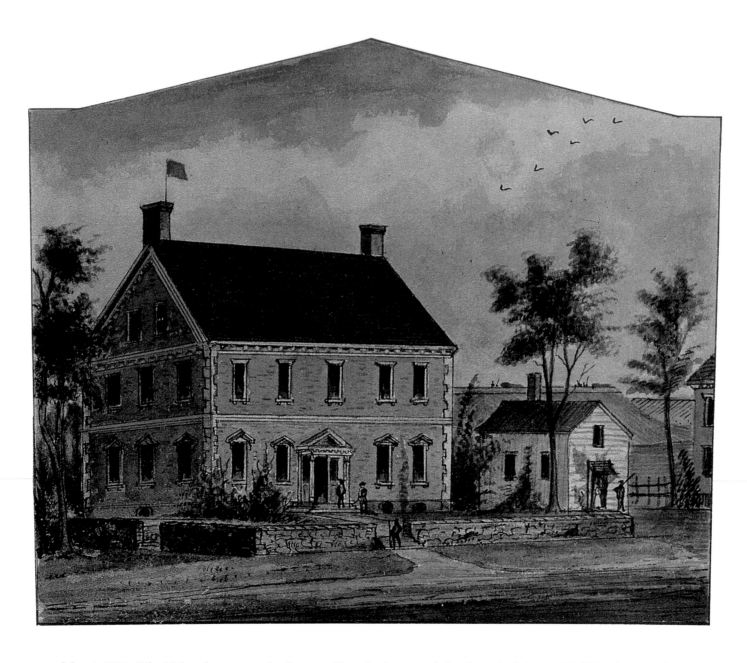

May 4, 1862. "The Nelson house was the finest and best in the town. It had been built by Governor Nelson in colonial times. The bricks and white marble trimmings had been imported from England, and was the headquarters of Lord Cornwallis during the siege of 1781. . . . A red flag was still attached to the chimney on the roof, which we had all plainly seen from the sawmill or on any part of our front line. This house had been the general headquarters of the Rebel generals Johnston and Magruder during the siege."

The Nelson house, Yorktown, Va., May 4, 1862. This was also known as the Proctor house and was the headquarters of General Cornwallis in 1781. During the siege it was used by Rebel officers as general headquarters and for an officers' hospital.

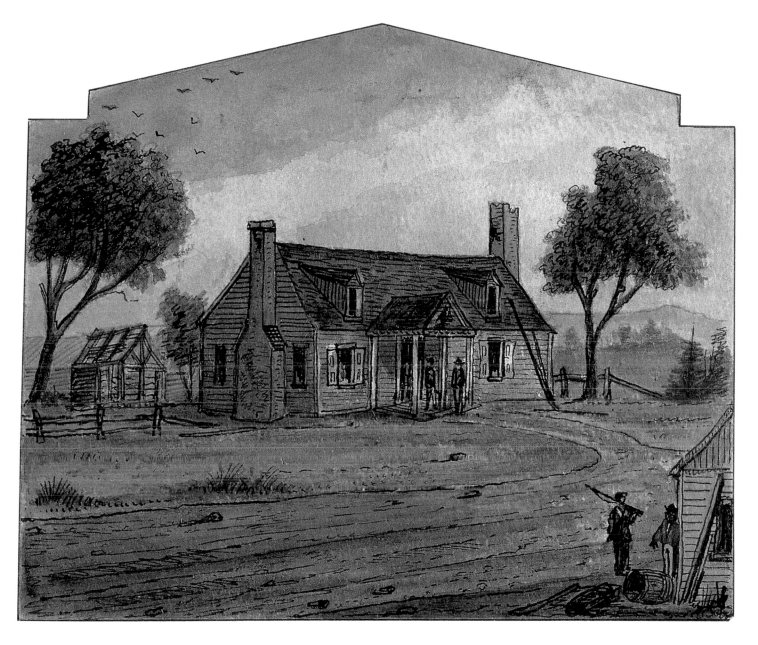

May 4, 1862. "Every house in the town had been used for some military purpose. In some were medical stores. Others which had probably been used as hospitals were littered with bloody rags, broken boxes and barrels, dirty straw beds, tin cups, and wooden canteens made like small flat kegs."

Old house, Yorktown, Va., Lafayette's headquarters after the surrender, 1781. Sketched May 4, 1862.

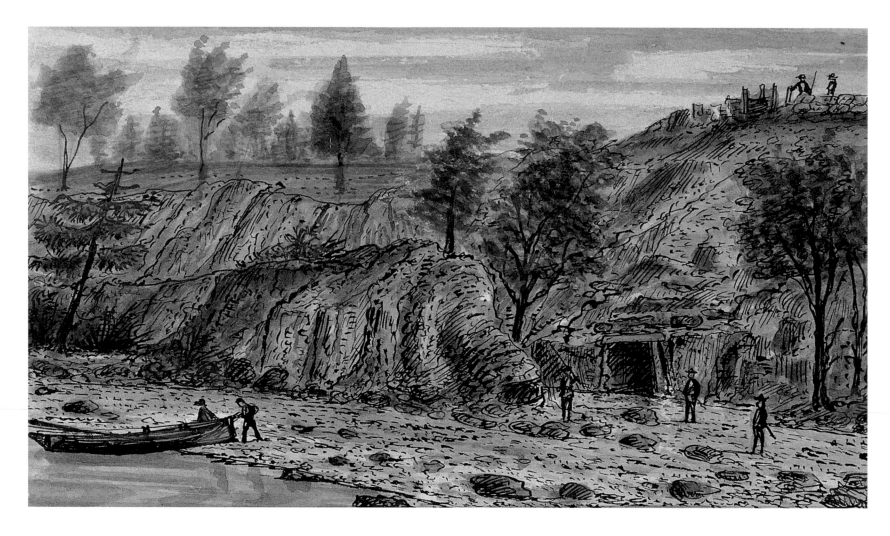

"This cave was dug in the York River bluff by English troops under Lord Cornwallis at the siege of Yorktown in 1781 and was used by them as a magazine. Bluff is sixty feet high."

The Cornwallis cave in the bluff at Yorktown, Va., April 1862. Used by the Rebels [as by the English earlier] for a magazine.

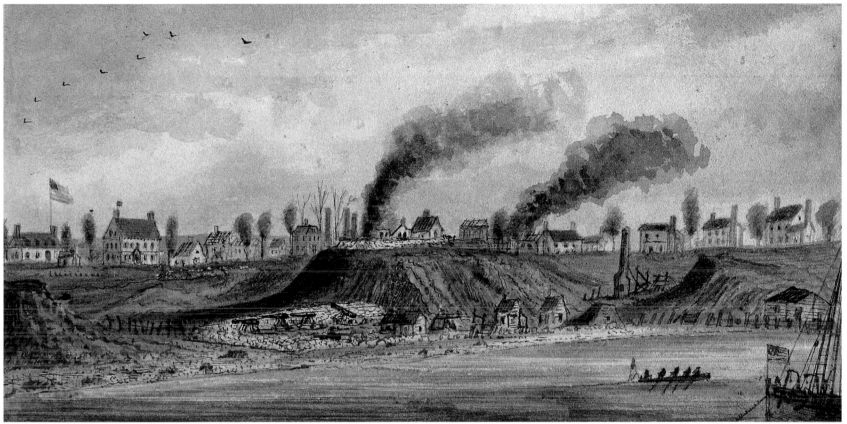

| General McClellan's headquarters | Nelson house | Water battery | Rebel stores burning and Rebel battery | Magazine and burnt house | Custom house | U.S. gunboat |

May 4, 1862. "In the ravines [below town], the Rebels, before evacuating, had piled high barrels and boxes of pork, rice, or meal mixed in with loaded shells and kegs of gunpowder. These were burning fiercely . . . with frequent explosions. Our engineers had soldiers throwing earth on the piles, smothering the fire, while guards were posted to keep anyone from going too near. Black smoke rose high in the air."

Yorktown, Va. after the evacuation. From the York River. Sketched May 4, 1862.

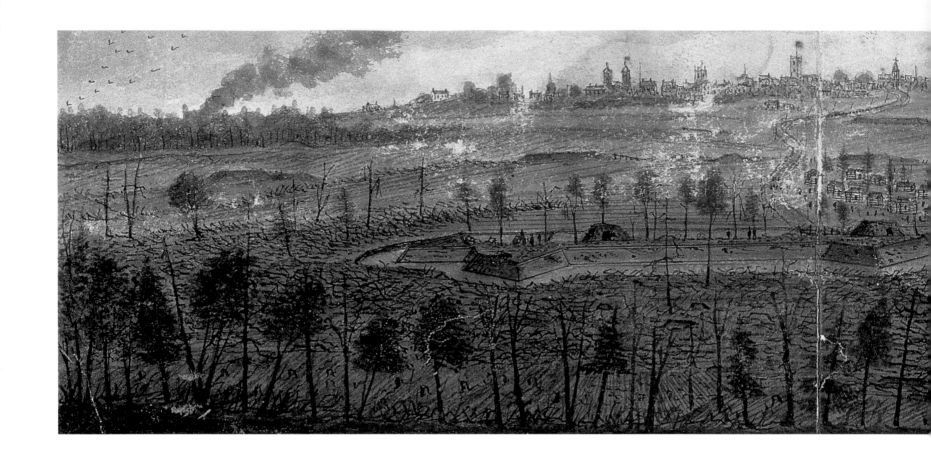

Because the second volume of Sneden's diary/memoir was destroyed, we are deprived of his detailed daily account from May 5 until June 26, 1862. This is unfortunate, because it was a period of intense activity, including participation in two battles. On the other hand, his scrapbook contains nearly thirty sketches from this period, many of which are accompanied by detailed captions that provide useful information about the advance of the Union army up the Peninsula and Sneden's whereabouts.

On the night of May 4, Heintzelman's III Corps marched out of Yorktown and closed in on the old colonial capital of Williamsburg. There it ran into a determined group of Confederate defenders under James Longstreet. A short but intense battle in a driving rain on May 5 ended when the Rebels withdrew. Sneden prepared after-action maps for Heintzelman and also made detailed sketches of the battlefield and town. Then, with sketchbook in hand, he drew crossroads and villages as the Union army slowly marched toward Richmond. Almost without fail, he drew the houses that General Heintzelman selected for his headquarters. Even though there is little narrative to accompany these sketches, they nevertheless provide an important visual chronicle of the Union army's advance on Richmond. In most cases, they are the only images of buildings and places that have long vanished from the landscape. By the middle of May, Sneden and his comrades had reached the Chickahominy River, only a few miles east of the Confederate capital.

Battlefield of Williamsburg, Va., from the interior of Fort Magruder. Sketched the day after the battle, May 6, 1862. Fort Magruder had parapets 9 feet thick, and a ditch 10 feet wide, 9 feet deep; the length of its interior crest was 600 yards. The redoubts had 40 foot faces.

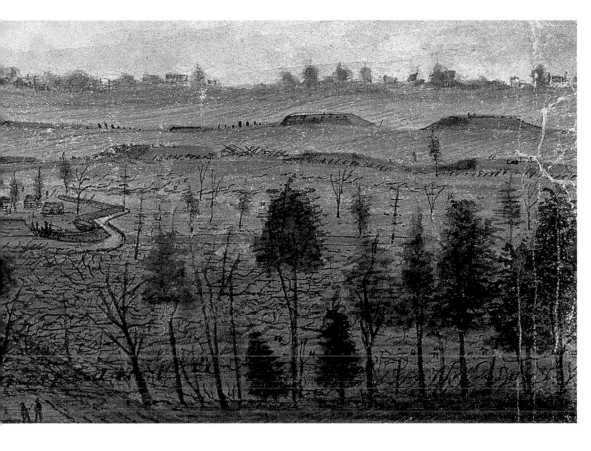

View of Fort Magruder. Battlefield of Williamsburg, Va. Showing obstructions, rifle pits, and other redoubts.

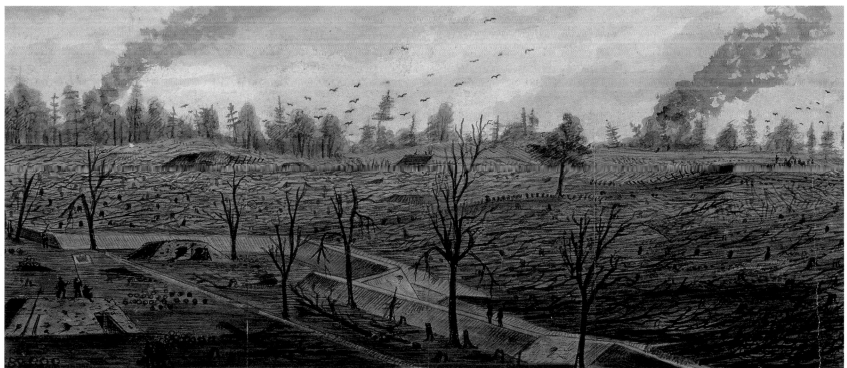

No. 1 magazine. Signal Corps on top No. 2 magazine Shallows drain through center Parapets of fort and ditch Redoubts and abatis in rear Burning houses in woods

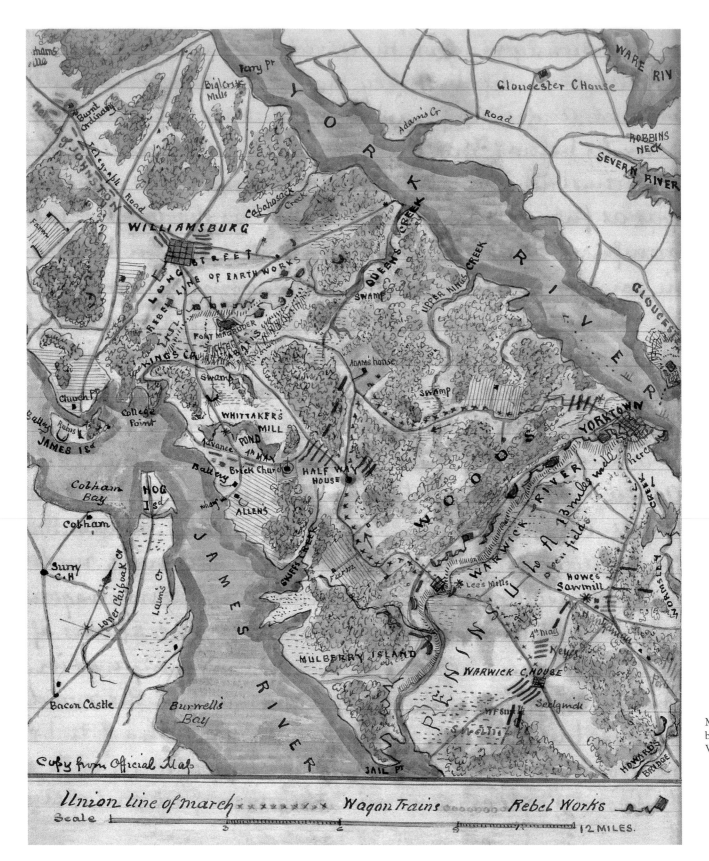

Map of country
between Yorktown and
Williamsburg, Va.

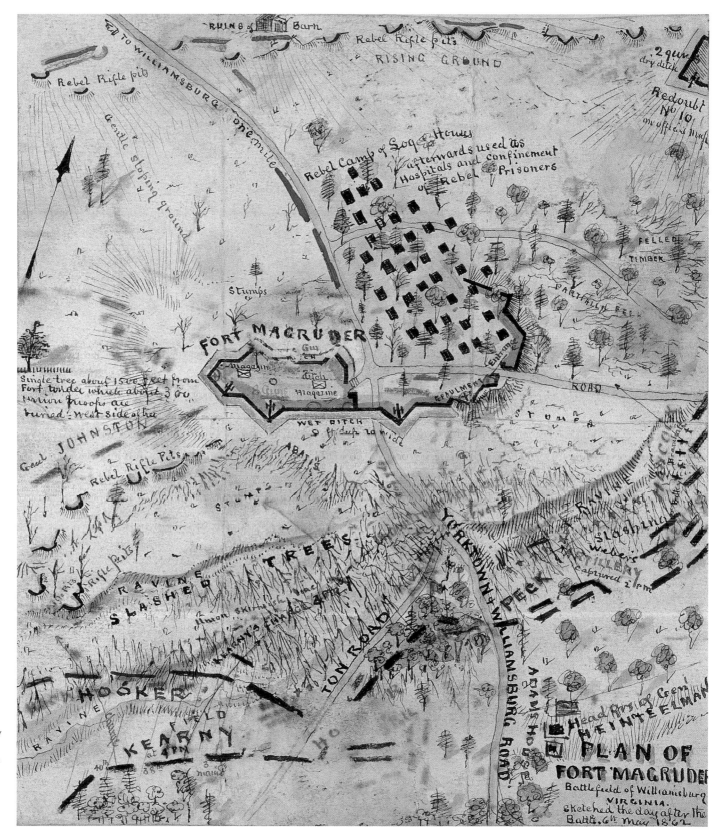

Plan of Fort Magruder. Battlefield of Williamsburg, Va. Sketched the day after the battle, May 6, 1862. Copy of official plan made for General S. P. Heintzelman.

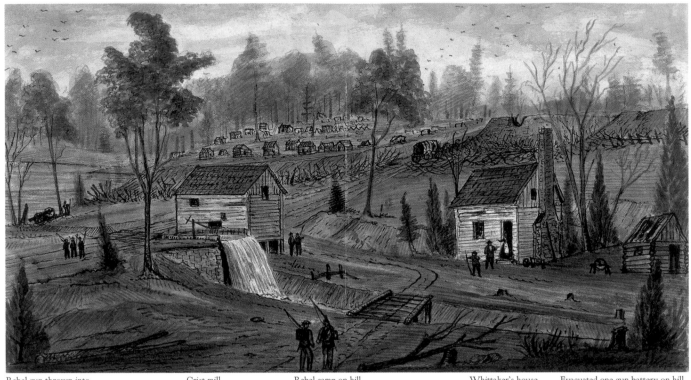

View of Whittaker's mill near the battlefield of Williamsburg, Va. Sketched May 4, 1862.

Rebel gun thrown into the mill dam and spiked Grist mill Rebel camp on hill, evacuated May 4 Whittaker's house Evacuated one gun battery on hill

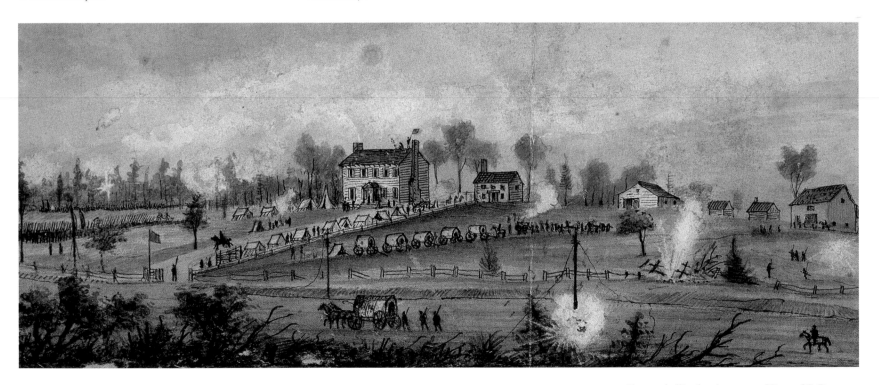

Enemy shelling headquarters of General S. P. Heintzelman, commanding III Army Corps, at the Adams house during the battle of Williamsburg, Va., May 5, 1862.

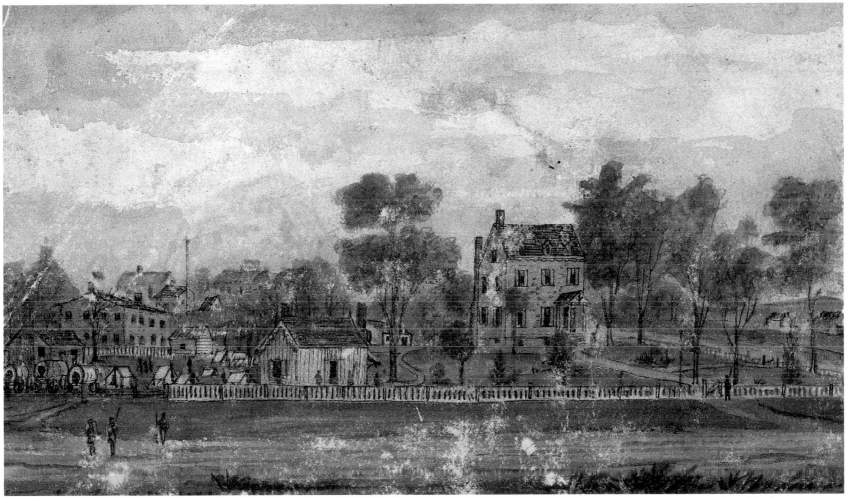

Wagons and clerks camped in yard Dr. Mercer's offices used for Adjutant General's office Dr. Mercer's house used by general and staff House was deserted by all occupants
Brick seminary used as hospital for Union wounded

Headquarters of III Army Corps at Dr. Mercer's house, Williamsburg, Va., May 6 to 12, 1862.

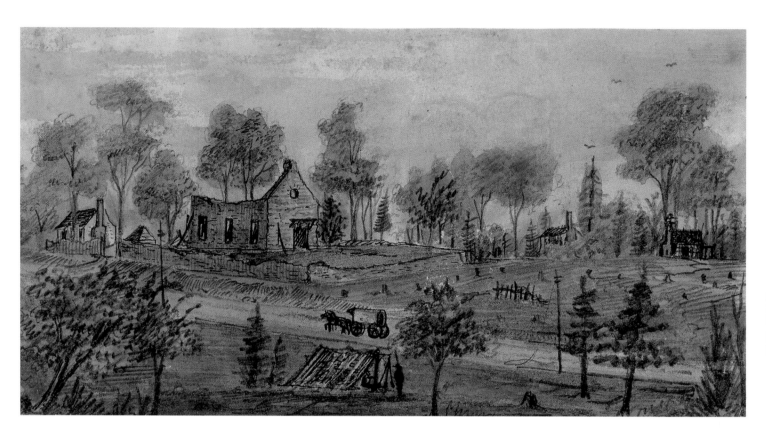

Burnt ordinary [tavern] between Williamsburg and Barhamsville, Va., May 9, 1862.

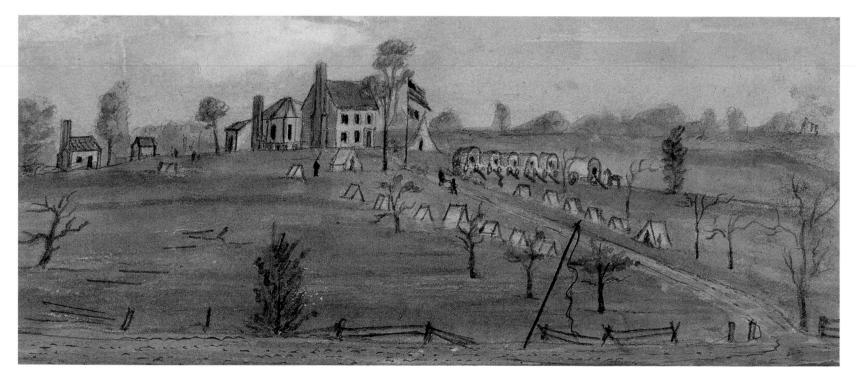

Headquarters of III Corps, General S. P. Heintzelman, at Mrs. Taylor's house, Barhamsville, Va., May 9, 1862.

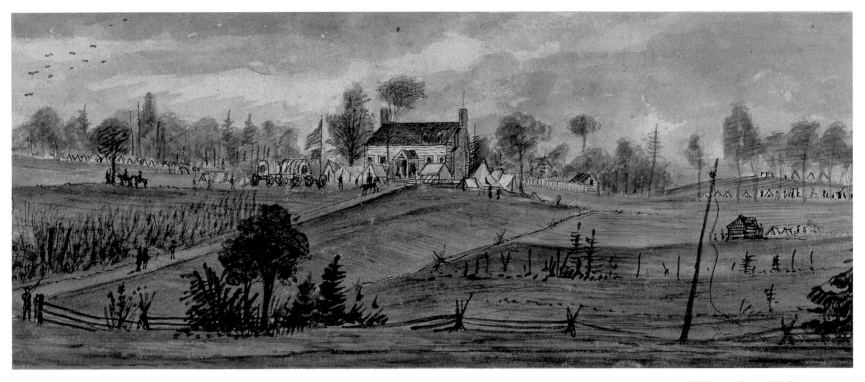

Headquarters of III Corps, General S. P.
Heintzelman, at Mr. William's house,
Barhamsville, Va., May 10–11, 1862.

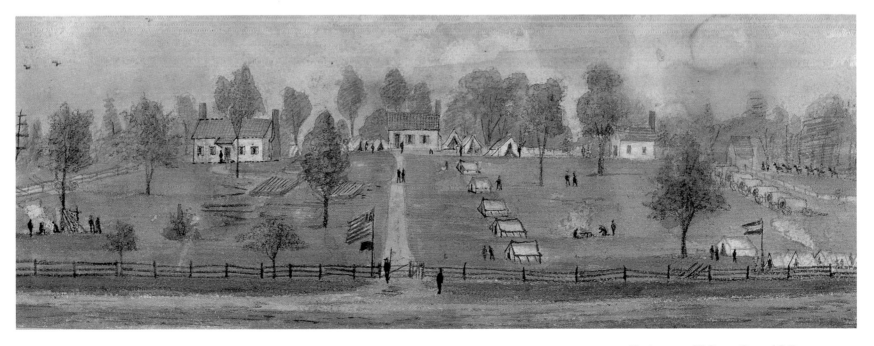

Headquarters, III Corps, General S. P.
Heintzelman, at Haggerty's house,
Barhamsville Va., Sunday, May 12, 1862.

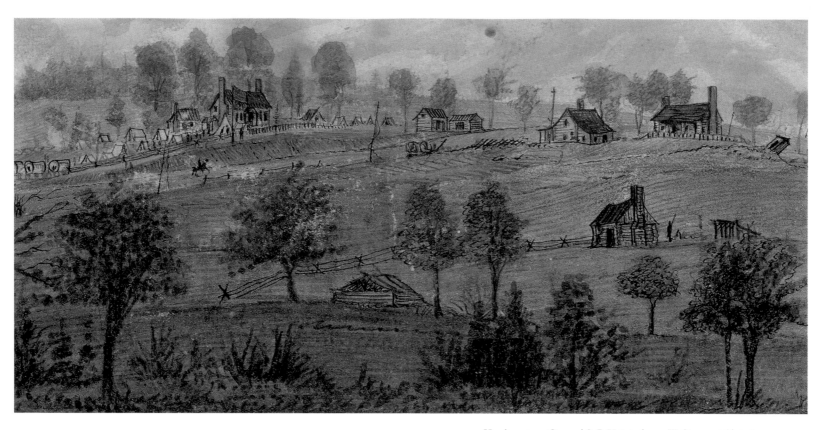

Headquarters, General S. P. Heintzelman, III Corps, at Slater's house, Slatersville, Va., May 16, 1862. Stoneman's cavalry had a hot skirmish here May 14 with rear of the Rebel army, who were retreating. Round shot passed through the houses.

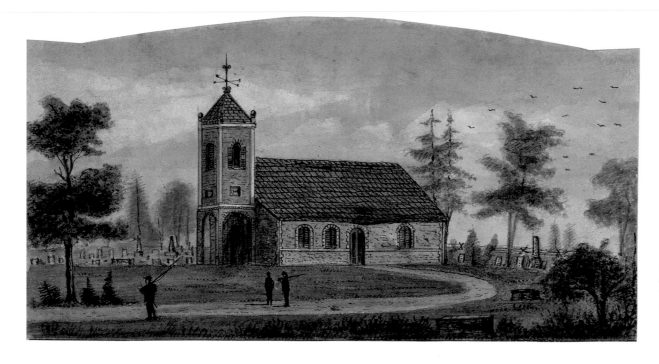

St. Peter's Church, New Kent Court House, Va., where Washington was married in 1759 to Martha Custis.

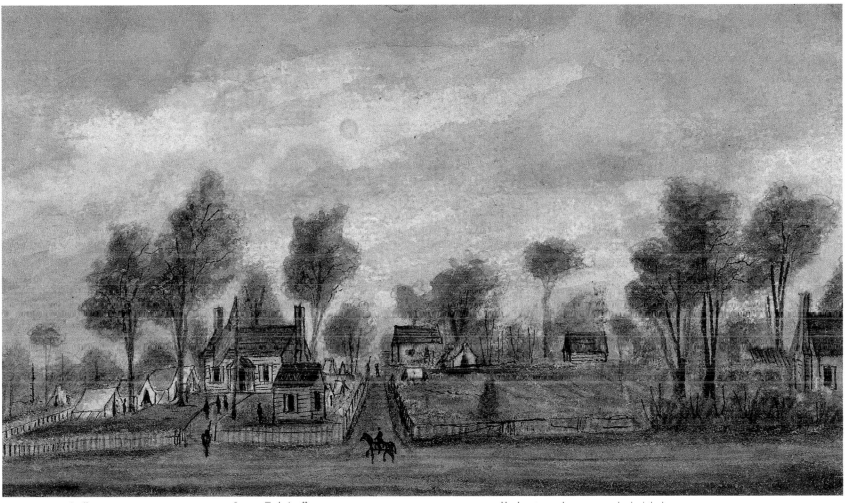

Staff tents Lawyer Taylor's office Headquarters and wagons were back of the lane

Headquarters, General S. P. Heintzelman, III Corps, at lawyer Telemachus Taylor's house at New Kent Court House, Va., May 19–22, 1862.

After the war, Sneden wrote: "The III Army Corps, Major General S. P. Heintzelman commanding, camped here May 18, 19, and 20, 1862. The enemy hastily evacuated as the 3rd Pennsylvania Cavalry, Colonel William Averell, approached. The Rebels burnt the jail, and all the houses were deserted by the inhabitants. The Union soldiers looted the court house, and records, office deeds, and legal parchments were carried off by them. Two Rebel soldiers were left behind by the Rebel army at two houses, desperately wounded. Three old women were the only persons in town. General Heintzelman's head-quarters were at the deserted house of Telemachus Taylor until the army resumed their forward march again May 20."

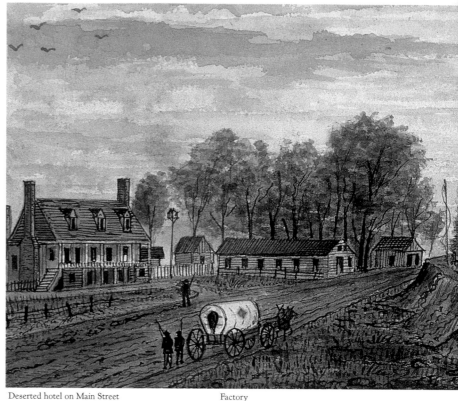

New Kent Court House, Va., May 19, 1862. Evacuated by the Rebels May 18.

Deserted hotel on Main Street Factory

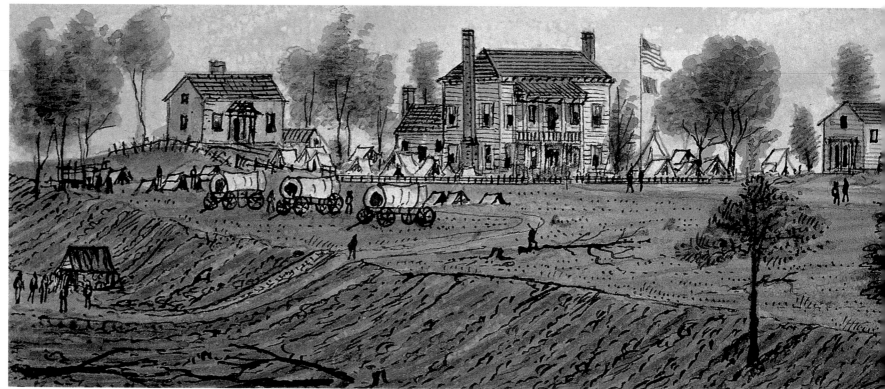

Spring Kitchens Dr. Tyler's house

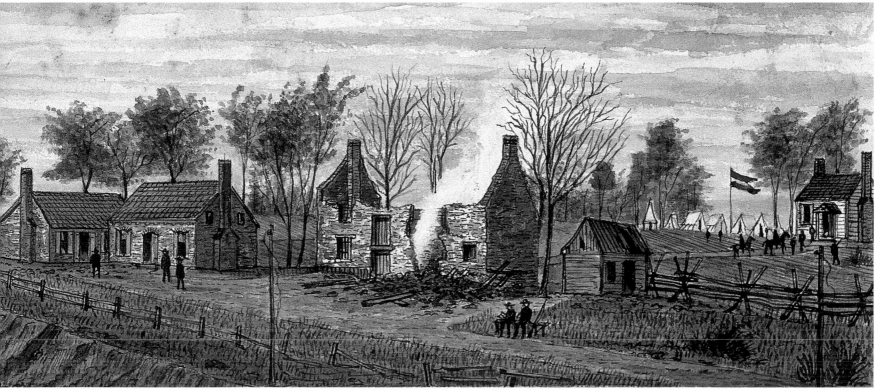

Record office Court house, slate roof with shutters Jail, burnt by the Rebels May 18 when they evacuated Headquarters of Colonel William Averell, 3rd Pennsylvania Cavalry

Averell's cavalry camp

In a postwar caption, Sneden wrote: "When General Heintzelman and staff arrived at Dr. Tyler's about 2 p.m. [on] May 21, the occupants had made a hasty exit but an hour before. Dinner was on the table with much silverware. Two old Negro women and one man servant remained in the house, which was nicely furnished throughout. All stock [and] horses had been run off previously. In the parlor as an ornament was a polished skull, across the forehead of which was printed in black, block letters 'A. YANKEE.' Dr. Tyler was a relative of ex-President Tyler."

View of Headquarters, General S. P. Heintzelman, III Army Corps, at house of Dr. John Tyler, Baltimore Cross Roads, Va., May 21, 1862.

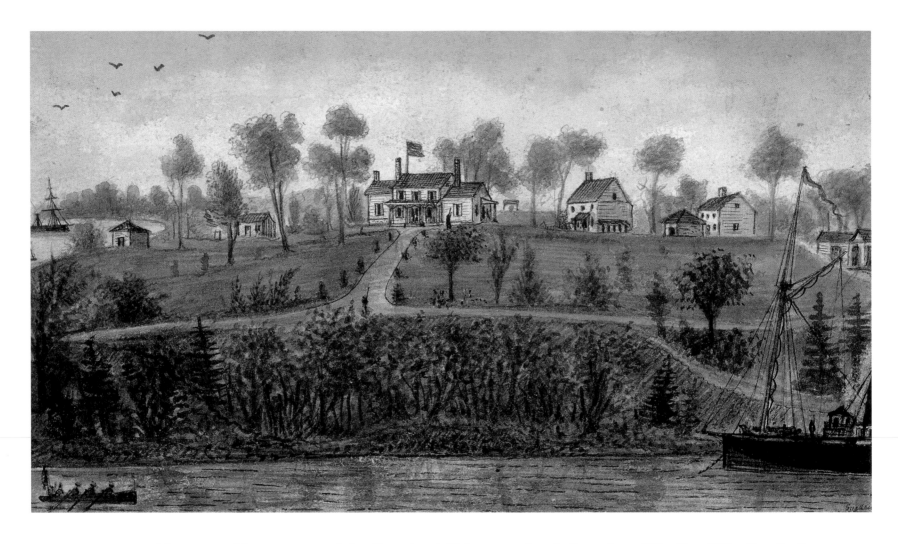

While a portion of the Union army, including Heintzelman's III Corps, moved up the Peninsula by road, McClellan led another contingent up the Pamunkey River, a tributary of the York River, to White House Landing, the 4,000-acre plantation where George Washington had courted Martha Custis. The property now belonged to the family of Robert E. Lee, whose wife was the granddaughter of Martha Custis Washington. By May 16, most of the Union army was encamped along the Pamunkey between White House Landing and Cumberland Landing to the south. McClellan turned the location into his main base of supply from which to continue his offensive. We can speculate from the drawing above, dated May 22, 1862, that Sneden visited the site.

"White House." White House Landing, Pamunkey River, Va., May 22, 1862. Burnt by McClellan's orders during the retreat from the Peninsula.

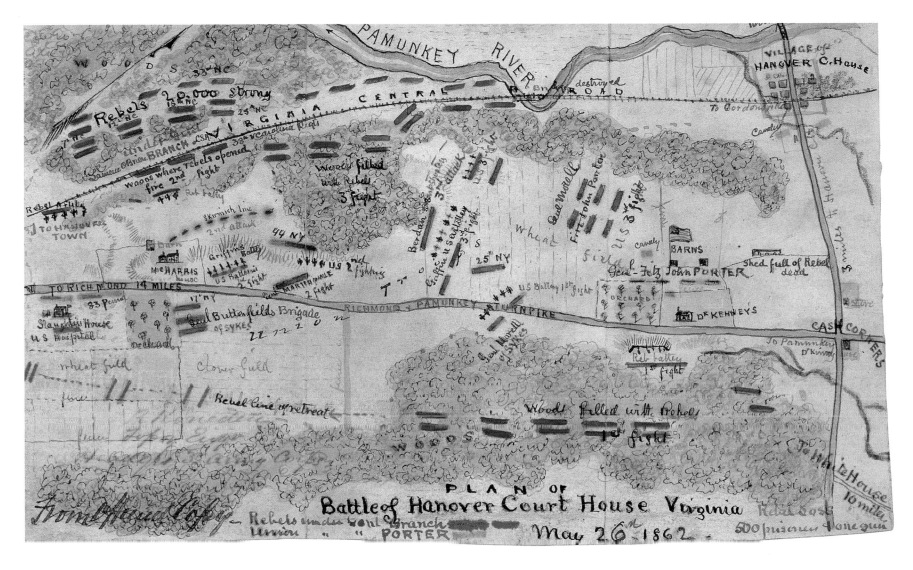

In the meantime, on May 27, McClellan ordered a division under General Fitz-John Porter to advance on Hanover Court House, north of Richmond, to drive off Confederate forces that threatened the right flank and rear of the Federal army. In a brief but sharp battle, Porter pushed the Rebels west, thus protecting the Union position. In this map, Sneden's date is off by one day, and there is no evidence that he was present at the battle.

Plan of the battle of Hanover Court House, Va., May 26, 1862.

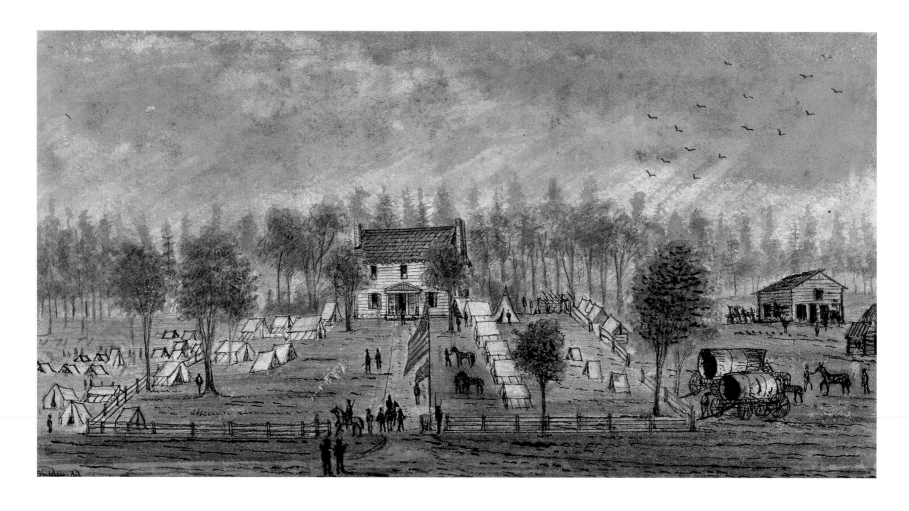

To get at Richmond, McClellan decided to split his army by putting two corps, including Heintzelman's, on the south side of the Chickahominy River, where they took up positions near Fair Oaks Station and Seven Pines. Not wanting to wait for McClellan to advance farther, the Confederates launched a furious assault on the isolated Union troops south of the river on May 31. The chaotic and bloody battle of Fair Oaks or Seven Pines ended in a draw the next day, and the fight for Richmond would now go on longer than either side had expected. Sneden's whereabouts during the battle are unknown, but we can speculate that he was a firsthand observer from the several images he drew of the Fair Oaks area before and after the action. Also, his superior officer, General Heintzelman, took command of the battlefield the first day and was in the heat of the fight much of the time.

Headquarters, III Corps, General S. P. Heintzelman, at a deserted house near Bottom's Bridge, Chickahominy River, Va., May 26–28, 1862.

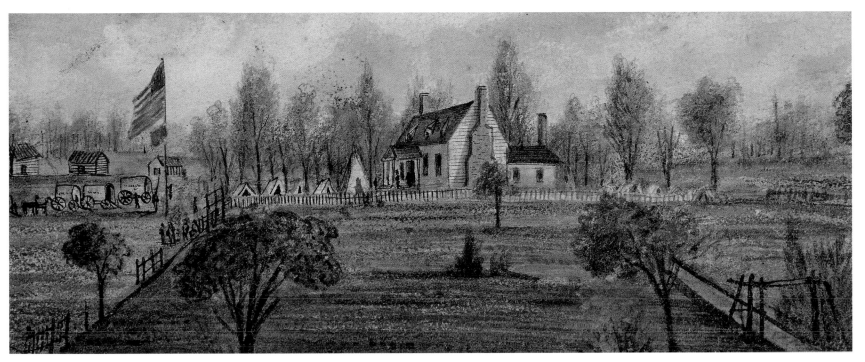

Headquarters, III Corps, General S. P. Heintzelman, at Cartwright's house, Linden Farm, Va., May 28–30, 1862. This house was afterwards used for a Union hospital until the retreat from the Peninsula.

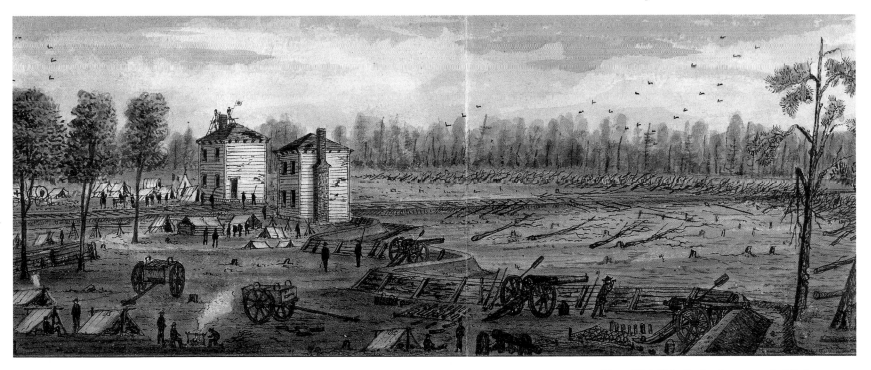

View of Fair Oaks Station, known as the "Twin Houses." Headquarters of Major General Joe Hooker after the battle of Fair Oaks, Va. Sketched June 15, 1862, from the south side of the station.

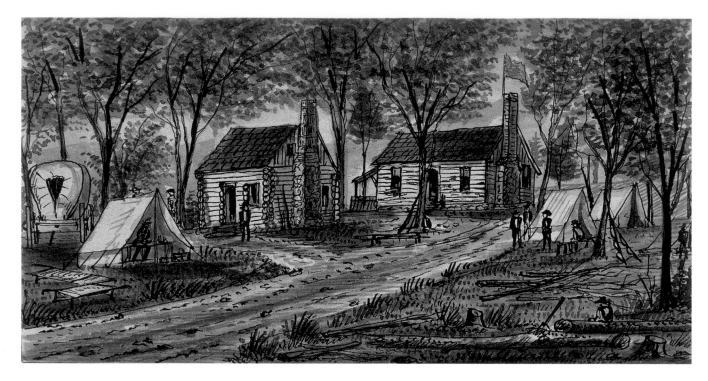

Houses used for Union
hospitals after battle of
Fair Oaks, Va. Burnt
during the retreat of the
army.

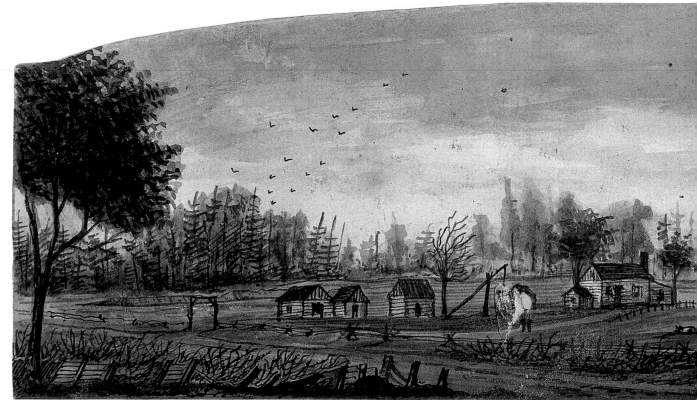

Myer's house, Seven Pines,
Va., May 1862.

Remains of the earthworks and abatis

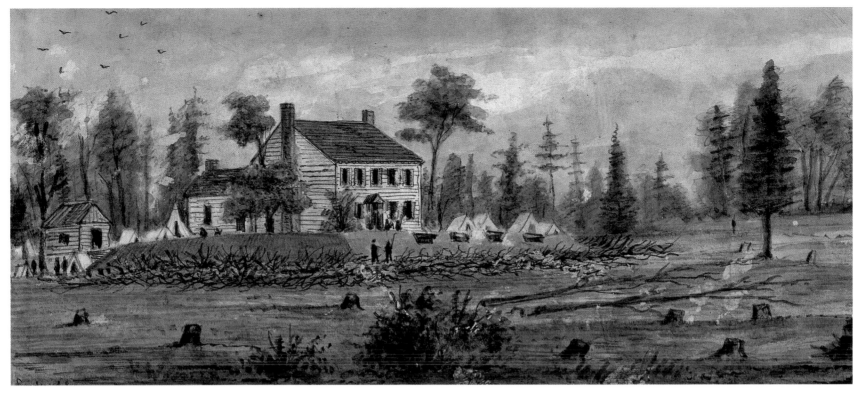

Earthworks built around officers' quarters,
1st Minnesota Regiment (Colonel Sully),
near Fair Oaks, Va., June 8, 1862.

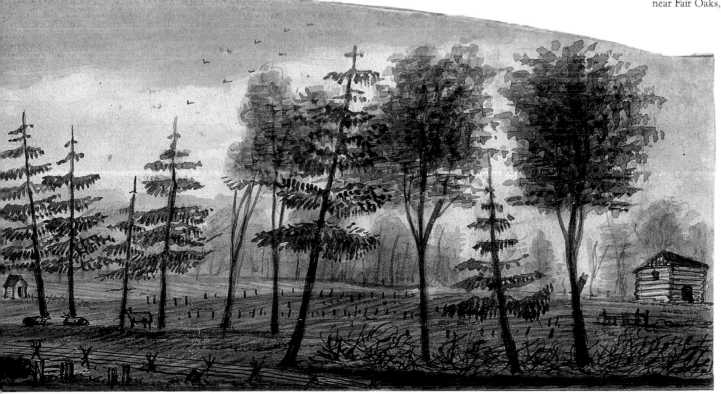

290 Rebel dead buried here in field

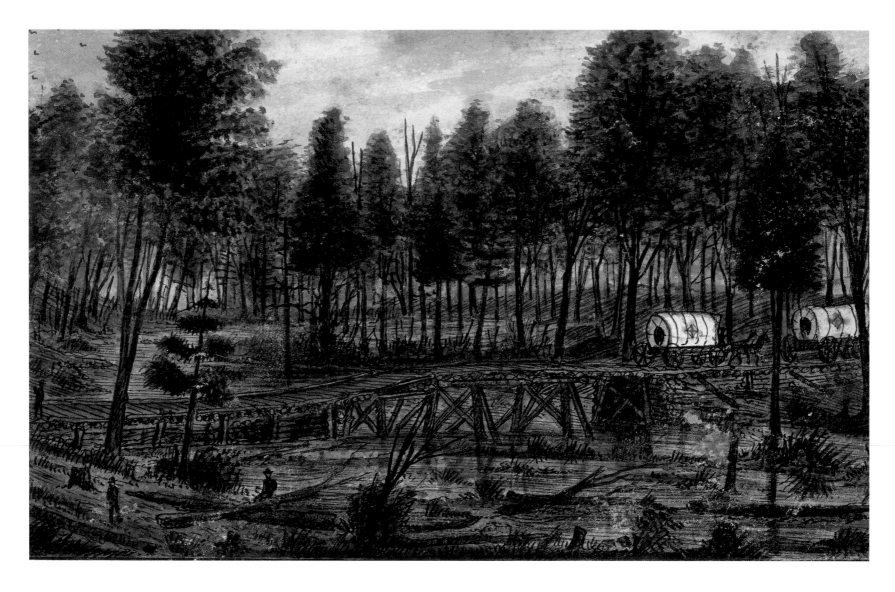

For nearly a month after the battle of Fair Oaks, the Union army lay virtually dormant astride the Chickahominy River. Even though McClellan maintained a decided numerical advantage over the Confederates, he seemed almost afraid to do anything other than prepare for another siege operation. On the other side of the lines, however, newly appointed Confederate commander Robert E. Lee developed a bold plan to drive the Union host from Richmond. While part of his army held the Federals in check east of the city, Lee launched a massive blow on an isolated Union corps north of the Chickahominy, thereby threatening McClellan's supply base at White House.

Alexander's bridge across the Chickahominy River, Va., June 1862.

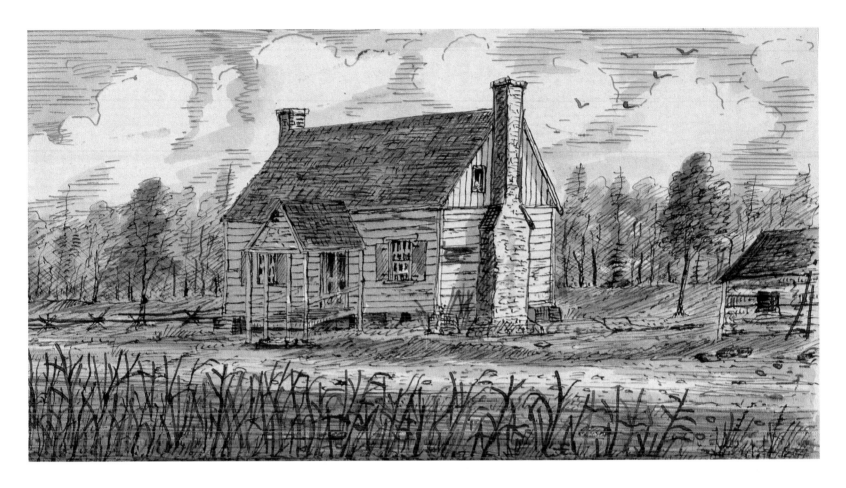

The first round of what would become known as the Seven Days' battles began on June 25, 1862, east of Richmond. Then, on June 26, the full weight of Lee's attack fell on the Union right at Mechanicsville. The next day the Confederate assault continued at Gaines Mill. By June 27, McClellan, now convinced that his army faced annihilation, decided to retreat to Harrison's Landing on the James River where his gunboats could protect him. Lee continued to hammer away, striking at the Union rear guard at Savage's Station, White Oak Swamp, and Glendale.

By July 1, McClellan's army had retreated to Malvern Hill, where it took up strong defensive positions. Lee, once again hoping to destroy the Federals, launched wave after wave of infantry up the hill, only to be turned back each time with heavy casualties. By nightfall, the Confederates called a halt to the slaughter, but the shaken Union army continued its withdrawal down the James River to Harrison's Landing. With sketchbook in hand, Sneden witnessed these events, observing the battles of Savage's Station, Glendale, and Malvern Hill firsthand. Fortunately, the third volume of his diary/memoir picks up the action at Savage's Station on June 29.

Allen's farmhouse, near the Williamsburg Road and railroad. Battlefield of Fair Oaks, Va. House used for Union hospital after the battle and for Sumner's headquarters. Battle fought June 29, 1862.

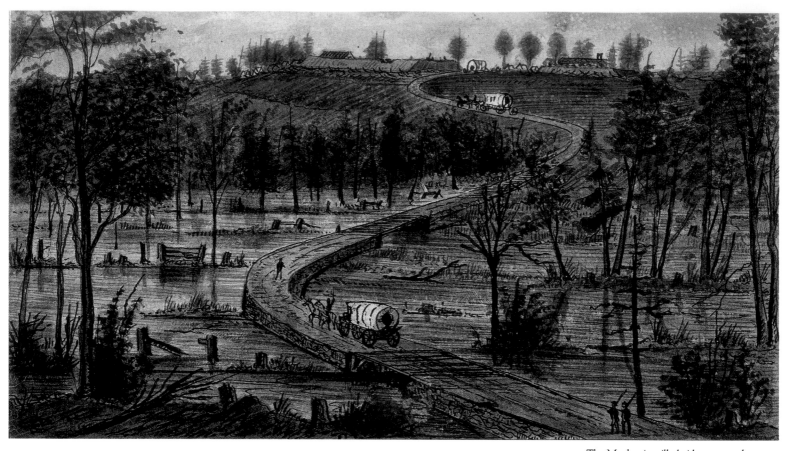

The Mechanicsville bridge across the Chickahominy River, June 1862. (Controlled by the Rebels.)

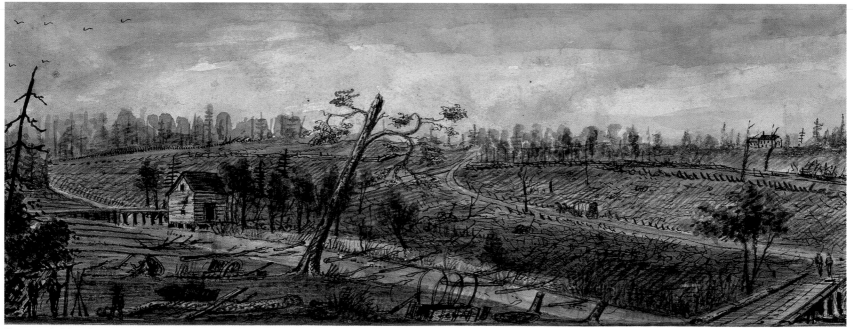

Enemy attacked from this side Ellerson's mill Beaver dam Line of Union defense on hill Adams house

Battlefield of Mechanicsville, Va., or Beaver Dam.

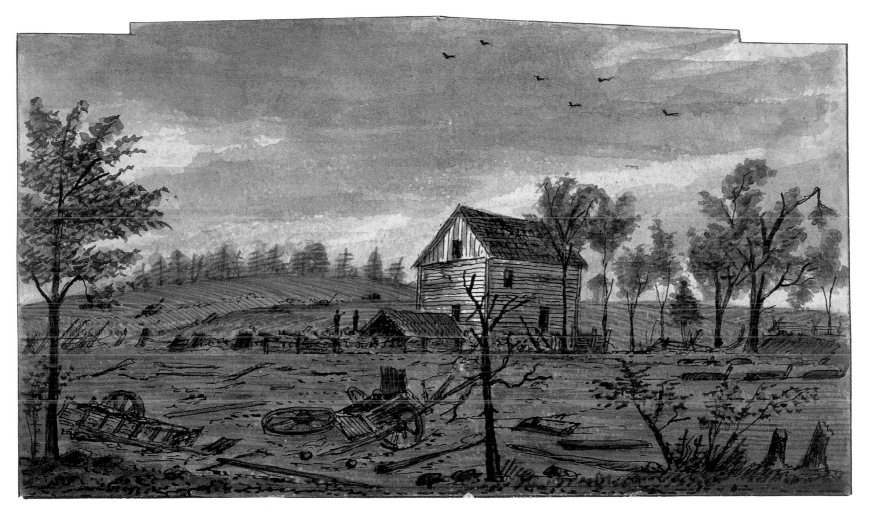

McClellan delayed action, but meanwhile the Union forces north of the Chickahominy River repulsed repeated Confederate attacks in the battle of Mechanicsville, June 26, 1862.

Rear of Ellerson's mill—battlefield of Beaver Dam Creek or Mechanicsville, Va. Sketched June 27, 1862.

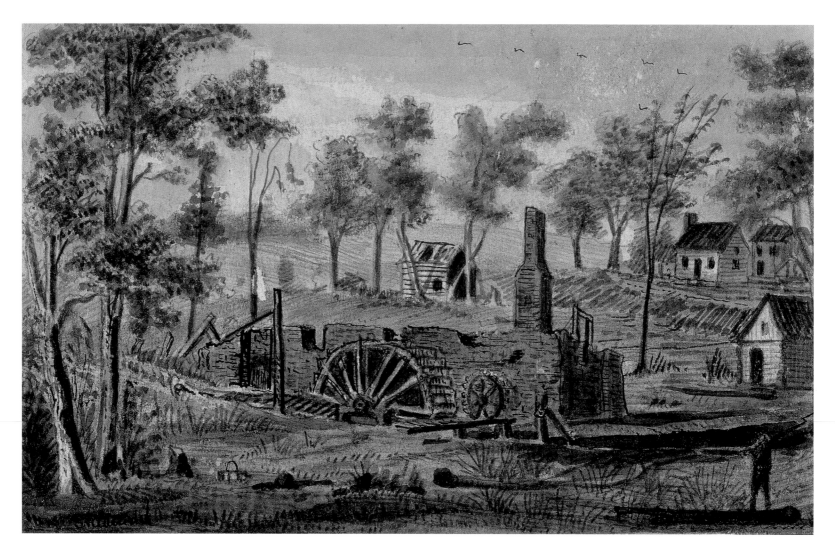

McClellan moved his soldiers south toward the James River for safety, and, at the end of the bloody daylong battle of Gaines Mill, June 27, 1862, the Union forces north of the Chicka- hominy were obliged to retreat southward as well.

Ruins of Gaines Mill, head of Powhite Creek, Va., 1865. At the time of the battle this was a five-story brick grist mill. It was not injured in the fight but it was burnt by General Sheridan's cavalry in May 1864, as were the large dwelling and log houses.

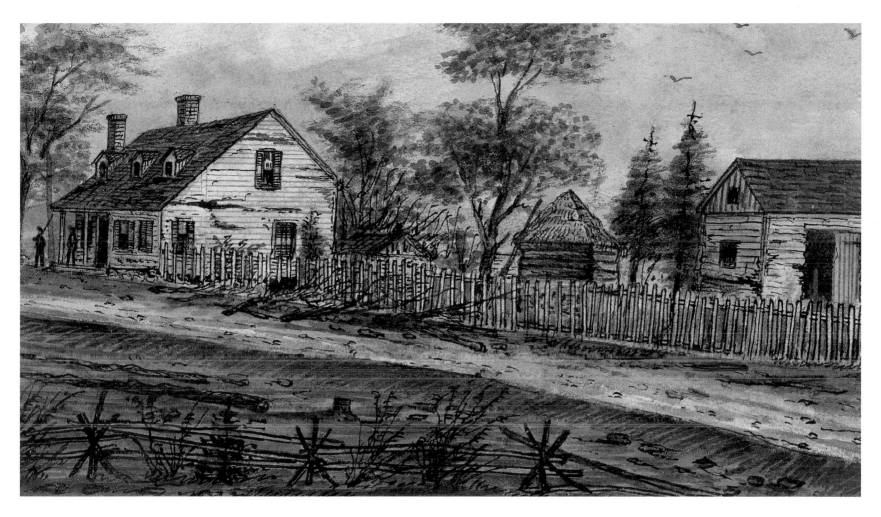

The tavern Sneden sketched was at Old Cold Harbor; Lee's headquarters were at nearby New Cold Harbor. The battle of Gaines Mill, June 27, 1862, is sometimes called First Cold Harbor. From May 31 to June 12, 1864, a much bloodier contest occurred there, including eight minutes in which "more men fell bleeding as they advanced than in any other like period of time throughout the war," in the words of Martin T. McMahon in Battles and Leaders, *volume 4: 217.*

The tavern, Cold Harbor, near James Mill, Va., June 26, 1862.

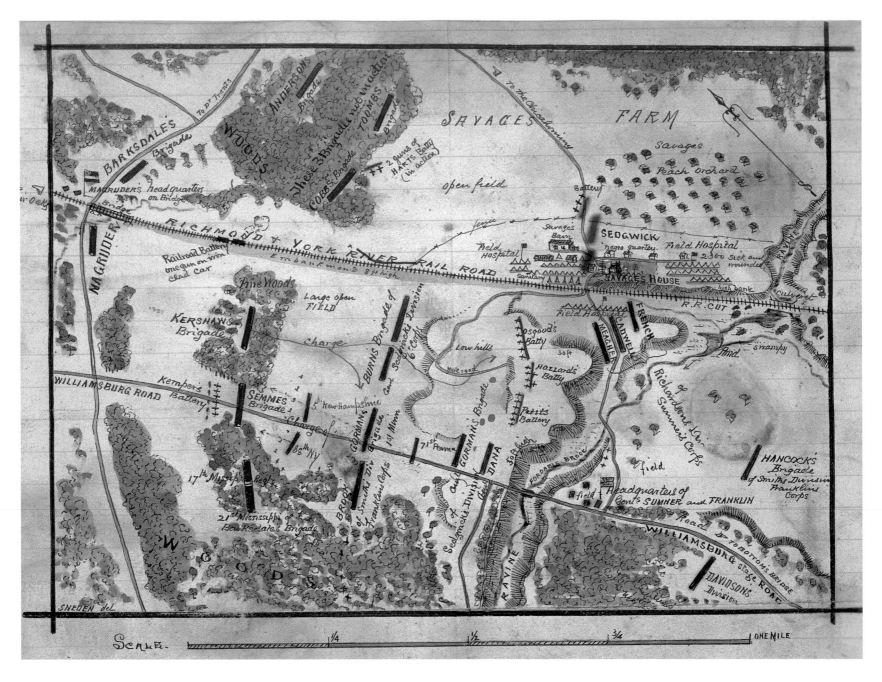

Plan of the battle of Savage's Station, Va., showing scale of miles. Fought Sunday, June 29, 1862, by the II and VI Corps.

June 29, 1862. "The heat was intolerable. The large trees near Savage's house afforded the only shade. Under these were collected generals and other officers, orderlies with their horses, surgeons, quartermasters, commissary officers, and artillery officers, all giving and receiving orders for future movements. The surgeons and assistants occupied the several Negro quarters attached to Savage's house. Everyone was cooking and eating a hasty meal. . . . Generals Heintzelman, Sumner, Sedgwick, Franklin, and their staff officers were consulting and giving orders. All were taking the situation coolly. No excitement showed itself in their faces, though all were more or less anxious. . . . I had furnished General Heintzelman with a good supply of maps before packing away those not to be used. These the general was now looking over in his tent, in company with Sumner and Franklin. . . ."

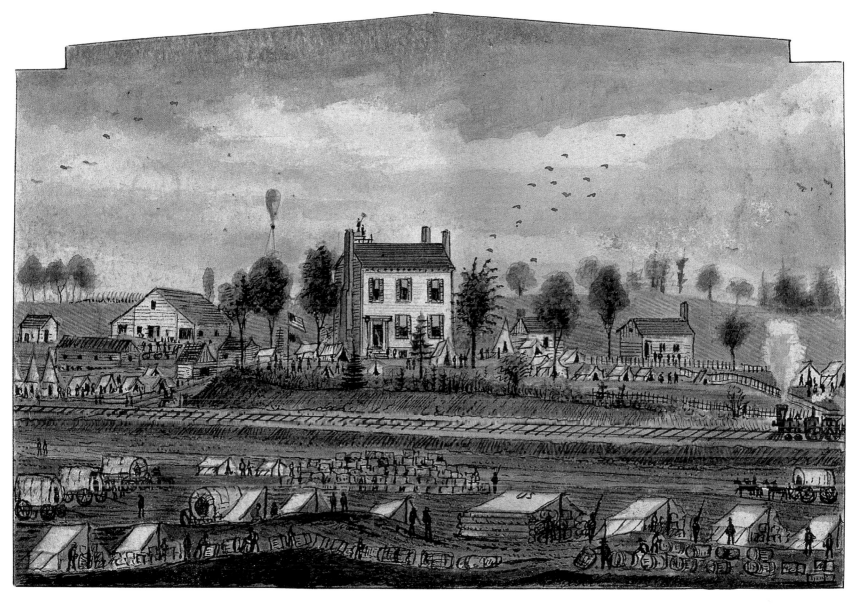

June 29, 1862. "Every room in the house was occupied by our surgeons and their assistants, who were probing wounds and putting on splints. The walls and floors were spattered with blood, and dozens of officers were lying on the floors and in hallways awaiting their turn. . . . A general feeling of despondency prevailed which was enhanced by the rain storm and the knowledge that the morning would bring another battle. . . . Several dead officers were boxed up in coffins in the main hall of the house, and the noise occasioned by moving them into wagons during the night kept many awake."

Headquarters of III Army Corps, Major General S. P. Heintzelman, U.S.A., at Savage's house, Savage's Station, Va., June 27, 1862, during the battle of Gaines Mill.

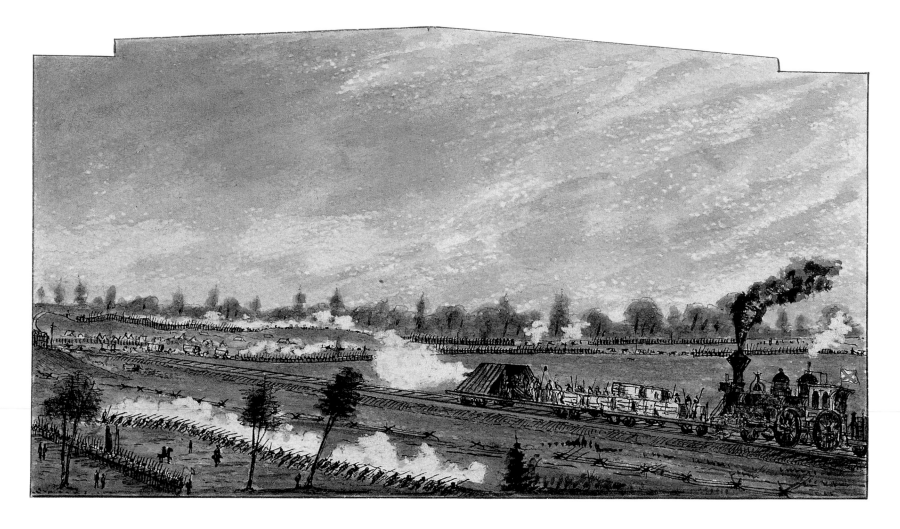

June 29, 1862. "After the Rebels had sustained their first repulse, and during a temporary lull in the firing, a shrill locomotive whistle was heard up the railroad at Fair Oaks Station. And soon appeared, coming down the track towards us, a nondescript car, which was roofed over at sides with railroad iron set at an angle, and from which in front projected a heavy gun. . . . A powerful locomotive pushed it along from behind. . . . Cotton bales were piled on both sides of the car, which concealed a hundred or more sharpshooters. . . . The railroad gun was suddenly withdrawn and steamed up fully half a mile on the track, where it continued firing until dark."

Battle of Savage's Station, Va., June 29, 1862. Rebel ironclad car with cotton bales in action.

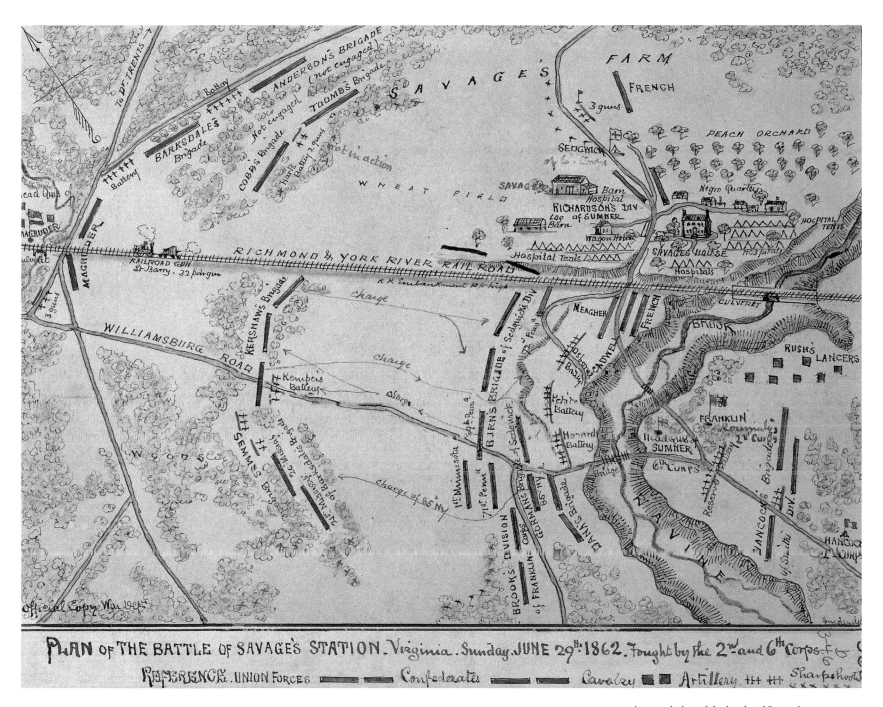

PLAN OF THE BATTLE OF SAVAGE'S STATION. Virginia. Sunday. JUNE 29th 1862. Fought by the 2nd and 6th Corps

REFERENCE. UNION FORCES — Confederates — Cavalry — Artillery — Sharpshooters

A second plan of the battle of Savage's Station, Va., with a key to fighting forces.

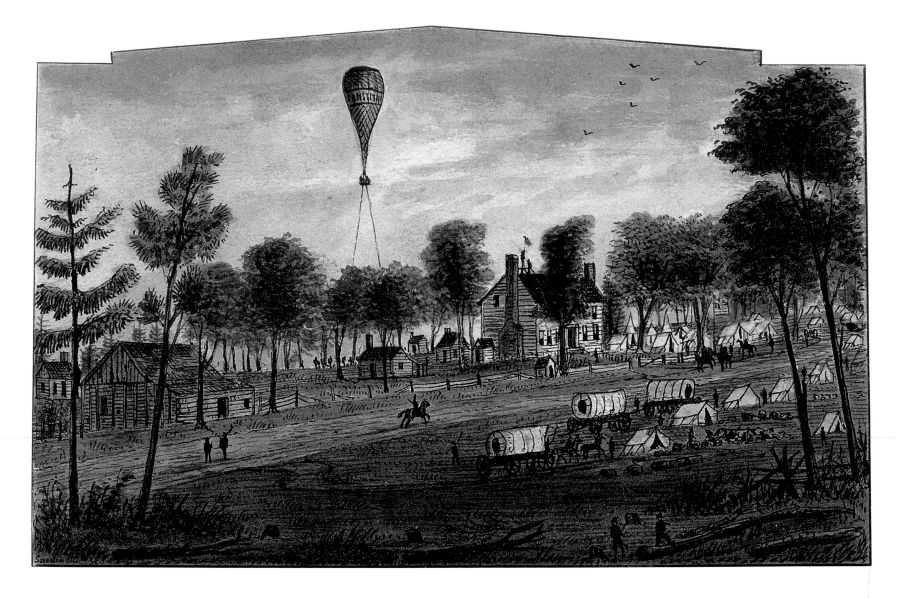

June 29, 1862. "At Dr. Trent's . . . everything betokened hasty exit. Wagons were loading up with baggage and tents. The cavalry escort were all mounted. As the general was moving to Savage's house, I found our troops strongly posted along the high ground which borders the Chickahominy."

View of headquarters of Major General George B. McClellan at Dr. Trent's house, near Savage's Station, Va., June 1862.

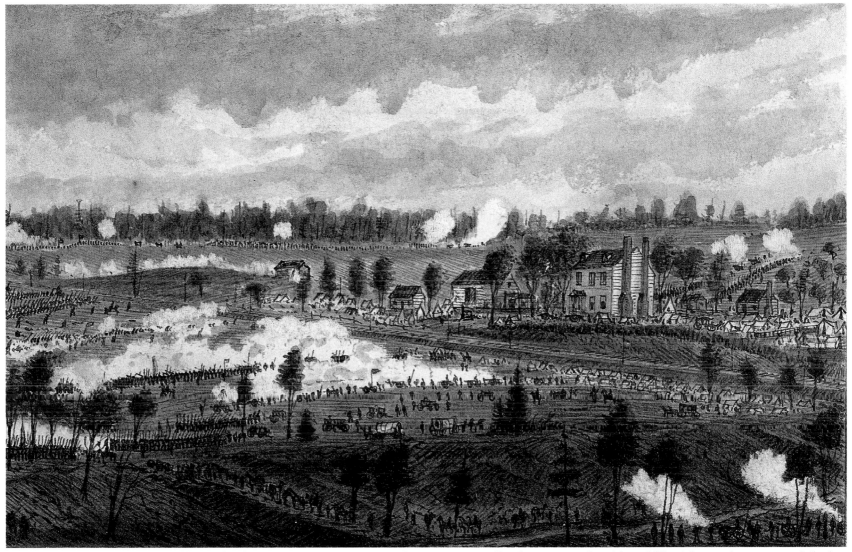

| Rebels charging the guns | Burns and Gorman's brigades | Ravine | Union batteries | Savage's house, field hospital on grounds | Railroad |

June 29, 1862. "The sun had began to lose itself over the tree tops of the woods in front, and the heat was stifling. The Rebels, in large numbers, burst from the cover with loud yells [and] opened on us at once with artillery. The enemy sent showers of shells into our lines. Two burst very close to where [the generals] were standing, covering them with dust and earth. Our batteries now vigorously replied . . . plying the enemy with shell and spherical case shot. And for an hour the crash and concussion of air was so great that I could hardly keep my feet."

The battle of Savage's Station, Va., Sunday, June 29, 1862. Fought by Sumner and Franklin's Corps. The Union forces were withdrawn to White Oak Swamp at 9 p.m. . . . leaving in the enemy's hands most of the dead and wounded and 2,500 wounded in hospital tents.

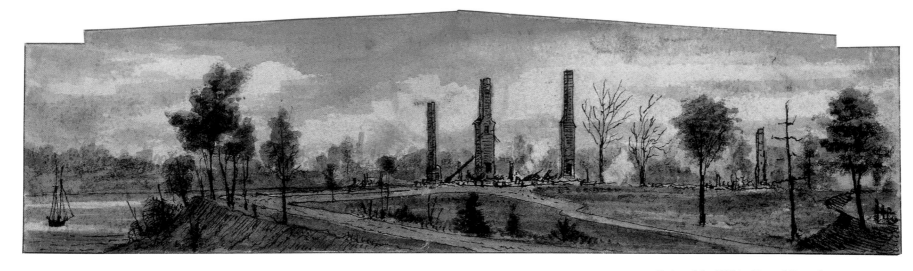

Ruins of the "White House," Pamunkey
River, Va., June 1862. Burned by [George]
Stoneman's [Union] cavalry in the retreat.

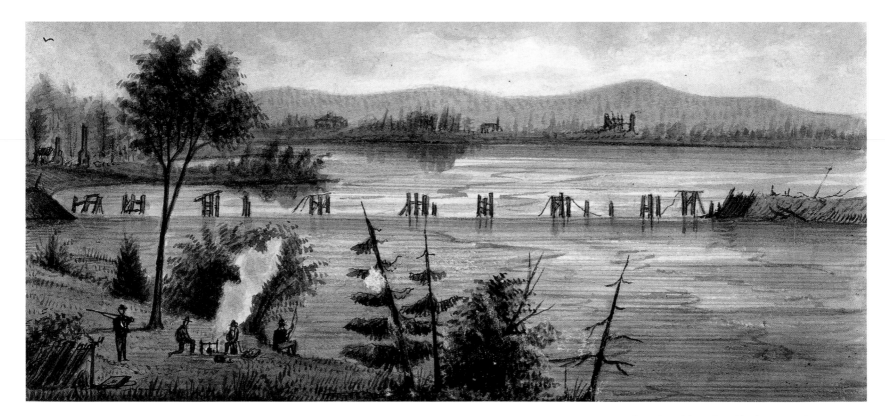

Remains of the railroad bridge across the
Pamunkey River at White House, Va.
Destroyed by Stoneman's cavalry on June
29, 1862.

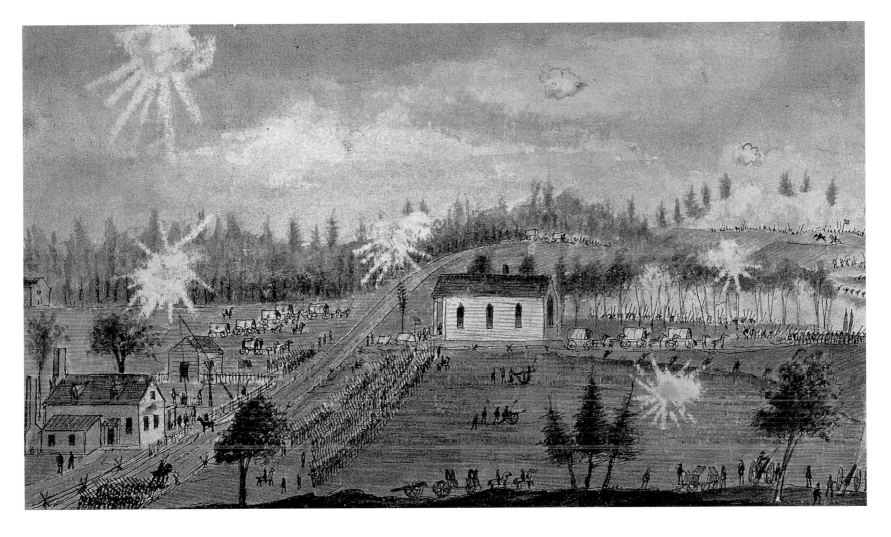

June 30, 1862. "The battle now was raging on Nelson's farm or Glendale, and the fighting was desperate and deadly in the extreme. The Rebel yells could be heard above the crashing musketry and the sharp report of the rifle cannon. A line of battle smoke a mile long showed over the tree tops, with the puffs of bursting shells still higher in the air. . . . The advance of the enemy was clearly marked by the battle smoke. And soon round shot and shell flew over our heads in the open ground. The teamsters and wagon guard laid flat on the ground, while the iron storm went past."

Headquarters of Major General S. P. Heintzelman, Commander, III Army Corps, at Nelson's house, Quaker Road, during the battle of Glendale, Va., Monday, June 30, 1862.

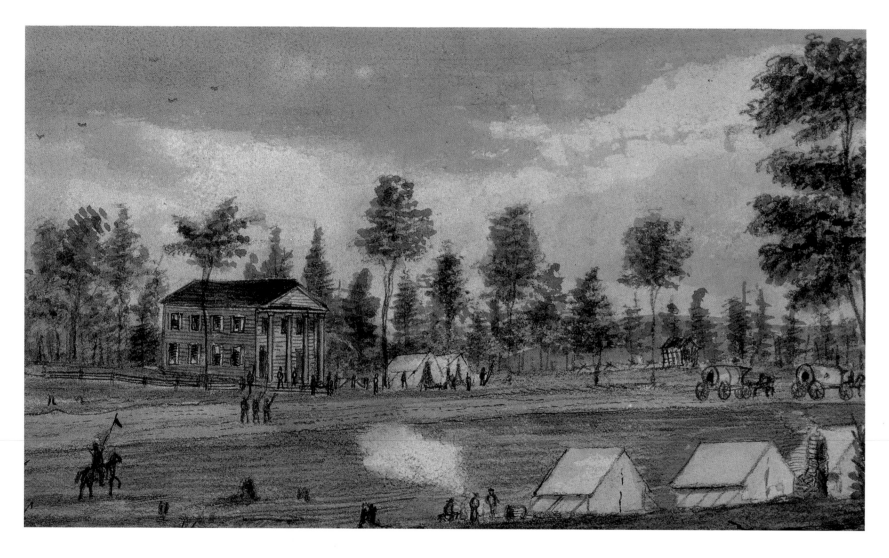

June 30, 1862. "This church . . . had been used as a hospital since yesterday and several tents were pitched near, which were occupied by surgeons. . . . There were about sixty wounded in the church who lay on the pew cushions on the floor. Many of the pews had been torn down and all the books carried off. . . . [Later] the surgeons [got] the wounded out of Willis's church in a great hurry, while the few tents were being struck and put into two wagons, and the wounded into ambulances. Long rows of empty ammunition wagons were being filled with wounded likewise, and all haste was made to start them on the road to Malvern [Hill]."

The Willis Methodist Church, Quaker Road, battlefield of Glendale, Va., June 30, 1862.

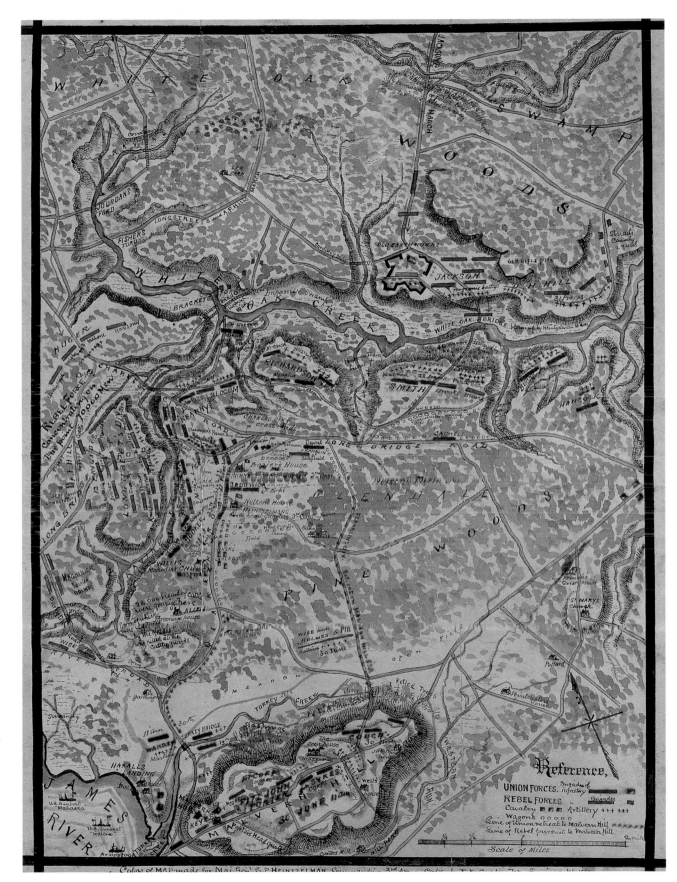

Plan of the battle of Glendale, Va. Copy of map made for Major General S. P. Heintzelman, commanding officer III Corps. Fought June 30, 1862, 10 a.m. to 5 p.m.

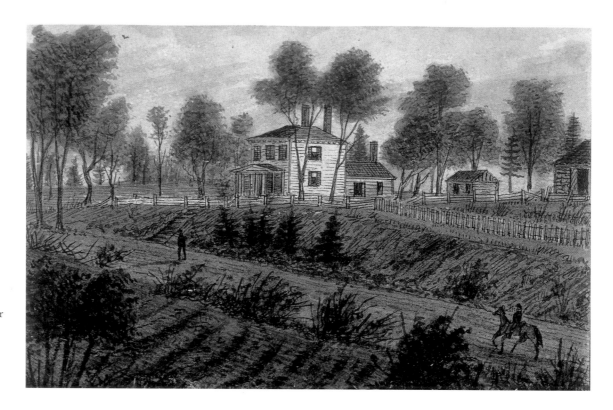

The parsonage house (Allen's) at the Quaker Road, near Willis Methodist Church.

West's house Artillery on hill—sixty-five pieces Crew's house Infantry on hill Wyatt's brick house, or Malvern house, headquarters of General Porter

July 1, 1862. "The sun rose in haze this morning and we had a very hot and sultry day. . . . [We] awaited the enemy's movements all the forenoon. [Hiram] Berdan's sharpshooters, all along our immediate front . . . could only be heard firing slowly at the opposing line of skirmishers . . . while artillery shots were now and then exchanged. . . . I busied myself in making several sketches until the enemy attacked [at 4 p.m.]. . . . The whole side of Malvern Hill seemed a vast sheet of fire. The smoke obscured everything from view. . . . The bursting shells could be seen dealing destruction on all sides to the yelling assailants.

"I went back to General [Porter's] headquarters at the Malvern house and made a sketch from the stone wall opposite. The staff tents were pitched in the front yard while the signal men were frantically waving their signal flags from the roof near the chimneys. When our troops first came here Sunday last the house was occupied by a Mr. Due. He had decamped with all the stock and slaves before we reached here. The house was now being filled with our wounded, while our surgeons were hard at work amputating limbs, which were in a ghastly heap near the house [having been] thrown out of the windows by the assistants. Groans and piercing cries from those undergoing the surgeon's knife were heard on all sides, while the air was sultry and hot as an oven. Battle smoke in huge drifts was in the meadow below, and settled along the tree tops of the pine forest beyond. There was a lull in the firing for half an hour, broken by a gun now and then from the gunboats in the river which were moored close in to shore. The artillerymen nearby were all stripped to the waist, while fresh ammunition wagons with six mules each were struggling up the incline road from the meadow below."

Battlefield of Malvern Hill on the James River, Va., showing Turkey Creek and Bridge. Union troops are in line of battle on the hill. Hancock's brigade supporting artillery of Warren's Corps are in front of the bridge, all awaiting the enemy's approach

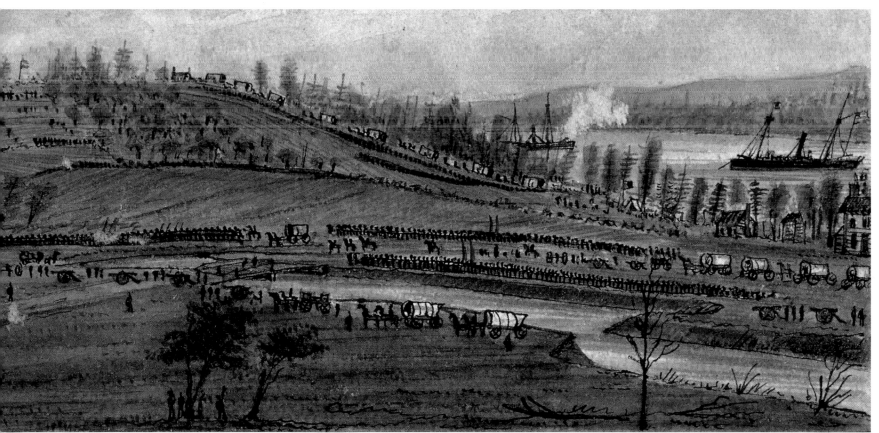

Quaker Road and Turkey Bridge

Headquarters of General Heintzelman

U.S. gunboat "Galena"
Haxall's landing

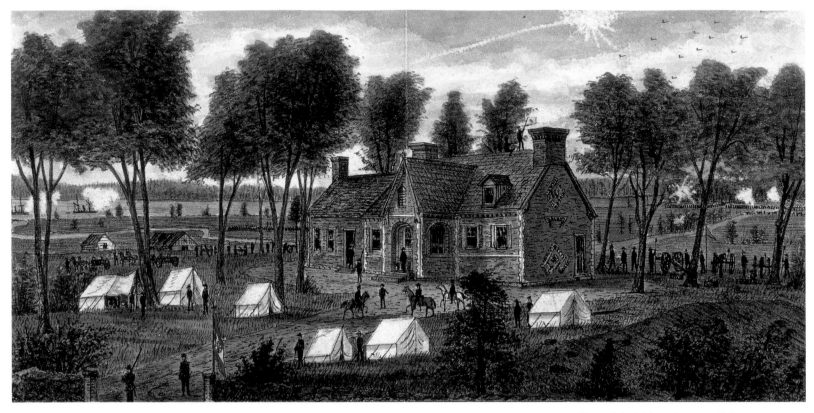

View of the Malvern house, or Wyatt
house, on Malvern Hill, Va. Headquarters
of General Fitz-John Porter, U.S.A.

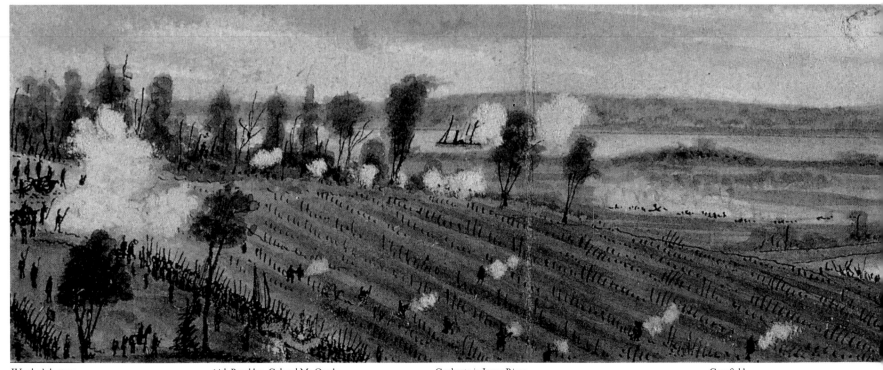

Weeden's battery 14th Brooklyn, Colonel Mc Quade Gunboats in James River Cornfield

July 1, 1862. "The enemy kept up a desultory artillery fire all along the edge of the woods in our front, while our guns . . . were slowly replying. To the right of where we stood I noticed quite a large depression in the corn field. . . . The spent shot or shell rolled into it, which would now and then explode. A large white dog of mongrel breed was amusing himself by chasing these shot . . . into the hollow, when a shell there burst and he was blown skyward in shreds. I heard afterwards that the dog was owned by one of our soldiers and had been in every battle including Fair Oaks, while his owner fought in the ranks. . . .

"Another lull in artillery firing on both sides lasted until 5:45 p.m., when terrific yells of the enemy and continuous roar of artillery showed that the Rebels were ready, and were now making their last charge on our lines. I scrambled and ran up the steep hill and got a partial view of the oncoming desperate assault from near the top of the cliff, the last desperate charge of the enemy.

"At 6 p.m. by pushing out about twenty pieces of artillery from their front, followed by four lines of solid infantry colors flying, as if on parade, [the Confederates] advanced at a run with terrifying yells, heard all above the crash of musketry and roar of artillery. We now opened on them with terrible effects. . . . Several times our infantry withheld their fire until the Rebel column, which rushed through the storm of canister and grape, [came] close up to the artillery. Our men then poured a single crashing volley of musketry and charged the enemy with the bayonet with cheers. [We] thus captured many prisoners and colors and drove the remainder in confusion from the field . . . leaving piles of dead and dying on the plateau along our front. Hundreds of poor maimed wretches were continually crawling on hands and knees across the open, many of whom were killed before they regained shelter in the woods."

West side of Crew's hill; Magruder charging Weeden's battery, near the River Road and meadow. Battle of Malvern Hill, Va., July 1, 1862.

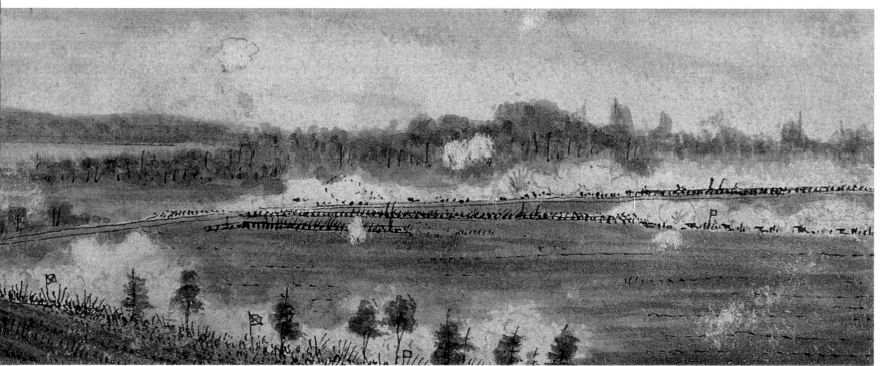

River Road Holmes' brigade in meadow

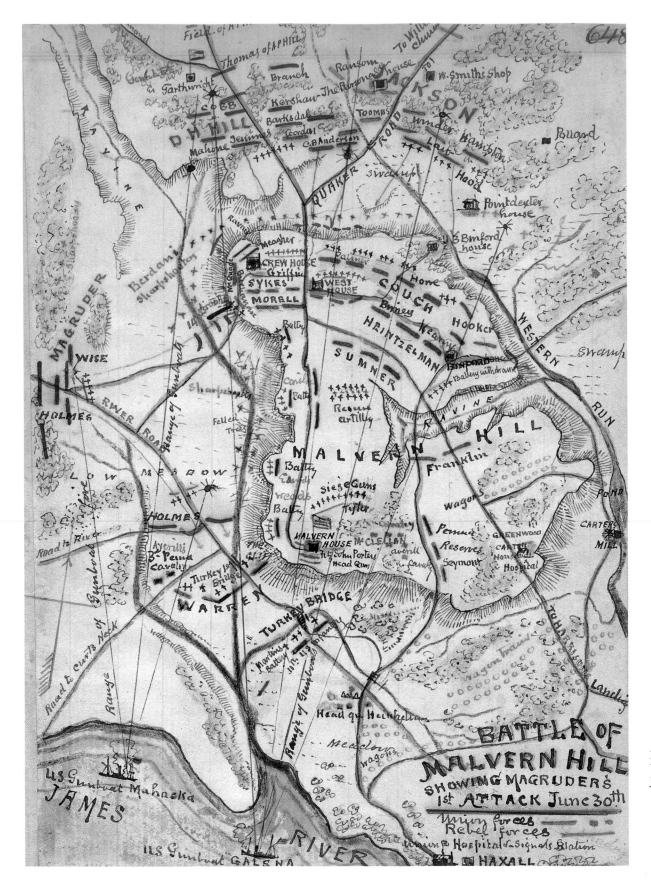

Map of the battle of Malvern Hill, Va., showing Magruder's first attack, June 30, 1862.

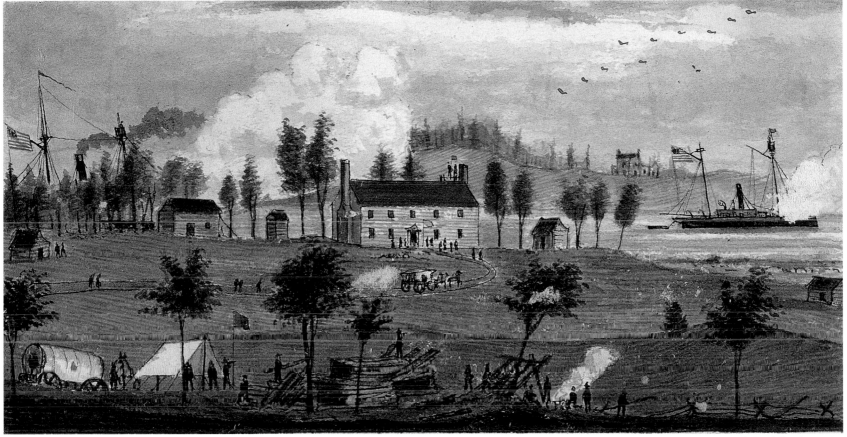

U. S. gunboat "Galena" shelling the Rebels in the woods Haxall's house, U.S. hospital and signal corps U. S. gunboat "Mahaska" shelling the woods

July 1, 1862. "Long lines of ambulances were passing our headquarters carrying ghastly wounded soldiers to the deserted house at Haxall's. . . . The sky drew dark and cloudy with appearance of rain, while the stunning reports of heavy guns on the "Galena" and "Mahaska" reverberated down the shores of the river. The red flashes and the shrieking shell lit up the woods and marsh, and the frogs croaked loud and hoarsely along the river bank."

Headquarters of Major General S. P. Heintzelman, U.S.A., during the battle of Malvern Hill, Va., July 1, 1862, near Turkey Bridge.

July 1, 1862. "Malvern Hill was . . . the most grand and affective [battle] I ever saw. The position was admirably chosen for defense, and great numbers of troops could be concentrated in a small space. The roar of 300 pieces of artillery, the crashing of more than 20,000 muskets, the immense shells from the gunboats racing across the sky, others crossing each other at eccentric angles, exploding in and among caissons, wagons, and around the artillerymen working the guns, the clouds of white smoke which hung on the summit and slopes of the hill, streaming upward, and the hundreds of puffing shells in midair, while the roar of artillery and the steady roll of musketry, above which the long piercing yells of the Rebels rose and fell, made the scene terrific and terribly grand."

Although Malvern Hill was a tactical victory for the Union, McClellan retreated eight miles to Harrison's Landing to rest and refit his battered army. Lee fell back to Richmond for the same purpose, but he could take satisfaction in knowing that he had prevented the capture of the Confederate capital. In the meantime, the Army of the Potomac spent the next six weeks in the wilting heat and stifling humidity of the James River bottomland licking its wounds and awaiting new orders. During this time, Sneden was kept busy making maps, but as always, he traveled about freely, recording the Union camps and an area of Virginia steeped in history.

Turkey Creek Bridge, Malvern Hill on James River, Va., morning of July 1, 1862, and headquarters of Major General S. P. Heintzelman, III Corps. The II Corps at "The Bridge" is waiting for the enemy to attack. Felling of trees is for defenses.

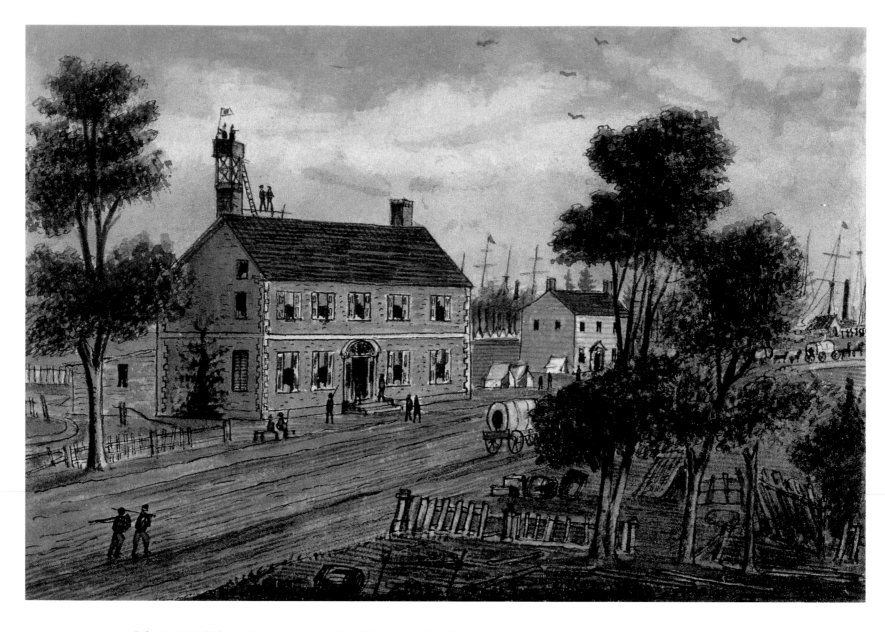

July 2, 1862. "About 5 a.m., we arrived at [Harrison's] Landing and turned our train into a wheat field near . . . [the] old Harrison house close to the river to await orders. General McClellan's headquarters were at this house, and the signal corps on the roof were signaling the gunboats . . . which had dropped down from Malvern Hill during the night. . . . The mud was nearly a foot deep all along the river bank, but having on large boots I got down to the . . . house . . . when the rain held up and we had sunshine once more. There I found several hundred Rebel prisoners lying on the ground, many of them sound asleep. They were mostly of the 17th Virginia Regiment, and we had captured their colors with them at Glendale. . . . A few old Negroes lounged around their neat looking houses near the mansion . . . and kept a respectful distance from the Rebel prisoners, who were cursing them for not bringing them something to eat."

The old Harrison house, Berkley Landing, James River, Va. Sketched July 13, 1862.

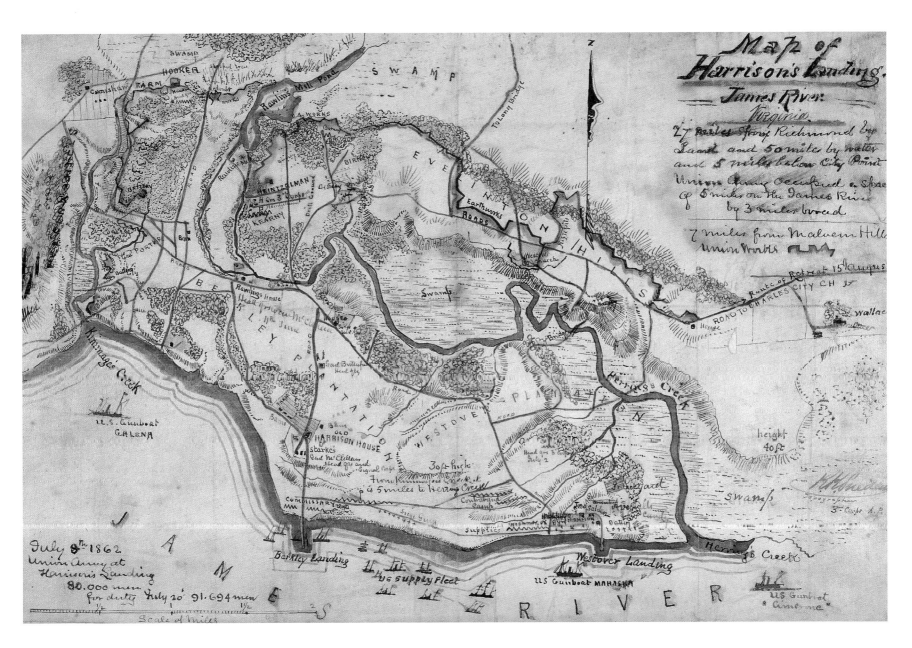

Map of Harrison's Landing, James River,
Va. Copy of official map made for General
S. P. Heintzelman, III Army Corps.

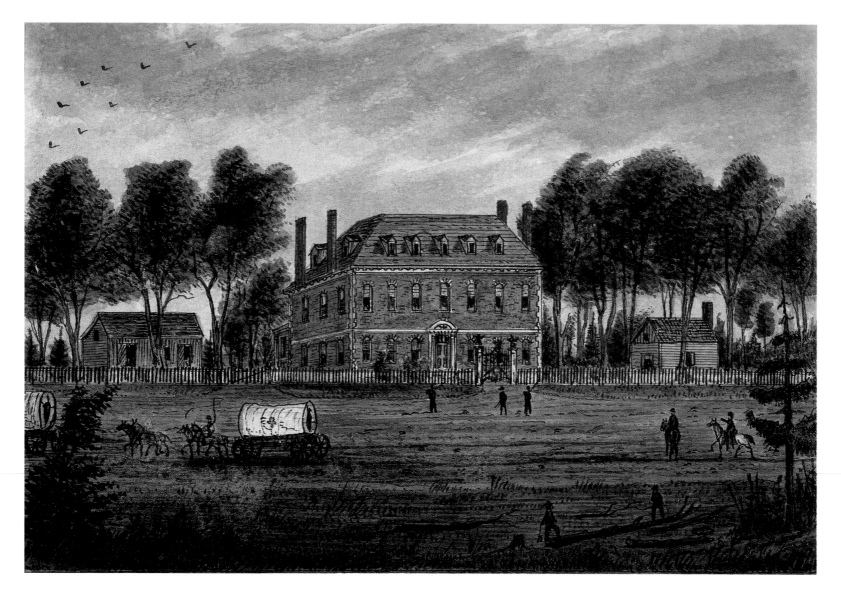

July 13, 1862. "The mansion was of brick, with white marble quoins and trimmings. . . . Everything outside denoted neglect; and several old slaves yet occupied the quarters adjoining. The mansion has much interest as having been the residence of a family, who for three generations were representatives of royalty in colonial times. It still bears evidence of wealth and high standing of its former occupants . . . but few articles of furniture remained, no carpets, or books in the library. The signal corps had quarters in the upper rooms. . . . There was a very handsome chimney piece in the parlor, the background of which was composed of rich black veined marble; while the border around the modern grate and the pediment above the mirror were of white marble. This was imported from Italy by Colonel [William] Byrd. The mirror was smashed, and the pieces had been taken away by relic hunters piece by piece. Soon it will all be gone."

The Westover mansion, former residence of Colonel Byrd, Harrison's Landing, Va. Sketched August 1862. Now occupied by Selden. Headquarters, V Corps, General Fitz-John Porter.

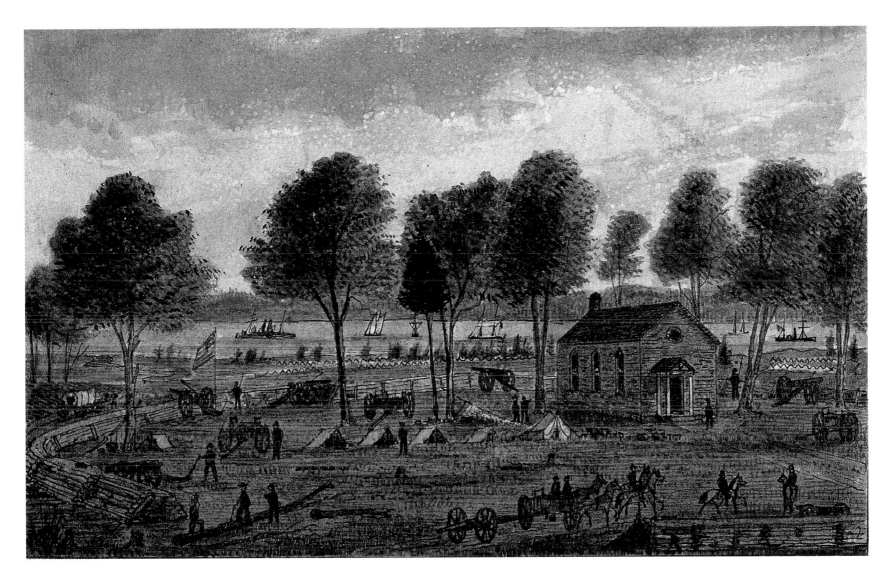

July 14, 1862. "Earthworks, batteries, and magazines have been completed by the working forces within the past week. Rifle pits and abatis have also been made along our entire front . . . [and] are being constructed on our left on the ridges commanding the ravines and on the right crossing the Charles City road and around Westover Church."

The Union entrenched position at Westover Church, Westover Landing, James River, Va. Sketched August 10, 1862.

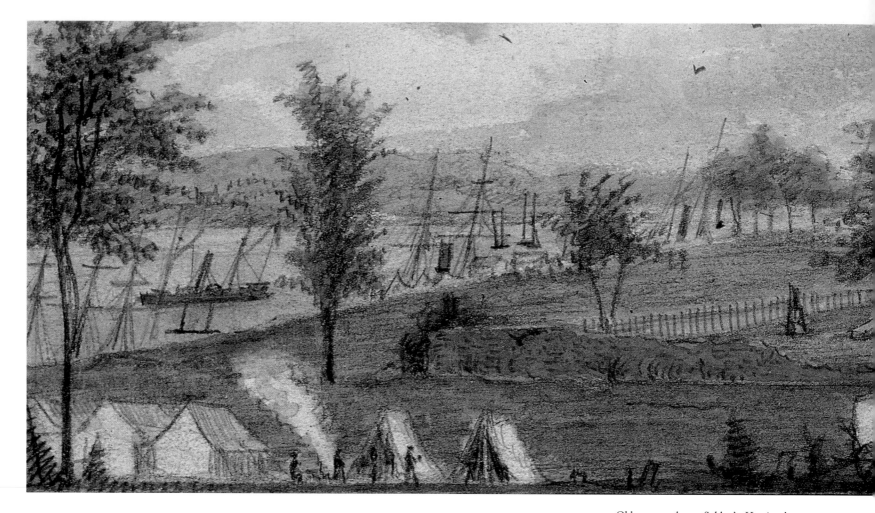

Old graveyard near Selden's, Harrison's Landing, or Westover, on the James River, Va. August 1, 1862.

July 30, 1862. "I rode down to the landing this afternoon . . . and along the James River to the old graveyard of the Byrd family. . . . The enclosure of about ³/₄ of an acre was surrounded partially by an old brick wall about four feet high. Large gaps were in this through which a team might be easily driven. Several old crooked trees were overshadowing ancient tombs which also were broken, cracked, and thrown out of position by age and frost. . . . I sketched and made copies of all the tombstones some of which were very interesting and antique. . . . Several were broken and so badly cracked that I had much difficulty to read them."

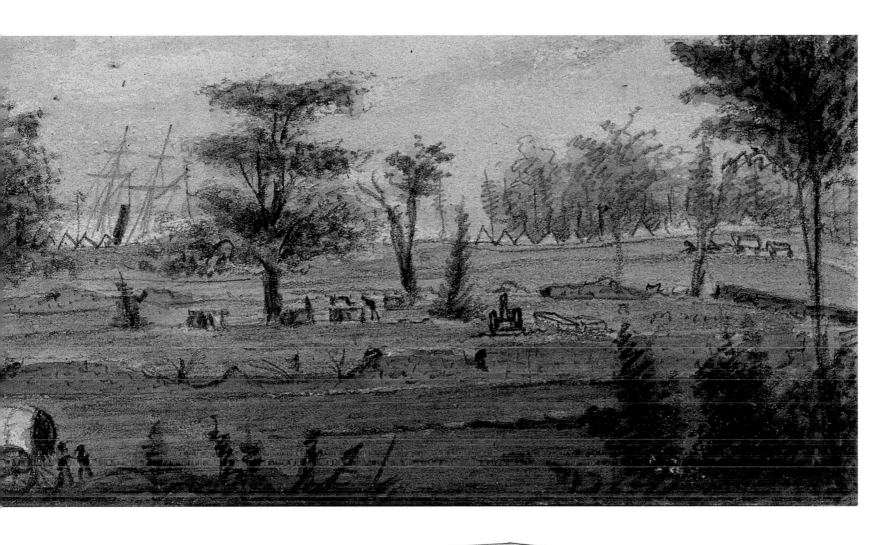

Old tomb at graveyard of the Byrd family, near Selden's, Harrison Landing, James River, Va. Sketched August 1, 1862 (centre tomb).

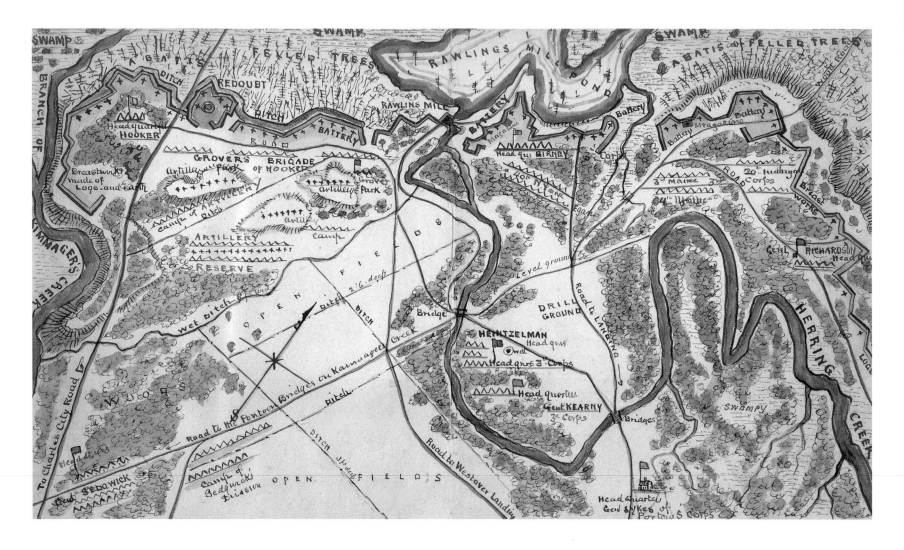

July 13, 1862. "At 2 p.m. I went over to the camps of [the] 3rd Maine and 40th New York regiments. The iron ovens were in full blast baking wheat bread for the division. We have good bread now, or 'soft tack' (the army biscuit is called 'hard tack' or 'monitors'). . . . I [then] rode down to the landings, and visited General McClellan's headquarters at the old house at Westover. I made a sketch [of it]. . . and everything else of interest about the premises. . . . A signal station had been erected on the roof, and all the fences had been used for firewood. Trees had been cut down for bough houses along the river bank. Quartermaster's tents were pitched between the house and another house about 100 feet from it, which had been used for the former overseer of the plantation. The landing was crowded with wagons and teams, while sutlers were erecting shanties and tents along the river bank. Steamers and vessels were discharging stores, and dozens more laid at anchor in the placid James. I got some new maps from the topographical engineers attached to the headquarters, and found several draughtsmen (all soldiers detailed for this purpose) at work in one of the lower rooms. This gave me an opportunity to examine the interior, and from an old white headed slave I got much interesting history of the place."

Position of the III Army Corps at Harrison's Landing, Va., July 9, 1862. From actual survey made for General Heintzelman, III Corps.

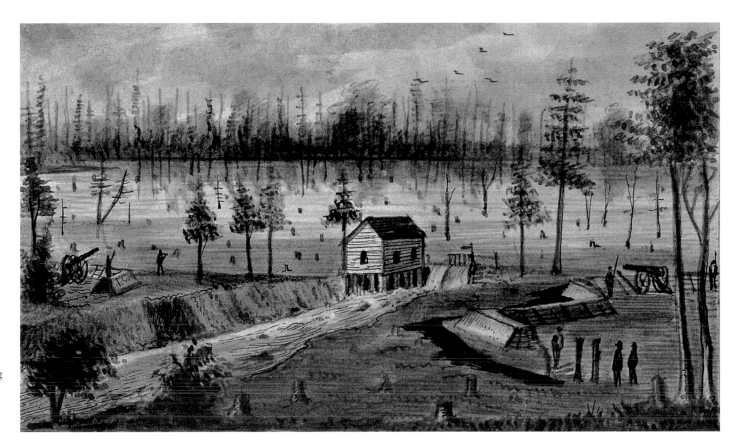

Rawlin's mill and mill pond, Harrison's Landing, Va., showing entrenchments of the III Corps.

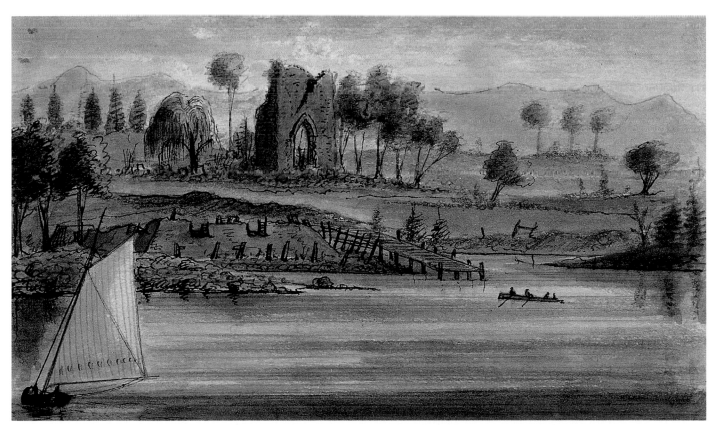

Old Rebel battery on Jamestown Island, James River, Va., showing ruins of Jamestown Church.

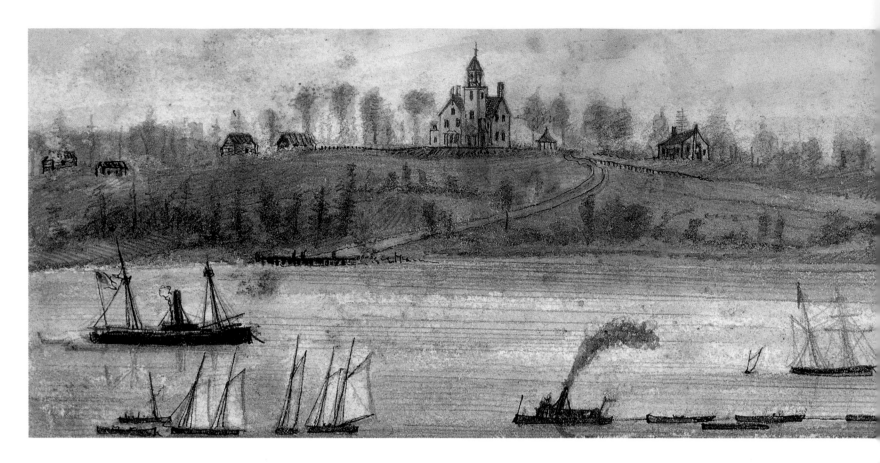

July 30, 1862. "I made a sketch of the Cole house on the opposite side of the river, and while doing so, was surprised to see persons in the cupola of the tower surveying our position. . . . I could plainly ascertain the cupola to be occupied by Rebel officers, and about 200 cavalry were seen close to the house in rear, sheltered by a hedge."

July 31, 1862. "At about 12:30 midnight, all were startled from their sleep by rapid and heavy artillery firing on the James River at Westover Landing. . . . The enemy had opened on us with artillery from forty-three pieces simultaneously! One battery was at Coggin's Point. Two others at the Cole house. . . . The enemy's guns . . . crashed and smashed into the steamers and vessels at anchor, and into the camp [of] the 3rd Pennsylvania Cavalry near [Westover]. . . . [Our gunboats] soon steamed to the landing and immediately opened fire. In twenty minutes they had driven off the enemy and silenced the guns."

August 1, 1862. "At 5:30 p.m., 1,800 of our troops were assembled at Westover Wharf, who soon embarked on three or four steamers. A large detail of axe men went with them and under cover of the gunboats, the crews of which were 'all at quarters.' The force steamed across, landed at the ruined wharf, deployed, and went over the hill to the Cole house. This was set on fire, and soon the flames streamed out of every window and wrapt the fine dwelling in sheets of fire. The sun had set, and the scene was grand."

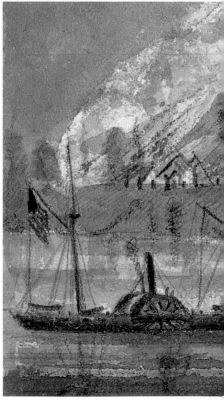

U.S. troops burning the Cole house and plantation, opposite Harrison's Landing, James River, Va., on the night of August 1, 1862.

U.S. gunboat "Cimerone"

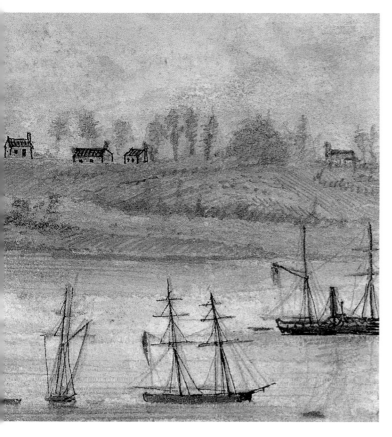

By early August 1862, it became obvious that McClellan's army could no longer remain on the James River, threatening Richmond by its mere presence. In the meantime, a newly formed Union army under General John Pope prepared to march on the Confederate capital from northern Virginia. Convinced that McClellan would remain relatively inactive, Lee detached a large portion of his army under Stonewall Jackson to deal with Pope. Two weeks later, Lee followed with the rest of his force. With this development, President Lincoln became gravely concerned and, despite objections from McClellan, ordered the Army of the Potomac to withdraw from the James River and join forces with Pope. Obeying these orders reluctantly, McClellan took his time removing his troops from the Virginia Peninsula. As the army slowly retraced its steps back to Yorktown and Fort Monroe, Sneden had plenty of time to sketch places that he and his comrades had advanced on with such high hopes only a few months earlier.

The Cole house on Ruffin's plantation opposite Harrison's Landing, James River, Va., before its destruction.

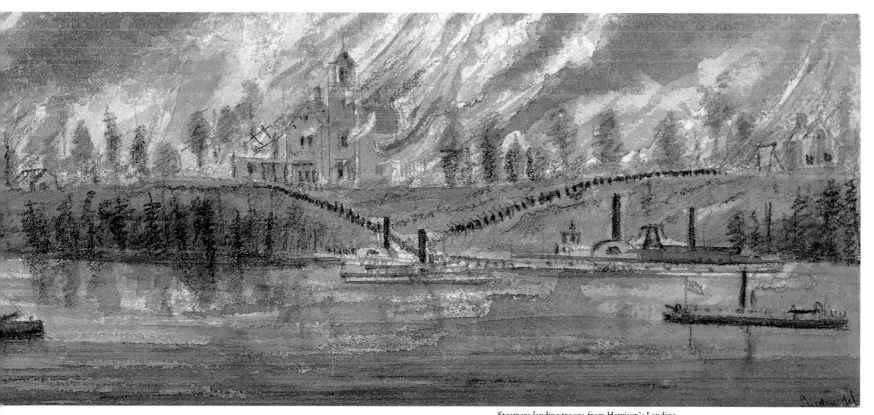

Steamers landing troops from Harrison's Landing

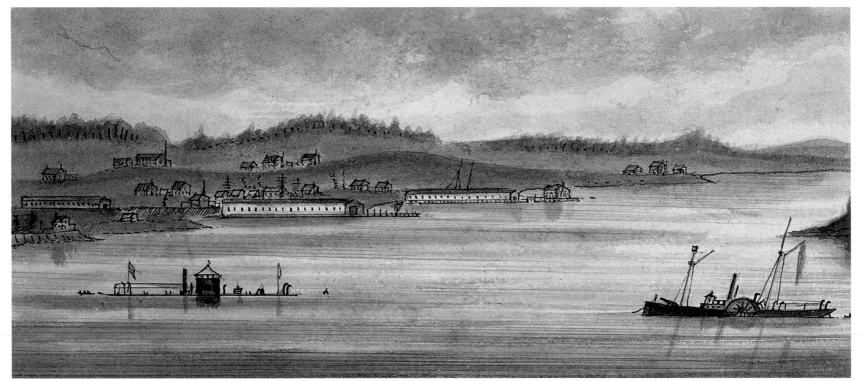

U.S. "Monitor"

U.S. gunboat "Galena"

August 13, 1862. "Today the enemy set fire to and destroyed all the sheds, buildings, and wharves at City Point. Clouds of smoke drifted down the James River all day. This shows that the Rebels must be under orders to join Lee's army on the Rapidan [River in northern Virginia]."

View of City Point, James River, Va., August 12, 1862. The Rebels evacuated City Point August 13, 1862, first burning all the sheds, wharves, houses, and stores.

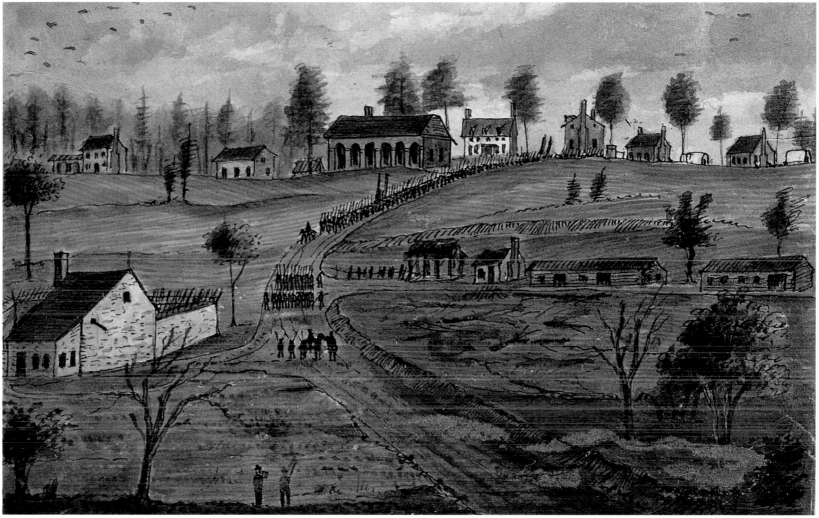

Deserted jail and jailyard Court house Hotel Rebel cavalry stables

August 15, 1862. "We arrived at Charles City Court House about 4 p.m. [The town] was composed of about twenty houses and was well shaded by trees. The old court house was an ugly and old fashioned brick building with hip roof and brick arched corridor. . . . The soldiers had forced an entrance into the court house and were rummaging over the archives for relics, strewing parchment title deeds and other law papers over the floors. They were [then] ejected by a guard and a sentinel [was] placed at the entrance to prevent further pillages. . . . Down from it stood the jail, a whitewashed brick two story affair with a jail yard surrounded by a high wall on the top of which [were] spikes and high pickets. . . . Most of the houses were occupied by old men and women. All the Negroes who had not previously run away to Harrison's Landing now joined our marching army, some on foot, others in broken wagons and farm carts."

The III Army Corps passing through Charles City Court House, Va., August 15, 1862, in retreat from Harrison's Landing to Yorktown.

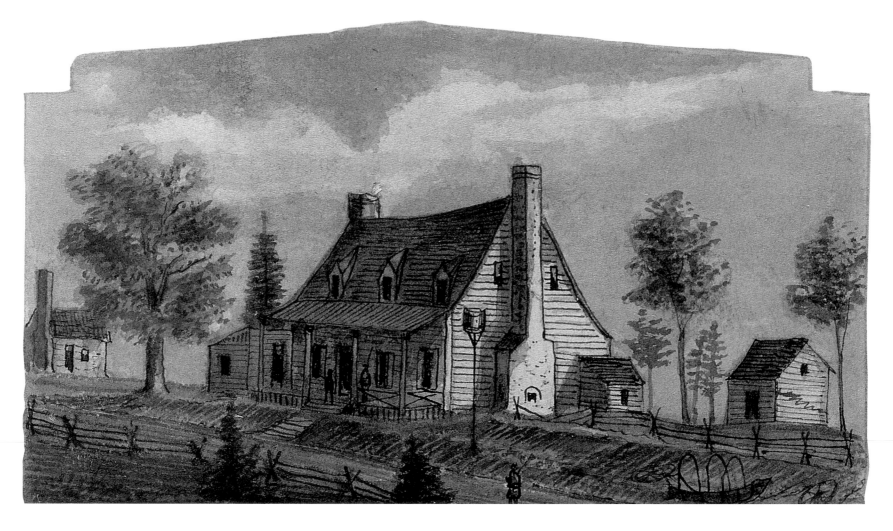

August 15, 1862. "We arrived at Charles City Court House about 4 p.m. The trains were kept well closed up and but few halts were made as the road was good though very dusty. We were six miles from Westover only but the troops kept on towards the bridges which had been thrown across the Chickahominy at Barrell's Ferry and Ford. General Heintzel-man's corps were to diverge more toward the northward and cross at Jones Bridge several miles above the former place. So at Charles City the III Corps was halted two hours to enable troops behind to pass. Our wagon train was turned into a field near a tavern, which although deserted afforded a good place to cook dinner. The building was a type of most of the country hotels found in Virginia and I made a sketch of it before leaving."

Hotel, Charles City Road, Charles City Court House, Va.

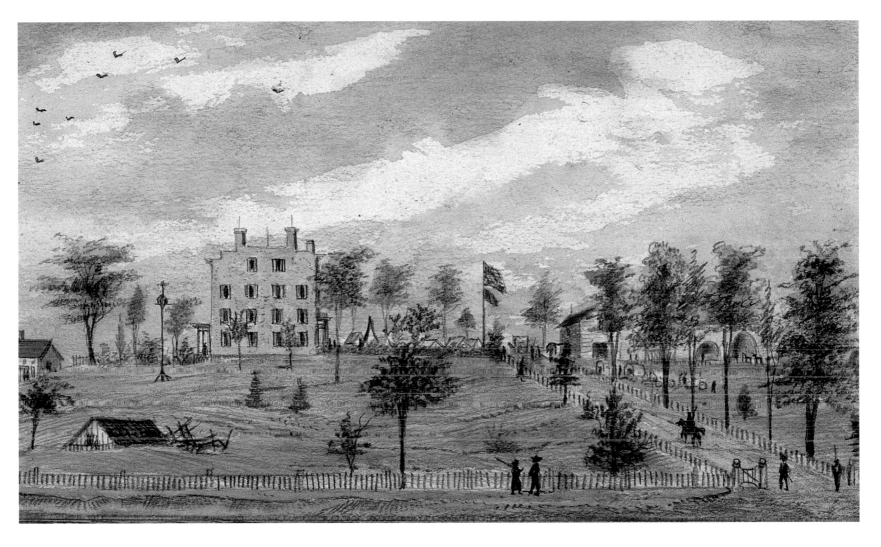

August 18, 1862. "At 2:30 p.m., we entered Williamsburg and made our headquarters on a bye road, near William and Mary College. All our flies and tents were here put up. And the wagons were unloaded for the first time since leaving Harrison's Landing. I made a sketch of headquarters at sundown. The national flag floated from the college park and a red hospital flag from the steeple of the largest church in Williamsburg."

Headquarters of General S. P. Heintzelman, III Army Corps, at Jourdan's house, near Jones Bridge, Va., August 16, 1862.

August 18, 1862. "I went through Williamsburg before dark and to the college and the monument, which is in the park, erected to Governor [Norborne Berkeley, Baron de] Botetourt in 1771. Several pieces of rough made artillery were here on grim black painted carriages. They were captured from the enemy by us when here . . . during the battle of May 5 last."

William and Mary College, Williamsburg, Va., August 18, 1862. The first college was built A.D. 1702, which was burnt in 1859. It was rebuilt in the same year and was burnt to the ground in 1862 by cavalry of Butler's command.

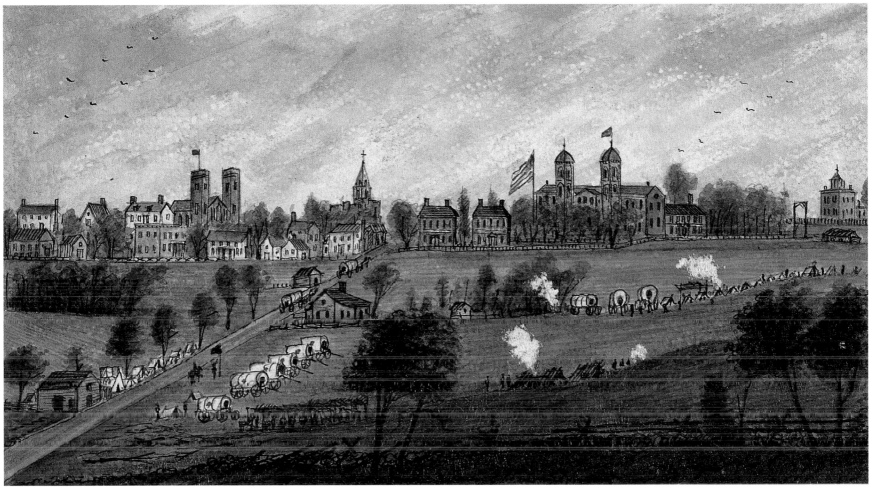

| Headquarters tents | Church used for hospital | The Governor's houses | William and Mary College—hospital | Gallows | Jail |

August 18, 1862. "The inhabitants [of Williamsburg] kept close to their houses, and peered cautiously at us behind shutters and doors. All the stores had been sacked and no business was being done. There were guards on some of the churches and public buildings. No safe guards were on any of the houses, yet our men did not disturb the inhabitants in any manner. The troops were bivouacked in the open fields on the outskirts of the town and not in it. The Negro population were cooking 'corn pones' for the soldiers, who repaid them in sugar, coffee, and money. . . . Bands were playing this evening at [the] headquarters of several generals, while the camp fires were seen all around the environs of the town."

Headquarters, III Army Corps, General S. P. Heintzelman commanding, at Williamsburg, Va., August, 18, 1862.

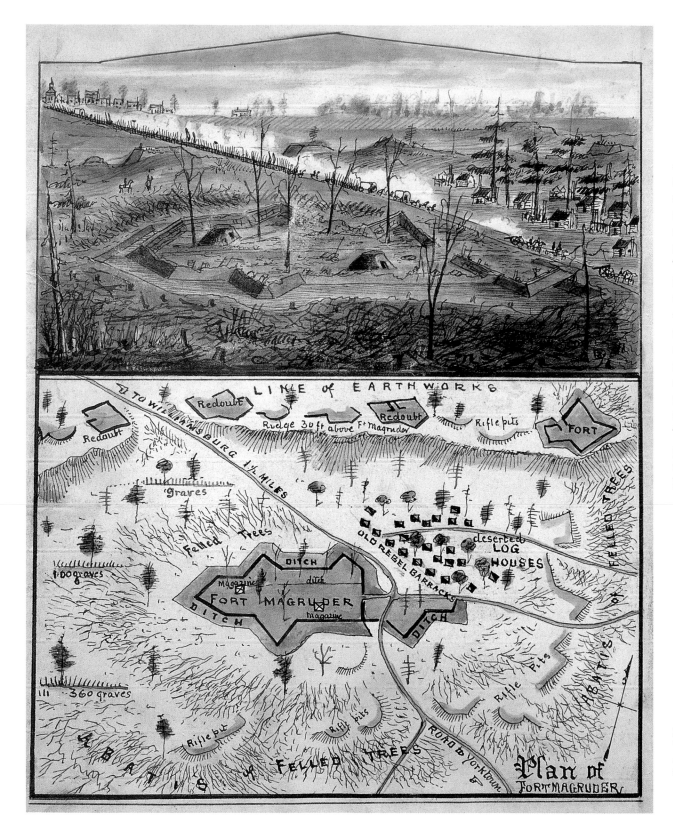

August 19, 1862. "Tents were struck at 7:30 a.m. and all were on the march again by 8:30. . . . About 10:30 a.m., our train came to near Fort Magruder and I left the column to go over once more the old battlefield [of May 5]. The Rebel fort was just as we had left it May 6 last. The ditches were full of water but the parapets were much washed away by the rains. A heavy undergrowth of weeds and vines covered all the grounds outside the main fort, among which, graves with stakes at their heads were numerous. On a trench, which was filled with dead, I found tomatoes growing plentifully. They were dead ripe, and I filled my pockets and everything else with them. I must have eaten several quarts before moving on."

Rebel Fort Magruder, battlefield of Williamsburg Va., III Corps A.P. passing, August 19, 1862. Army in retreat on Yorktown, Va.

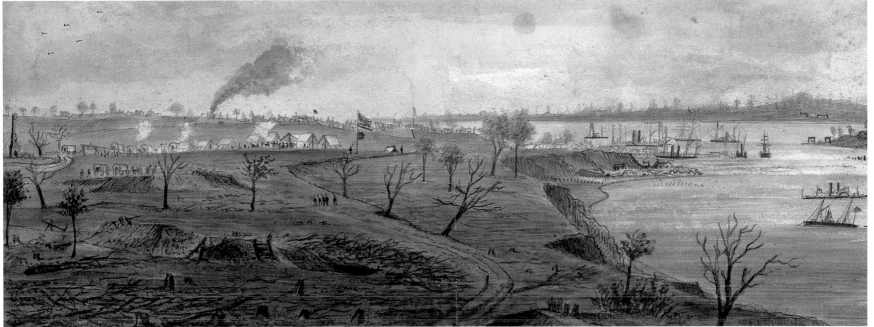

| Chimney where "California Joe" shot an Indian secreted on top | Orchard and old earthworks in foreground | Yorktown | Old Rebel battery and wharf | Union transports | Gloucester Point |

August 19, 1862. "The roads were very dusty and the long black columns wound down the dreary road . . . towards Yorktown, where we will embark for Alexandria. . . . At 5:30 p.m. [we] went through Yorktown and made headquarters . . . outside the fortifications, near the steep banks of the York River. . . . The clerks had to sleep in the wagons. I put up my rubber tent and laid smoking, looking at the river below me until near midnight. Bands were playing in the town and thousands of camp fires showed themselves all over the open ground, while the twinkling of lights from numerous steamers and vessels at anchor in the river made it impressive."

Two days after this journal entry, the Army of the Potomac set sail for Washington. Once it disembarked in Alexandria, McClellan slowly marched a few divisions to join forces with Pope near Manassas Junction. Their arrival came none too soon. By the end of August, Pope had been completely outmaneuvered by Lee and found himself locked in a major battle with the Confederates near Bull Run Creek. At first Pope convinced himself that he was winning, but on the second day of battle, Lee unleashed two mighty attacks that all but crushed the Union army. By nightfall of August 30, Pope's men were in full retreat to Washington, passing through Centreville on the way. The next day, the Confederates kept up the pressure, attacking the retreating Federals at Chantilly. Once again, Sneden found himself in the heat of battle and then the chaos of retreat. Throughout, he managed to record the ordeal of the second Bull Run Campaign in both words and pictures.

Headquarters of III Army Corps, Major General S. P. Heintzelman, outside of Yorktown, Va. III Corps embarking for Alexandria, Va., August 1862.

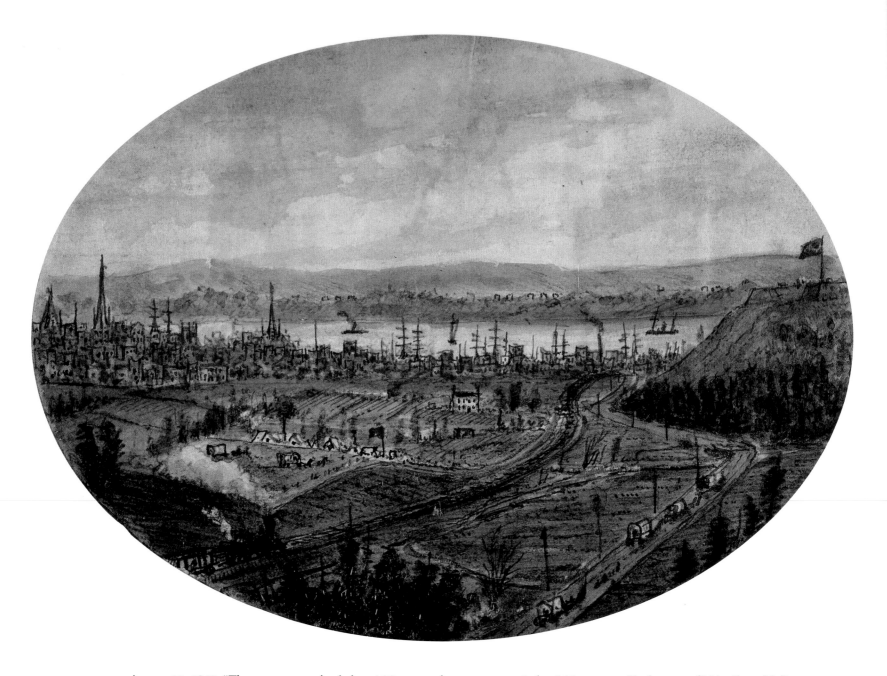

August 22, 1862. "The troops were landed at 4:30 p.m. and our wagon train by 5:30 p.m., which proceeded up King Street and thence to the turnpike. We pitched [headquarters] in a field below Fort Lyon about 1,000 feet from the old slave pen of Alexandria. . . . All the streets and suburbs of the city were strongly picketed as [John Singleton] Mosby's cavalry often made dashes into Alexandria at night so as to facilitate the escape of Rebel spies who are here always and are prompt to furnish information to the enemy. The jail and guard houses are full of these fellows."

Headquarters of Major General S. P. Heintzelman, III Corps., near Alexandria, Va., August 22 to 24, 1862.

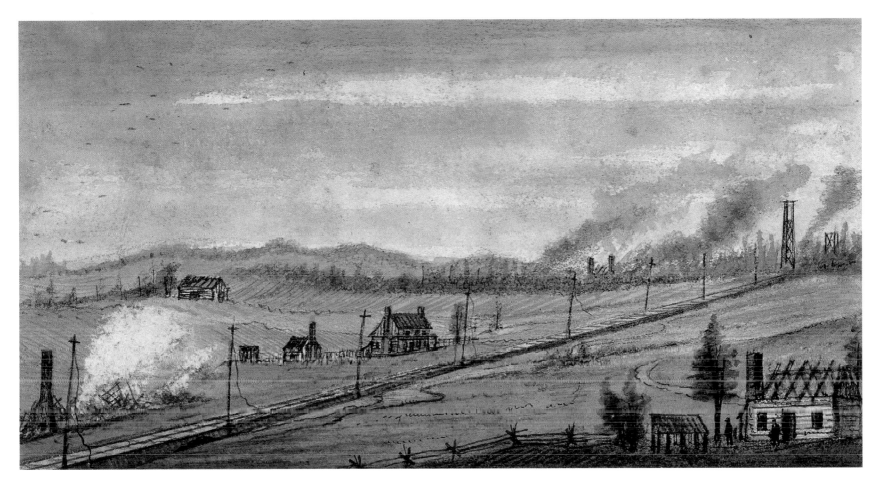

August 28, 1862. "Before leaving Bristoe Station, I went over most of the battlefield [of the previous day]. I made two or three sketches, and went into an old stone house near the railroad which had been occupied by the enemy during the battle. . . . The rooms were fitted up in bunks all around . . . full of dirty straw and covered with blood. The stench of the blood and dirt made it unhealthy to stay long. . . . The house had evidently been used for hospital purposes, the floor and yard was strewn with dirty and bloody grey clothing, torn blankets, hard looking shoes, old battered felt hats, [and] canteens, while the floor and walls was smeared all over with blood. The stench was terrible."

Battlefield near Bristoe's Station, Va. Fought by Hooker's division, III Army Corps, August 27, 1862.

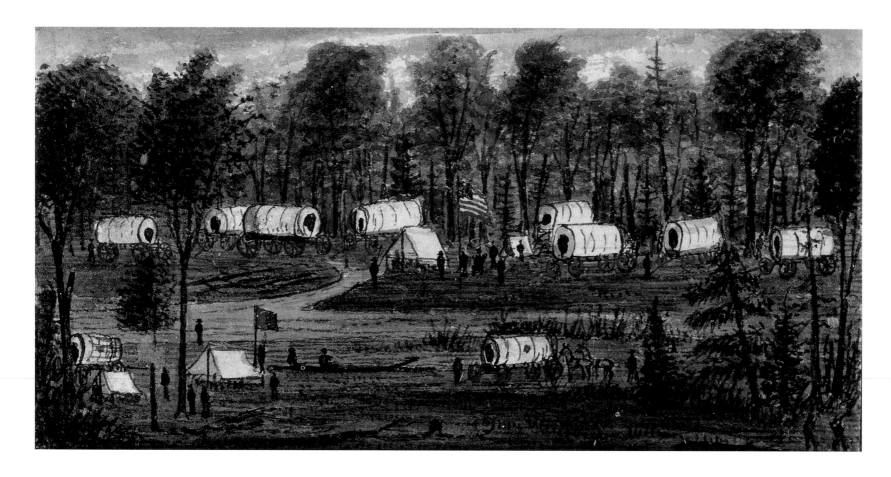

August 28, 1862. "Before leaving Warrenton Junction [yesterday] our headquarters and General Pope's were together in a clump of heavy pines. The wagons of each general were drawn up in two half circles, mules unhitched to the rear. One or two flies were spread among the trees for use of generals and staffs. General Pope sat in a large wicker arm chair smoking. His staff were in groups discussing the affair at Catlett's Station, and bewailing the loss of their personal baggage now being put in practical use by Jackson and Stuart. Pope's staff officers were gorgeously arrayed in different styles of uniform with all the gold lace and buttons which could be possibly be put on them. Pope himself had on a fine new major general's uniform the lapels being quilted inside with white satin!"

Headquarters of Generals Pope and Heintzelman at Warrenton Junction, Va. Afternoon of August 28, 1862.

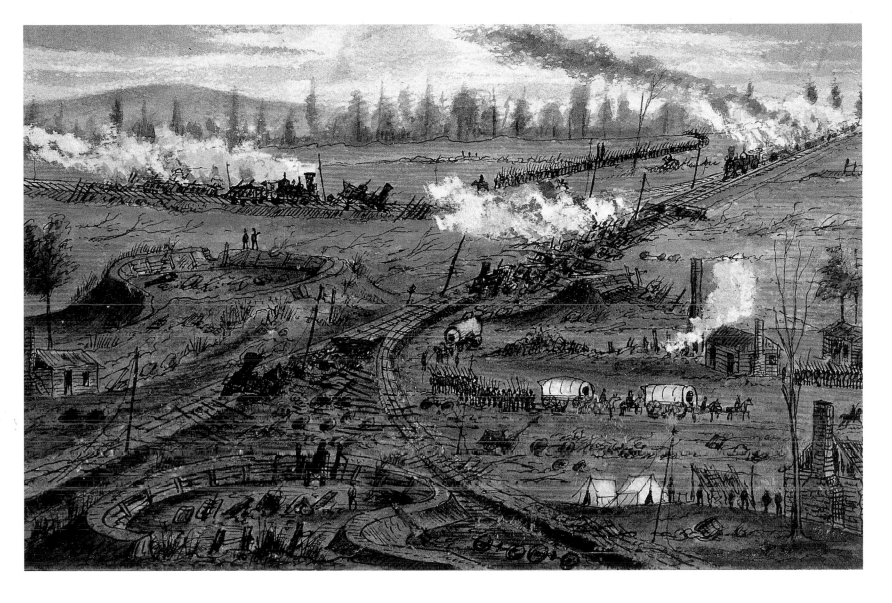

August 28, 1862. "After much delay . . . we came up to Manassas during a shower of rain and waited . . . there for further orders. . . . The whole ground was covered with half burnt barrels, boxes, dirty clothing, which the Rebels had exchanged for new clothes when the cars containing them were captured by [Stonewall] Jackson's forces. The wrecks of the trains laid on the track, nothing but the wheels and other iron work having escaped the burning. Ten locomotives laid on their sides with running gear destroyed or carried away. They had run off the track and were wrecked. . . . The whole railroad track smoked for 1,000 yards from the yet smouldering fires."

Manassas Junction, Va., Orange & Alexandria Railroad, August 28, 1862. Destruction of railroad cars by the Rebels.

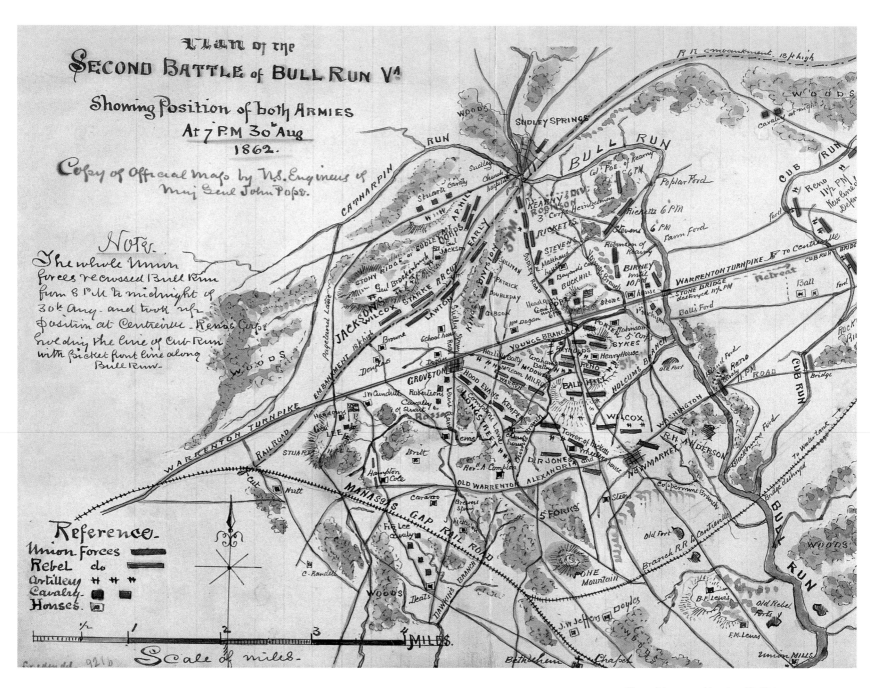

Plan of the second battle of Bull Run,
Va., showing positions of both armies
at 7 p.m. August 30, 1862.

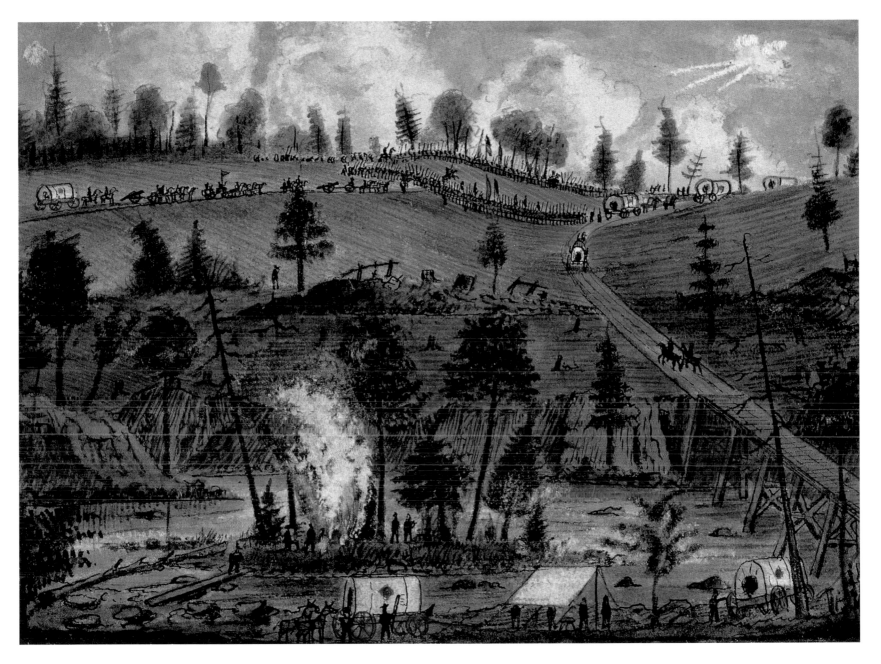

August 29, 1862. "Our camp was [on an island] between high banks on either side of the run and off the road so we were not interrupted by wagon trains or any stragglers. So we smoked our pipes and watched the sky full of bursting shells over the hill top, while infantry were deploying along the ridges. . . . The running waters of Bull Run had a very pleasant effect on our tired nerves. And while everything was hot and dusty on the hills, we were in a shady, cool spot and enjoyed our situation until we had orders to move . . . which we were loath to do."

Headquarter teams of Major General S. P. Heintzelman, III Corps, at Island Ford during the second battle of Bull Run, Va., August 30, 1862.

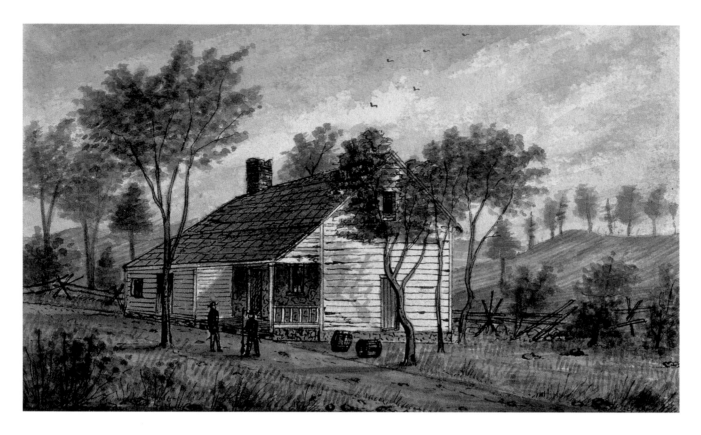

The Robinson house, battlefield of Bull Run, Va., August 1862.

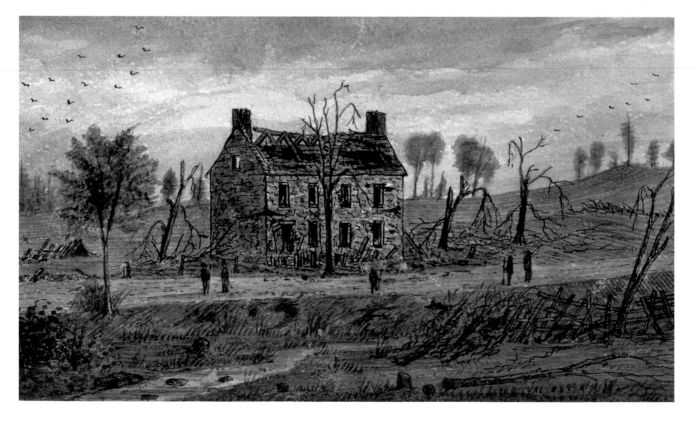

Maltby's stone house on the Warrenton Turnpike, battlefield of Bull Run, Va., destroyed by batteries of III Corps, August 30, 1862.

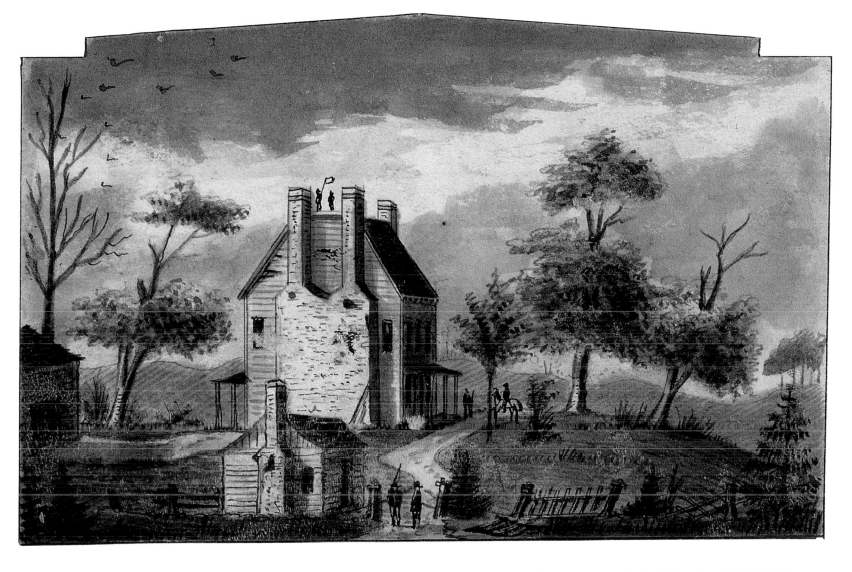

August 30, 1862. "At 5 p.m., while [I was] watching the battlefield just as the sun was going down behind the tree tops, came the outburst of the Rebel attack and advance on our left at Bald Hill and Henry House Hill. The shells were bursting in the air above the woods while the discharges of musketry and artillery were incessant and terrible in volume. At 6 p.m., long lines of wagons and ambulances began to file past towards Centreville, while wounded stragglers came from all points across fields en route for the same place. . . . We moved off in no good humor, and . . . kept on until halted by a breakdown of a train ahead of us. As we were ascending all the while, the battlefield came in sight in the now deepening shades of the evening. Artillery firing was heard at intervals. The flashes were all along the hills in rear of Stone Bridge, while the faint sputtering of musketry was heard still away to our right where [our troops] were holding the enemy at bay while our army was falling back over Stone Bridge."

The Lewis house, battlefield of Bull Run, Va., August 30, 1862. Headquarters of Johnston during the first battle, 1861. Sketched August 29, 1862.

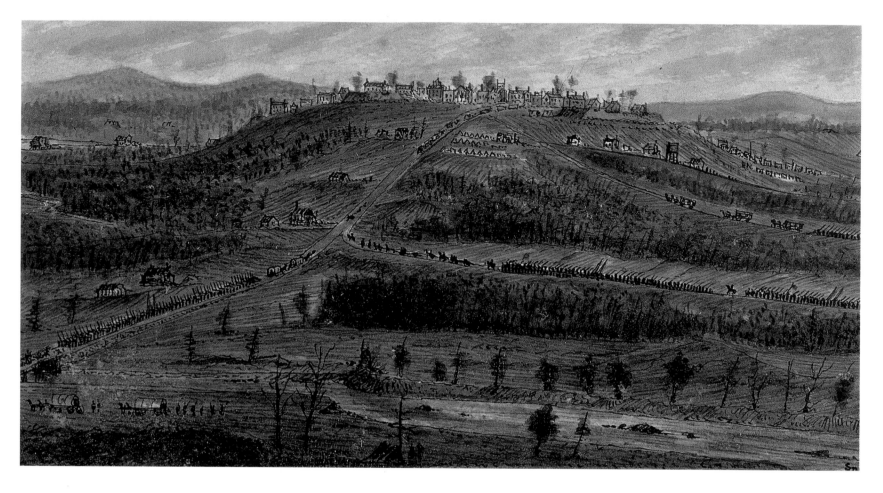

August 30, 1862. "Lanterns were seen moving all night on the old Rebel forts at Centreville, while the sound of hundreds of axes were heard on all sides. Our engineers were putting Centreville in a state of defense, pulling down houses and mounting guns. At 11:30 p.m. all was quiet. Occasionally a musket shot was heard down in the valley where our forces were holding the line of Cub Run."

Eastern view of Centreville, Va., from Cub Run. Union army falling back evening of August 30, 1862.

Sneden sketched these faux artillery pieces, left behind by the Confederate army when it abandoned its position at Centreville and Manassas in March 1862 prior to the Peninsula Campaign.

Quaker guns at Centreville, Va.

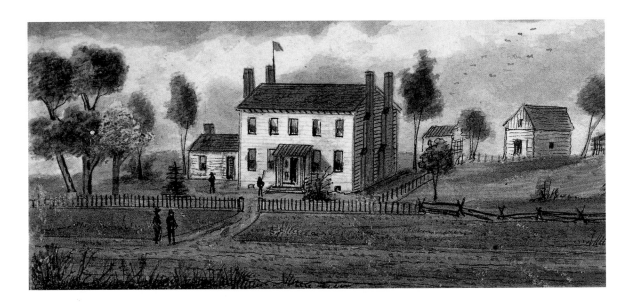

Grigsby's house, Centreville, Va. Headquarters of General Pope, August 31, 1862. Hospital.

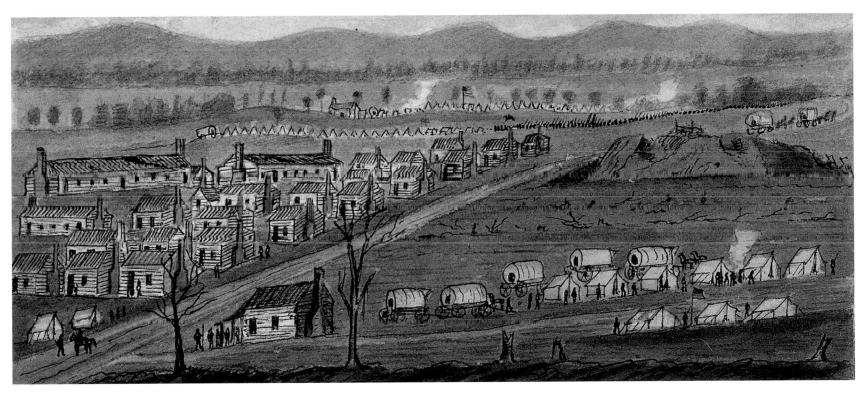

September 1, 1862. "At about midnight orders came to move Pope's wagon trains. . . . The night was very dark with light showers of rain. The roads were heavy and a throng of stragglers crowded it, [along with] teamsters who had lost their horses, sutlers, coffee boilers, and numbers of wounded soldiers. All were tramping toward Alexandria."

Lee kept up the pressure by attacking the rear of Pope's retreating army at Chantilly. This short but hot encounter, fought in a driving thunderstorm, lasted until nightfall, when the Union forces withdrew. It was a costly engagement for the Federals, however. Two of the most promising commanders of the army, Isaac Stevens and Philip Kearny, were killed.

Centreville, Va., September 1, 1862. Showing old Rebel fort and Rebel barracks of log houses and encampments of Sumner and French's division. General Heintzelman's headquarters in foreground.

September 1, 1862. "Generals Heintzelman, [David] Birney, and everyone of the old III Corps were in low spirits for the stunning facts were known of the death of General Phil Kearny at Chantilly. . . . All flags on the forts and headquarters were at half mast while the whole Army of the Potomac mourned inconsolably the tragic death of the Ney* of the Union army. No officer in the army was so much respected and known for cool bravery under fire, daring in judgement when a crisis occurred in battle, [and] leading charges in front of his command direct into the lines of the enemy regardless of personal danger."

Sneden was not present at Chantilly but sketched this scene based on after-action reports.

*Michel Ney was one of Napoleon's most aggressive generals.

The battle of Chantilly Va., September 1, 1862.

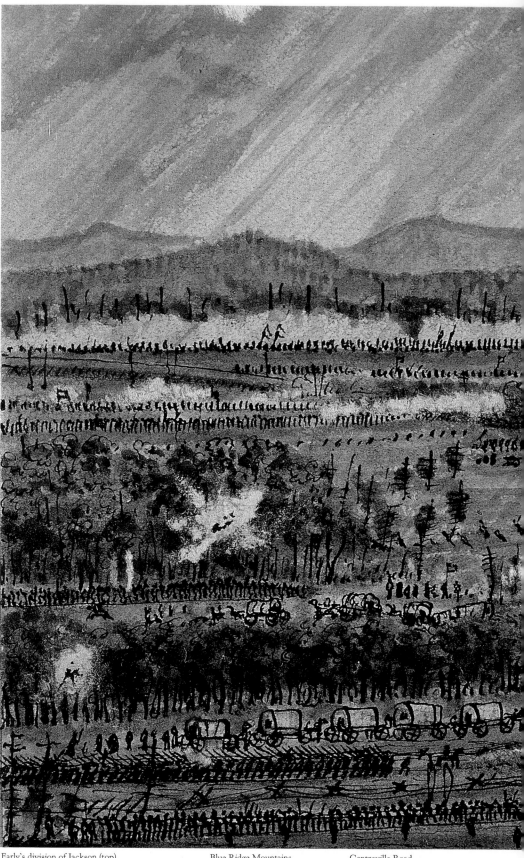

Early's division of Jackson (top) Blue Ridge Mountains Centreville Road
Porter's division (bottom) Rebel forces at foot of distant hills

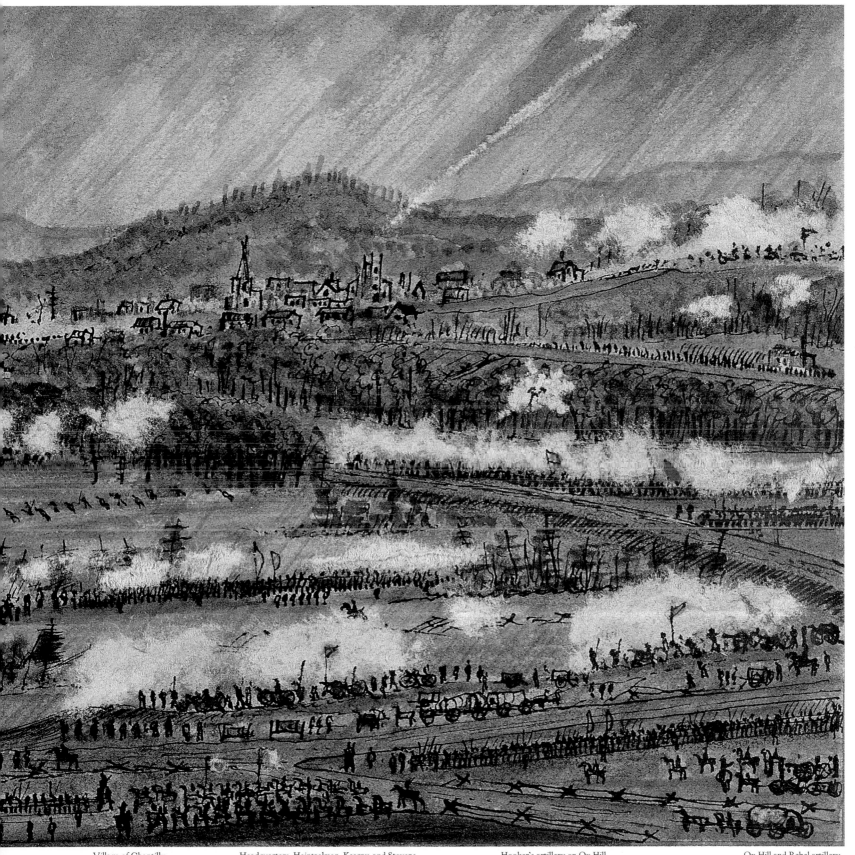

Village of Chantilly Headquarters, Heintzelman, Kearny, and Stevens Hooker's artillery on Ox Hill Ox Hill and Rebel artillery

Railroad embankment

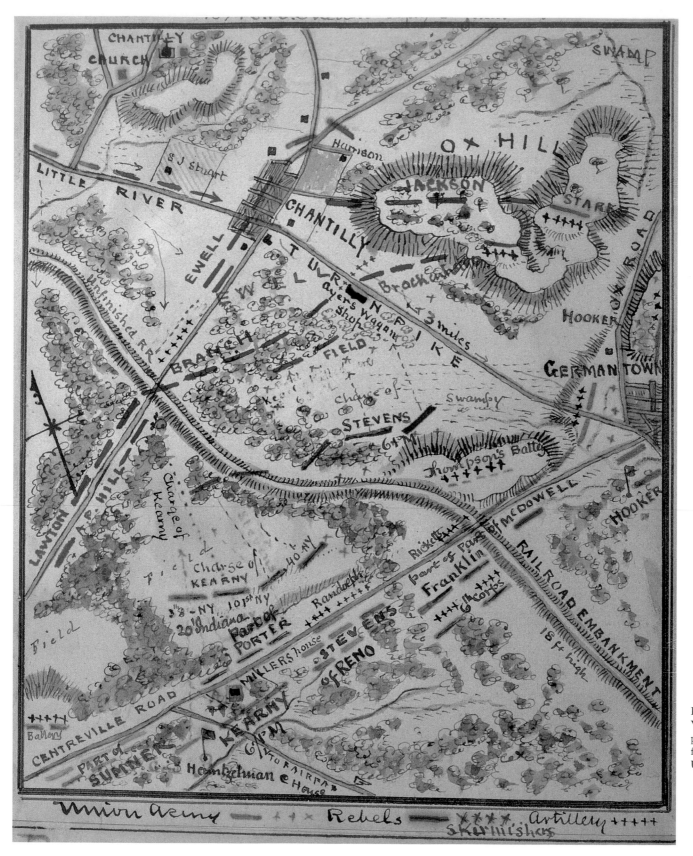

Plan of the battle of Chantilly, Va., September 1, 1862, 5 to 9 p.m. Copy of official map made for General S. P. Heintzelman, U.S.A.

PART THREE

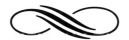

THE GOOD LIFE

AFTER THE SECOND BATTLE AT MANASSAS, III Corps was in no condition to accompany General McClellan as he pursued Lee through Maryland. It remained instead to man the fortifications around Washington. At first General Heintzelman had responsibility only for the Virginia side of the Potomac River, and Sneden worked at headquarters, first in Alexandria, then at Arlington House. Sneden frequently visited the city, however, attending plays and baseball and cricket matches, going to see Barnum's circus, taking meals at Willard's Hotel, viewing George Washington relics at the Patent Office, and admiring the view from the dome of the Capitol. When Heintzelman was given command of the entire military district of Washington, his headquarters moved to Pennsylvania Avenue, and Sneden went with him. There he heard reports from all theaters of action, which he would later use to create sketches and watercolors of many of the war's key events. His maps of Fredericksburg, Chancellorsville, and Gettysburg demonstrate that his attention to detail extended to secondhand sources.

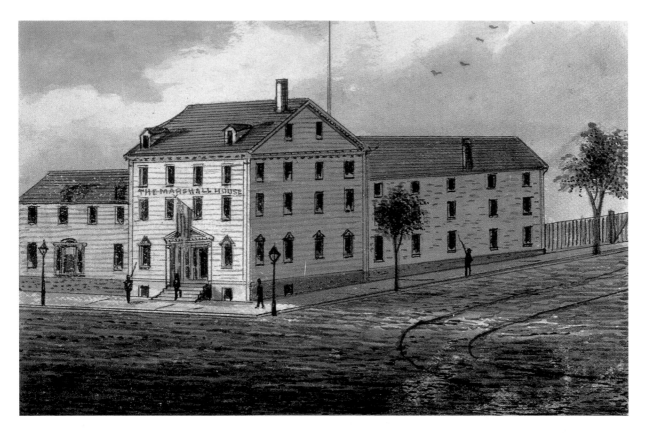

When Sneden returned from the second battle at Manassas, he put "the Marshall House" in quotation marks because the inn was already famous as the place where Colonel Elmer Ellsworth had become one of the war's first casualties when he was shot by the owner of the property for removing the Confederate flag on the roof.

September 1, 1862. "From telegraph headquarters at 'the Marshall House' on King Street we got information of where General Heintzelman could be found."

"The Marshall House," King Street, Alexandria, Va., where Colonel Ellsworth was shot.

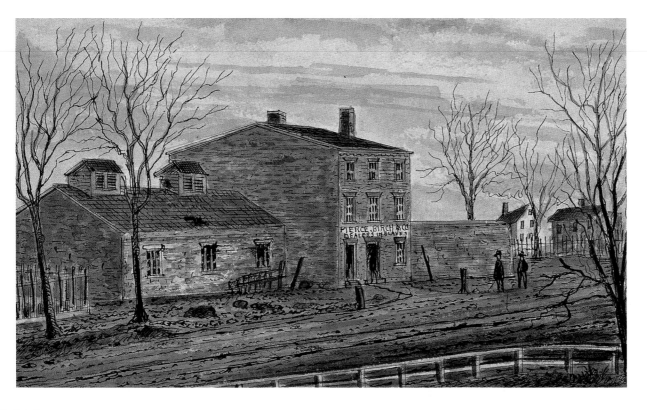

Sneden found General Heintzelman's headquarters in a commodious house at the head of King Street, in a field on the old Fairfax Turnpike near the slave pen.

September 3, 1862. "I went over to the slave pen near here, found it deserted, very dirty and smelling abominable. Saw lots of shackles which were used to chain up the slaves in Alexandria in 1860 and before that if they were caught in the streets after 9 p.m. without a pass from their masters."

Slave pen, Alexandria, Va.

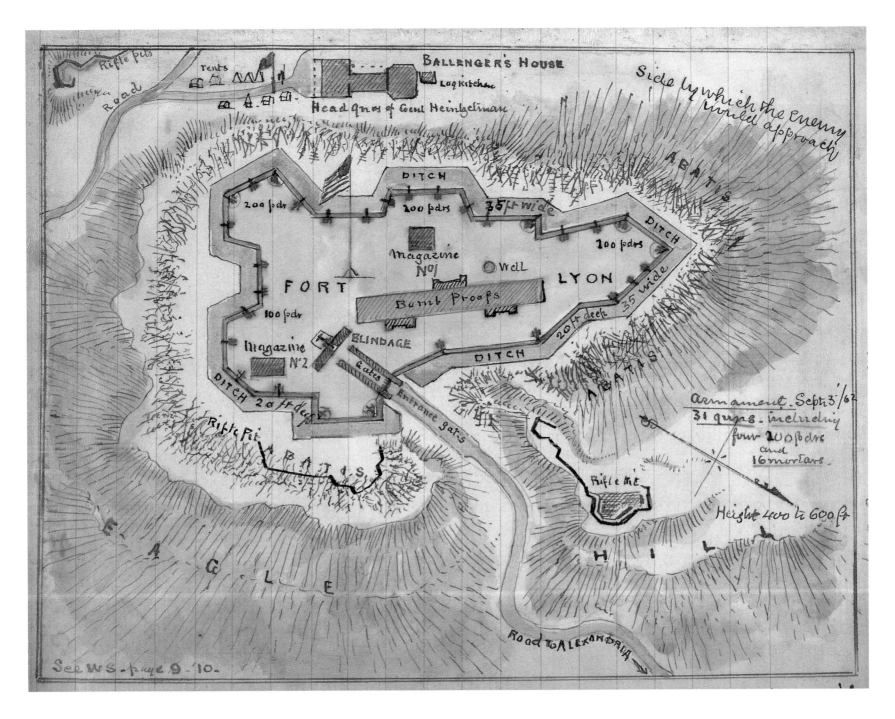

Plan of Fort Lyon on Eagle Hill above Alexandria, Va., and headquarters of Major General Heintzelman.

September 4, 1862. "At 11 a.m. we struck our headquarters and marched up on Eagle Hill and Fort Lyon and made our headquarters at Ballenger's house. These were the same quarters we had occupied from January to March last, before we went on the Peninsular Campaign. . . . I made a plan of the fort before leaving."

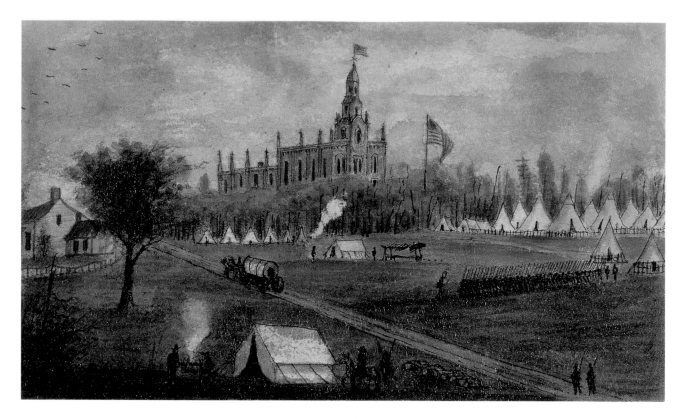

The Episcopal Seminary near Alexandria was General McClellan's headquarters in late August 1862 during Pope's campaign. McClellan was grudging about ceding troops for Pope's use. With Pope's resignation, McClellan regained complete control of the Army of the Potomac.

The Episcopal Seminary, Old Fairfax Road, near Alexandria, Va. Headquarters of General McClellan August 26–31, 1862, during Pope's campaign.

Union forces first occupied Arlington House on May 24, 1861, and Heintzelman was the third general to have his headquarters there. This drawing of the structure is dated twice, "Sept 1862" and "Octr 1862." The proportions of the columns are rendered slightly differently in Sneden's several drawings. This one is the closest to reality.

September 12, 1862. "I had my tent put up on the lawn in front of the house. . . . All the fences on the premises had been used for fire wood. . . . The garden fence was as yet intact. . . . Several Negro women, who were former slaves of General Lee, occupied the quarters which were detached from the house, and earned money by washing all our clothes. They said that Lee was a hard taskmaster. I made two sketches of headquarters today and worked on maps until 9 p.m."

Arlington House, Va., headquarters, Major General S. P. Heintzelman, III Corps, October 1862. Major General Heintzelman now commanded all the defenses on the Virginia shore.

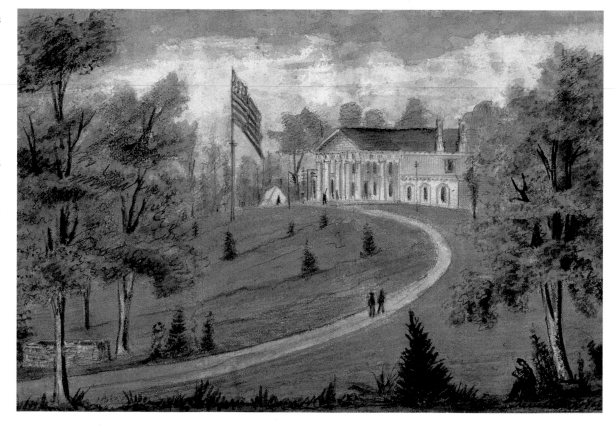

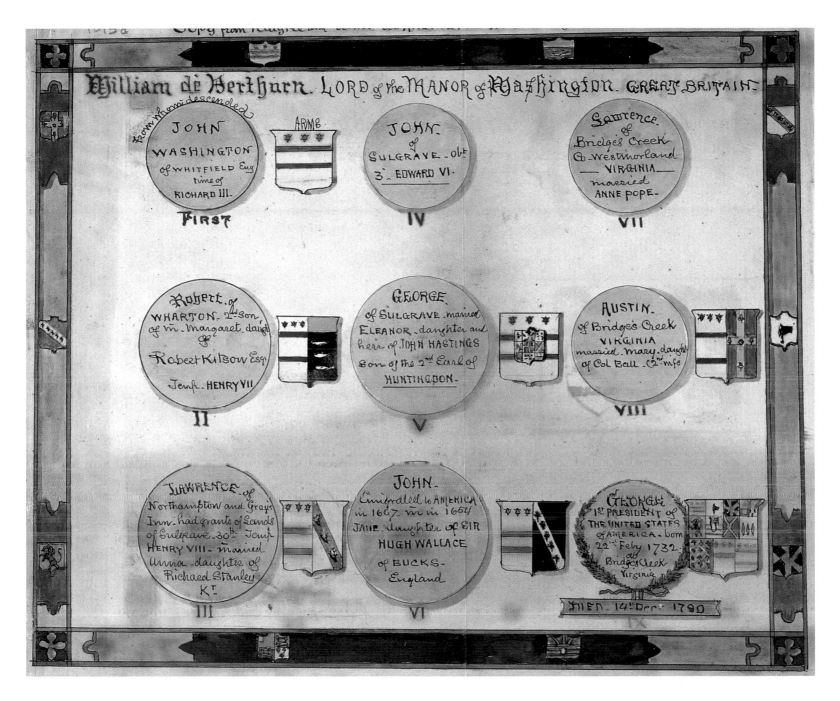

Copy from pedigree and arms at Arlington House, Va. 1862 (true colors).

September 14, 1862. "I spent most of the day in looking over the books in General Lee's Library, many were rare and very valuable. Among them were twelve volumes of Voltaire with antique engravings. Many valuable works on Military Engineering and Fortification were here also, which I eagerly studied for hours."

On this or another day Sneden executed watercolors of several pedigrees of the Washington family hanging on the walls. On October 22, while visiting the Patent Office in Washington, Sneden saw another Washington coat of arms that was a duplicate of the one at Arlington.

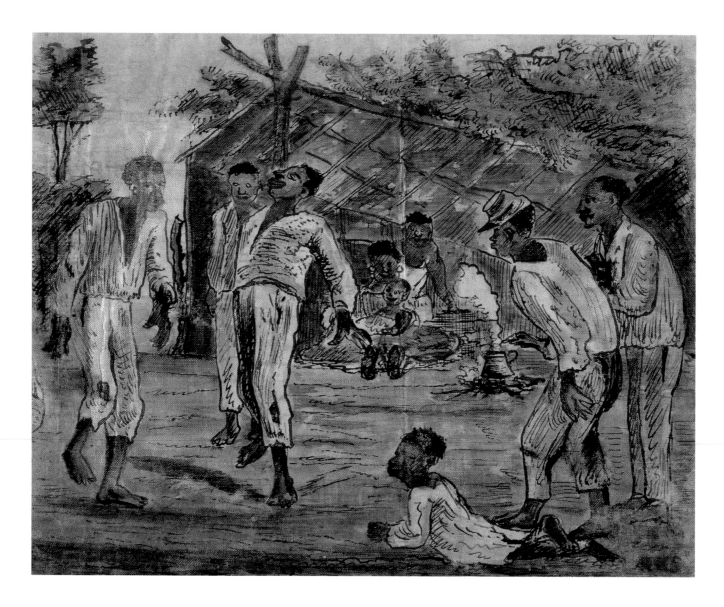

October 14, 1862. "The camp of contrabands near Arlington Springs on the river now numbers several hundred Negroes. At night they have their prayer meetings, and the woods resound with their shouts and singing."

November 15, 1862. "The contraband camp below Arlington House contains over 300 Negroes—men, women and children. They sing, dance, play cards and get drunk, and are a nuisance. In the meantime they get plenty to eat from the government."

The "contraband" camp below Arlington House, Va., November 1862.

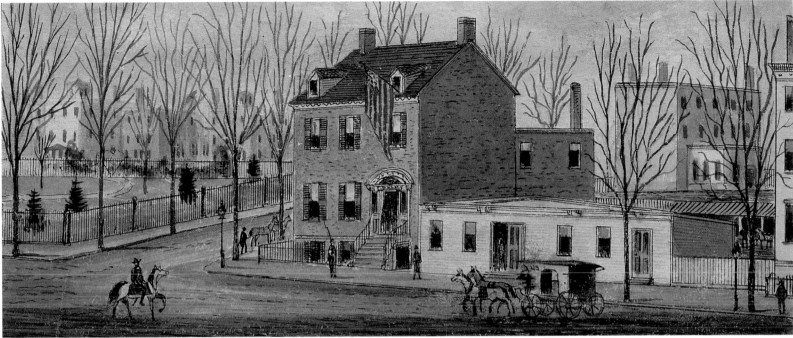

Lafayette Square Rebel J. B. Floyd's house Pass officers' and clerks' building

December 10, 1862. "General Heintzelman having assumed the command of 'The Department of Washington' on the first of this month, Headquarters will be transferred from here to 15½ Street and Pennsylvania Avenue, Washington City tomorrow. . . . The building at 15½ Street was once the property of [John B.] Floyd, the Rebel Secretary of War. It has for a long time been 'sequestered' by the U.S. government as military headquarters."

The building adjoined Lafayette Park, opposite the White House. The wooden addition to the right of the brick structure housed the quartermaster offices.

Headquarters of Major General S. P. Heintzelman, U.S.A., commanding the Department of Washington, at corner of 15½ Street and Pennsylvania Avenue, Washington, D.C., January 1863.

May 8, 1863. "Passes are examined at the theatres during the performance by officers of provost, whose guard block the exits until passes are scrutinized."

Lieutenant Drake DeKay was the pass officer of General S. P. Heintzelman at Washington, D.C.

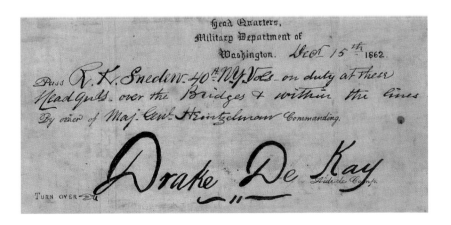

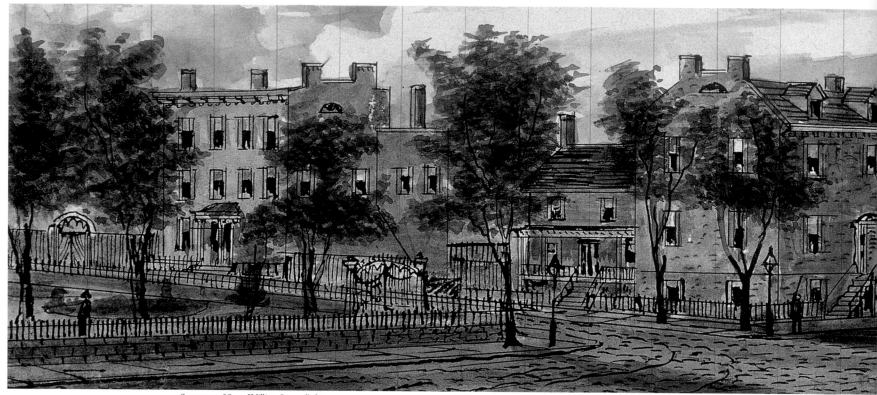

Secretary of State William Seward's house

Rebel confiscated house—headquarters

This Sneden view is dated August 1864, but probably he meant 1863, toward the end of his service there. In August 1864 he was at Andersonville.

July 18, 1863. "The large tree on the corner of Pennsylvania Avenue and 15½ Street standing on the side walk in front of these headquarters was cut down today by General Heintzelman's orders, as it was in danger of falling on the horses picketed in front of the house. This was the veritable tree under which General Dan E. Sickles shot Keyes some years ago. As soon as it fell a troop of women, men, and boys began cutting off the branches to make canes and relics of."

November 15, 1862. "The crew of five Rebels were captured in a boat while crossing the Potomac from Occoquan yesterday. They had $1,700 among them . . . in gold. They are now in the Old Capitol Prison, but who got the money?"

December 15, 1862. "The 'secesh' were joyous in this city, and many were molested and terribly beaten by the more loyal citizens for expressing their Rebel ideas too freely at the hotels. Several were sent to the Old Capitol Prison."

July 27, 1863. "The draft began in Washington today, and the Rebel sympathizers and copperheads keep in doors. They are now in very low spirits and keep 'shady.' Over 200 are now in the Old Capitol Prison."

The prison had been built in 1817. Sneden's quotations show the range of prisoners kept there. Those arrested following the Union defeat at Fredericksburg were incarcerated partly for their seditious sayings, but partly for their own protection.

The Old Capitol Prison, Washington, D.C. Built A.D. 1817.

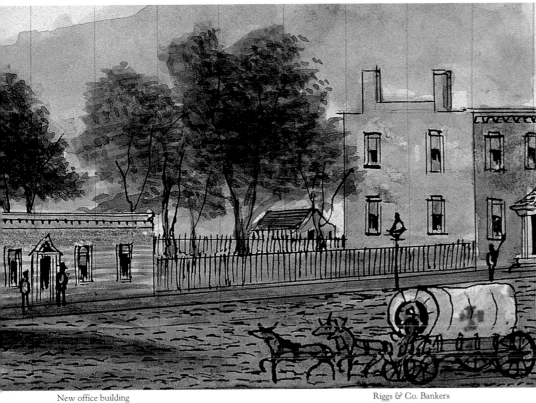

New office building
 Riggs & Co. Bankers

Headquarters of General Samuel P. Heintzelman, U.S.A., commanding the Department of Washington, $15\frac{1}{2}$ Street and Pennsylvania Avenue, Washington, D.C., August 1864.

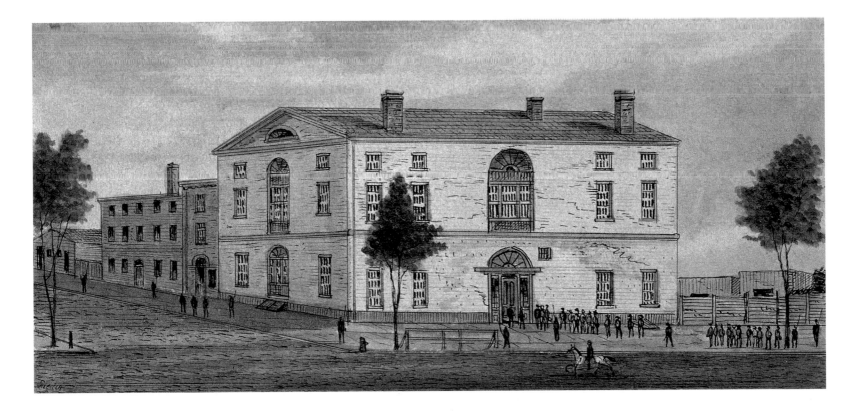

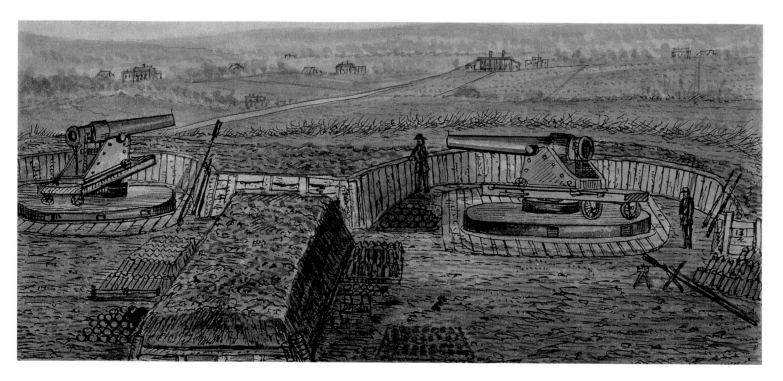

Washington was protected by a ring of forts. Those north of the city included Fort Stevens, Fort Slocum, Fort Kearny, and Fort Reno. The most serious assault on the city was made by Jubal Early on July 11–12, 1864. In September 1862, while serving on General Heintzelman's staff at Arlington House, Sneden learned of the fierce fighting at Antietam. After he moved to head-quarters on Pennsylvania Avenue in Washington, he closely followed news of the disasters at Fredericksburg and Chancellorsville and of the victory at Gettysburg.

Fort Stevens, Washington, D.C.

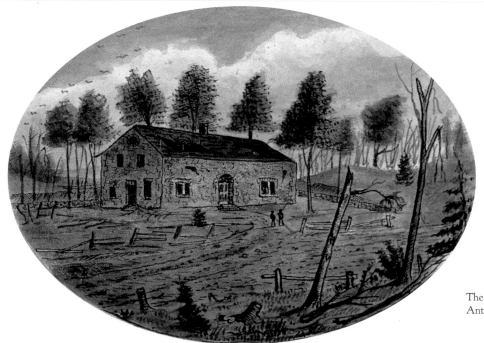

Along the Hagerstown Turnpike, near Sharpsburg, an old whitewashed Dunker meeting house stood on high ground commanding the adjacent countryside. The German Baptist pacifist sect that worshiped there never called it a church, and even a steeple was thought pretentious. It became the main objective of three Union army corps at the beginning of the battle of Antietam and was the site of numerous attacks and counterattacks. As "Fighting Joe" Hooker's troops closed in on it, Stonewall Jackson sent in his last reserves, who held the position.

The Dunker Church, battlefield of Antietam, Md., September 19, 1862.

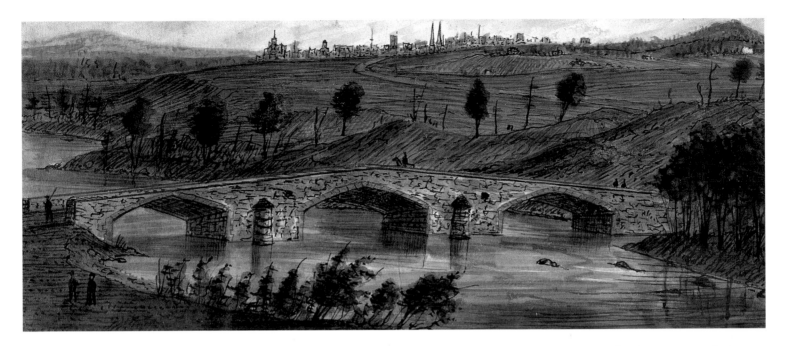

The third phase of the battle at Antietam focused on a narrow stone bridge across Antietam Creek. It lay on the Confederate right and was strongly defended. Despite the overwhelming numbers of General Ambrose Burnside's attacking force, the bridge's defenders held it for three bitterly contested hours. Finally, however, two Union regiments fought their way across and almost made it into Sharpsburg itself. They withdrew, however, when Confederate reinforcements under A. P. Hill appeared at the end of the day. Sneden's image below is dated 1885. A similar watercolor mounted in his diary is clearly dated 1887 and specifically refers to buildings that were erected since the war. One survivor of the battle, Captain James Hope of the 2nd Vermont Volunteers, afterward painted the battle in oils.

View of Bridge No. 3 across Antietam creek in front of Burnside's position, battle of Antietam, Md.

The Sharpsburg Bridge over the Antietam. Known as Burnside's Bridge during the battle, September 1862. The Rebels were posted . . . on the hill above the bridge which was swept by his artillery. The bridges were carried by the 51st New York and 57th Pennsylvania regiments.

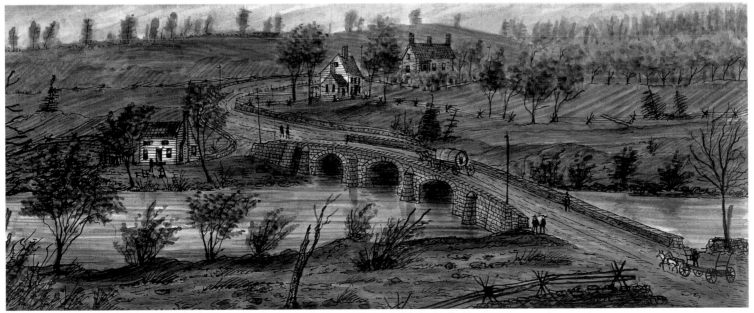

The houses have been built since the battle.

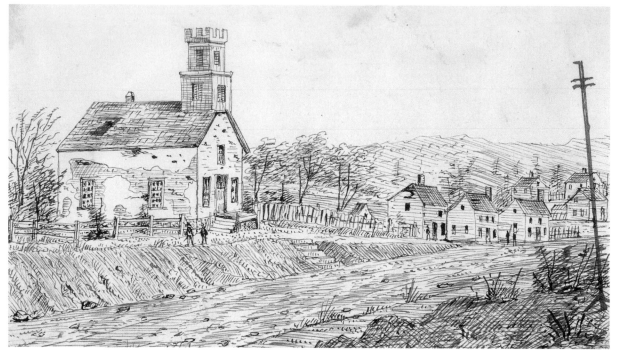

Federal gunners attacked the Lutheran church on Main Street in Sharpsburg because Rebel flag signals were given from its tower. After the fighting it was used as a hospital. Sneden's image is similar, though not identical, to a wartime photograph by Alexander Gardner.

The old Lutheran Church, Sharpsburg, Md., September 18, 1862. Used for Union hospital after the battle.

Union flag pole

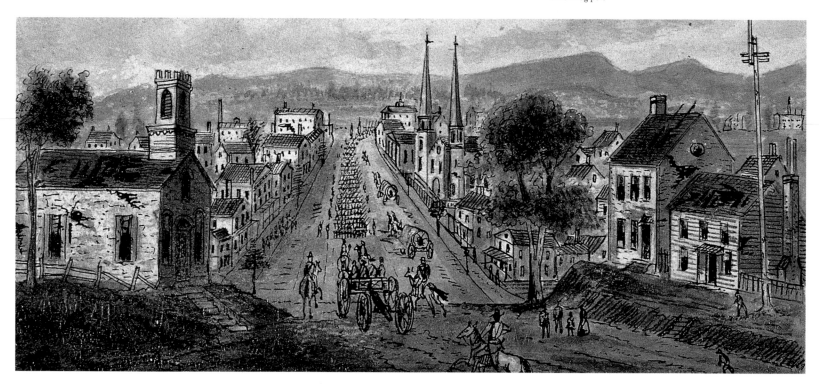

The damage from Union shelling during the battle of Antietam is most evident in the near wall of the Lutheran church in the far left foreground. Sneden's caption to another, similar image reads "Burnside's skirmishers gained a hold at the first cross street below this church where there was desperate fighting," and paraphrases the caption to an image published in Battles and Leaders.

View of Sharpsburg, Md., near the battlefield of Antietam. Union army passing through September 19, 1862. Showing effect of shells from Union batteries during the battle.

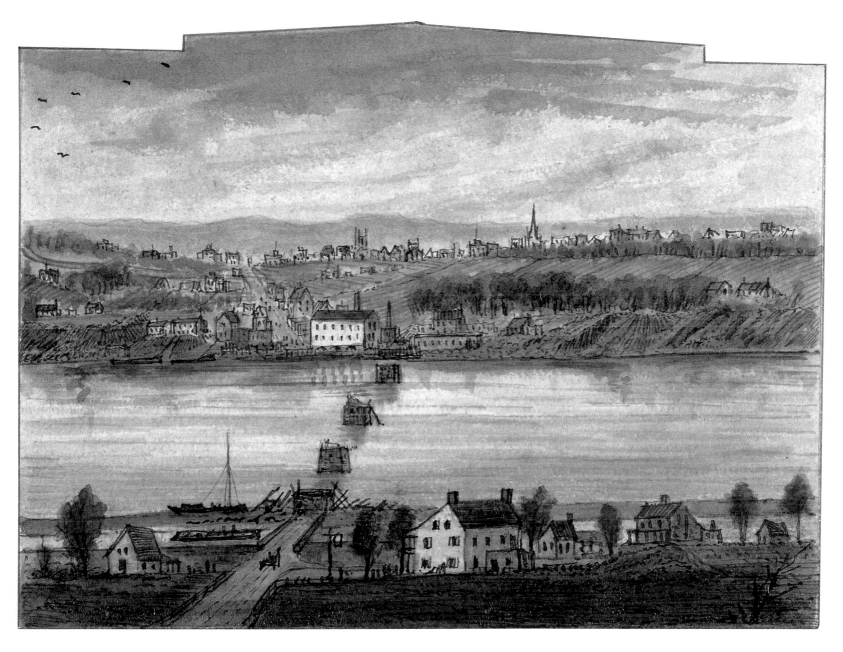

On September 18 Lee held his line for a full day before slipping back into Virginia. McClellan, persisting in the delusion that Lee outnumbered him, failed to advance. Lee thus crossed the Potomac River unmolested at fording sites below Shepardstown, leaving many wounded behind. Sneden's image seems the same as that used in Battles and Leaders, which is attributed to "war-time photographs."

Shepardstown, Va., from the Maryland side of the Potomac. Lee's army crossed by wading below the town and mined bridge.

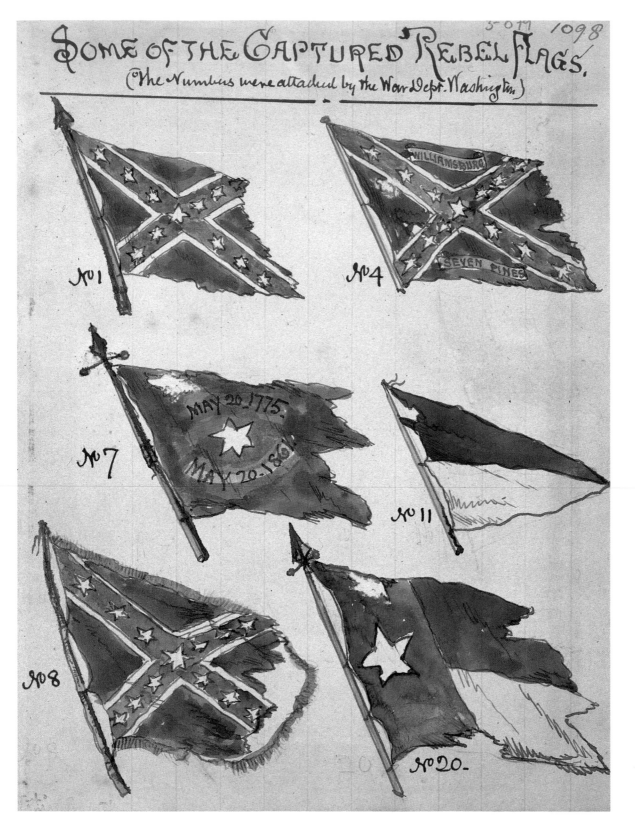

Some of the captured Rebel Flags.
(The Numbers were attached by the War Dept. Washington.)

№ 1

№ 4

№ 7

№ 11

№ 8

№ 20

Sneden's watercolor gives the War Department numbers for the flags captured at Antietam, suggesting that it was drawn after the war. A similar image in one of his scrapbooks, with more details about the capture of the flags, is dated 1892.

Some of the captured Rebel flags. The numbers were attached by the War Department, Washington, D.C.

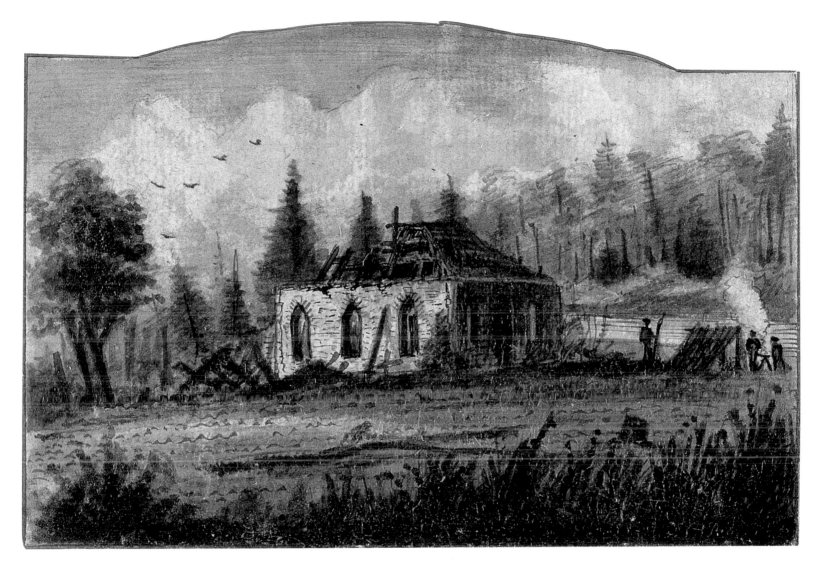

According to a book published by Episcopal bishop William Meade in 1857, the ruination of old Potomac Church dated to the War of 1812 when, already abandoned, troops were quartered in it. The condition noted by Sneden—partial demolition of the walls to construct camp hearths—merely completed the process.

Ruins of Potomac Church, between Potomac Creek and Fredericksburg, Va., built A.D. 1765. Picket post of Burnside's Corps, 1863. Walls torn down by soldiers and used for camp hearths.

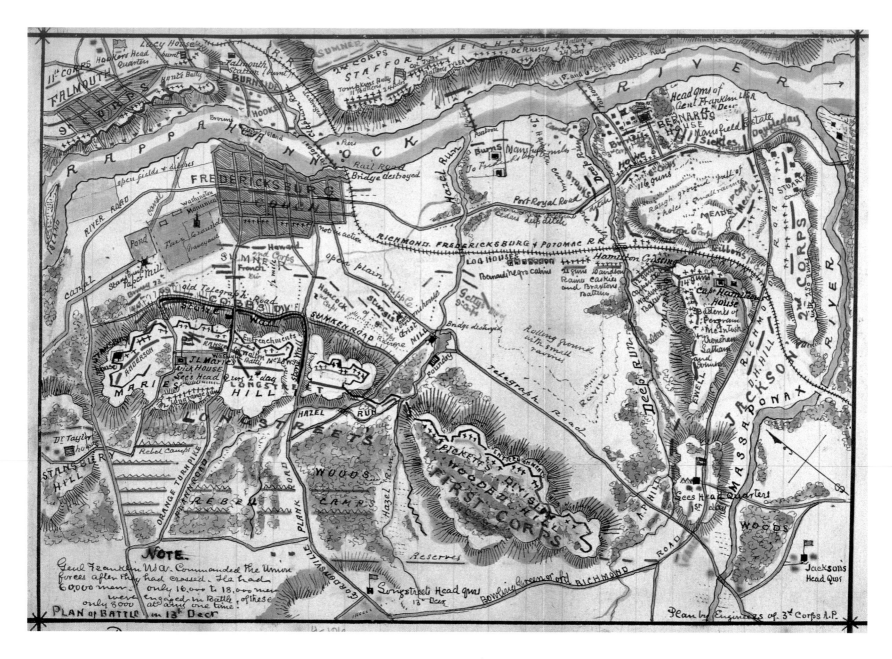

December 26, 1862. "Am working full hours on maps of Fredericksburg and vicinity for the use of the general's staff."

At some point Sneden also copied this "Plan by Engineers of III Corps" showing the battle of Fredericksburg fought December 12–13, 1862. Robert E. Lee beat Ambrose Burnside to Fredericksburg and occupied the heights overlooking the town. The main Union attack was by Hooker's troops against Marye's Heights (left center). Fourteen assaults failed to dislodge the entrenched Confederate artillery on the heights.

Plan of the battle of Fredericksburg, Va. Fought December 12 and 13, 1862. The II and IX Corps were the right grand division under Sumner. The I and VI were the left grand division under Franklin. The III and V were the center under Hooker. The XI were in reserve.

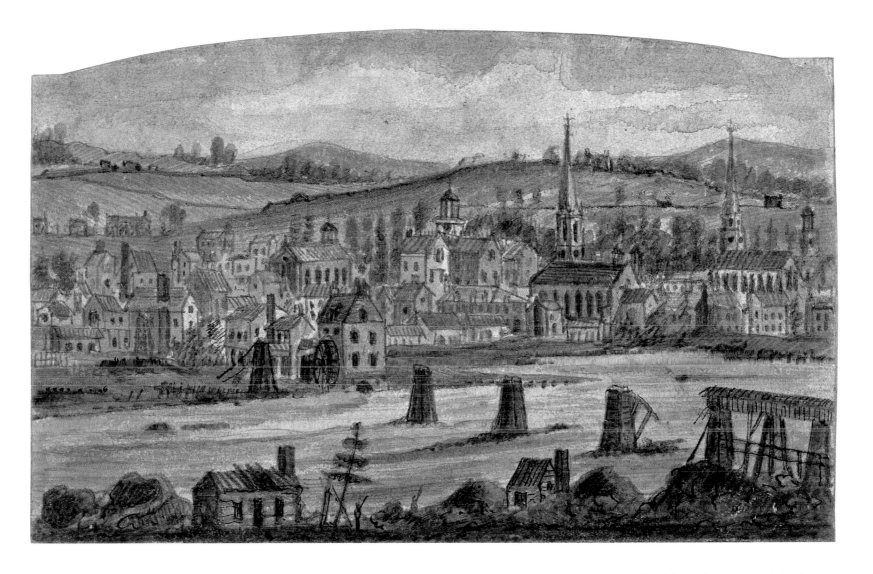

December 14, 1862. "A great battle at Fredericksburg, Va. has been in progress since yester-day morning. . . . After repeated attempts to carry the heights our troops were compelled to fall back to the river defeated with great slaughter. Burnside has proved a failure."

The heights are visible in the background of this picture.

Fredericksburg, Va., 1862. Founded 1727.

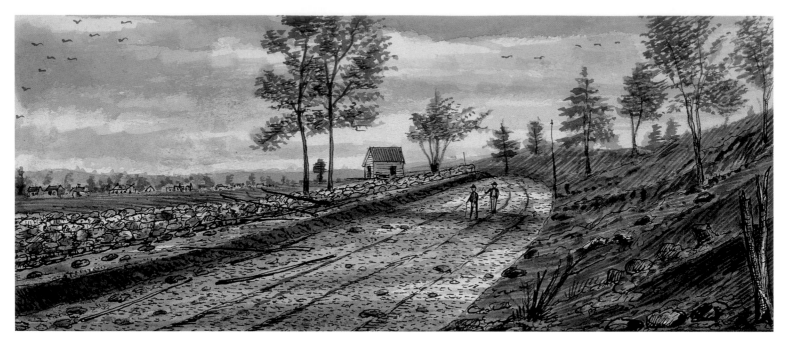

Two weeks after the battle of Fredericksburg, Sneden wrote down what he had learned of the engagement. Marye's Heights, where the Union suffered its greatest casualties, rise to the right in this view.

The stone wall and sunken road, Fredericksburg, Va., after the battle.

December 26, 1862. "Longstreet, who held the position in the rear of Fredericksburg, formed the Confederate left, and had taken up as his advance line the stone wall and rifle trenches along the telegraph road at the foot of Marris [Marye's] hill, and here he posted two brigades along the wall in the sunken road where lines, four and five deep, were sheltered by the wall. Those in the rear loaded the muskets quickly and passed them to those in front, so a continuous sheet of fire blazed over the wall, which nothing could withstand."

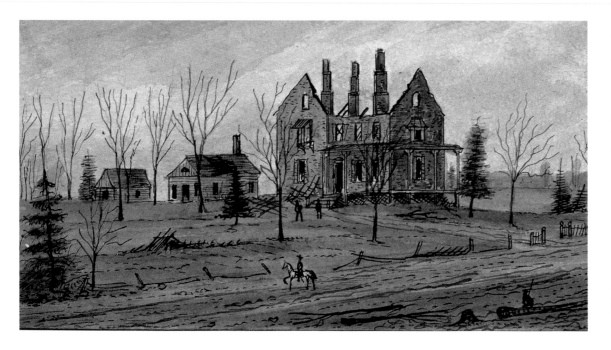

December 26, 1862. "Burnside's headquarters were at the Phillips house at Falmouth, which was subsequently burnt."

Sneden's sketch is based either on Alexander Gardner's February 1863 photograph of the house burning, or, more probably, Walton Tabor's drawing for Century *magazine (August 1886: 627) and* Battles and Leaders, *based on Gardner's photograph. In Sneden's image, however, the fire is over, one of the small distinctions he made so that his images were not literal copies of other men's work.*

Ruins of the Phillips house, burnt during the battle of Fredericksburg, Va., December 1862.

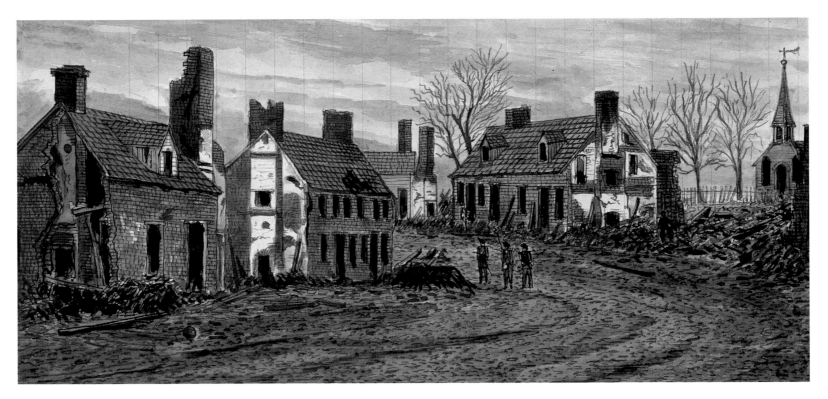

Union shelling of Fredericksburg began on December 11, 1862, and set much of the town afire. Most of the inhabitants had already evacuated. When they returned they found most homes looted. This is one instance where Sneden acknowledges he has copied a photograph.

Street in Fredericksburg, Va., after the bombardment by General Burnside, December 1862. (From photo.)

Whether Sneden sketched this house in 1865 or merely copied another image of that date is not known. His vantage point, however, is identical to an image that appeared in Century magazine (August 1886: 615) "from a wartime photograph." If this is a copy, Sneden made just enough small changes to not seem derivative.

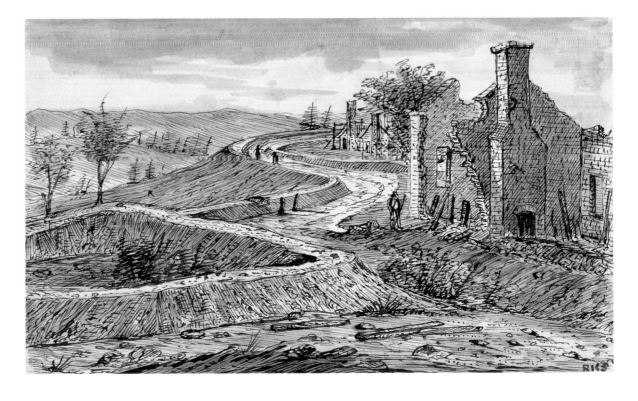

Old Confederate works on Willis Hill, Fredericksburg, Va., 1865.

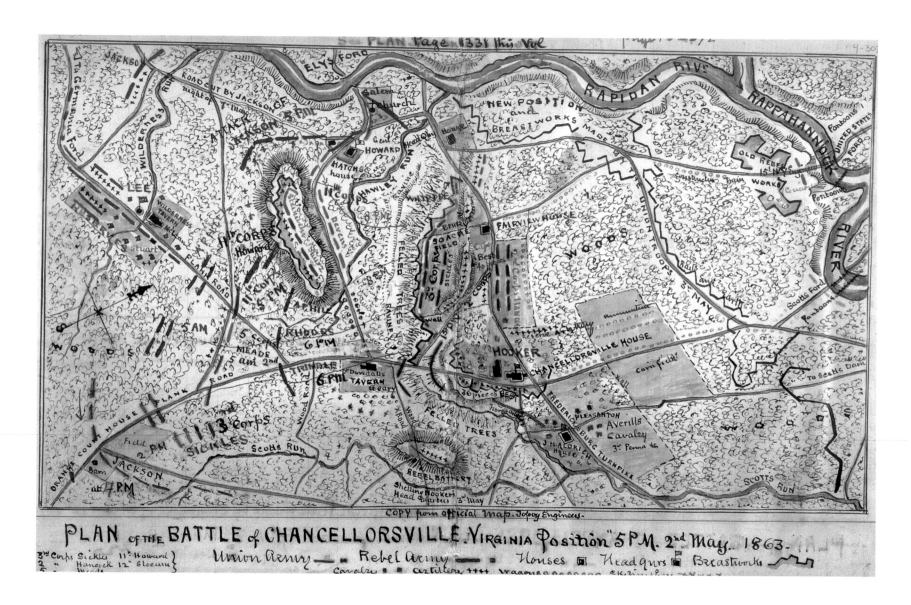

PLAN OF THE BATTLE OF CHANCELLORSVILLE. Virginia Position "5 P.M. 2nd May. 1863.

Copied from an official map of the Topographical Engineers, this map shows the Chancellorsville house in the center. In fact, Chancellorsville was not a town but a single dwelling, albeit a substantial one, amid a cultivated field.

Plan of the battle of Chancellorsville, Va. Position at 5 p.m., May 2, 1863.

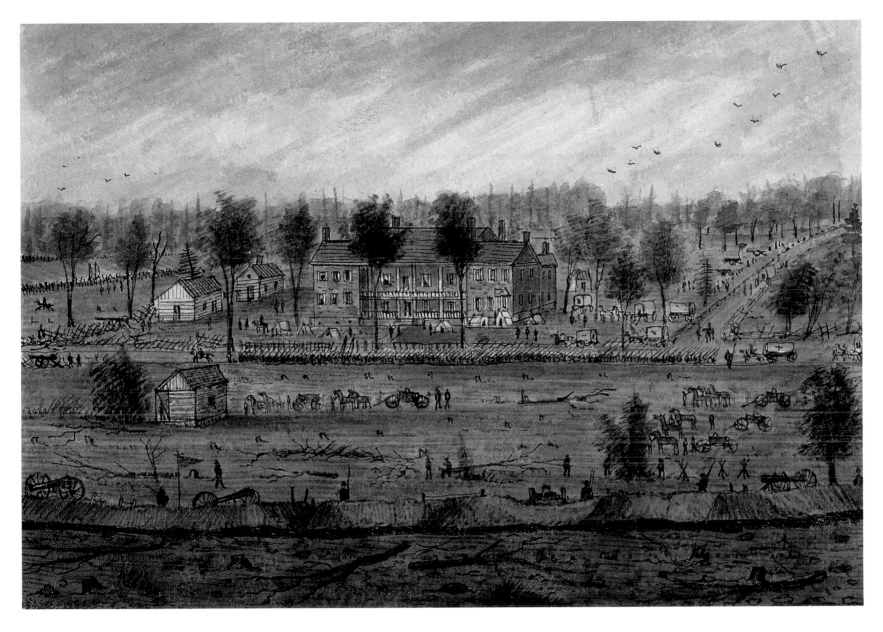

Joe Hooker made his headquarters here on April 30, 1863. "The house," wrote an Iowa private, "is of the Southern type, belonging to a well-known family of the neighborhood, still occupied by their women. Upon the upper porch was quite a bevy of ladies in light, dressy attractive spring costume. They scolded and reviled [us] bitterly. [Before] another day was over they would pitifully plead to be carried to a place of safety." (Quoted from Geoffrey C. Ward et al., The Civil War, New York: Alfred A. Knopf, Inc., 1990, p. 203.)

The Chancellorsville house, Hooker's headquarters, May 2, 1863.

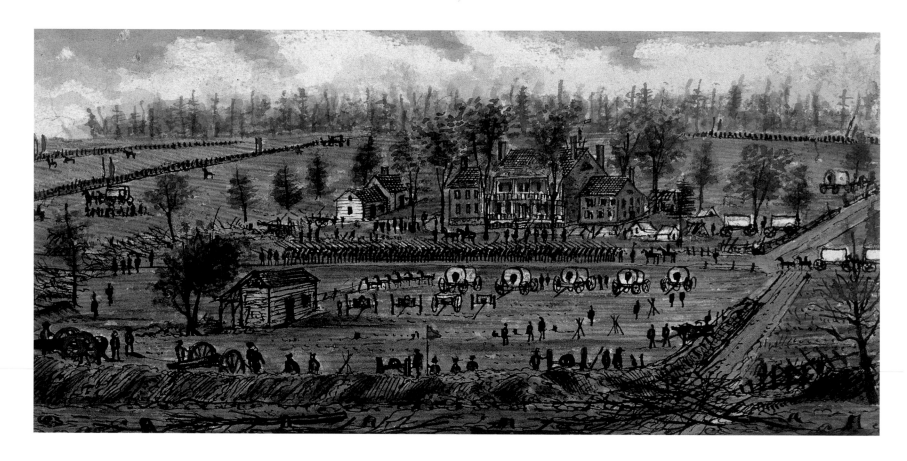

Troops of the 29th Pennsylvania covered the Chancellorsville house during the battle, where it became the Union army's last stand. Confederate artillery brought to within 500 yards of the house set it afire and Hooker abandoned the field. On this view Sneden has written "Sketched there" and, indeed, his view differs sufficiently from the views published in Century magazine and in Battles and Leaders to suggest that it may be firsthand.

Defenses of the Chancellorsville house, headquarters of General Joe Hooker, May 2 and 3, 1863. Sketched there.

Hooker watched the battle unfold from the front porch. A Confederate shell hit a pillar he was leaning against, knocking him senseless. The house was set afire. Sneden's before and after sketches were juxtaposed by Charles Vanderhoof, who redrew Sneden's images for Battles and Leaders.

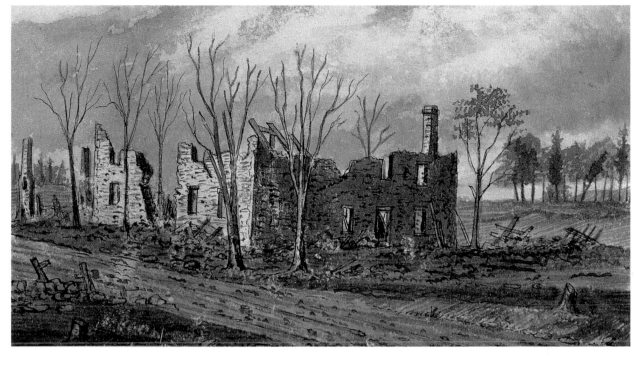

Ruins of the Chancellorsville house, Hooker's headquarters. Shelled and burnt by Rebels May 3, 1863.

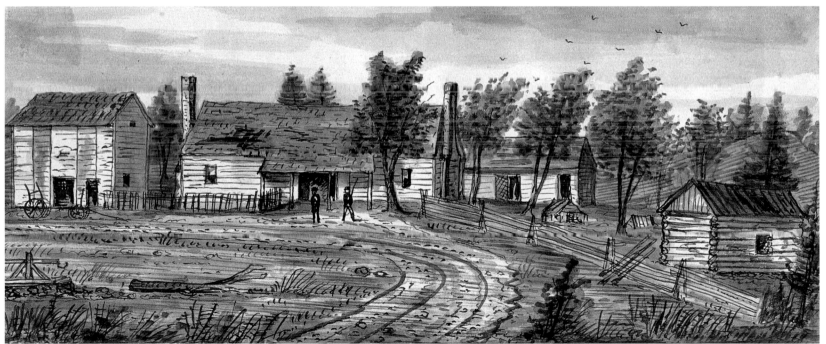

Todd's Tavern, due south of Chancellorsville, played a role in both the battles of Fredericksburg and Chancellorsville Campaigns of 1863 and in the Wilderness and Spotsylvania Campaigns of 1864. On the earlier occasion, Stonewall Jackson's flanking force brushed by the tavern on its famous maneuver against General Hooker's right flank. In 1864 it was the site of a skirmish between cavalrymen of Philip Sheridan and J. E. B. Stuart. Sneden depicts a one-story structure, whereas the image published in Battles and Leaders, *"from a sketch made in 1884," shows a two-story building.*

Todd's Tavern, battlefield of Chancellorsville, Va., 1863.

155

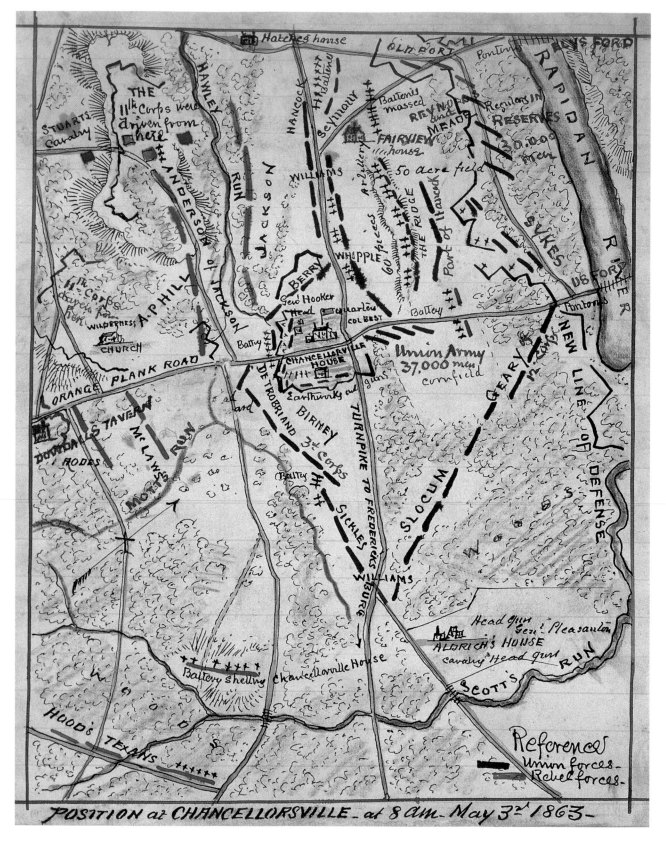

Five days after the main fighting at Chancellorsville subsided, Sneden wrote in his diary what he understood had taken place, and how the news had been received in Washington.

May 8, 1863. "The battle of Chancellorsville has been fought and the Union army repulsed with heavy losses and compelled to fall back again to Falmouth. There was great anxiety in Washington, at headquarters, and at the War Department, as telegrams came in hourly May 2 giving news from the front. The bulletin boards at the hotels were crowded day and night by the excited citizens."

Position at Chancellorsville at 8 a.m., May 3, 1863.

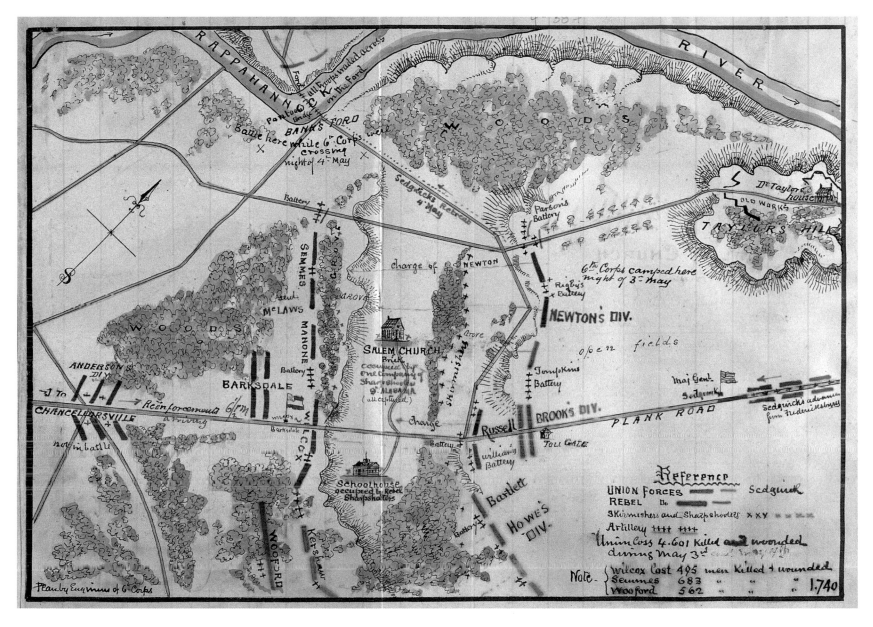

On May 3 General John Sedgwick's troops streamed across the stone wall at the base of Marye's Heights that had caused the Union so much grief in December 1862. Hurrying toward Chancellorsville, Sedgwick was intercepted by Lee, who had defeated Hooker the previous day. Almost completely surrounded, Sedgwick nonetheless held his ground until after midnight on May 5 and then crossed the Rappahannock at Banks's Ford. A similar map in one of Sneden's scrapbooks is inscribed "From Plan by VI Corps Engineers."

Plan of the battle of Salem Church or Salem Heights, Va. Attack and repulse of the VI Army Corps, Major General John Sedgwick, U.S.A. Afternoon of May 3, 1863.

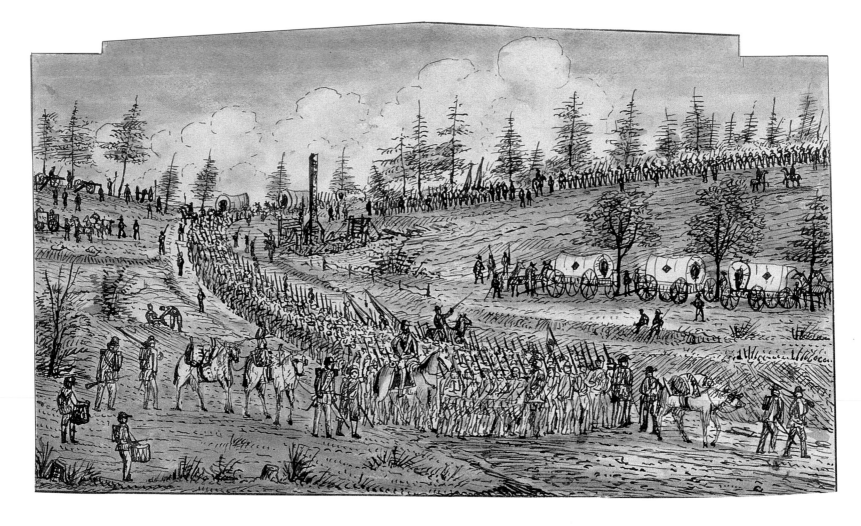

When Joseph Hooker took command of the Army of the Potomac, General Daniel E. Sickles was given the III Corps, which, during the battle of Chancellorsville, located Stonewall Jackson's flanking march but was cut off as Jackson attacked the Union right flank. Late on the night of May 4 Hooker decided to recross the Rappahannock River. The source of Sneden's image is unknown.

The III Army Corps, General Daniel E. Sickles, covering the retreat from Chancellorsville.

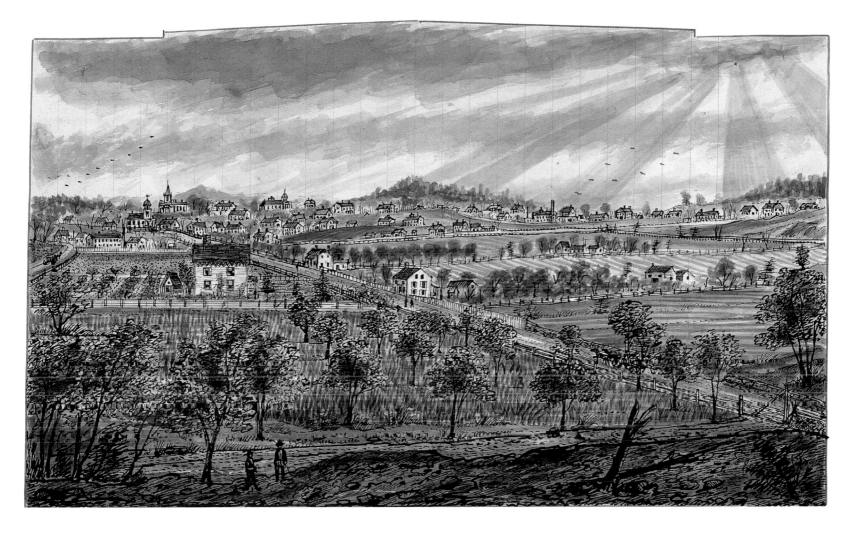

July 1, 1863. "Today a terrific battle is taking place at Gettysburg. The War Department has direct telegraphic communication from the field of battle and the context is yet very doubtful. Great excitement prevails in the city. . . . The telegraph with Gettysburg ceased working at 10 a.m. All news must now come to Frederick and from there [be] transmitted here."

Within a short time of the battle of Gettysburg, Sneden had access to full descriptions of the town and terrain and perhaps to photographs. He acknowledges this view to be taken from photographs.

View of Gettysburg, Pa., looking northeast from the Emmitsburg Road, July 1863. (From photo.)

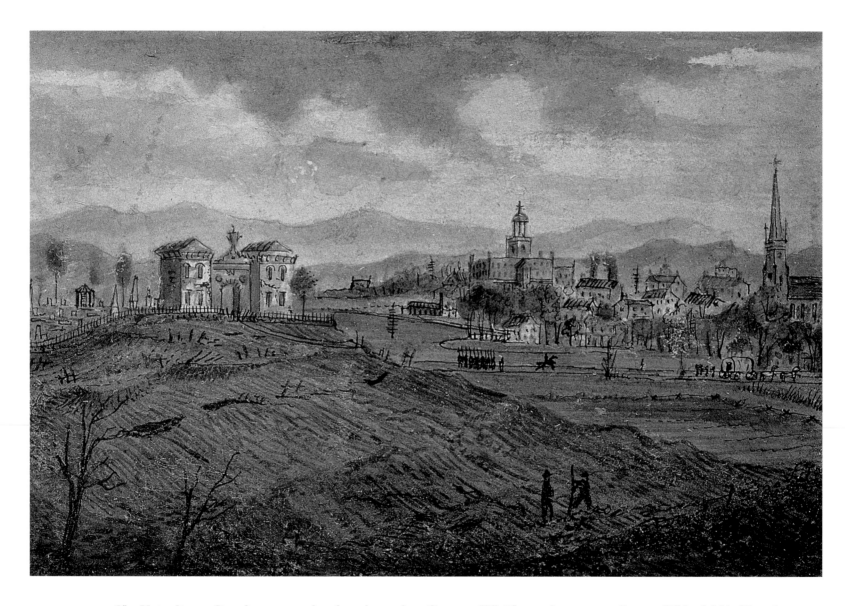

The Union line at Gettysburg was anchored on the north at Cemetery Hill. The gatehouse to Evergreen Cemetery had a placard threatening prosecution of anyone using firearms on the grounds. Notwithstanding, on the second day of the battle, July 2, hand-to-hand fighting swirled around the gatehouse before Jubal Early's Confederates were repulsed. Big and Little Round Top were hills that anchored the southern end of the Union defensive line.

Cemetery Hill, battlefield of Gettysburg, Pa., held by the II and XI Corps, July 1863.

James Longstreet's troops rushed into the ravine between Little and Big Round Top, but were driven off. Colonel Joshua Chamberlain of the 20th Maine was ordered to hold Little Round Top "at all hazards," and in intense close-up fighting, his 350 men succeeded. Sneden's image is a composite of two sketches published in Century *magazine (December 1886: 279) with an identical thirteen-word title.*

Union breastworks on Little Round Top, Gettysburg, Pa. Big Round Top in distance.

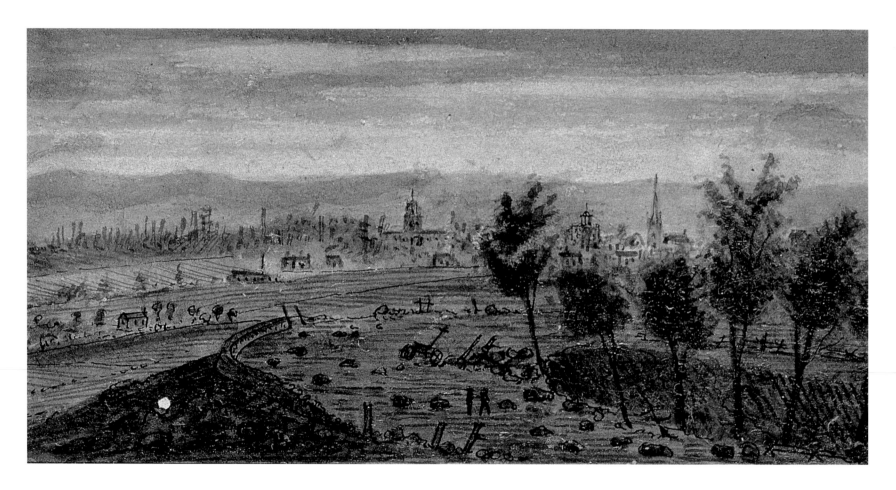

Sneden's watercolor panorama of the commanding view of Gettysburg from Little Round Top shows why possession of that site was so critical in the battle. Artillery placed there could wreak havoc in any direction. Meant to anchor the southern end of the Union line, it was left vulnerable to Confederate occupation by an unauthorized movement of General Dan Sickles, resulting in some of the fiercest fighting the second day of the battle of Gettysburg.

View from Little Round Top Mountain, battlefield of Gettysburg, Pa., July 1863. Strength of Union army July 1: 82,000 and 300 guns. Strength of Rebel army July 1: 73,500 and 190 guns.

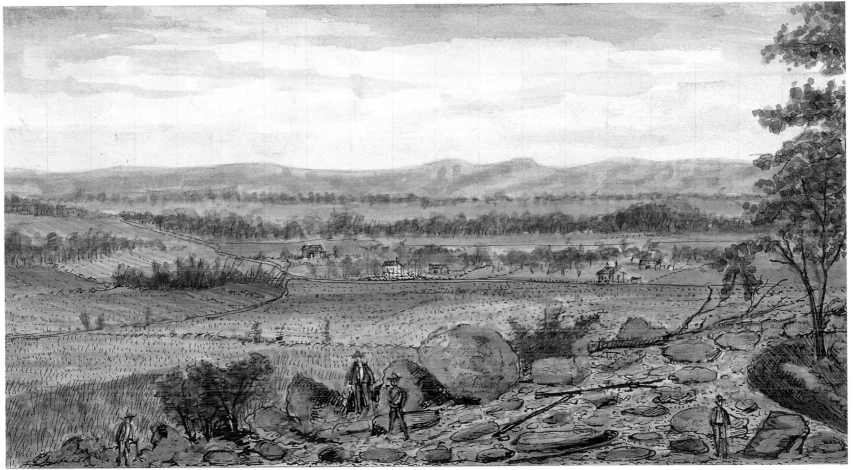

Peach orchard, background Wheat field, middle ground Trostele's [house], middle ground Codori's house Cemetery Hill, background

Finding Little Round Top unoccupied, Lieutenant Hazlett's battery (Battery D, 5th U.S.) and two brigades were hurried to the summit. Hazlett was subjected to fire from sharpshooters in Devil's Den, who, hiding amid boulders there, could not be dislodged. Three of his cannoneers were shot in succession before a fourth managed to fire his piece. Hazlett himself was killed, but Little Round Top was held. Sneden explicitly acknowledges taking this view from a photograph. However, the image is almost identical to an illustration published in Century *magazine (December 1886: 298) with the identical, detailed title.*

View from the position of Hazlett's battery on Little Round Top looking across the Valley of Death, battle of Gettysburg (from photograph).

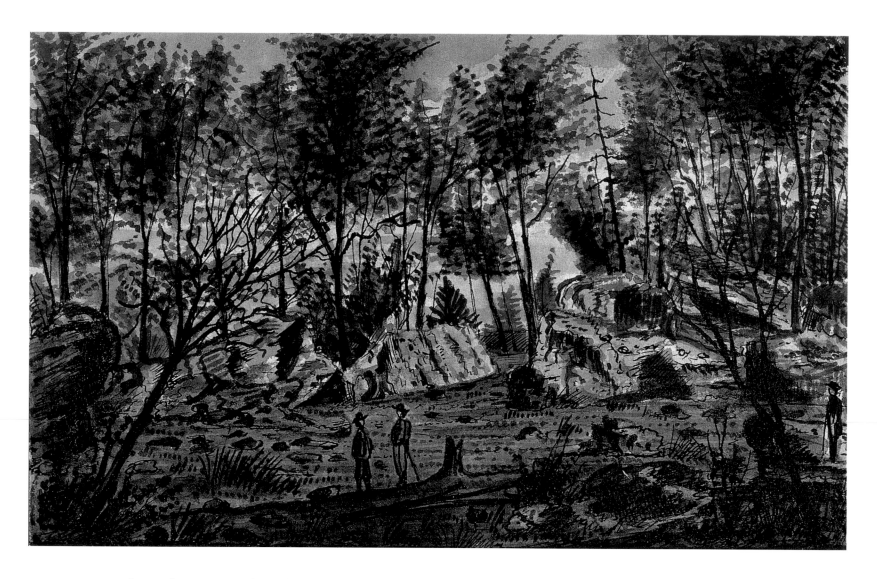

A *pivotal moment on July 2, 1863, was John Hood's overrunning the rock outcropping called Devil's Den. Union artillery, however, halted a breakthrough. There were many photo and print sources for Sneden to copy in producing this image.*

View in the "Devil's Den" facing Little Round Top, battlefield of Gettysburg, Pa.

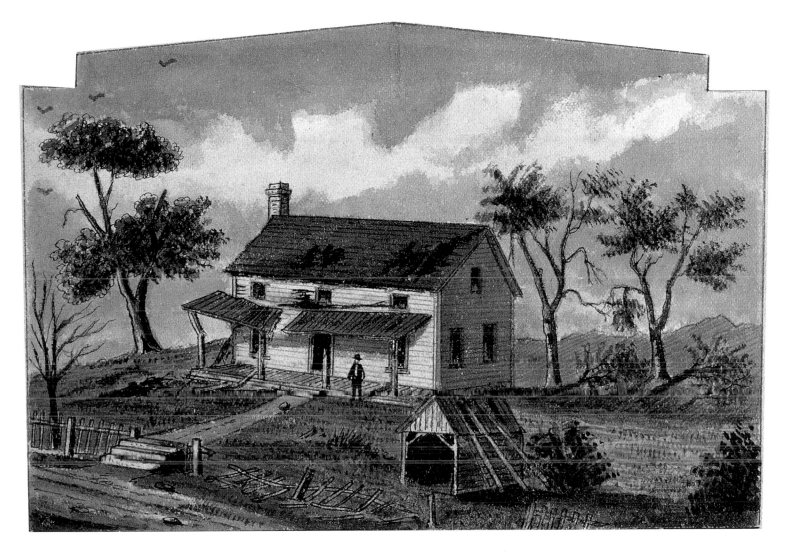

After Chancellorsville George Gordon Meade replaced Joseph Hooker as commander of the Army of the Potomac. Mrs. Leister's house on the eastern side of Cemetery Ridge was his head-quarters during the battle at Gettysburg.

July 9, 1863. "The battle of Gettysburg has been fought and a glorious victory gained for the Union. . . . The house was shelled by the enemy during the battle [so] that General Meade and staff were driven out of it and compelled to ride to Howard's position at Cemetery Hill under fire. Nearly all the staff officers' horses which were tied to the fence in front of the house were killed or mortally wounded. Seventeen in number."

Headquarters of General Meade, U.S.A., during the battle of Gettysburg, Pa. (Effects of Rebel shelling.) Mrs. Leister's house.

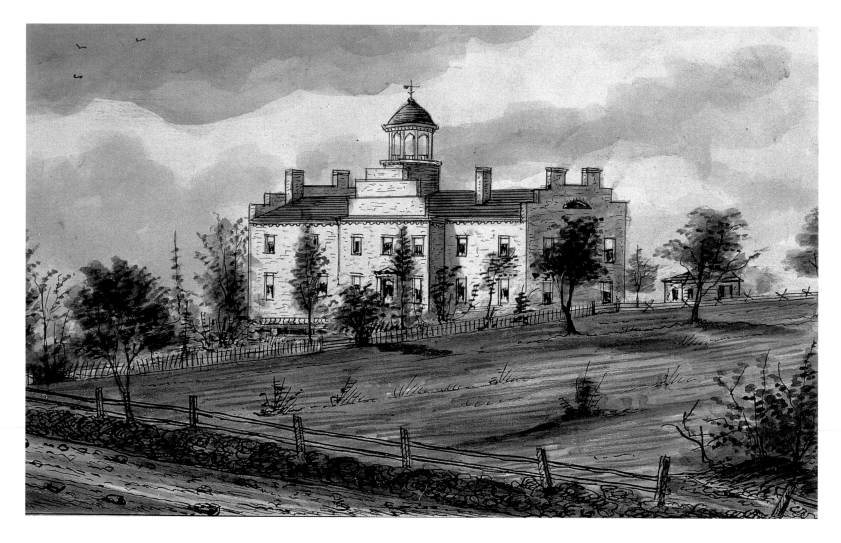

On July 9 Sneden wrote a brief account in his diary of how the battle of Gettysburg had tran-
spired. This is a drawing of the theological seminary on the outskirts of town that gave its name
to Seminary Ridge. Lee was headquartered at Mrs. Marshall's house quite near the seminary.
Pickett's Charge was launched from the foothills of Seminary Ridge. Sneden's date, "Sept.
1863," may be that of a photograph he copied. There are subtle differences between Sneden's
rendering of the seminary's cupola and an image published in Century magazine (November
1886: 113), which was "based on a war-time photograph."

The Lutheran Seminary, Gettys-
burg, Pa., September 1863.

PART FOUR

CAPTURED

IN OCTOBER 1863, THE ARMY PUT AN END TO Sneden's respite in Washington with orders sending the New York private back into the field as a general's mapmaker. Sneden wrote later that he was glad for the change, but those were words written in hindsight.

That autumn, in the rolling hills of the Virginia Piedmont, Robert E. Lee's Army of Northern Virginia and George G. Meade's Army of the Potomac maneuvered for position along the Rappahannock and Rapidan rivers. Assigned first to the headquarters of General David Birney and then to those of General William H. French, commander of Heintzelman's old III Corps, Sneden witnessed sharp fighting before the opposing forces settled into winter quarters. In his journal, he had recorded exploits of Confederate partisan rangers in that part of the state and would soon experience them firsthand when he was taken prisoner by John S. Mosby at the beginning of the Union army's abortive Mine Run Campaign.

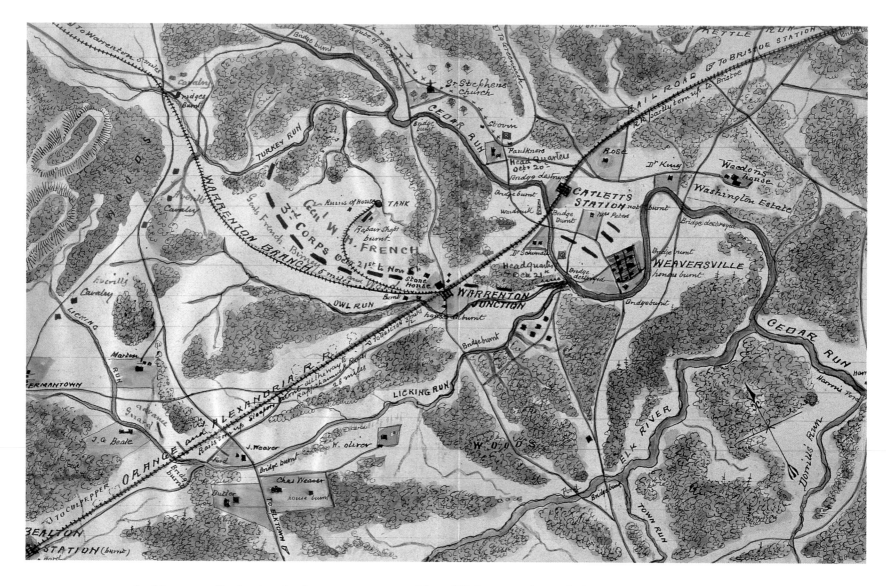

In this passage, Sneden describes his inauspicious arrival from Washington a few weeks before he sketched his map of the region around Warrenton Junction.

Map of Warrenton Junction, Va., Orange & Alexandria Railroad, showing destruction of railroad by Birney, October 1863.

October 8, 1863. "There were fourteen or sixteen platform cars, piled high with pressed bales of hay for the cavalry horses at the front. . . . At about 2 p.m. we all jumped on top of the hay and started. When nearing Warrenton Junction, the sparks from the engine set the hay on fire, which was not noticed by the engineer for some time. The smoke and flame came rushing past us, and all scrambled for the last car on the train. This almost stifled us, and getting from one car to the other was very dangerous as we were yet going very fast. . . . The engineer saw the trouble and stopped the train just in time."

Sneden was familiar with Centreville, Virginia, shown in this map, from the ill-starred second Manassas Campaign of 1862 and later when he returned to the field from Washington in autumn 1863. Then he was caught up in the Union army's retreat leading up to the battle of Bristoe Station.

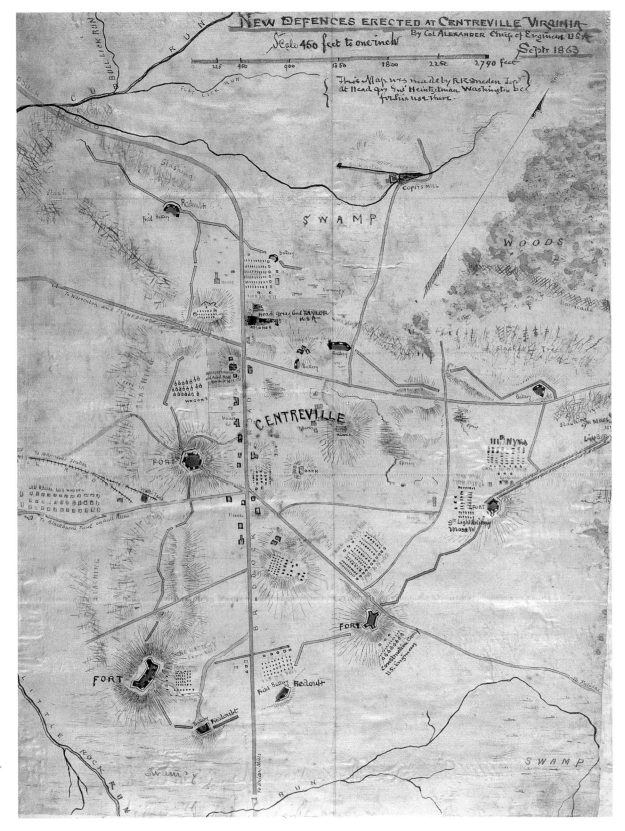

New defenses erected in Centreville, Va., September 1863.

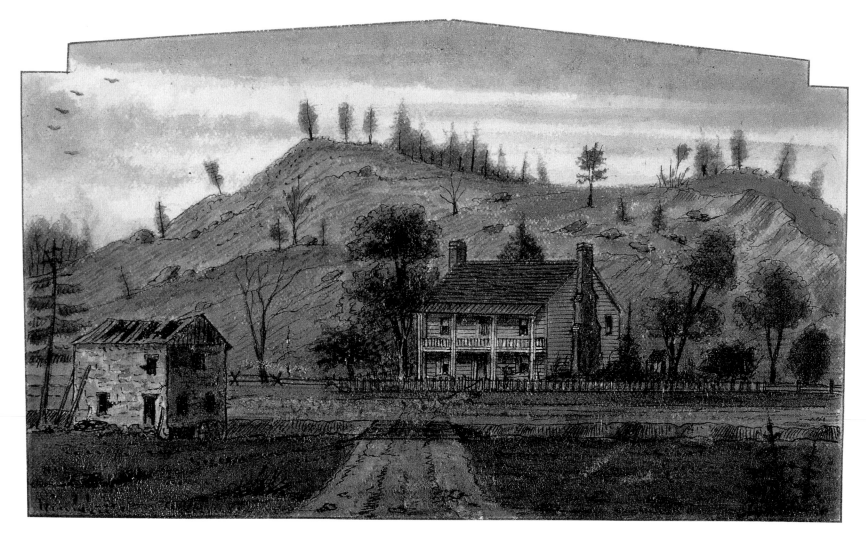

October 14, 1863. "At the turn of the road as the column approached the Rebel ambuscade was an old fashioned farm house, two story, with piazza to both stories and the chimneys built on the outside as usual in Virginia. It was occupied by McCormack, a very old man, and a white-haired Negro. . . . The position was well chosen by the enemy. . . . So we fell into a complete trap, which only the steadiness of the men in advance prevented from causing confusion in the ranks. The column was delayed an hour only when we resumed the forward march. I went all over the ground and made a sketch of McCormack's house before leaving."

McCormack's house and old mill, Auburn, Va. Scene of skirmish with the Rebels by III Army Corps, October 16, 1863.

October 14, 1863. "A section of our artillery had taken position on a round hill behind McCormack's and now opened a sharp fire on the enemy in the ravine below. I got upon the stone wall to see and grasped a pine tree for support, when a solid shot from the left across the open field struck the tree not six feet over my head! I jumped down in a hurry, and was covered by falling limbs and twigs."

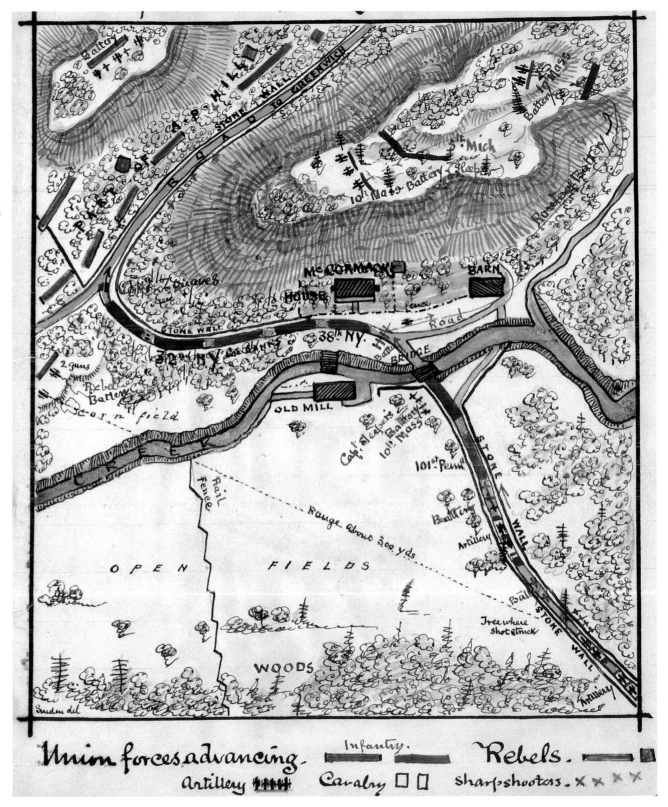

Skirmish at Auburn, Va., October 14, 1863.

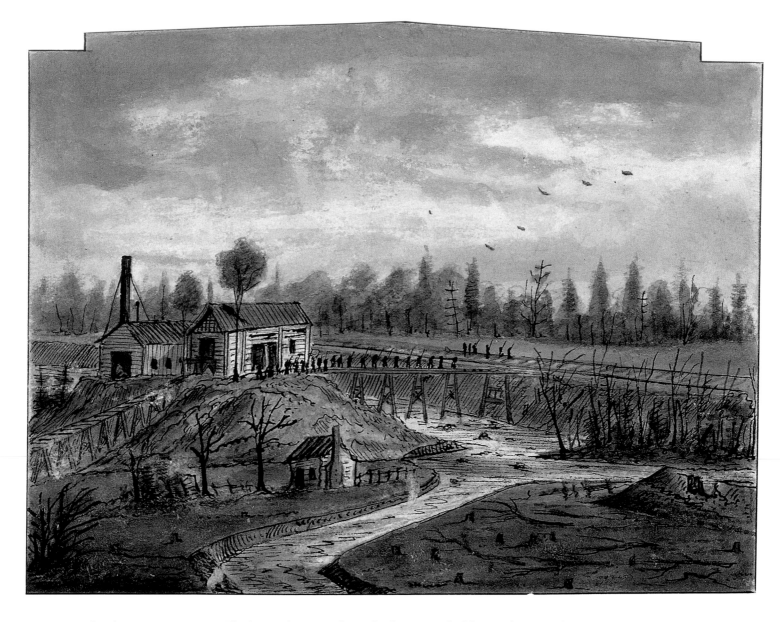

October 14 or 15, 1863. "The burnt chimneys showed where once had been a home, and the mud was deep and sticky and the roads ploughed by the passages of artillery and heavy wagons. We still went to the right and arrived at Union Mills at 6 p.m. These consist merely of two sawmills, long since silent. The rain had swollen Bull Run so as to make it a roaring torrent, and a section of the pontoon bridges thrown over here had to be taken up to prolong the other one before we could cross. While waiting for this operation, I made a sketch of Union Mills from below."

Union Mills on Bull Run, Va., October 15, 1863. Showing old Rebel fort of 1861.

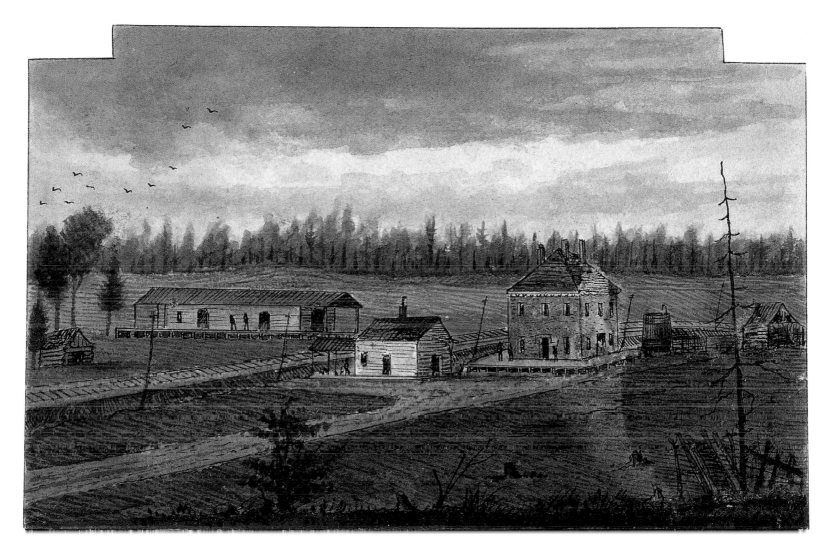

October 20, 1863. "Some of the fires had gone out, and the rails were not bent, but most of them were twisted all out of shape and could not be relaid. The branch road, which here goes off to Warrenton—five miles distant—was left intact, but the road running to Bealton and Rappahannock Station above Kelly's Ford was all thoroughly destroyed by fire. The stone houses at the junction were burnt out and gutted, while the whole country for miles in advance smoked like a furnace."

Bealton Station, Va., Orange & Alexandria Railroad, November 1863.

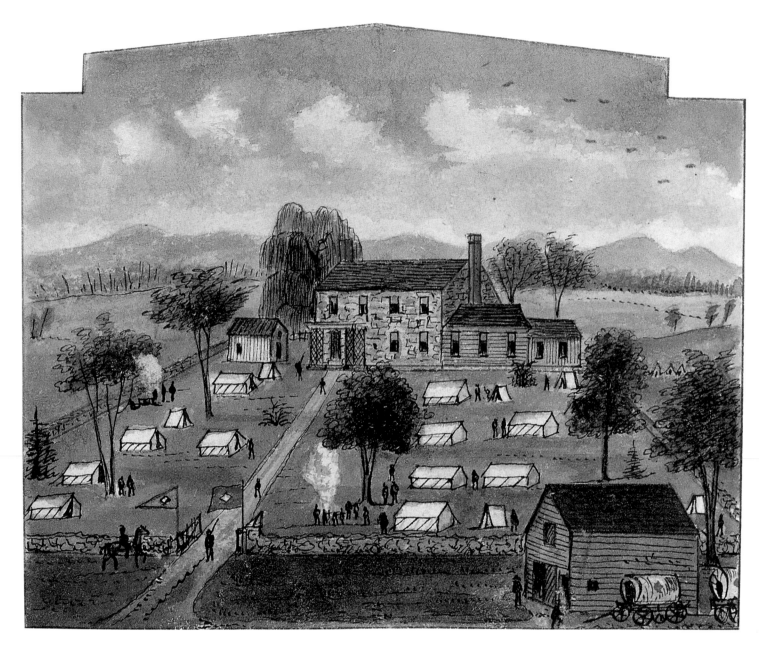

October 20, 1863. "All our tents were put up on the lawn which was enclosed by a stone wall. I had mine pitched near the entrance gates on which was put the red flag with white diamond in center denoting the resting place of the general of 1st Division of III Corps. . . . The Faulkner family consisted of a very old man, and two women with two Negro slaves or servants as they call them. They made much ado about our occupying the premises."

Faulkner's house, near Catlett's Station, Va. Headquarters of General D. B. Birney and J. H. Ward, III Corps, A.P., October 20, 1863.

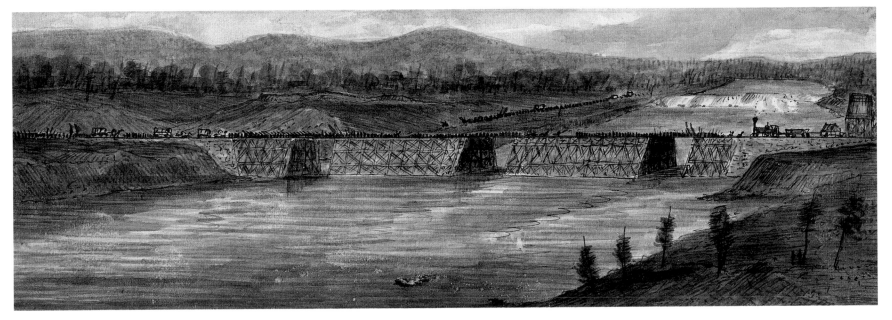

October 23, 1863. "[Confederate] troops occupy all along the other side of the Rappahannock River and are building redoubts and rifle pits at Rappahannock Station, and earthworks at Kelly's Ford to oppose our advance. The railroad bridge at the former place was destroyed by the enemy in their recent retreat, and the track and rails all destroyed from Warrenton Junction to the river."

The railroad bridge at Rappahannock Station, Rappahannock River, Va. Destroyed October 1863 by Union army.

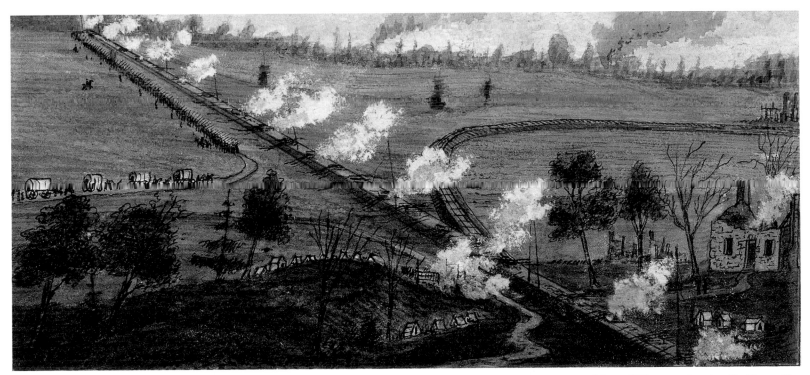

View of Warrenton Junction, Va. Orange & Alexandria Railroad. Showing destruction by the Rebels. October 20 and 21, 1863. Arrival of Birney's Division, III Corps.

November 6, 1863. "The fog settled down again at night, and the wagons coming up from the bridge rumbled through the single street of Kellysville. Orderlies were coming and going, rations and ammunition being issued until after dark, when all was again quiet. The water dashed over the undershot wheel of the mill, [and] soon lulled me to sleep, as I had made a soft bed on a pile of meal bags. I made [a] sketch of Kelly's Mill during the day . . . and slept until daylight."

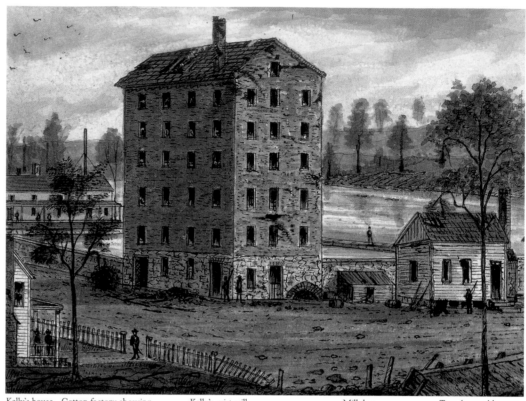

Kelly's Mill. Kelly's Ford, Rappahannock River, Va.

Kelly's house Cotton factory showing Kelly's grist mill Mill dam Two deserted houses
 shot through chimney showing effect of artillery Rappahannock River Earthworks

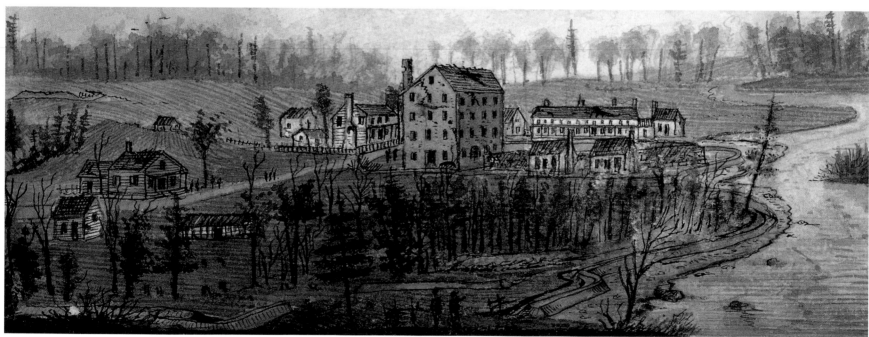

Rebel battery Store Kelly's house and grist mill Factory Rebel rifle pits River and island

Kelly's Ford and Mill, Rappahannock River, Va, captured by III Corps, November 7, 1863. Sketched November 19, 1863.

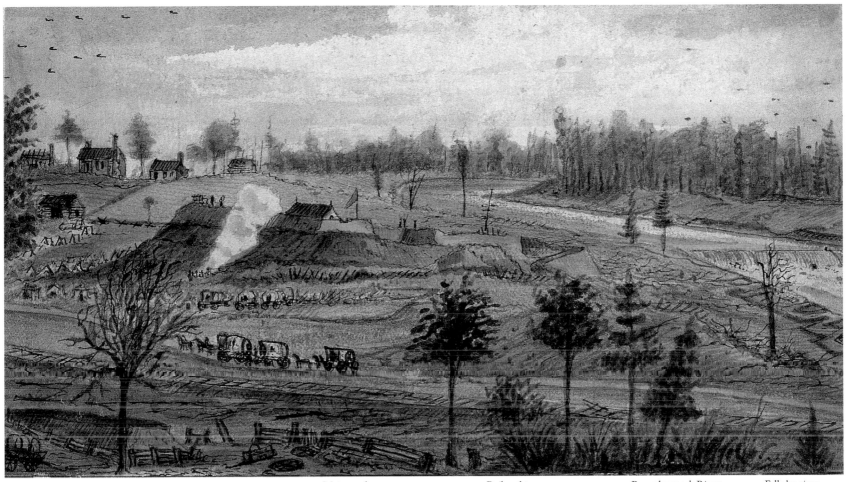

| Main works | Railroad torn up | Rappahannock River | Falls by river |

November 7, 1863. "A strong fort, two redoubts, and a series of intricate rifle pits were constructed by the Rebels on the north side of the river, and numerous rifle pits and entrenchments on the opposite side at the station and railroad which confronted our advance. A pontoon bridge connected the forces on either side which was thrown across just below the dam which here crosses the Rappahannock."

On the day of Sneden's diary entry, General Meade and the Army of the Potomac bestirred themselves and crossed the Rappahannock River both at Rappahannock Station and Kelly's Ford, with major fighting at both places. Several weeks of maneuvering ensued, but by December 1 Meade gave up his attempt to outflank Lee, recrossed the river, and settled into winter quarters. The next Union offensive would be in the hands of Ulysses S. Grant.

Rebel redoubt and rifle trenches at Rappahannock Station, Va. Captured by the VI Corps, November 7, 1863.

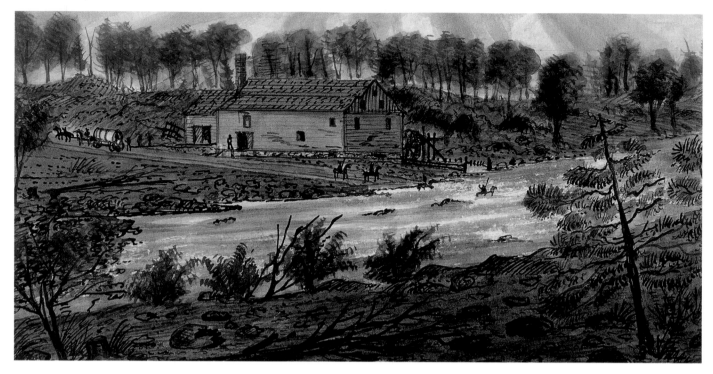

In autumn 1863, Sneden was based near Brandy Station, Virginia, first with General David Birney and then with General William French. Although he visited numerous sites along the Rappahannock and Rapidan rivers, in his memoir he never mentioned Jericho Mills, sketched here.

Jerico Mills and Ford on the Rapidan River, Va.

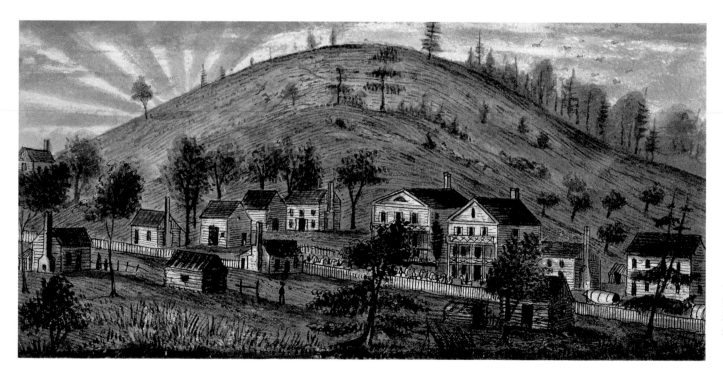

View of Aldie Gap in the Blue Ridge Mountains, Va. Headquarters of Mosby's guerrillas.

While assigned as a mapmaker near Brandy Station, in Culpeper County, Sneden heard more about the exploits of Confederate ranger John S. Mosby, whose guerrilla tactics plagued the Union army behind the lines in that part of northern Virginia. His successes in the area—including Aldie, in Loudoun County, shown in this sketch—led to its being called "Mosby's Confederacy."

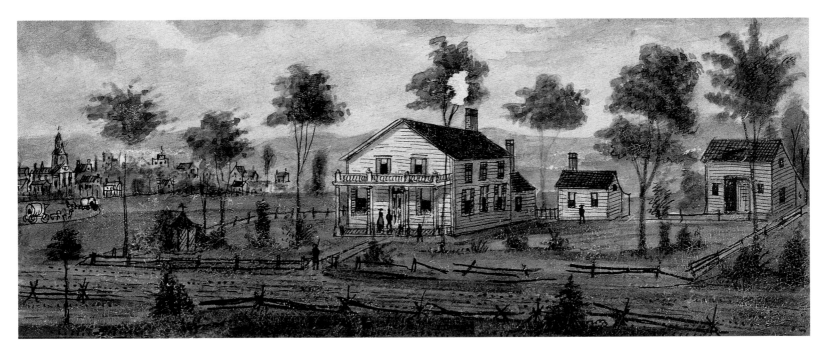

Earlier in the war, former United States Congressman John Minor Botts had been jailed in Richmond for his Unionist opinions. When Sneden sketched Botts's house in Culpeper County in 1863, the politician had been released and was sitting out the war on his farm.

Auburn. Residence of John Minor Botts, near Culpeper Court House, Va., October 10, 1863.

November 18, 1863. "John Minor Botts's house was in the plain below. Our troops were now encamped around it, and his garden was all torn up by horses' hoofs, and ruined of course."

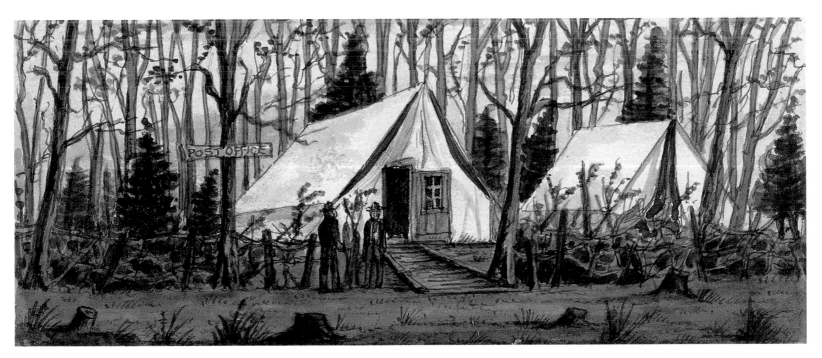

When Sneden sketched this post office for soldiers near Brandy Station, he had begun work as a mapmaker at the headquarters of General French.

The general post office, Brandy Station, Va., November 1863.

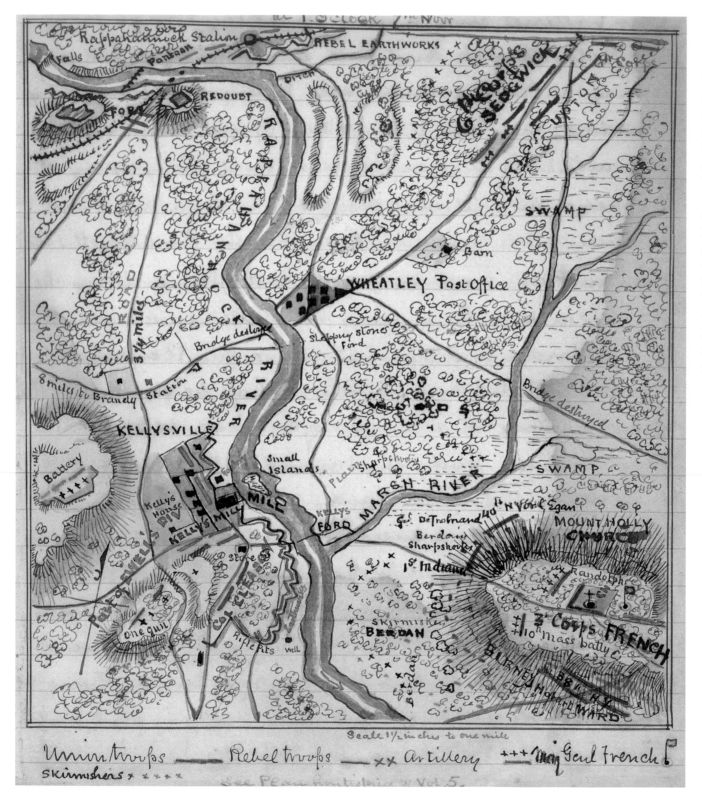

Battle of Kelly's Ford, Va.
Plan of position of Union and Rebel forces at 1 o'clock, November 7, 1863.

November 18, 1863. "General Birney ordered me today to ride over to Kelly's Ford and make a survey and plan of the late battlefield there, to accompany his report of it to Washington. I started about 10 a.m., went over to headquarters of Major General French commanding III Corps and got Sergeant Alexander there to accompany me, as he had a theodolite and chain. We took one cavalryman with us, then rode to Rappahannock Station first where I made a sketch of the Rebel redoubt and pits."

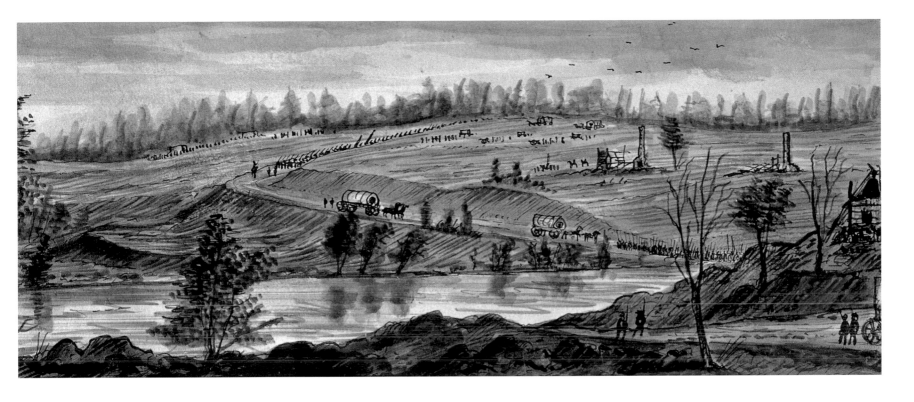

November 19 and 20, 1863. "A strong cavalry reconnaissance was made yesterday towards the fords of the Rapidan as ordered by General Meade which returned this afternoon after some heavy skirmishing with the enemy. They report that Lee is now entrenching strongly along Mine Run, which is an effluent of the Rapidan River. Between Jacob's Mill Ford and Germanna Ford, it runs south, through a valley bordered on both sides by gradual slopes, with here and there a farm house.

Germanna Ford, Rapidan River, Va., 1863.

"The enemy were seen felling trees along the front of the ridge on the farther side of the run. The main force of the enemy under General Lee were at Orange Court House with their pickets thrown forward to near Stevensburg and Richardsville, confronting our cavalry pickets there. The turnpike which ran out from Orange Court House was fortified by rails and low stone walls. The position at Mine Run was well chosen for defense. Its natural strength is of a formidable character, being a succession of ridges overlooking the northern bank by which an enemy must approach. These ridges are from thirty to one hundred feet above the level of the water. In front the ground is quite level, with but little woods affording cover, presenting every disadvantage for strategic movements. The enemy have transferred their line from the south side of the Rappahannock to the south side of the Rapidan, and blocks the Orange Turnpike and [the] plank road leading to Ely's Ford.

"A council of war will be held at General Meade's headquarters today ([the] 20th) to determine further operations. I went over to General French's headquarters today, saw Adjutant General O. H. Hart there and delivered my map, returning at 11 p.m. The band played at General French's and Meade's quarters from 9 to 10:30 p.m."

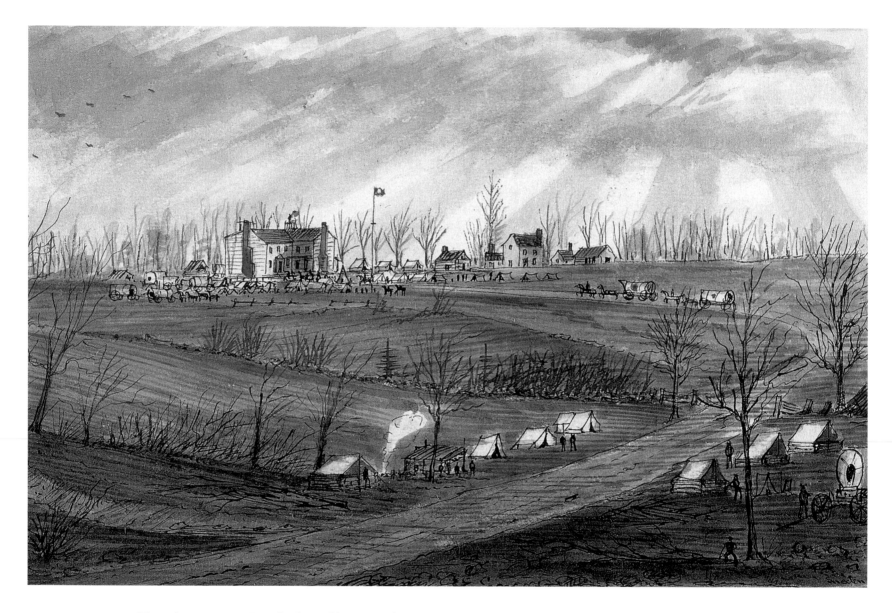

November 25, 1863. "Fine day but cold. A general inspection of the whole army under General Meade was had this forenoon on the wide plateau in front of the range of hills where headquarters were located. The troops were in fine condition and looked fine, arms and bright uniforms glistened in the sun, bands playing while the whole marched past in review."

Headquarters of General G. Meade, U.S.A., near Brandy Station, Va., November 1863.

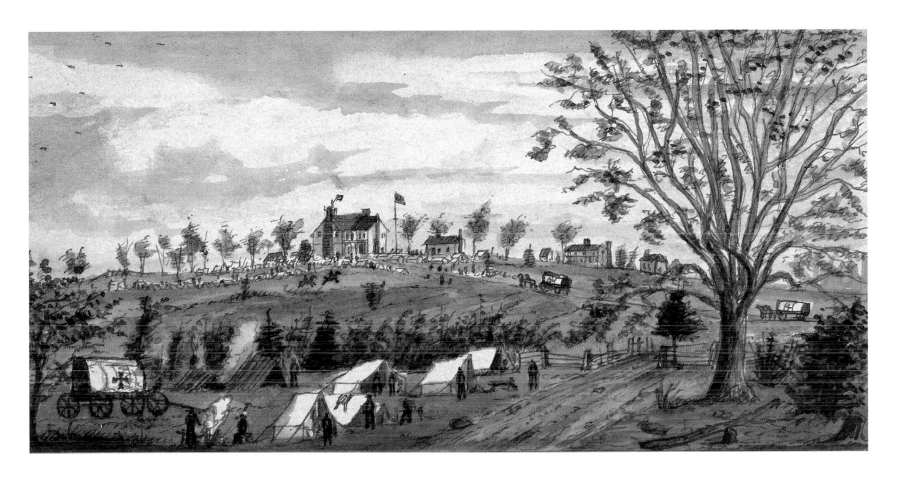

"Several British officers [who] were here to see [the general inspection] pronounced the whole army in fine condition. They were entertained by the officers of different headquarters, with great conviviality until a late hour, while the band played several English army tunes in the evening at headquarters of Generals Meade and French, where they were staying."

Headquarters of General G. Meade, U.S.A. [another view].

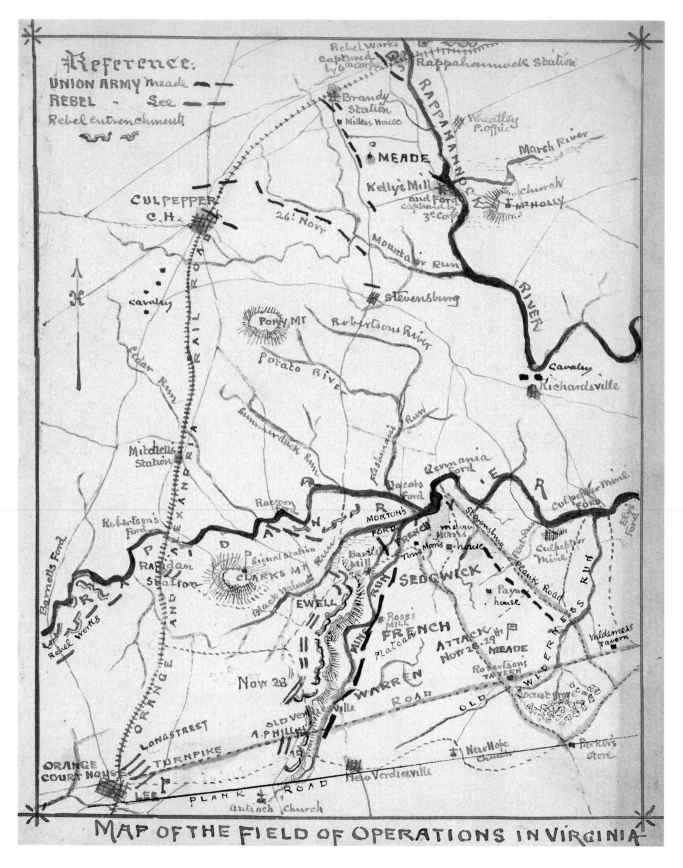

Map of the field of operations in Virginia and the battle of Mine Run during November 1863.

Before the Union army went into winter quarters to wait out the bad weather until resuming campaigning in the spring, General George G. Meade planned one more offensive action for the Army of the Potomac. This was the abortive Mine Run Campaign of November and December 1863, shown here in Sneden's map drawn after the war. Miller's house, where he was captured, is near Brandy Station at the top center of the map.

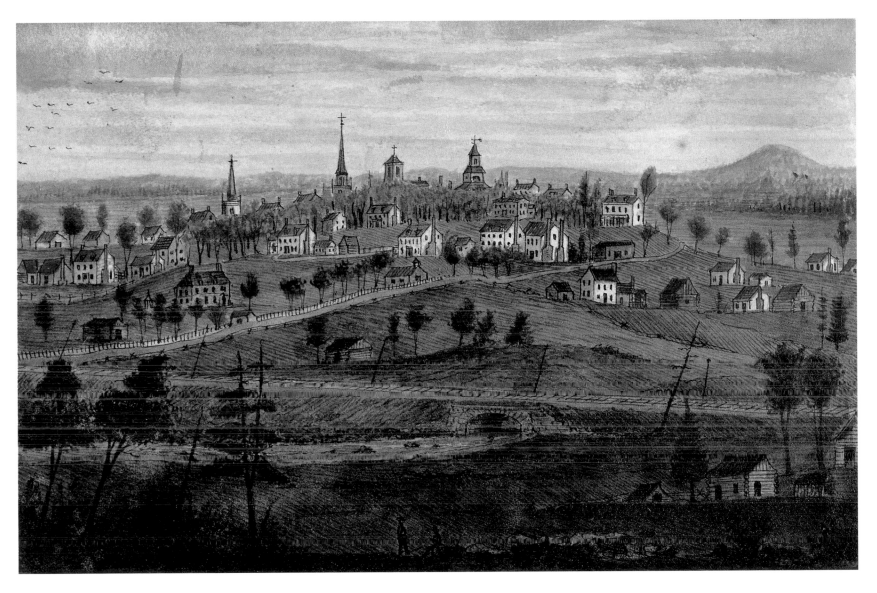

November 25, 1863. "I went with a friend to Culpeper Court House, about three miles up the railroad, it being the next station to Brandy Station. I made a good sketch of the town from the plain outside of the place first. . . . Few inhabitants were on the streets. It was a nice place, and had not suffered from the ravages of war thus far. I made a sketch of the quaint and ancient court house, which then was being used for a hospital for our troops."

View of Culpeper Court House, Va., November 1863. Cedar Mountain in distance.

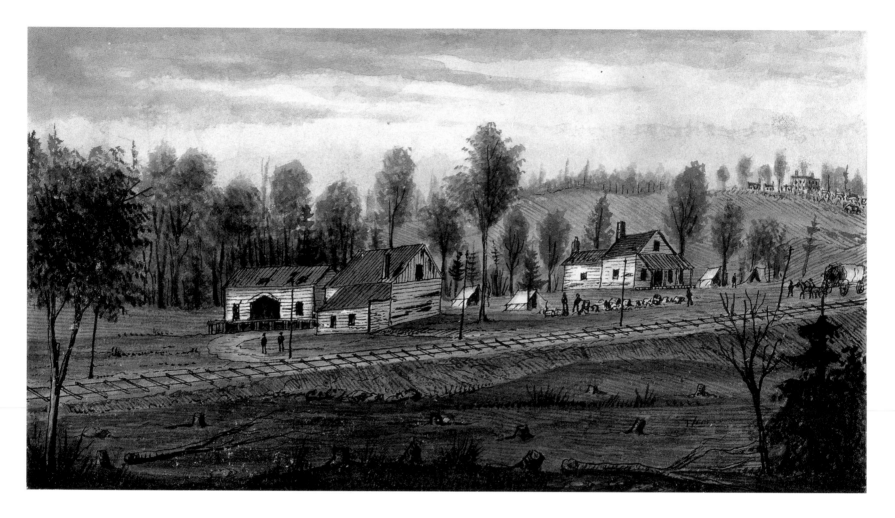

November 25, 1863. "After going over the place [Culpeper Court House] we rode back to Brandy Station where I made another sketch. Also one of John Minor Botts's house, and got to headquarters at 6:30 p.m. and worked on maps with the help of four candles until 11:30 p.m."

Brandy Station, Va., Orange & Alexandria Railroad. November 1863.

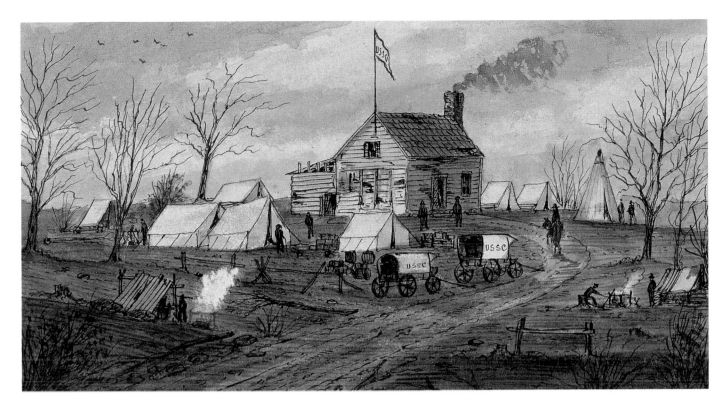

November 26, 1863. "I finished up some loose sketches which I had made of General Meade's headquarters, the telegraph operator's camp, and the Sanitary Commission camp at a half demolished house known as 'The Shebang.'"

"The Shebang," quarters of the U.S. Sanitary Commission, Brandy Station, Va., November 1863.

Camp of the Military Telegraph Corps, Brandy Station, Va., November 1863. Captain Thomas Eckert, Superintendent.

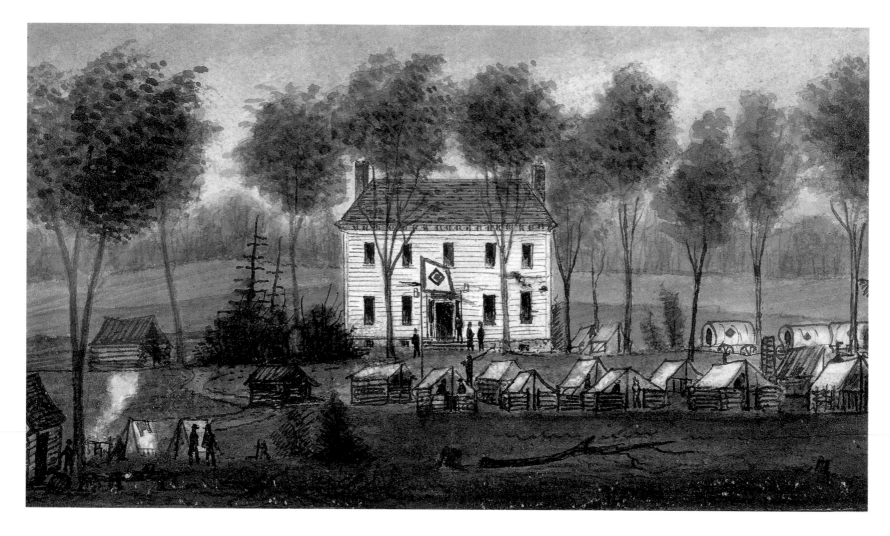

When Sneden agreed to make maps for General French, he moved to the general's headquarters at Miller's house, near Brandy Station, which commanded the view from a hill near the Orange & Alexandria Railroad about two and a half miles from Culpeper.

Miller's house, Brandy Station, Va. Headquarters of Major General W. H. French, commanding III Corps, November 26, 1863.

November 26, 1863. "Several log houses were in close proximity to Miller's house, which had been slave quarters. The staff of General W. H. French occupied the whole front ground of the rising knoll. A few trees were around the house whose sides showed bullet marks, and the front porch had been carried away by shells. It was painted white, and could be seen for miles over the plain below. . . . After a good dinner of roast beef, etc., I cleaned my Remington pistol, got my things together and going to the upper floor of [Miller's] house made a good bed on the floor and slept until near sundown."

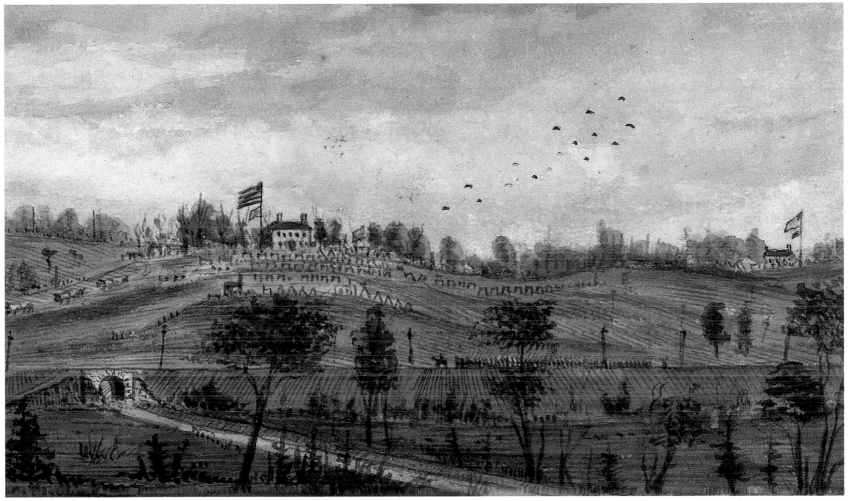

Orange & Alexandria Railroad and culvert

Headquarters of General Meade

It was here, just before dawn on November 27, after most of French's staff had left for the Mine Run Campaign, that Mosby captured Sneden along with the handful of other Union soldiers who remained. The Confederates forced their prisoners to ride bareback on captured mules around the Union army and into captivity. At Gordonsville, Mosby's men turned over their prisoners to be shipped by train to Richmond.

Headquarters of General French, III Corps A.P., at Miller's house, Brandy Station, Va., November 26, 1863.

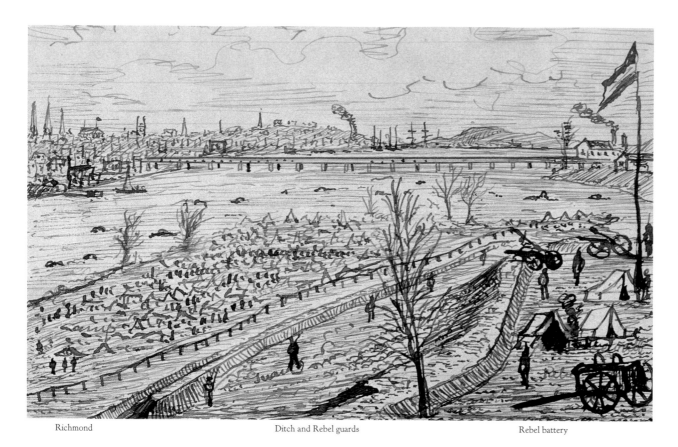

While he was incarcerated in Rich-
mond, Sneden never saw the city from
the perspective shown in this drawing
of Belle Island, a small island in the
James River where other Union enlist-
ed men were kept. He did know about
the island camp, because from time to
time the Confederates moved inmates
to his prison warehouse from Belle
Island.

Prison on Belle Island. Belle Island, about
six acres. Earthworks were three feet
high. Rebel jailors: Sergeant Hyatt, C.S.A.
and Sergeant Barrett, C.S.A.

Richmond Ditch and Rebel guards Rebel battery

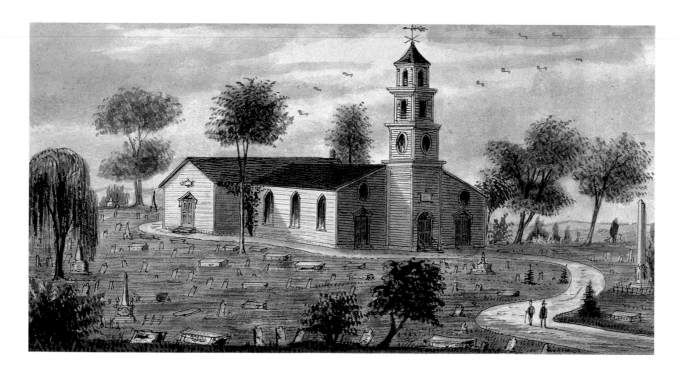

December 20, 1863. "I got up in
the attic [of Pemberton Prison] on
top floor for a few minutes and
from the windows up there got a
good view of the city: Capitol Hill
and Church Hill with old St.
John's Church on its summit."

Old St. John's Church, Church Hill.
Building erected A.D. 1701, Richmond,
Va. Sketched 1865. This church could
be seen from the windows of the
Crew and Pemberton Prison.

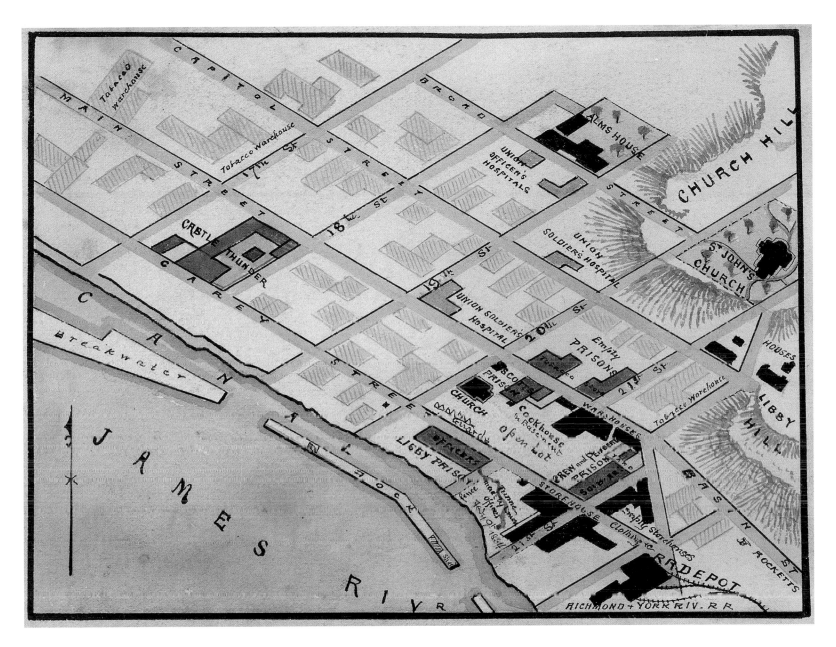

Though Sneden's plans of Richmond were probably drawn after the war when he had access to printed maps, while he was incarcerated in the Confederate capital, he made frequent observations and pencil sketches from the windows of Pemberton Prison.

Plan of part of Richmond, Va., showing locations of Rebel prisons, winter of 1863.

December 21, 1863. "By the small windows [of Pemberton Prison] we could see into the rear yard, and had a good view of the city towards Capitol Hill and 'the Rocketts' which were quite near. The roof of the Capitol was plainly in sight with a rebel flag flying at each end. Church steeples, and large hotels showed above groves of trees. Fine residences were numerous, relieved by the dark brick factories and warehouses in the lower ground."

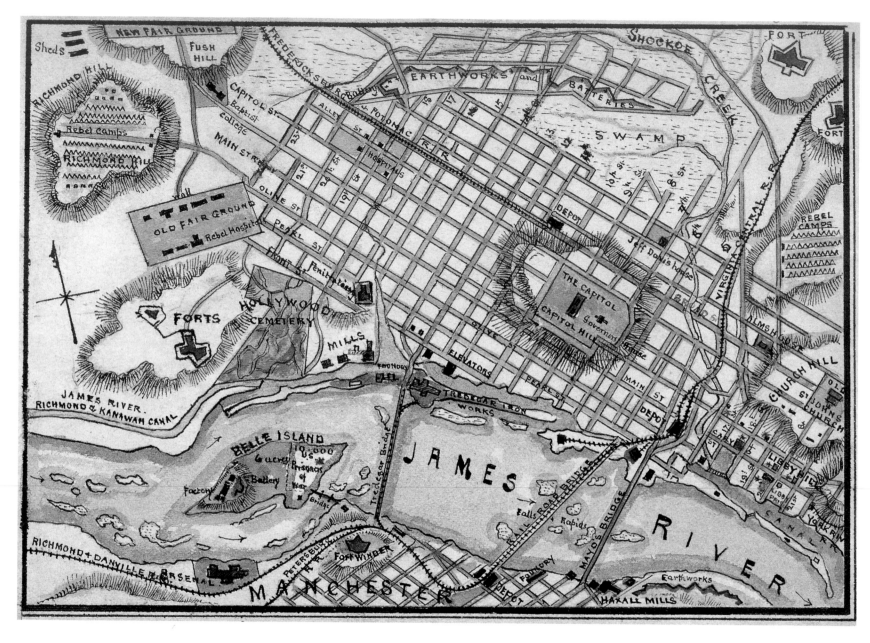

December 21 to 24, 1863. "The sailors returned about 5 p.m. bringing us good news which cheered up many of us. They have unloaded or helped unload two barges which had come up from Aitken's Landing on the James about fifteen miles down river with clothing which was sent to us prisoners by flag of truce from our government and the Sanitary Commission. They recounted how hundreds of boxes and bales had been landed and most of them carted by mule teams to Scott's building on Main Street, which can be seen from any of the windows here facing north. Lots of provisions were landed also, hams, canned vegetables, boxes of all kinds and sizes. The sailors managed to break the ends of some of these boxes while unloading and "sequestered" several packages of real coffee, sugar and canned milk. So the sailors' mess lived sumptuously while this lasted. The smell of the coffee alone set the rest of us nearly crazy."

Map of Richmond, Va., 1863. Rebel prisons.

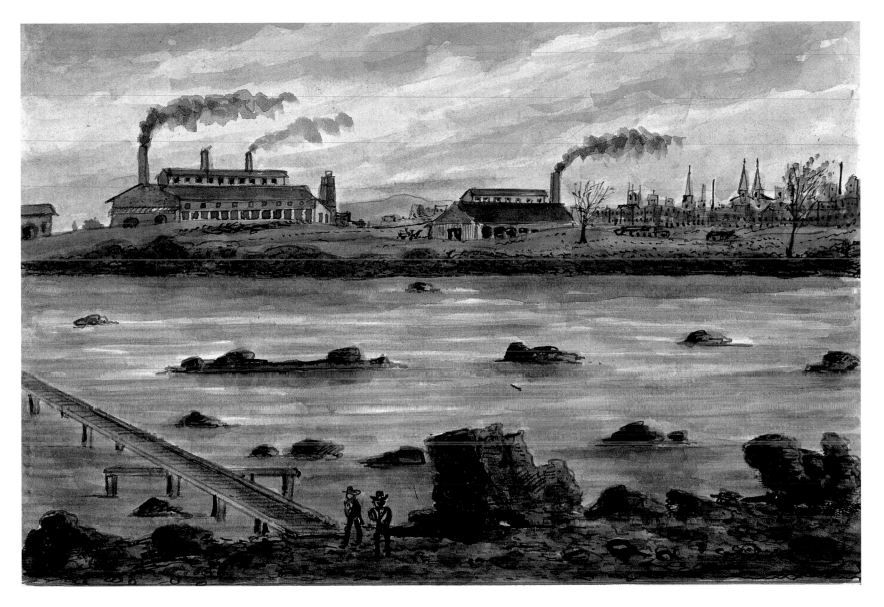

December 21, 1863. "The smoke from the Tredegar Works near here, showed that the Rebels were busy forging cannon to be used against our army yet in the field."

The lower end of Belle Island, James River. Showing footbridge to Tredegar Iron Works, 1863. From a photograph.

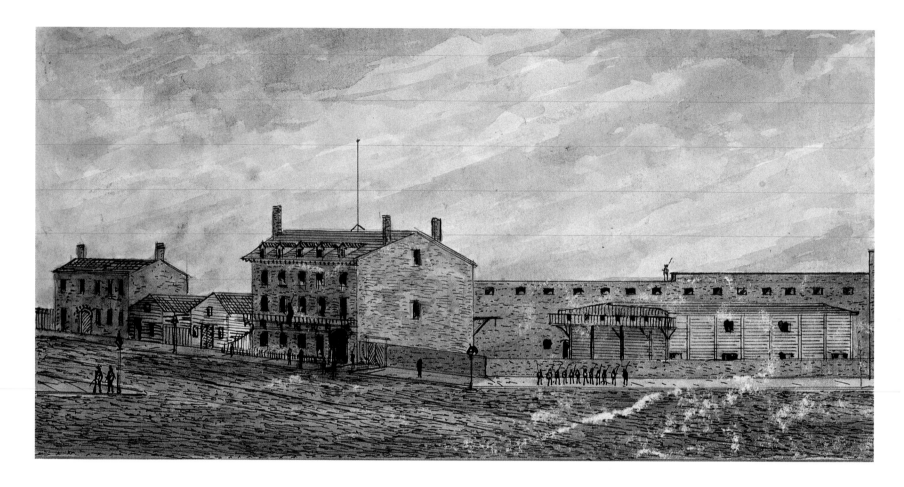

December 2, 1863. "From the front windows I got a fine view of the Libby Prison, the bridges across the James River, Manchester, with its tall cotton factories, and could see away down the river several miles towards Fort Darling. I made a long and careful sketch . . . and another of Castle Thunder, from my rough lines I had taken when we halted in front of it on Sunday last. . . .

"The gallows is seen projecting from the building in prison yard. Scores of spies and deserters from the Rebel army recaptured were here hung in February 1864. All the guard and Rebel officers escaped capture by running off at the evacuation of Richmond."

Castle Thunder, 19th and Cary Streets, Richmond, Va. Captain Alexander, C.S.A., jailor, 1863.

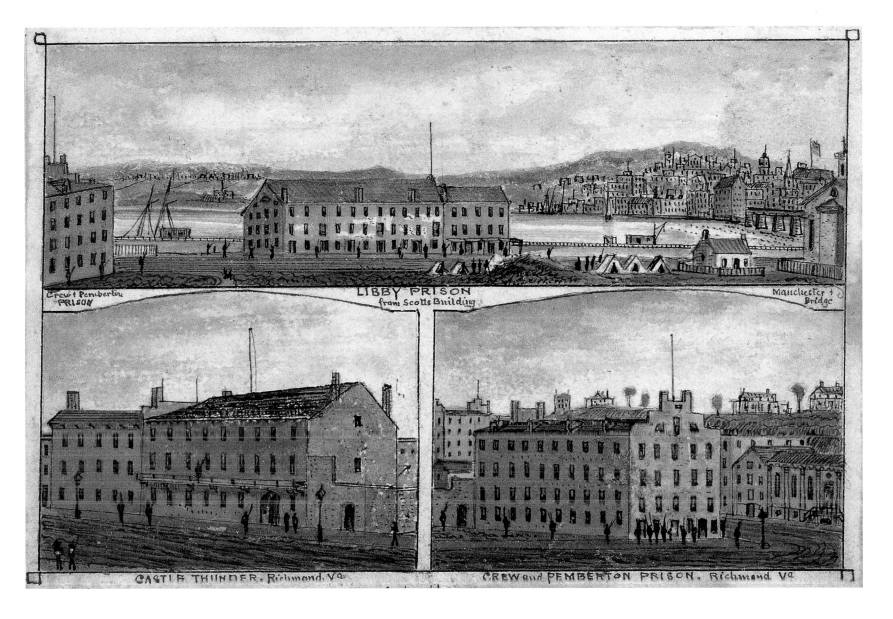

Top: Libby Prison from Scott's building, with Crew and Pemberton Prison (left) and Manchester and bridge. Bottom: Castle Thunder (left), Richmond, Va. and Crew and Pemberton Prison, Richmond, Va.

November 30, 1863. "We were hustled out of the cars, and put under a detachment of the home reserve guard, who were dressed in homespun clothes, dirty slouching looking young men and old men mixed together. They were forty in number under an officer of some kind for he wore nothing to denote his rank. We were surrounded by a mixed crowd of citizens and Negroes. The guard soon marched us off in single file to Libby Prison. We halted in front of another prison known as Castle Thunder on Cary Street and 18th Street which was a gloomy dirty looking brick building with a high wall on one side and a large arched entrance, where stood held by a chain an immense fierce looking dog, a species of Russian bloodhound."

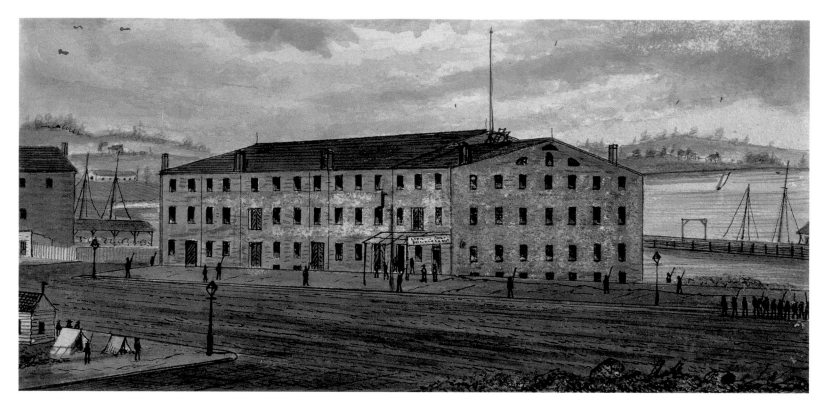

December 25, 1863. "Our officers seemed to be having a good time over in Libby tonight. (There are about 1,100 of them prisoners of war.) We could hear them shouting and singing for hours. 'Red, White, and Blue,' 'Star Spangled Banner,' and many others. We had some good singing on our floor too until it was broken up by a fight among several drunken sailors and marines about 1 o'clock. Sailors and marines will fight whether ashore or afloat."

Libby Prison, Cary Street, Richmond, Va. 1,100 to 1,500 Union officers confined, February 1863. Total number of deaths during its occupancy: 6,540. Sketched from Scott's Prison.

Sneden was never a prisoner at Castle Thunder, where the Confederates jailed disloyal Southerners. Although he may have heard accounts of a vicious guard dog there while he was imprisoned in Richmond, it is likely his details came from reading postwar prisoner-of-war stories. His figures for executions and the mortality figures for prisoners are inflated.

December 28, 1863. "A strongly barred gate in the archway on Cary Street is guarded by an immense Siberian bloodhound called 'Hero' . . . who would tear anyone to pieces when ordered."

The Russian bloodhound "Hero" kept at "Castle Thunder" (Rebel prison), Richmond, Va.

The chance to conduct an inventory gave Sneden and eight lucky sergeants an opportunity to feast on donated food. After this fortunate interlude, lasting about two weeks, Sneden and hundreds of other Union enlisted men would be shipped south by train to a new Confederate prison at a place in rural southwest Georgia called Andersonville.

January 2, 1864. "About noon Colonel [James M.] Sanderson and Captain Chamberlain, both of the 123rd Ohio U.S. Volunteers, came in here from Libby under guard of ten Rebel soldiers and went among us looking for intelligent men to act as clerks to open the boxes of clothing [sent by the U.S. Sanitary Commission] stored in Scott's Building on Main Street which would now be delivered to us prisoners. . . . Eight sergeants were called for to go out and do the work. These were selected in about half an hour, while I volunteered to go out with them to act as invoice and entry clerk."

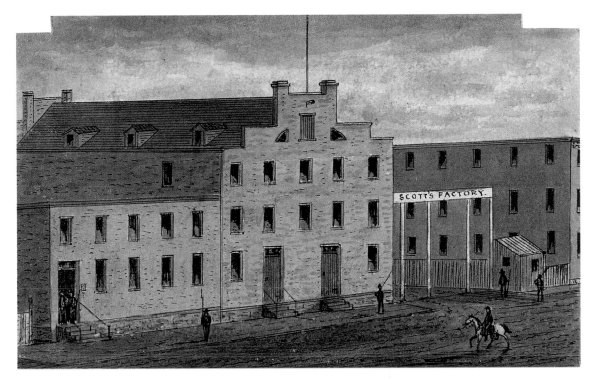

View of Scott's Prison, Main Street, Richmond, Va. Occupied by prisoners from Belle Island. Captain Munroe, C.S.A., jailor, December 1863.

When Sneden left Richmond by prison train, he crossed this rail bridge and had time while the engine waited on the south end of the trestle to make pencil drawings.

February 23, 1864. "I made a sketch showing the railroad bridge . . . a thin skim of ice was along the shores of the river, and the Tredegar Works were in full blast. Richmond, with the capitol and church steeples, was in full view. Hotels, factories, and huge flouring mills were all along the river."

View of Richmond & Petersburg Railroad Bridge crossing the James River, and the Tredegar Iron Works, Richmond, Va. February 1864. Prisoners crossed here to go to Belle Island.

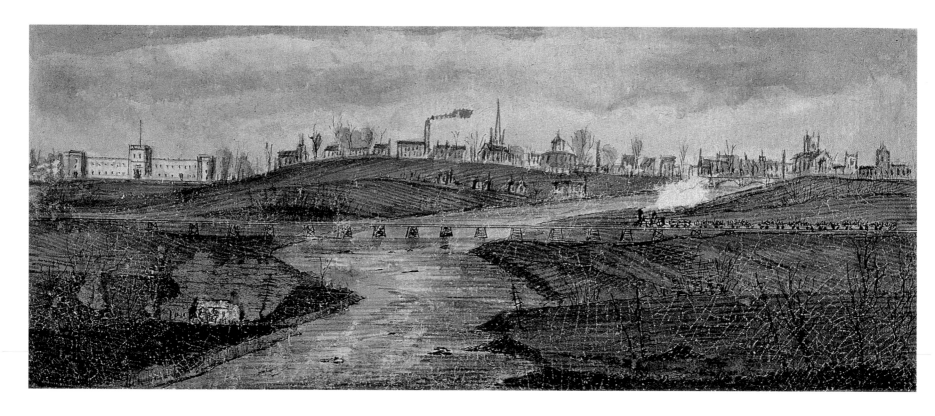

Sneden's account of his prison train as it clattered south from Richmond gives details of the run-down state of Confederate railroads. At Lawrenceville, the train crossed the Meherrin River, which Sneden mislabeled "Molveria" on this watercolor.

February 23, 1864. "The guards were on the roof, and on the ground twenty feet or so from the cars, with their muskets at a 'ready' to shoot any one of us who would try to escape. . . . The tender of the engine leaked badly, and the rickety old engine puffed and wheezed all the while. So we had to make many stops to take wood and water. No coal was burnt by the engines on the southern railroads. Long piles of cordwood were met with at every station, and along the tracks."

Union prisoners of war crossing the Molveria River at Lawrenceville, Va., on platform cars, February 23, 1864. Sketched while en route.

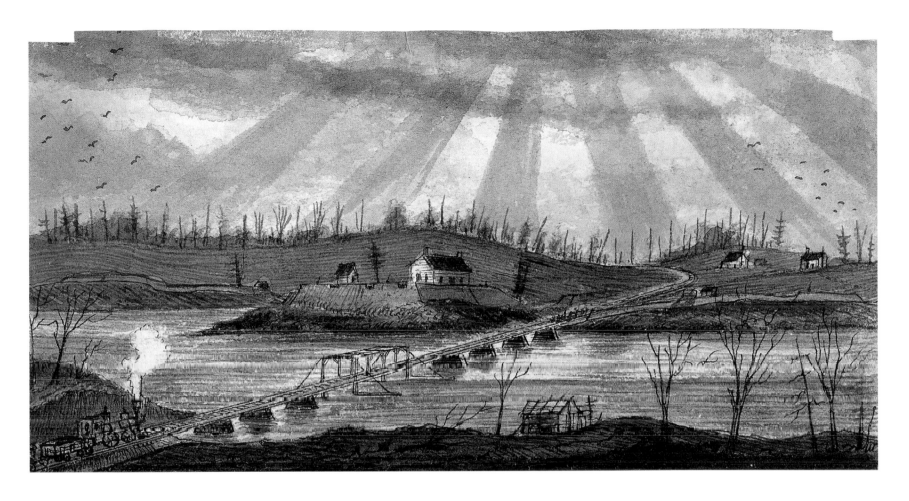

February 23, 1864. "Then we crossed the Roanoke River over a long trestle bridge at Gaston. The opposite side was fortified by a redoubt and a series of rifle trenches extending along shore. The hills were low and scrub oak was plentiful. We had sixteen cars in our train, and before we crossed over the engineer must have thought that we would break through the bridge, as he and two others walked down to see the timbers before risking going over."

Union prisoners of war crossing the Roanoke River near Gaston, N.C., on fortified railroad bridge, February 23, 1864.

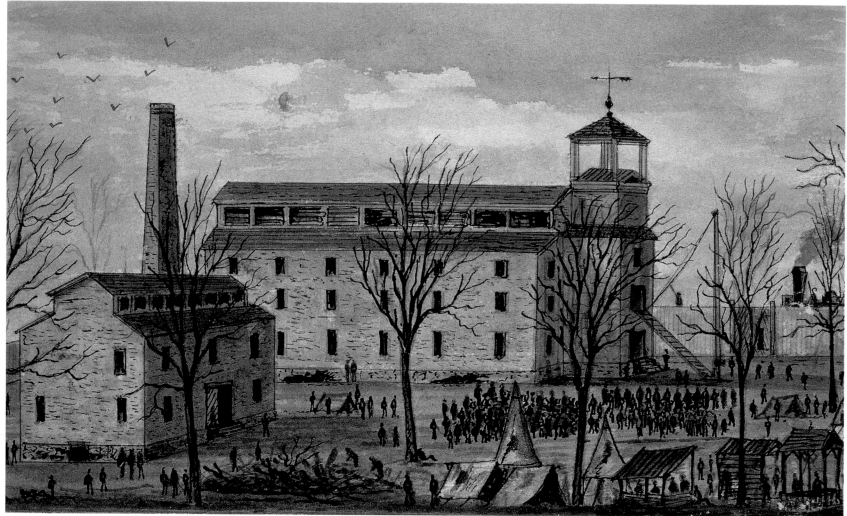

Cookhouse and yard for prisoners, five acres of ground Cotton factory prison, about 1,350 men Hoisting steps to second story Gate Well

February 24, 1864. "We were marched into the [Salisbury, N.C.] prison yard for the night, there were about eighty of us. Here we met several hundred of our fellow prisoners who were dirt begrimed, ragged and in a deplorable state, covered with mud from the yard which looked and smelt like a hog pen. They shouted 'Fresh fish, where did you come from? What army do you belong to? Where is Meade?' and a hundred other questions all at once. There were five or six ragged sibley tents in the yard with the mud a foot thick all around them and dozens of skeleton looking prisoners crowded around us."

Rebel prison at Salisbury, N.C.

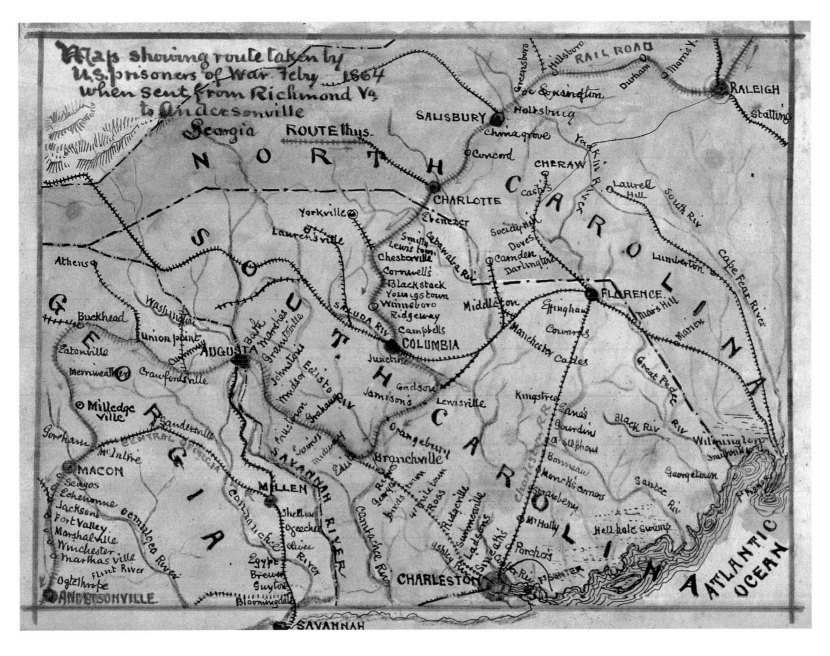

Map showing route taken by U.S. prisoners of war February 1864 when sent from Richmond, Va., to Andersonville, Ga.

February 24, 1864. "We were all taken out of the box and cattle cars at 5 a.m. and marched towards Raleigh, where at the depot we were all put upon platform cars, three or four of us had escaped during the night, but were caught and brought back covered from head to foot with red mud. We had eight Rebel guard on each car with us. We got three crackers apiece of the same kind as last night. Another old battered engine took us in tow, and we pulled out of the station about 7 a.m."

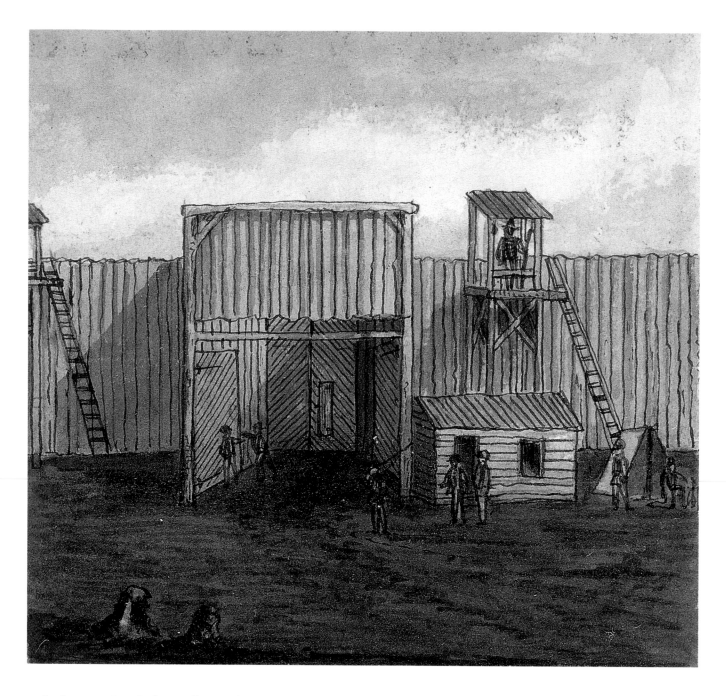

Sneden arrived at Andersonville at night and recalled seeing the changing of the guard for the first time the following morning.

South gate, Andersonville Prison, Ga. View from the outside.

March 1, 1864. "We heard a Rebel drum beating on the hill about 7 a.m., which was for the guard to be relieved, and soon a long file of Rebel soldiers were seen coming down towards the south gate."

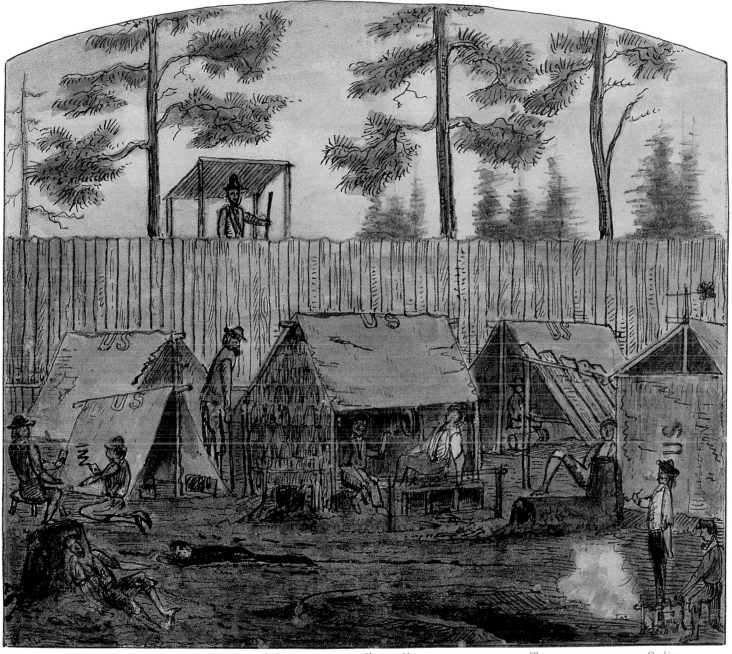

Playing cards Dying alone Rebel guard on stockade Shanty and burrow Clay oven Cooking

View of R. K. Sneden's shanty at
Andersonville Prison, Ga., July 1864.

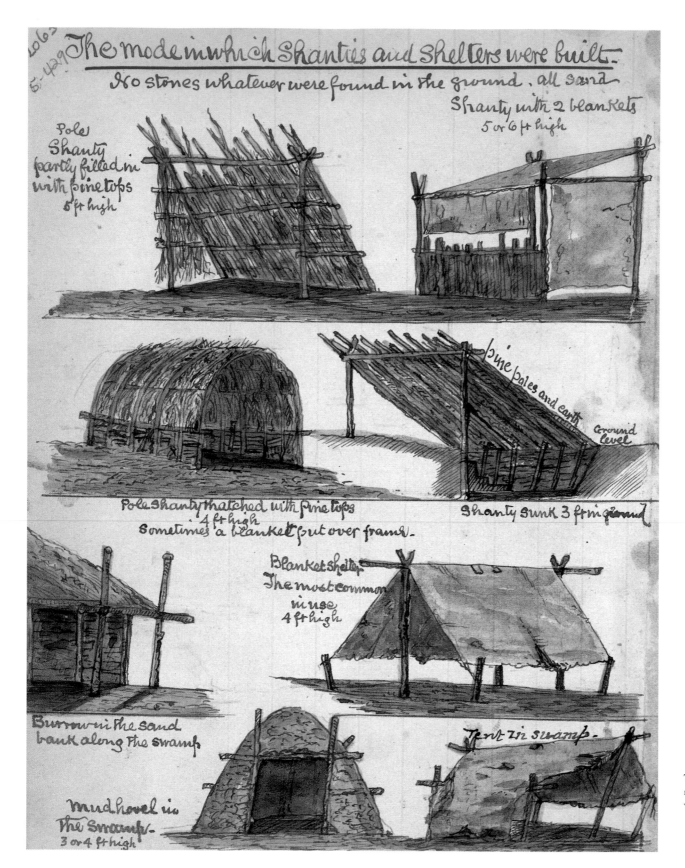

The mode in which
shanties and shelters
were built.

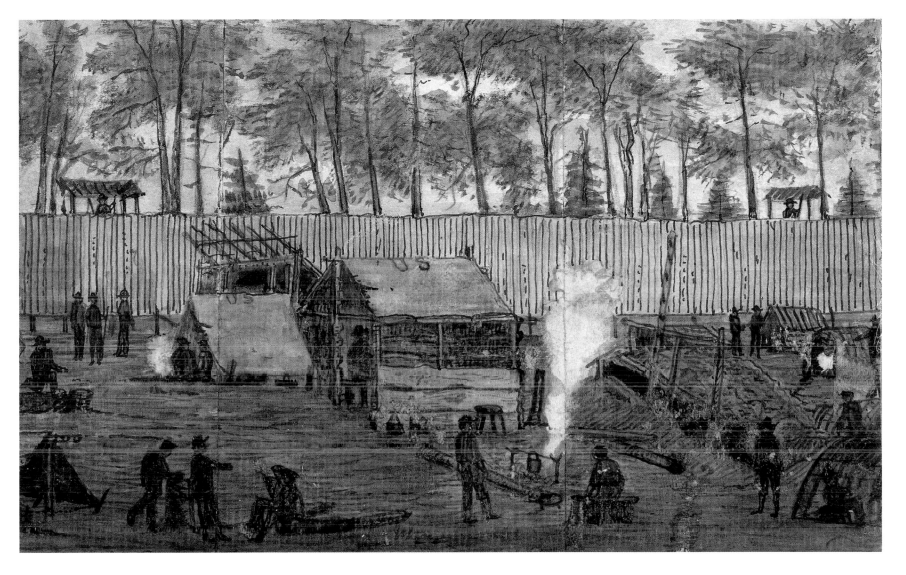

March 1, 1864. "The camp was not laid out in any order or shape, everyone had built his tent or shanty where he thought would be a good place, all along the road which ran from the north gate straight through the camp. Huts and shelters had been built by those who got here first of pine boughs, sticks and mud taken from the swamp. There was not a single stone in the whole place larger than a marble. Old tattered overcoats and ragged dirty blankets were propped up with three sticks with just room enough to crawl under while some had dug holes in the ground three or four feet deep and made a slanting roof over them of poles and pinetop boughs. The whole camp looked like a collection of pig pens."

R. K. Sneden's shanty at Andersonville Prison, Ga., sketched May 10, 1864.

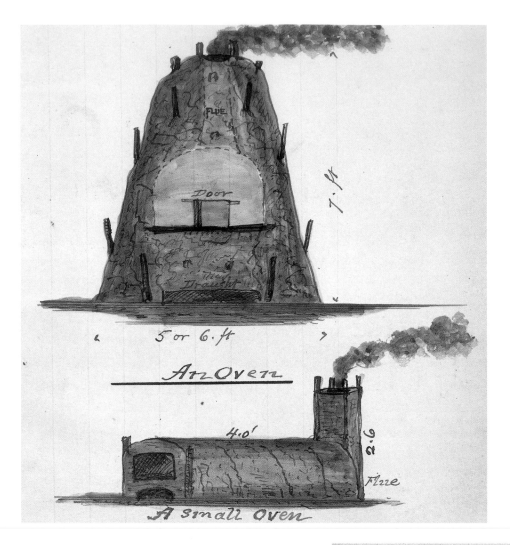

Door

FLUE

7. ft

5 or 6. ft

An Oven

4.0'

2.6

Flue

A small Oven

March 8 to 15, 1864. "The ovens now being made are five to six feet high, and are made by kneading clay and muck from the swamp into slabs or lumps a foot square. . . . Several prisoners clubbed together and did the work, carrying all the mud from the swamp, they then were the owners. The ovens are ugly, uncouth looking things, but two have been built and are in operation and work well, though they take a large quantity of wood; and the black pitch pine smoke nearly blinds everyone who chance to be near them."

March 15, 1864. "Several of the prisoners who have razors keep barber shop. The stump of a pine tree serves for the chair, [and] a ragged blanket propped up on four poles for a shelter. They have a sort of black looking soap which smells very strongly of pitch pine. For payment the barber takes one-third of the ration of cornmeal from each customer. This is put into a bag and when it gets to be enough for a big cake or pone, is cooked in the big ovens. Just near my tent is a barber shop. The owner [who] lives, or exists, in a sunken shanty . . . has a barber pole too—made of a long stick with the bark cut out in serpentine shape like any barber pole in a city."

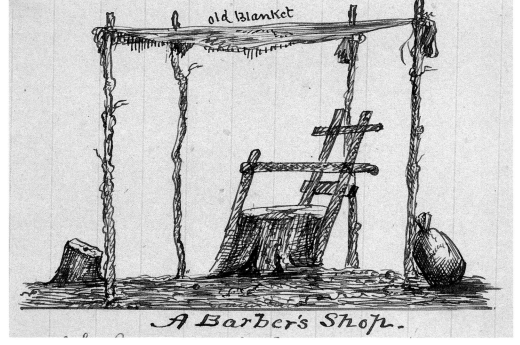

old Blanket

A Barber's Shop.

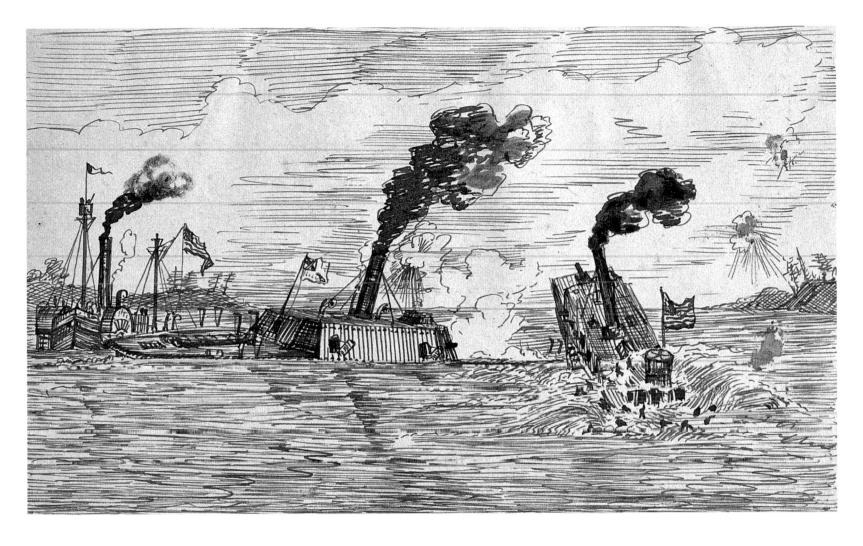

In April 1864, Confederate forces captured the small Union garrison at Plymouth, N.C. and sent their prisoners to Andersonville. In his memoir, Sneden frequently mentioned these men, who were called the "Plymouth Pilgrims" by the other prisoners. He sketched the role of the Southern ironclad C.S.S. "Albemarle" in the action at Plymouth, which ended in the sinking of the U.S.S. "Smithfield," not the "Southfield," as labeled in his drawing. The source of Sneden's image is unknown.

The Rebel ram "Albemarle" sinking the U.S. steamboat "Southfield," off Plymouth, N.C.

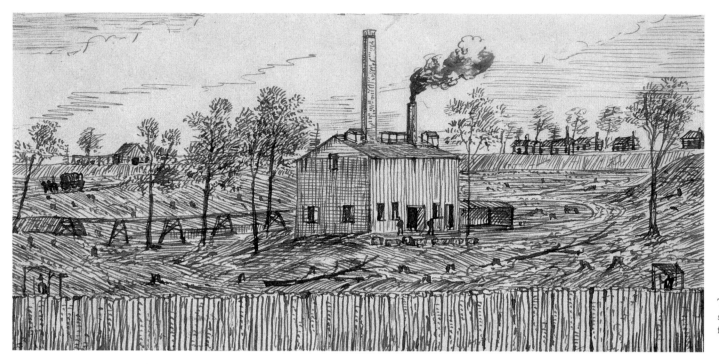

The cookhouse at Andersonville Prison, Ga., as seen from over the stockade.

April 3 to 6, 1864. "After roll call [Captain Henry] Wirz's adjutant gave out at the various detachments that prisoners were wanted to go outside to help build the cook house. None but good carpenters and masons were wanted. They were to be paroled and fed outside until the building was completed. . . . It was wonderful to see how many hundreds of carpenters and masons offered their services. Not one in twenty knew anything about the business in reality, but it was a grand chance to get out of this hell hole and get enough to eat outside."

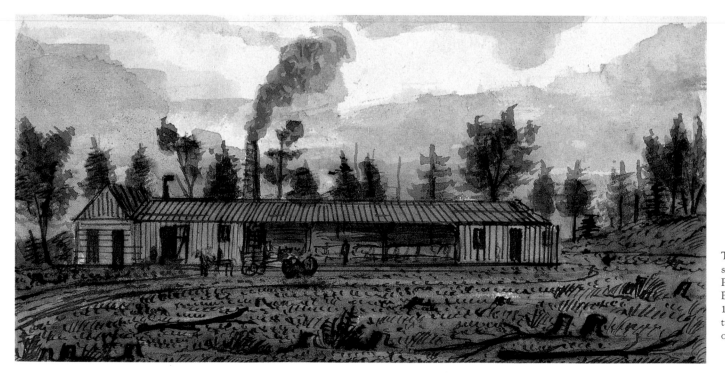

The cookhouse outside the stockade, Andersonville Prison, Ga., August 1864. Built of rough pine boards, 100 x 40 feet. Contained two ranges and four boilers of fifty gallons each.

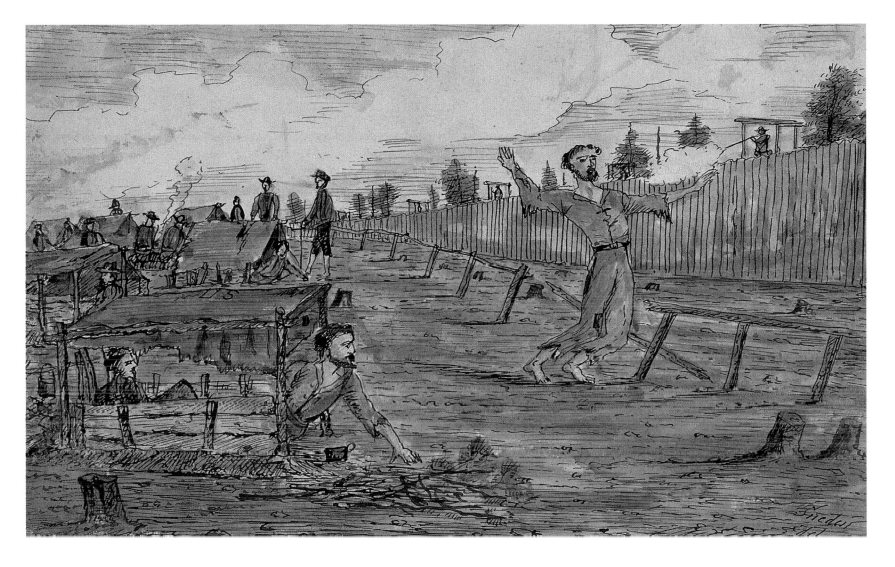

April 7, 1864. "They measured off from the foot of the stockade a line twenty feet wide all the way around. The short stakes were driven in the ground and the scantling nailed on top of them forming a rail around the whole camp inside. Stakes were about ten feet apart and the rail about four feet high. Wirz now went all over the camp and informed us that this was the dead line which no prisoner could approach nearer than ten or twelve feet or the guard on the top of the stockade would shoot him at once. No more trading was to be had with the guard. All of them had orders to fire on anyone near the dead line, etc."

The dead line, Andersonville Prison, Ga. Shot by the guard while taking a part of the dead line for firewood.

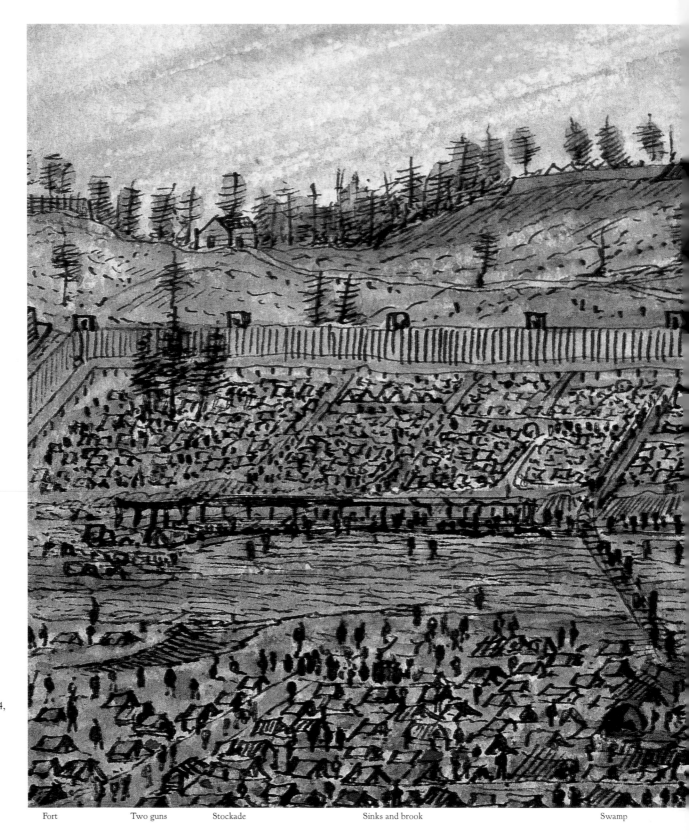

Perhaps Sneden's most popular subject for painting was a panorama of the vast outdoor prison that the Andersonville stockade encompassed.

Andersonville Prison in July 1864, showing fort and Wirz's headquarters, "The South Side."

| Fort | Two guns | Stockade | Sinks and brook | Swamp |

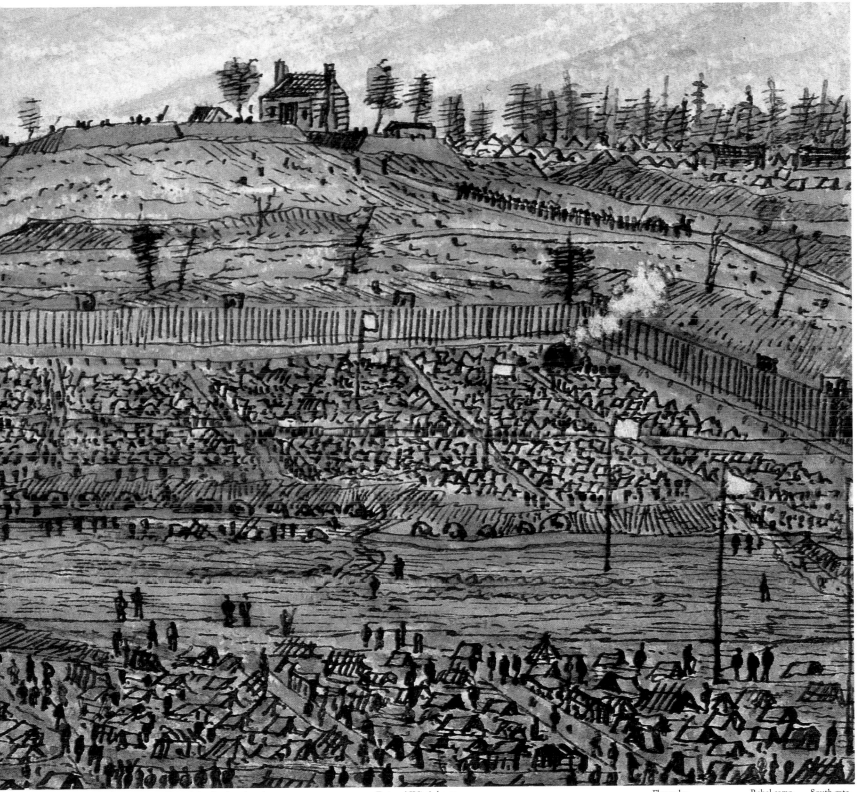

Raider's Island in swamp Caves in banks along brook Fort and Wirz's house Flag poles Rebel camp South gate

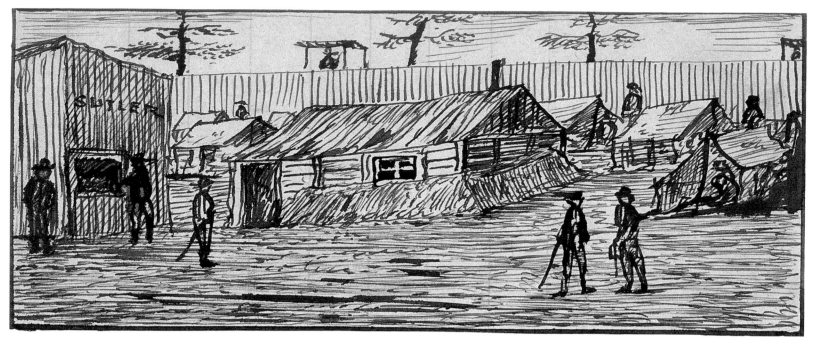

The watchmaker's shanty [center building].

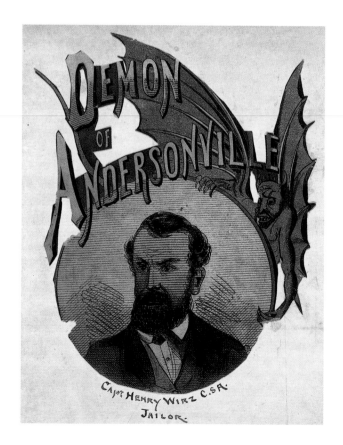

Captain Henry Wirz, C.S.A., jailor.

Although Sneden did not mention a watchmaker's shanty in his memoir of Andersonville, he did write about the wide range of goods that could be purchased for hard currency from the sutlers, or merchants, who set up shop in the camp.

June 19, 1864. "The sutler seems to be doing a good business as crowds throng his shanty window. He has two of our men to help him. The greenbacks he scoops in from the gamblers is wonderful to see."

Among Sneden's postwar drawings are several fanciful, derivative ones labeled "Demon of Andersonville." These featured the mapmaker's elaborations on the work of other artists that depicted the jailor, Captain Henry Wirz, the man universally despised by Union prisoners incarcerated there.

September 1, 1864. "The Rebels keep several hounds and other dogs in a kennel outside near the sticks who track those who escape as soon as it is known to them. These dogs are of two kinds—large ferocious blood hounds and another like mongrel bull dogs, with two or three rabbit dogs. The blood hounds first take the lead, yelping and baying all the time until they overtake the escaping prisoner. They then circle around him at about fifty feet distant. If the prisoner keeps quiet on the ground they won't bite him, but hold him until the mounted squad of Rebels come up."

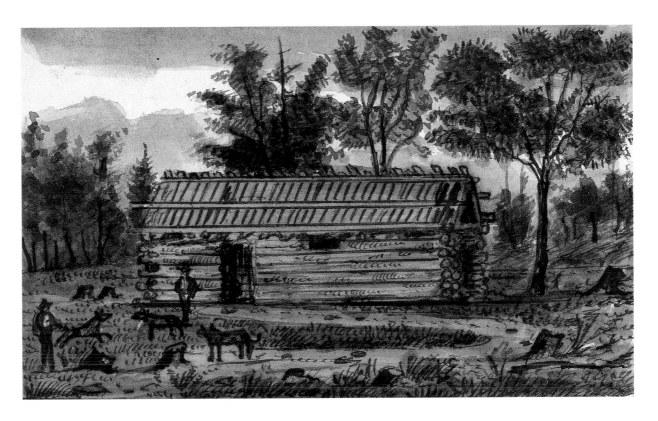

Hut for bloodhounds outside the stockade, Andersonville Prison, Ga. Harris, keeper.

Prisoners at Andersonville hanged six fellow Union soldiers, the "Raiders," who preyed on their weak and dying comrades. Sneden witnessed the execution, which was sanctioned by the Confederate prison authorities.

July 11, 1864. "About 8 a.m. a Rebel guard came in the stockade armed only with revolvers and stood near the dead line at the South Gate. Wirz was with them and other officers. A mule team came in soon after drawing a wagon load of timbers. Five or six carpenters unloaded it and in an hour or so they constructed a rough gallows to hang the Raiders on."

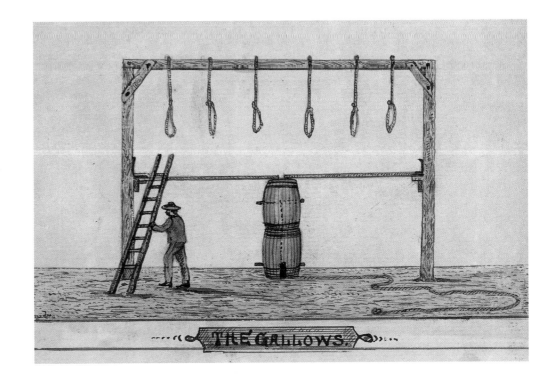

THE GALLOWS.

July 11, 1864. "[Within ten minutes,] all the bodies were swaying at the end their ropes. . . . After hanging about twenty minutes, they were examined and found to be dead. The ropes were cut, and the meal bags taken from their heads. They laid on the ground until sunset while hundreds of the prisoners filed past two abreast to see them between two rows of 'Regulators.' Their faces were much distorted, one only had his neck broken. All the remainder died by slow strangulation. The immense crowds of prisoners dispersed slowly to their shelters all glad that the terrible example had been made of the murderers, while the remaining Raiders yet in the stockade were cowed at once, and thieving, robbery, and murder stopped for a time."

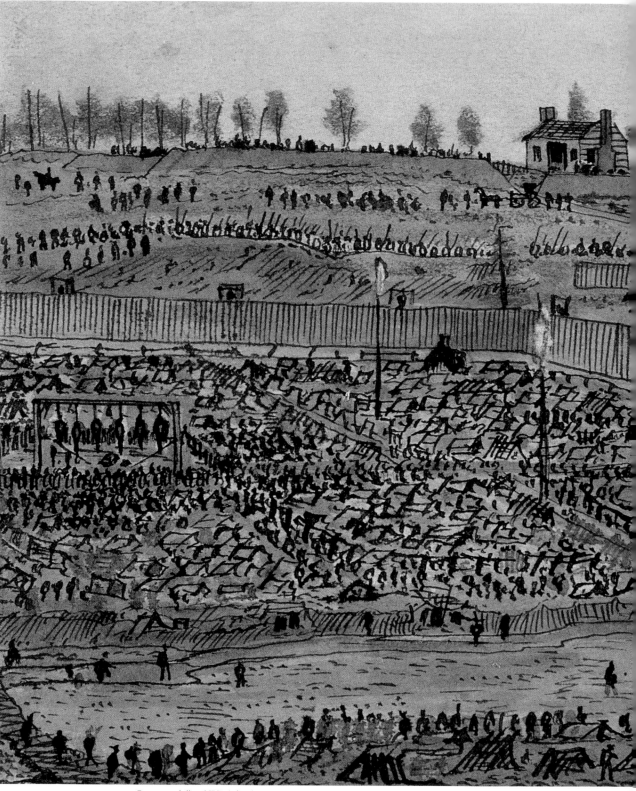

Hanging of the Raiders, July 11, 1864, at Andersonville Prison, Ga. From the north side.

Battery on hill and Wirz's headquarters

Brook and swamp

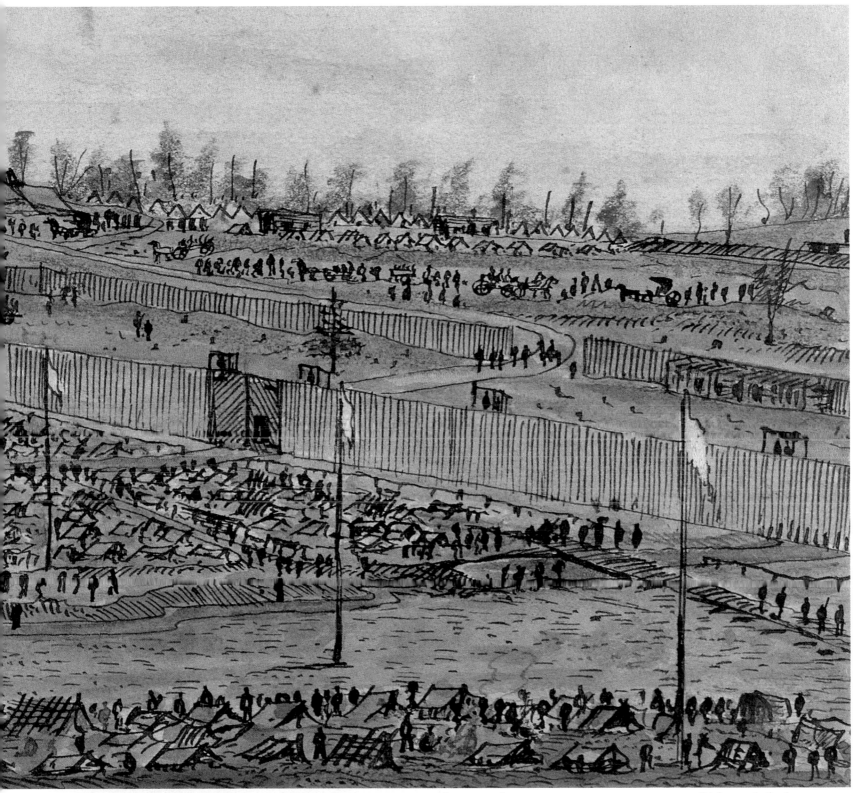

South gate Spectators outside Rebel camp and railroad

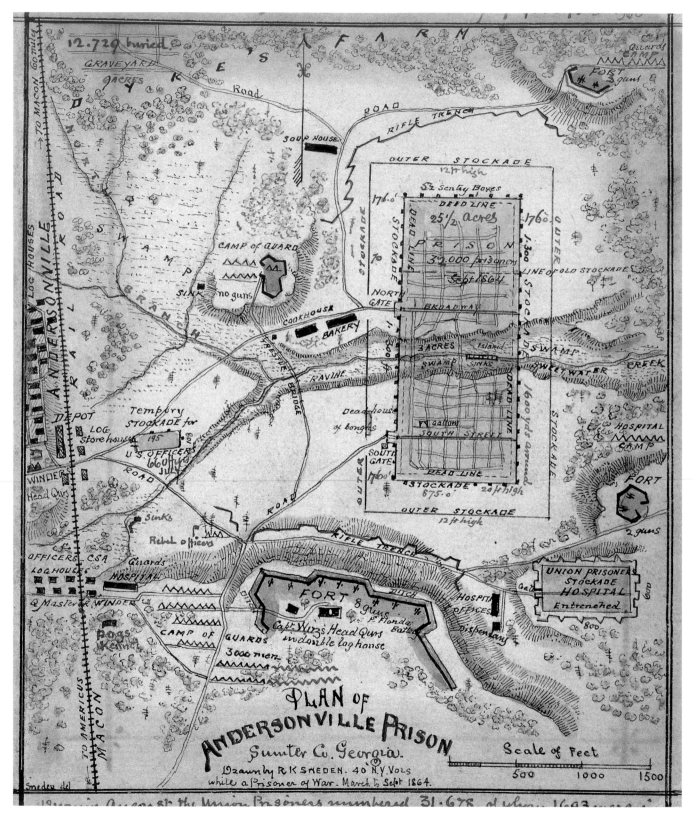

12.729 buried

GRAVEYARD
9 ACRES
Road
SOUP HOUSE
RIFLE TRENCH
OUTER STOCKADE
12 ft high
5½ Sentry Boxes
DEAD LINE
176.0'
25½ acres
PRISON
32.000 prisoners
Sept 1864
1760.0
1.300
LINE OF OLD STOCKADE
NORTH GATE
BROADWAY
SWAMP
3 ACRES
Island
SINKS
SWEET WATER CREEK
DEAD LINE
1600 yds around
Gallows
SOUTH STREET
HOSPITAL CAMP
SOUTH GATE
1760.0'
DEAD LINE
STOCKADE
875.0
24 ft high
OUTER STOCKADE
12 ft high

CAMP of GUARD
SINK no guns
COOKHOUSE
BAKERY
TRESTLE BRIDGE
RAVINE
Dead-house of bodies

Tempory STOCKADE for
LOG Storehouse 195
DEPOT
U.S. OFFICERS
660 July
WINDERS Head Quis
Sinks
Rebel officers

OFFICERS CSA
LOG HOUSES
Q Master WINDER
Guards HOSPITAL
RIFLE TRENCH
FORT
DITCH
Hospital offices
Dispensary
FORT 2 guns

DOGS Kennel
CAMP OF GUARDS
3000 men
FORT 8 guns
Capt. Wirz's Head Qurs in double log house
F. florida Battery
UNION PRISONERS STOCKADE HOSPITAL
Entrenched
800

PLAN OF
ANDERSONVILLE PRISON
Sumter Co. Georgia.
Drawn by R K SNEDEN. 40 N.Y. Vols
while a Prisoner of War. March to Sept 1864.

Sneden del

Scale of Feet
500 1000 1500

TO MACON 60 mile
ANDERSONVILLE ROAD RAIL ROAD
TO AMERICUS MACON

The date on this map of the Andersonville camp and vicinity is August 1864. This plan, one of several Sneden made of the same subject, was drawn after the war but based on a pencil sketch made while he was imprisoned there. Though most of the statistics Sneden included in the caption below are fairly accurate, his estimate of 300 prisoners shot by guards is a gross exaggeration.

Revised plan, August 1864. During August the main prisoners numbered 31,678, of which 1,693 were in hospital. 2,993 died in August. There were 31,693 prisoners August 31. Number of prisoners shot by Rebel guard: 300. Number buried in graveyard: 12,729.

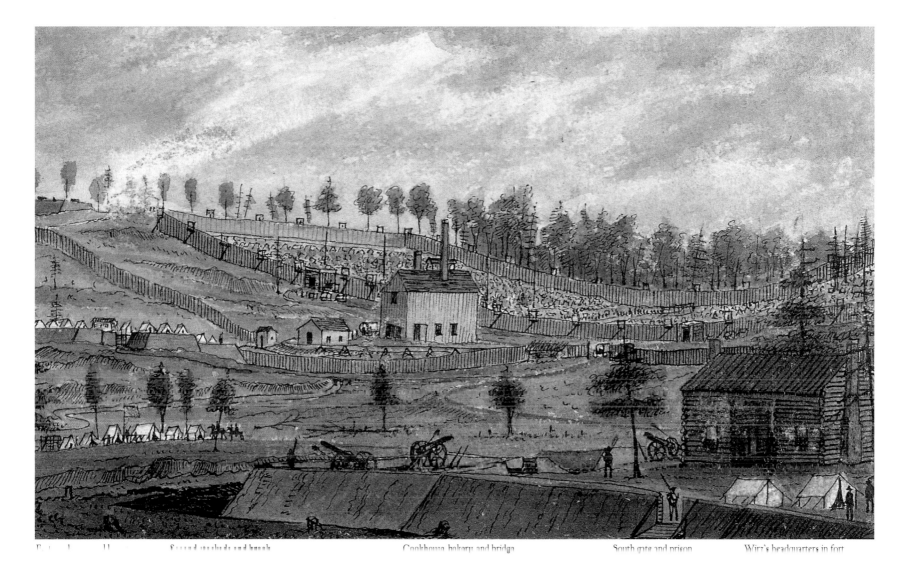

F...ll... S... ...d ...o..o d ...h Cookhouse, bakery, and bridge South gate and prison Wirz's headquarters in fort

In September 1864, the Confederate prison authorities began sending their charges from Andersonville to a new prison at Savannah.

September 17, 1864. "Notice being given at roll call for the 6th thousand 'to pack up' we were all busy tearing down blanket shelters, bidding sick companions good bye, and giving away all we could not conveniently carry. . . . We mustered 600 in line, and went out of the South Gate and up the hill to the fort, and halted in a dry ravine just outside: as we staid here until sundown I made a careful scrutiny of the ground, earthwork, forts, etc., etc. out-side the stockade and made a rough sketch of the surroundings under the nose of the Rebel guard."

View of Andersonville Prison, Ga., from Captain Wirz's headquarters at the fort, September 17, 1864.

In this variation on one of Sneden's popular subjects, a panorama of a prison camp, the artist has drawn the men in the foreground with slightly more detail than his accustomed stick figures.

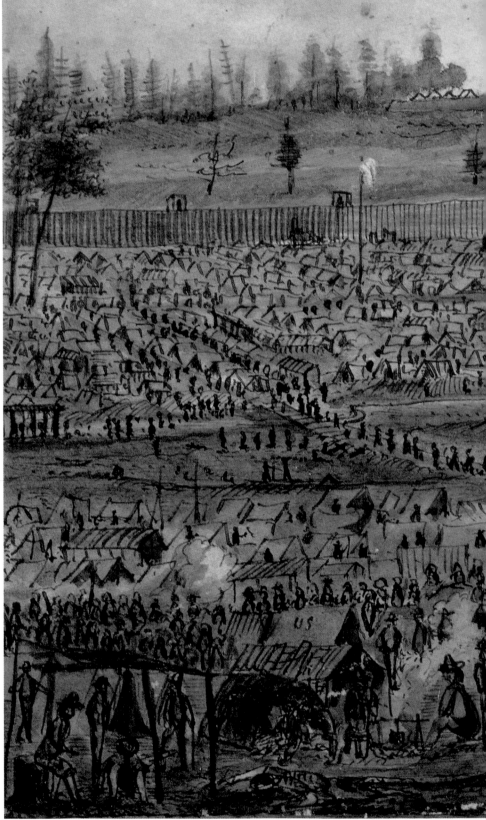

View of interior of Andersonville Prison, showing Wirz's headquarters in fort outside. Sketched September 1864.

Brook and swamp inside

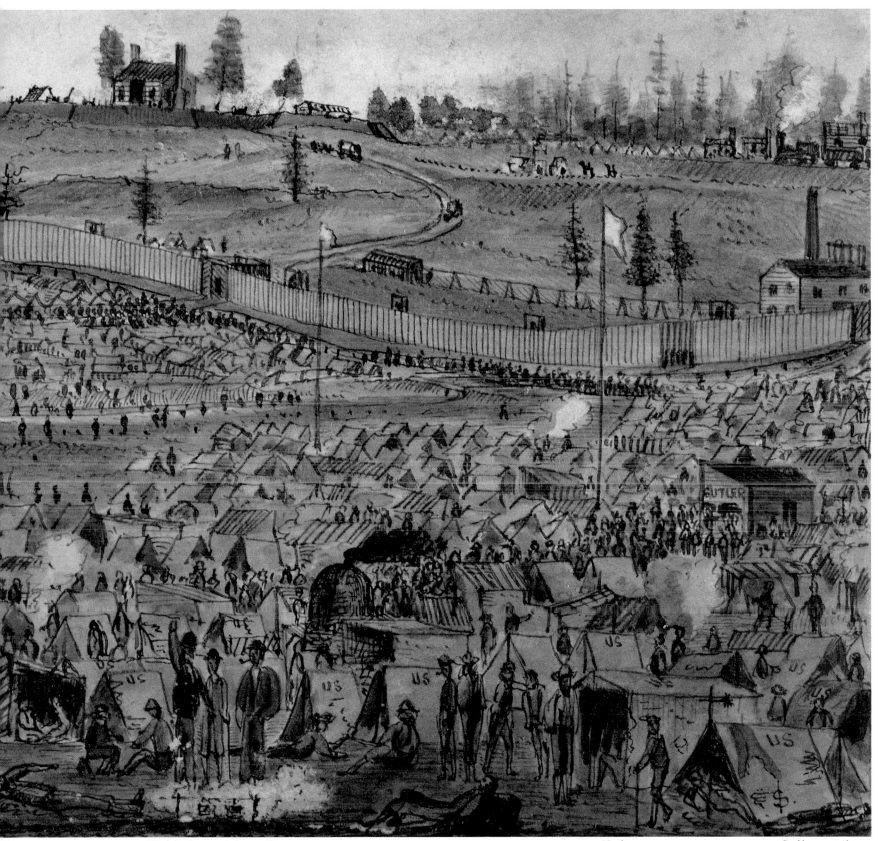

Wirz's headquarters in fort outside North gate Cookhouse outside

September 18, 1864. "We were marched past the waterworks, the reservoir of which consisted of an immense tub sixty feet high or more set on a brick foundation; thence to the South Common; where a large new stockade loomed up before us. We were kept closed up, and orders given to shoot any of us who should struggle. Several villainous looking Rebel officers were at the entrance gate to the pen and yelled to hasten the column."

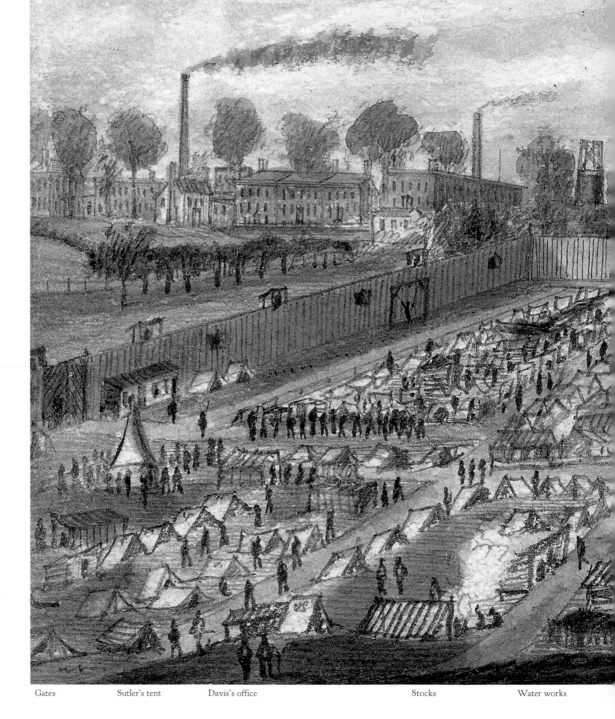

Rebel prison at Savannah, Ga. 5,000 prisoners of war. Sketched October 1864. Occupied by Union prisoners of war from September 19 to October 15, 1864. Lieutenant S. R. Davis, C.S.A., had command of the prison. The stockade was torn down before Sherman's army reached Savannah.

| Gates | Sutler's tent | Davis's office | Stocks | Water works |

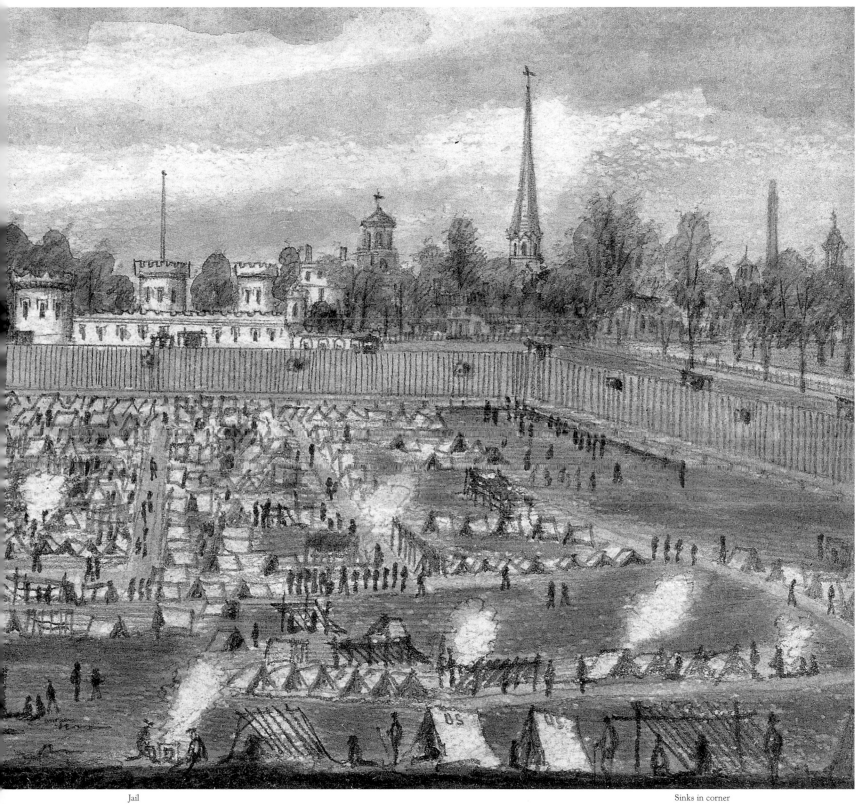

Jail

Sinks in corner

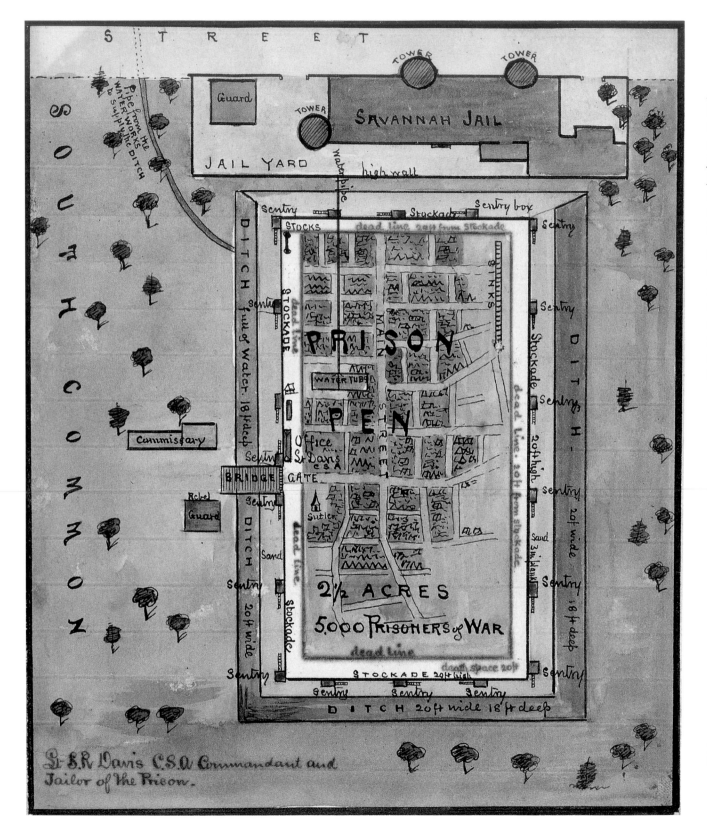

STREET

TOWER TOWER

Guard

TOWER

SAVANNAH JAIL

JAIL YARD

high wall

Pipe from the WATER WORKS to supply the DITCH

Water pipe

SOUTH COMMON

sentry
Stockade
Sentry box
sentry

STOCKS
dead line 20ft from stockade
Sentry
dead line

DITCH filled with water 18 ft deep
STOCKADE

PRISON
PEN

WATER TUBS

Office
St Davis
C.S.A

BRIDGE GATE

Commissary

Rebel
Guard

Sentry
Sand

DITCH 20ft wide

dead line

Stockade

Sutler

2½ ACRES

5,000 PRISONERS of WAR

dead line

STOCKADE 20ft high

Sentry Sentry Sentry

DITCH 20ft wide 18 ft deep

dead line 20ft from stockade
Stockade 20ft high
Sentry
sentry
sand
3 in plank

DITCH 20ft wide 18 ft deep

Sentry
Sentry
death space 20ft
Sentry

Lt S.R Davis C.S.A Commandant and
Jailor of the Prison.

As soon as they were turned loose in the new stockade at Savannah, the prisoners set about building shelters. They fought over the planks and pieces of lumber left by the workmen who built the prison and soon had their shanties built and cook fires burning.

September 19, 1864. "The whole camp has the appearance of a village of dog kennels. All are cooking, and fires are kept up all night, at which the ragged and shoeless prisoners sit, eating and smoking until midnight."

Plan of the Rebel prison pen at Savannah, Ga., September 1864.

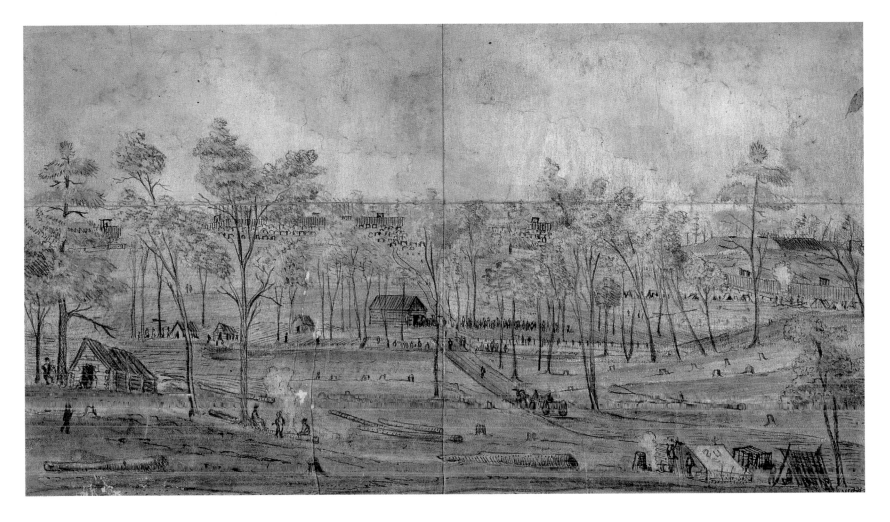

After only a month at Savannah, Sneden was sent by train to yet another newly built prison, Camp Lawton at Millen, Georgia. Early in his time there, he decided to give his parole and promise not to attempt to escape, in exchange for which he worked as a clerk for a Confederate army surgeon, Isaiah White. By making this bargain, Sneden lived outside the stockade and received much better rations than his comrades inside. At Andersonville he had scorned the "Galvanized Yanks" who worked for the prison administration, but by the time he reached Camp Lawton, he must have realized that making the same choice for himself might be the only way to stay alive.

Some of Sneden's best, most detailed panoramas of prisons depict Camp Lawton, though he was there for only a few weeks, compared to half a year at Andersonville. The reason may have had something to do with the greater freedom he enjoyed as a paroled prisoner. Living outside the stockade and having a pass as a surgeon's clerk gave him greater opportunity for sketching.

The Rebel prison and stockade at Millen, Ga.

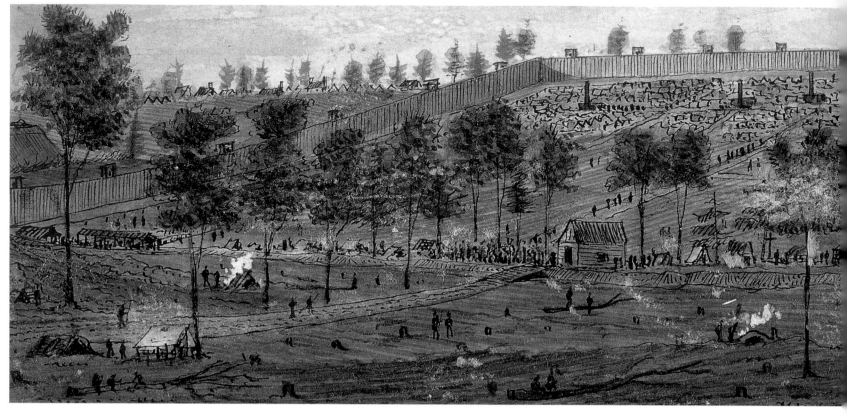

The Rebel prison and stockade at Millen, Ga.,
from inside the gate, November 1864.

October 16, 1864. "We arrived at Millen about daylight, and went three miles nearly north, when we stopped at a rough looking collection of log shanties and barns in a thick pine woods. . . . On our way, we marched within 200 feet of a gallows, upon which hung a dead Negro, who had been there for some time. The carrion crows were fluttering in the air, and the stench sickening. We could not learn what he had been hanged for, as the guard were a surly set, and would not answer questions. . . . We trudged along in hopes and fears as to our new situation. After marching about a quarter of a mile through woods, we came to a large clearing when the stockade came in view, with several log houses and wall tents outside all along the ridge, and a large earthwork and fort on a bluff which overlooked the interior, while several pieces of cannon were visible over the parapets."

View of Camp Lawton, or
Rebel prison at Millen, Ga.

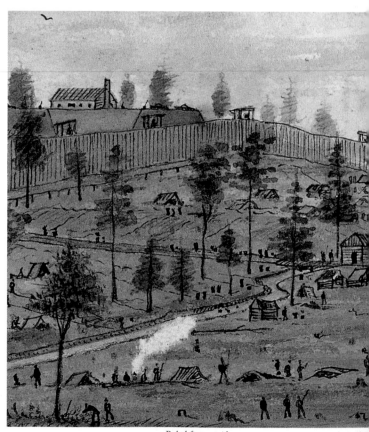

Rebel fort outside

"Camps of Rebel guards were in the woods, and nothing could be heard but the sighing of the wind through the trees, until we entered the gate, when the noise of a large camp of prisoners who were already here shouting to us across a small stream broke the monotony, and all was confusion in our ranks. Guards were posted along the brook and we were kept on one side of it all night, until we could be counted and messes formed properly, no communication being allowed with the other prisoners until next day.

"On the side near the entrance were large numbers of pine and scrub oak trees, and from branches and underbrush we made large fires and cooked our corn pones and rice, making temporary shelter at night of boughs and blankets, and sleeping very well after the cramped and unpleasant journey. . . ."

October 20, 1864. "Cold rain storm. We who came into the stockade were this morning moved across the brook, and soon were lost to each other by mixing up with the prisoners already here. All day was occupied in making new shelter. Those who had first come found numbers of felled trees on the ground with which some good shanties had been made. Now all the small sticks had been used up by them, and we had to put up with anything we could collect for the same purpose. Many large trunks of trees were left however, but having no axes, could not be of use, except for building fires against. Numerous stumps of pine trees were about the ground which made good fires, which were kept going night and day. We were not allowed to use the trees which grew on the other side of and along the brook, and they served for shade for those who had no blankets to make shelter with. The brook was of good clear water, and about twelve feet wide and in some places four feet deep. This was the greatest luxury we had, as for about thirty feet we could use it for bathing. . . ."

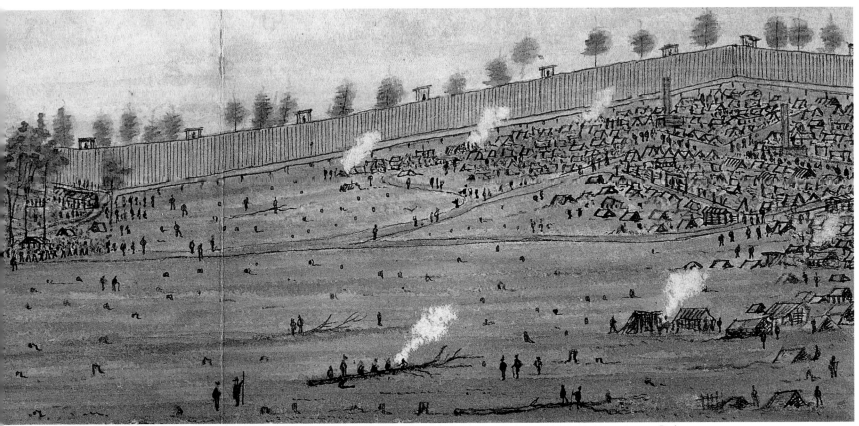

Sutler's shanty and brook Stockade and dead line Prisoners' camp Brick ovens

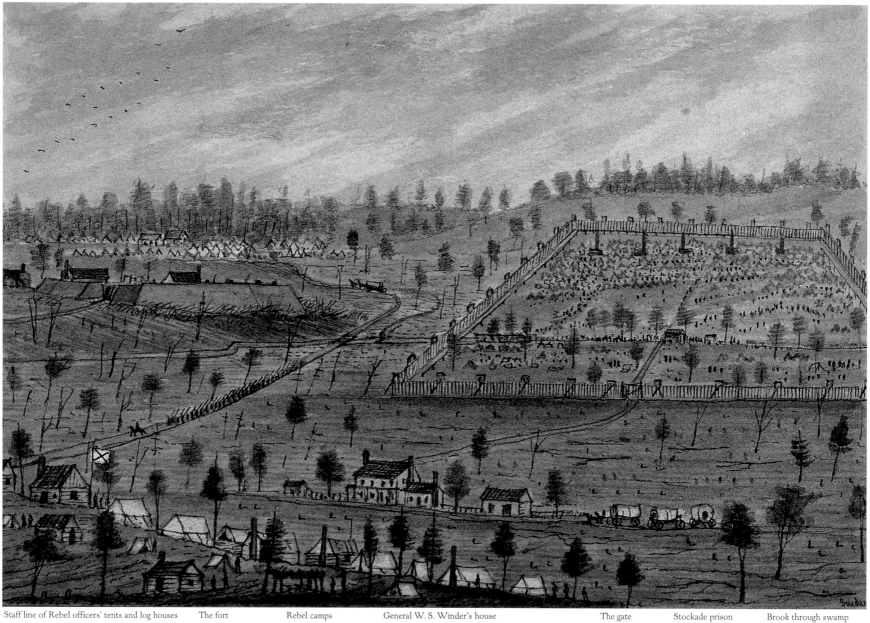

Staff line of Rebel officers' tents and log houses The fort Rebel camps General W. S. Winder's house The gate Stockade prison Brook through swamp

View of the Rebel prison at Millen, Ga., from the headquarters of General Winder, C.S.A. Forty-four acres, 8,600 prisoners. September 1864.

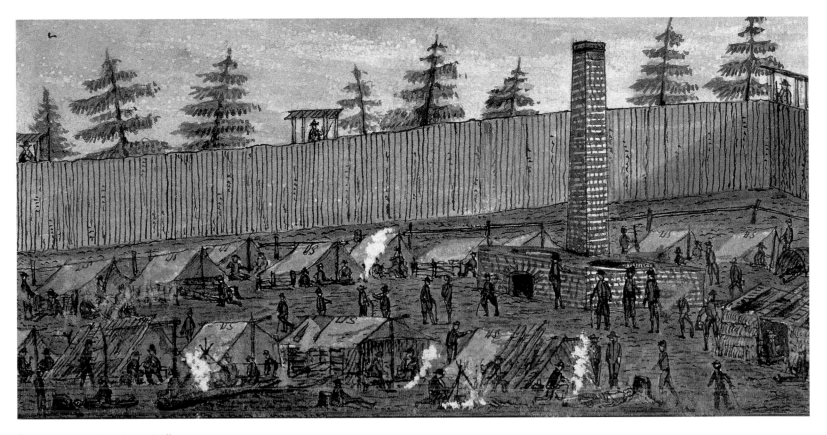

Interior view on Main Street, Millen Prison, Ga., showing brick oven and dead line.

October 20, 1864. "The foundation for several brick ovens had been started in the camp for our use, and as fast as the bricks were dumped for their completion, they would be appropriated by the prisoners at night for making side walls to their shanties, so a guard composed of the camp police had to be set over the brick piles, and the stocks, and buck and gag, [were] the penalty for using them."

Brick ovens built by Rebels, Millen Prison, Ga.

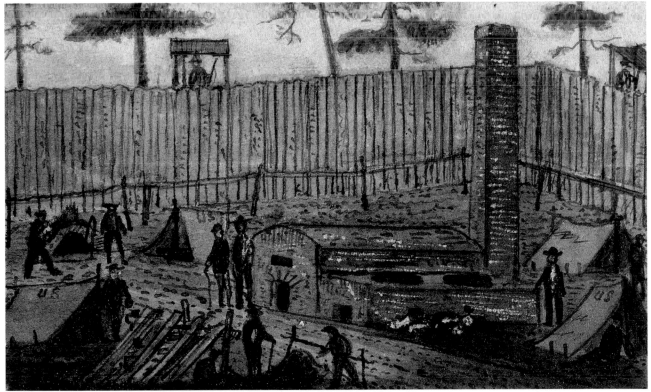

R.K. Sneden's shanty Rebel guard and dead line Brick oven (never used) and two kettles Stockade

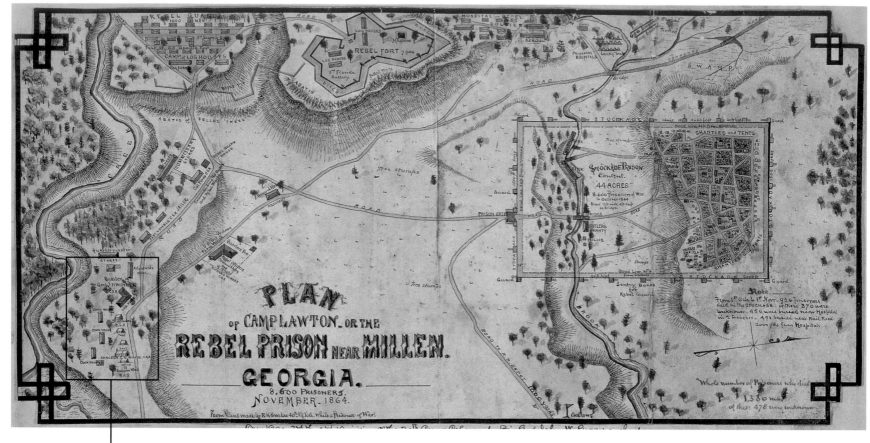

Plan of Camp Lawton, or the Rebel prison near Millen, Ga., November 1864.

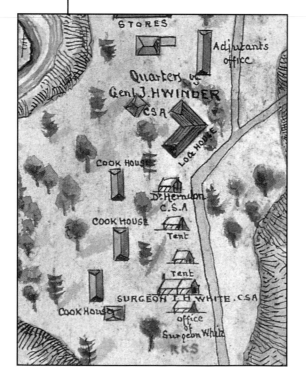

Detail: Sneden initialed his "office" *(bottom)* outside the stockade.

November 12, 1864. "I walked round the prescribed limits today, but did not wear the tin star for protection. I carried it in my pocket however in case a guard should stop me. I saw several of our fellows, who were paroled clerks to Commissary and Quartermasters. . . . I made a careful plan of the grounds and stockade. . . . So I did not work at anything for the Rebels today, and after three good square meals and a pipe, turned in."

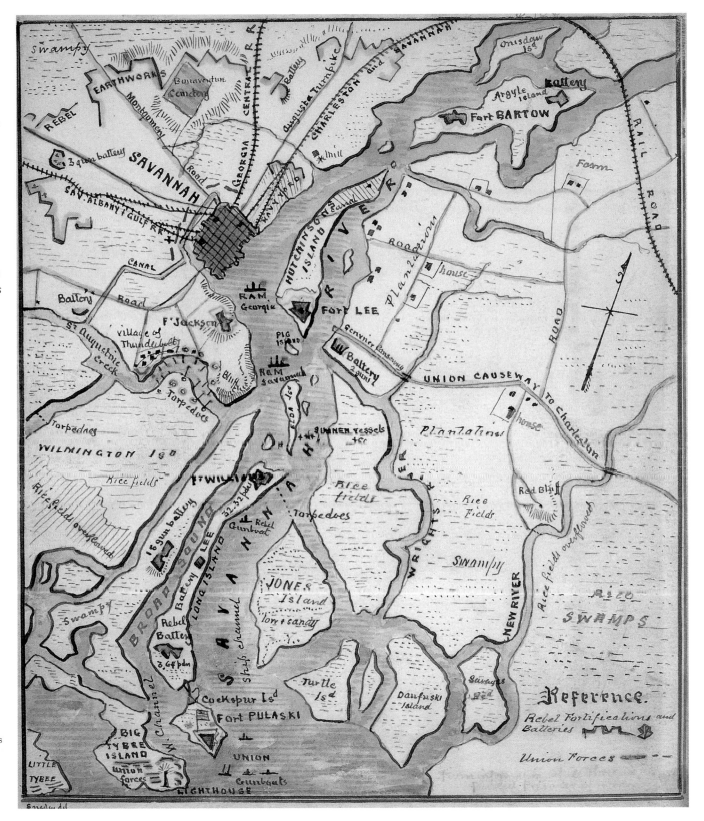

After a little more than a month
at Camp Lawton, Sneden went
back to Savannah, still paroled
as a clerk to Isaiah White, the
Confederate surgeon. While he
was in Savannah in November
1864, he had the freedom to
roam around the city, making
sketches and notes. This plan of
Confederate defenses of the area
drawn after the war relied on his
notes and memory and on post-
war maps as well.

The Rebel defenses
at Savannah, Ga.,
November 1864.

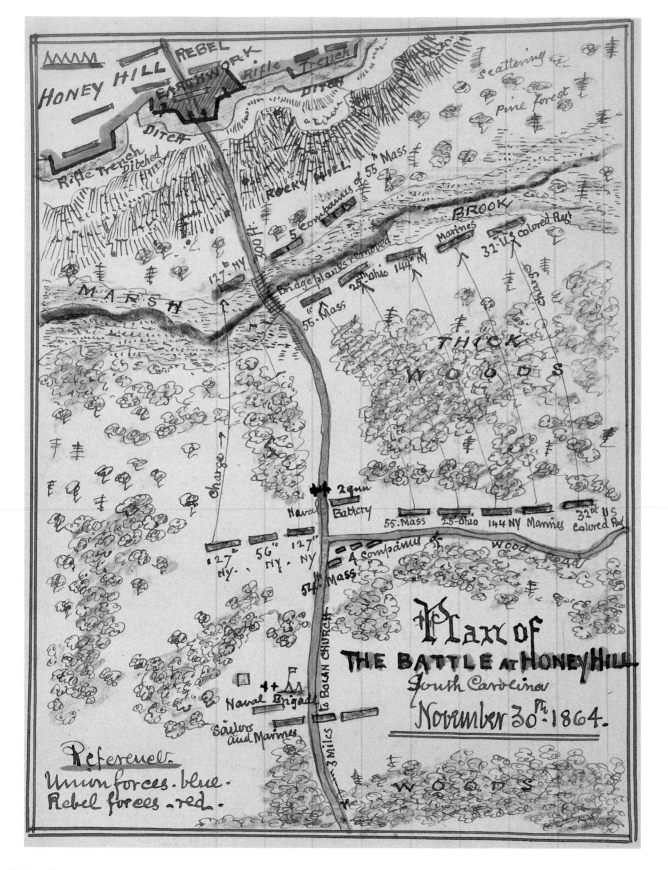

On November 30, 1864, Federal troops moving in from their coastal foothold tried to cut the Savannah–Charleston railroad. In the ensuing battle of Honey Hill, or Grahamsville, Confederate forces threw them back. Recounting his trip from Savannah to Charleston on that rail line, Sneden described how his train came under fire. Because he places the incident on the 29th and geographically closer to Charleston than the battle occurred, he must have been relying on faulty memory rather than on any notes taken at the time.

November 29, 1864. "I got on the roof of the car but could see nothing but smoke over the tree tops, while the musketry grew heavier. . . . I was at the open door of the baggage car all the time, but could only see a battery of horse artillery, and large numbers of cavalry on the edges of a clearing; all else was woods and white smoke. The shells flew all over and about the locomotive, and I hoped every one would hit, or disable the cars, but we passed through safely, going very fast."

Plan of the battle of Honey Hill, S.C., November 30, 1864.

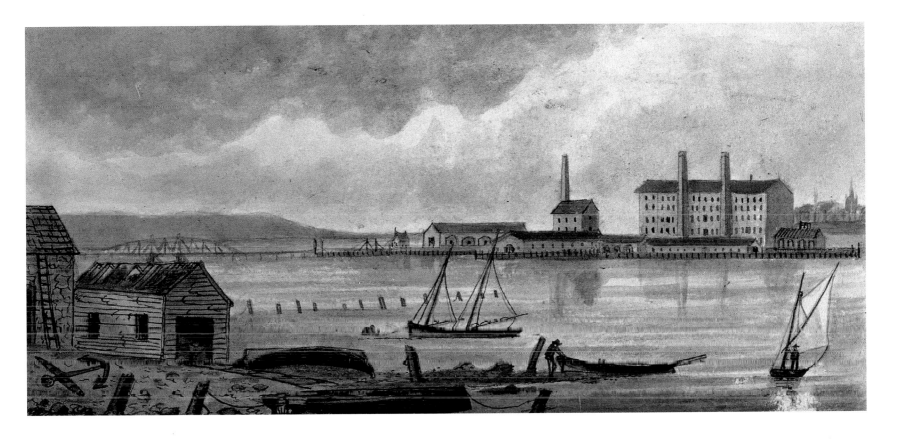

November 30, 1864. "I was up at sunrise, and soon after went to Wappo Creek on the Ashley, where I made a sketch of the city, showing the West Point Mills, etc. . . . I then went all over the deserted Rebel forts, which never seemed to have had any quarters. The main redoubt was of sand, and had been built with fascine and gabions. The embrasures were all badly washed out by rain, no platforms for guns were visible, and loose sand was everywhere. A large mill in the vicinity was deserted, and as only freight came by railroad, but a few persons were to be seen anywhere."

The West Point Mills, Ashley River, Charleston, S.C., from Wappo Creek, November 30, 1864.

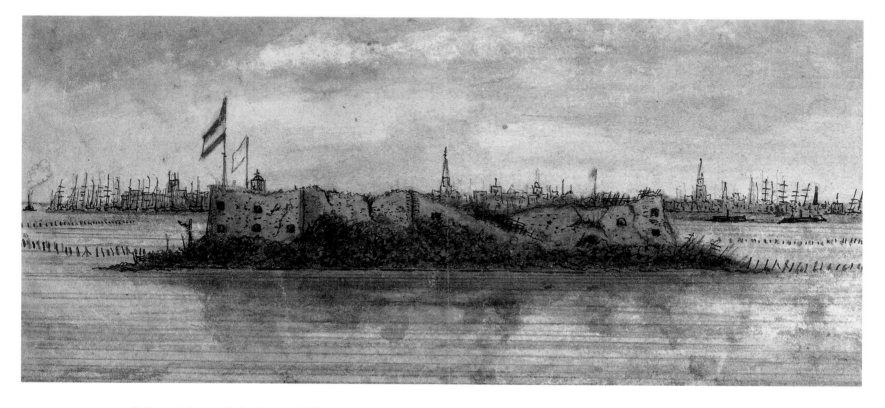

Still paroled to work for Surgeon White, Sneden had an opportunity to investigate Charleston, S.C. Though he could see Fort Sumter, this image is likely based on postwar photographs or engravings.

November 30, 1864. "Fort Sumter, still defiant, though half in ruins, long embankments of white sand lined both sides of the harbor, over which black guns pointed sea-ward, while Rebel flags were flying at Moultrie, and Fort Sumter, Castle Pinckney, Johnson, etc. bright in the morning sun."

Ruins of Fort Sumter, Charleston Harbor, S.C., sketched from on board steamer "Varuna" while waiting for exchange of prisoners under flag of truce, December 11, 1864.

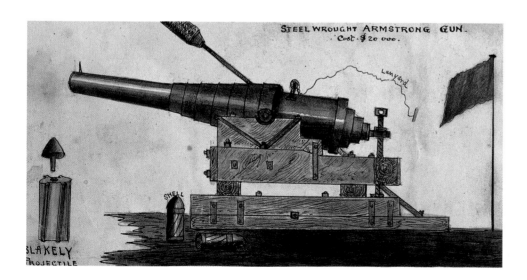

STEEL WROUGHT ARMSTRONG GUN.
Cost $20 000.

Lanyard

BLAKELY PROJECTILE

SHELL

Sneden sketched the siege guns of Confederate defenses at Charleston and also commented on the artillery fire from the besiegers.

November 30, 1864. "During the night our forces on James and Morris Island down the harbor shelled Charleston until daylight. I could see the trail of the burning fuses on the sky, and heard plainly the bursting shells, and the dull roar of the falling walls in Charleston. Two or three small fires were burning at the same time, which flickered against the dark sky, but died out after a while."

English gun.

December 1, 1864. "I passed through Queen Street and St. Michael's Church and noticed the accurate effect of firing—thence down Meeting Street to Battery Point, or Walk. It was laid out in nice plots, with trees, and had a fine sea wall, and in many respects like the Battery at New York. Soon I came upon a battery of eight heavy guns and one 600 pound Blakley gun on barbette carriages: cannon shot piled alongside for use, a solitary Rebel soldier was on guard who taking me for a Rebel officer saluted, which I returned of course. . . . The Rebel guard pointed out the places of interest in the bay which was now before me, and I spent an hour in this vicinity sketching, and watching Sumter and our fleet and batteries, but no firing took place which I most wished to see."

Rebel defenses of Charleston Harbor, S.C., December 11, 1864. From original plan made while a prisoner of war.

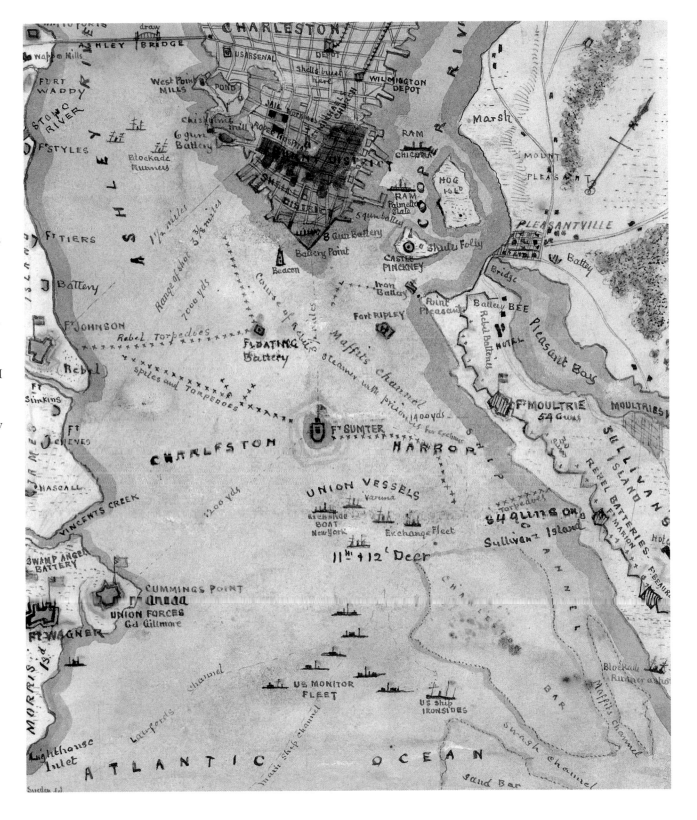

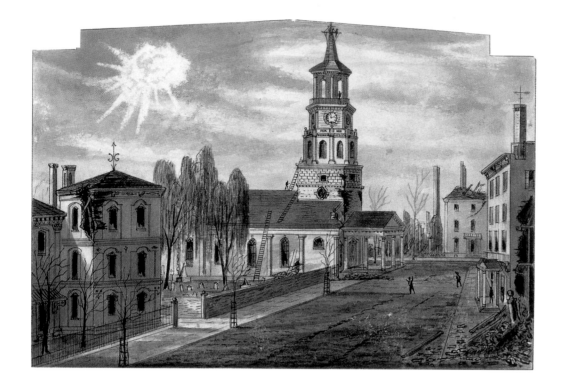

December 1, 1864. "St. Michael's had the corners of the tower shattered. . . . The Rebels had a scaffold look-out rigged at the top of the spire, where watchmen were at all times during the day stationed to observe the movements of our fleet down the harbor, rope ladders were on the outside of the steeple, and from thence to the ground for escape."

View of St. Michael's Church, Charleston, S.C., December 1, 1864. Showing effect of shelling by Union force on Morris Island. From a rough sketch drawn while a paroled prisoner of war.

December 3, 1864. "Last night another shell passed through the roof, and going through to the cellar had there exploded, tearing out the main rear wall, and knocking down many of the iron columns which supported the floors. Fortunately the building was empty the officers having long ago been sent to Columbia, S.C. The Charleston jail and workhouse is in the immediate rear of Roper Hospital: and is now full of our prisoners, Negro soldiers, and Rebel deserters."

Later the same day, Sneden took the train to Florence, S.C., to report to Surgeon White for work at the Confederate stockade there.

Charleston jail and workhouse, S.C., sketched from rear of Roper Hospital, December 10, 1864.

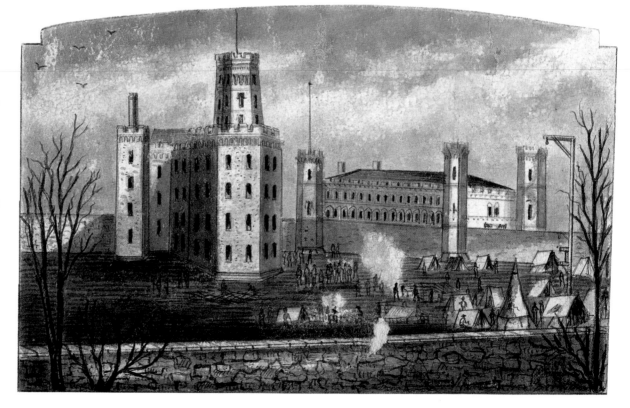

December 4, 1864. "Winder and White occupied two large tents in the vicinity of the hotel; while during the forenoon I succeeded in pitching another for myself; and as I had nothing to do as usual, went over the ground to see the sights. The prisoners' stockade was situated nearly two miles up the railroad towards Cheraw. About twenty log houses were near the hotel, which were filled with 'galvanized Yanks' making shoes for the Rebels. I saw several here who had taken a parole while at 'Camp Lawton.'"

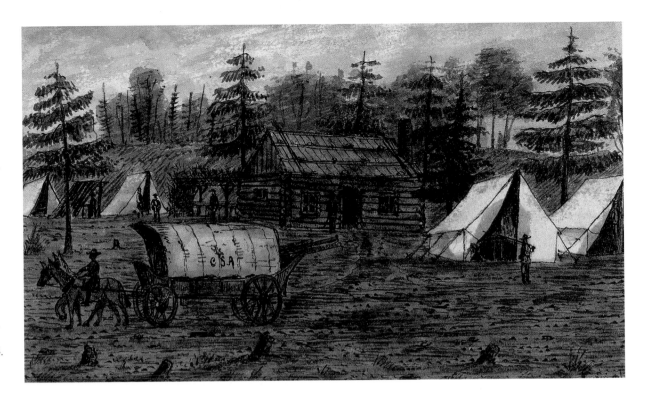

Headquarters of General John H. Winder, C.S.A. in the woods at Florence, S.C., December 4, 1864. He died here February 1865.

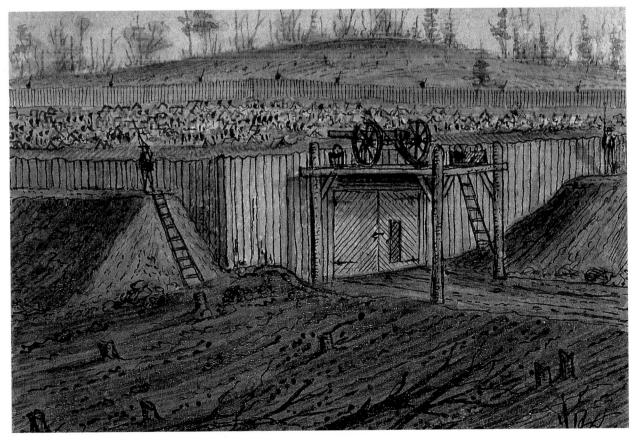

View of the gate of the Rebel prison at Florence, S.C., sketched December 8, 1864. Content of stockade: fifteen acres (two acres swamp). Number of prisoners: 9,000. 3,000 died from September to December 1864.

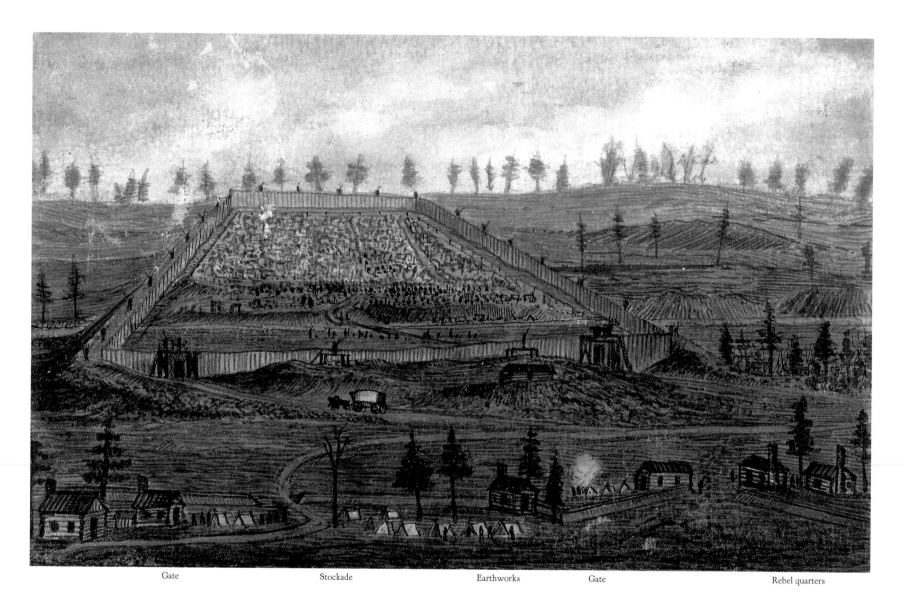

| Gate | Stockade | Earthworks | Gate | Rebel quarters |

December 4, 1864. "About one half of the enclosure was swamp, through which a sluggish stream flowed, and the Rebel guard had an entrenched camp in the vicinity. A piece of field artillery was mounted on platforms erected over each of the two entrance gates, while the earth had been thrown up from the outside all around which formed an embankment on which the guards walked their beats."

After only a week at Florence, Sneden joined a large shipment of prisoners bound for Charleston and a mass prisoner exchange arranged by Union and Confederate authorities to take place in the harbor there.

The Rebel prison near Florence, S.C., from the original sketch made there December 8, 1864. Established September 25, 1864. Jailor: Sergeant Barrett, C.S.A.

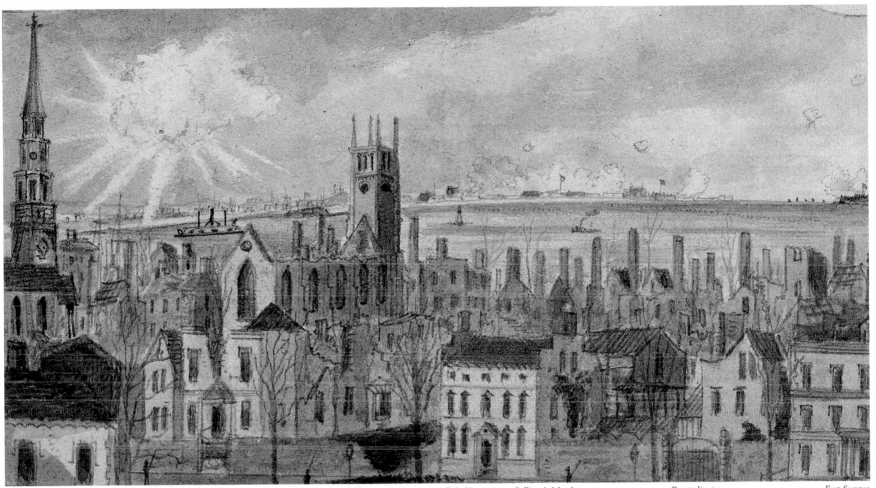

| St. Michael's Church | Rebel ram | Ruins, destroyed by shells | Rebel batteries on Sullivan's Island | Burnt district | Fort Sumter |

While they waited to be exchanged, Union prisoners were jailed in the former Roper Hospital, where they observed the bombardment of Charleston.

December 9, 1864. "Several of us scrambled to the roof, where we saw our missiles coming towards the city from our batteries away down on Morris Island. The next shot went away to the left, and we heard it crash through some buildings: this did not explode, but hit something however. The shelling continued all night, one in about every fifteen minutes. Some went over our heads at a great height, [and] a crashing noise or a dull thud told that the cursed city was being demolished slowly but surely."

Sketch made under fire from the roof of Roper Hospital, Charleston, S.C., while a prisoner of war, December 1864.

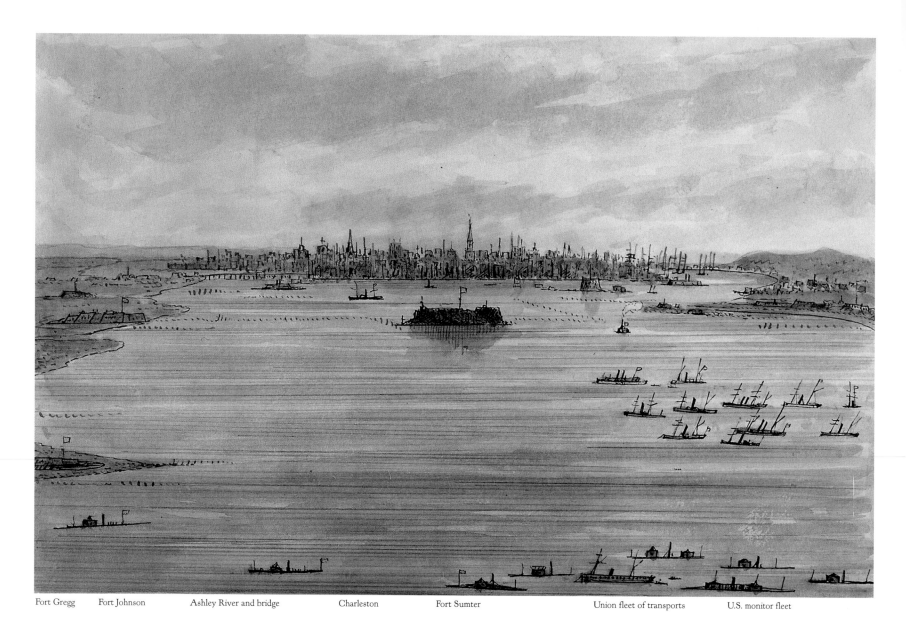

| Fort Gregg | Fort Johnson | Ashley River and bridge | Charleston | Fort Sumter | Union fleet of transports | U.S. monitor fleet |

December 11, 1864. "Soon we descried our fleet of transport steamers with large white flags at the fore [for the mass prisoner exchange in Charleston harbor]. And 'the Stars and Stripes' at the peaks and three feeble cheers were raised by us, which was responded to by waving of handkerchiefs from our vessels. The steamer "New York" was the flagship of the commission, and the name on her paddleboxes was enough to raise our spirits. We soon came alongside another large river steamboat to which our steamer was lashed, and we walked over the fore and aft gangplanks in single file, being counted by one of our officers and one Rebel officer until all had been transferred, [at] which the Rebel steamer cast off and returned to the city for more prisoners."

Exchange of 10,000 Union prisoners of war, Charleston Harbor, S.C., December 11 and 12, 1864. The U.S. steamers and transports anchored within 1,000 yards of Fort Sumter under flags of truce while exchange took place.

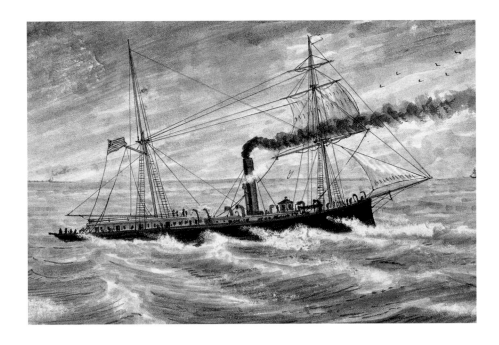

Sneden's imprisonment ended with the mass exchange in Charleston harbor. He sailed to freedom on board the steamer "Varuna," which was sold to the prince of Korea after the war and later went down off the China coast in a typhoon.

December 12, 1864. "Fine and clear with strong wind from north-east. At 7 a.m. all had a ration of whiskey, and breakfast at 8 a.m. We were given more to eat but not as much as we craved for sanitary causes. About 11 a.m. we slipped anchor and [were] towed to the steamer 'Varuna' near us when we all embarked on board."

The U.S. steamer "Varuna," with 600 exchanged prisoners of war, off Cape Hatteras, homeward bound, December 12, 1864.

When the "Varuna" left Charleston for the voyage up the coast, filled with soldiers from the prisoner exchange, Sneden observed the U.S. Navy fleet blockading the harbor.

December 14, 1864. "Fine, but blowing half a gale with a 'heavy cross sea on.' About 8 a.m. we tripped anchor and headed seaward. We passed within fifty feet of our monitors soon after, which were laboring heavily in the sea at anchor, the spray was making clean breaches over the turrets and smoke stacks."

U.S. monitor fleet at anchor on Charleston Bay during a gale, December 14, 1864. Sketched on board the "Varuna" steamship

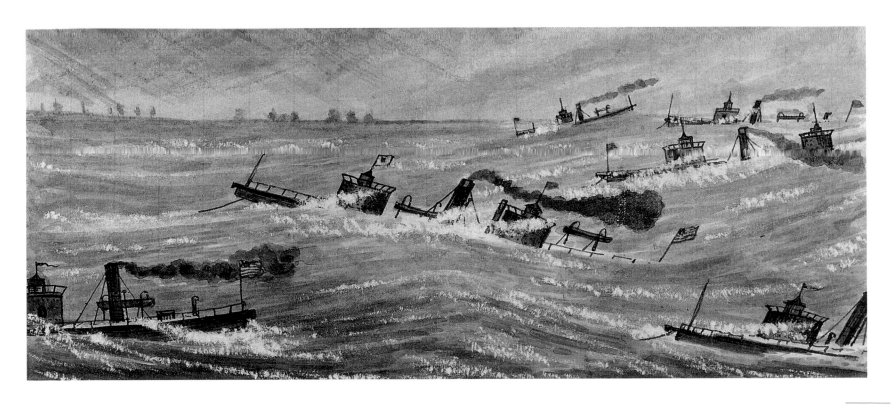

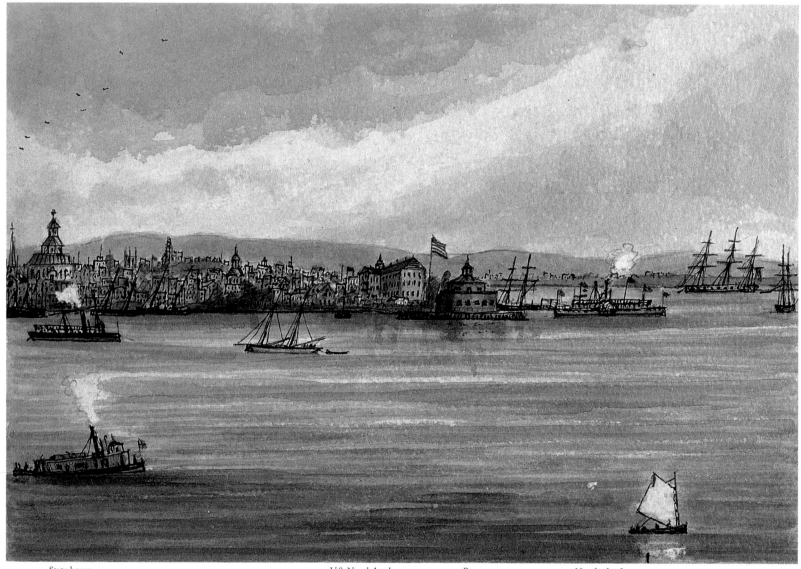

| State house | U.S. Naval Academy | Battery | Naval wharf |

December 18, 1864. "About 4 p.m. we made the harbor of Annapolis and came to anchor, while we were taken off by a large tugboat, and landed about dark at the wharf near the Naval Academy. A band of music, and about 200 people were waiting here to receive us, who escorted us to 'Camp Parole' in the vicinity, where we were all put into long barracks, in which bunks were fitted up where after rations were issued we smoked and discussed matters to a late hour."

After being processed through Camp Parole, Sneden took the train to Washington, D.C., to collect his back pay. It had been fourteen months since he had last seen the Union capital. He found only a few acquaintances still at his former office at the corner of 15 ½ Street and Pennsylvania Avenue. He remained in town for four days and then took the train home to New York. He arrived in the snow the day after Christmas and surprised his family, who had given him up for dead.

Annapolis, Maryland, 1864, "Camp Parole."

PART FIVE

AFTER THE WAR

FROM LATE 1865 UNTIL 1877 SNEDEN WORKED in an architect's office. His work entailed "Architectural and Perspective Drawing, Plans of Hotels and Manufactories, and Fire Surveys of Same. Hydrographical and Land Surveys, and Machine Drawings for Patents." In 1867 eighteen of his drawings were published in F. W. Beers's *Atlas of New York and Vicinity.* The following year his "Map of Jersey City, New Jersey" was published. After 1877, however, his health and output declined.

Sneden had no success in finding publishers for his Civil War art until, in November 1887, *Century* magazine published an engraving based on a drawing he had done of Appomattox Court House. About three dozen more of his watercolors were used as the basis for engravings in *Battles and Leaders of the Civil War* (1887–1888), a widely sold compilation of illustrations and memoirs from both sides of the conflict. Then his collections lay unconsulted for more than a century.

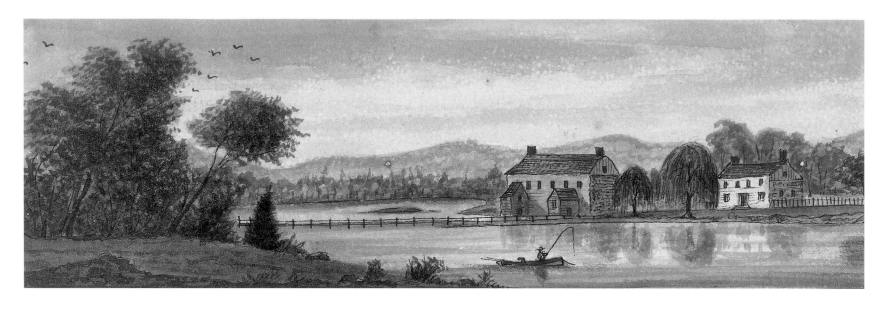

This Sneden watercolor and ink drawing may have been done for pleasure or to be engraved and published. It encompasses the view toward the house and mill from across the mill pond near the Albany Post Road. Philipsburg Manor was a stone dwelling and mill erected by Frederick Philipse in the 1680s on the Pocantico River, in what is now North Tarrytown, on a 90,000-acre manorial estate covering one third of present Westchester County. It was confiscated because the owners were Loyalists in the Revolution, as were Sneden's forebears.

Philipse Castle, Tarrytown, N.Y., 1865. *New-York Historical Society purchase.*

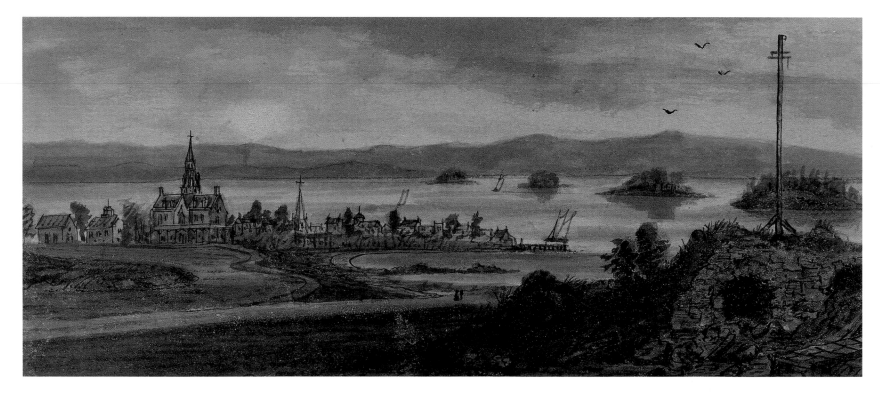

This sketch of an old French colonial fort (foreground) is executed in pencil, ink, washes, and glazes on paper.

Ruins of French fort, Castine, Maine, 1876. *New-York Historical Society purchase.*

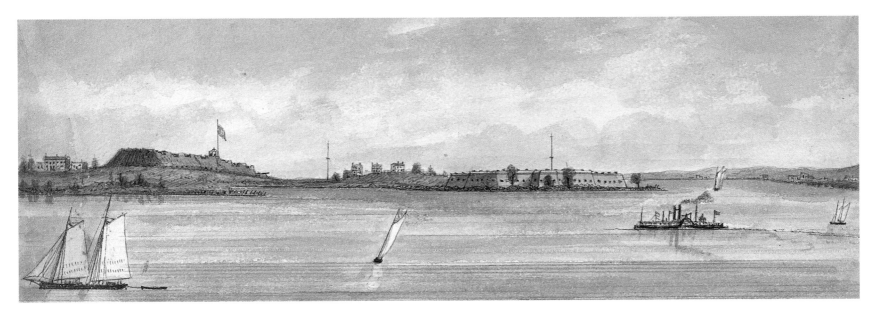

Though unsigned, there is little doubt this ink and watercolor view is by Sneden. It looks across the East River from Whitestone, NY

Fort Schuyler, Throgg's Neck, Bronx, N.Y., 1883. *New-York Historical Society purchase.*

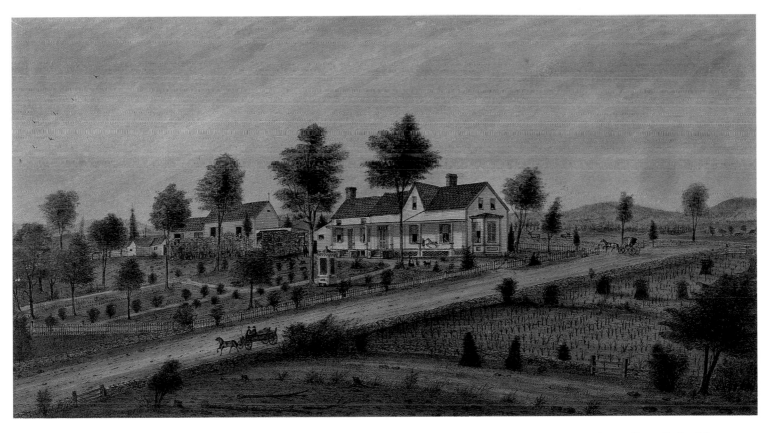

This pencil, ink, and watercolor view shows a house like those Sneden drew to illustrate F. W. Beers's Atlas of New York and Vicinity. However, this view is not known to have been published.

Residence of James Taylor, Monsey, N.Y., 1886. *New-York Historical Society purchase.*

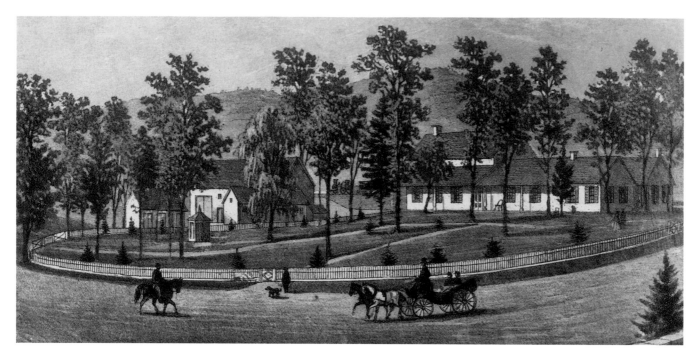

This drawing is signed at lower left "R. K. Sneden, del[ineator]" and is one of eighteen drawings he did to be engraved and published as illustrations for F. W. Beers's Atlas of New York and Vicinity in 1867. An overrun was printed to enable loose copies to be sold commercially. The Halstead home was in Westchester County, north of New York City.

The Halstead homestead at Bedford, N.Y.

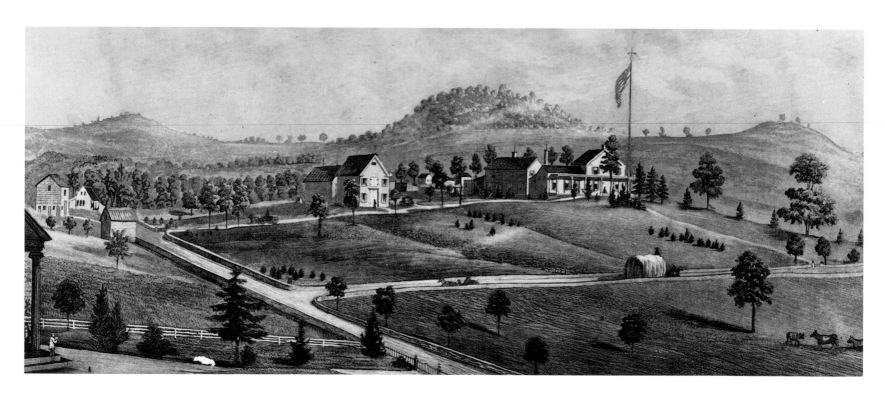

This is another of Sneden's drawings for Beers's Atlas. Southeast is the name of a town. William H. Drew was the son of Daniel Drew, who at one time had a virtual monopoly of steamboat traffic on the Hudson River and was one of the country's first "robber barons." This image may depict property transferred from father to son in the 1860s and known as Drewville.

Residence of William H. Drew, Southeast, Putnam Co., N.Y.

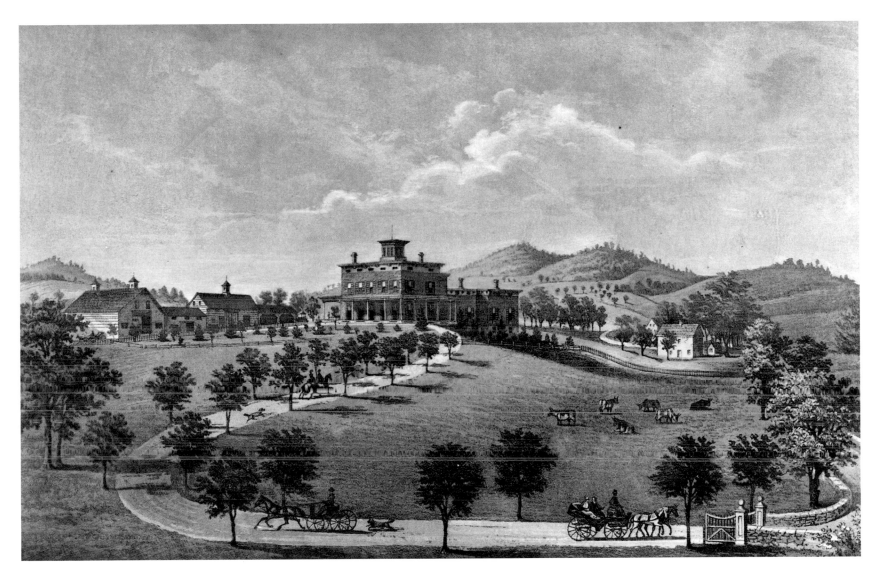

This is another engraving from Beers's Atlas based on a Sneden drawing. According to J. Thomas Scharf's History of Westchester County, a large farm "was purchased early in 1853 by James S. Libby, a prominent business man of New York, who, after the purchase, decided to erect a suitable mansion in place of the old-style farmhouse. . . . The main building is square, two stories and attic, flat roof, surmounted with an observatory, and surrounded by a broad piazza." Later it was sold to Ulysses S. Grant, Jr., and "General Grant, previous to his last illness, frequently visited his son at this beautiful home."

Inland Vale, residence of J. S. Libby, N. Salem, Westchester Co., N.Y.

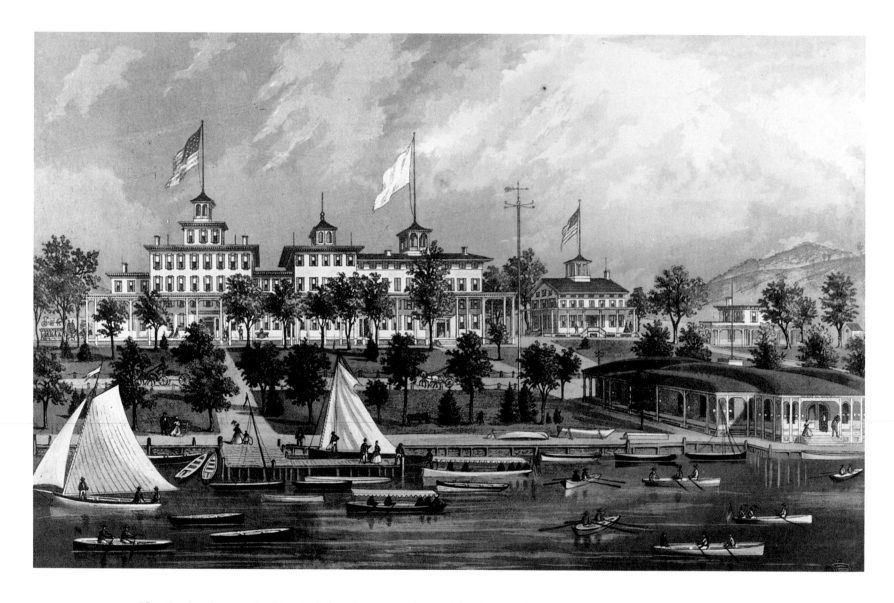

This Sneden drawing for Beers's Atlas shows one of several hotels on Lake Mahopac, just north of New York City, to which city residents flocked to escape the noise, congestion, and contagions of the city. Built about 1857, it burned on October 2, 1878, and was not rebuilt. Sneden was not this gifted at drawing figures. Probably the engraver made good the deficiency.

The Gregory House, Lake Mahopac, Putnam Co., N.Y.

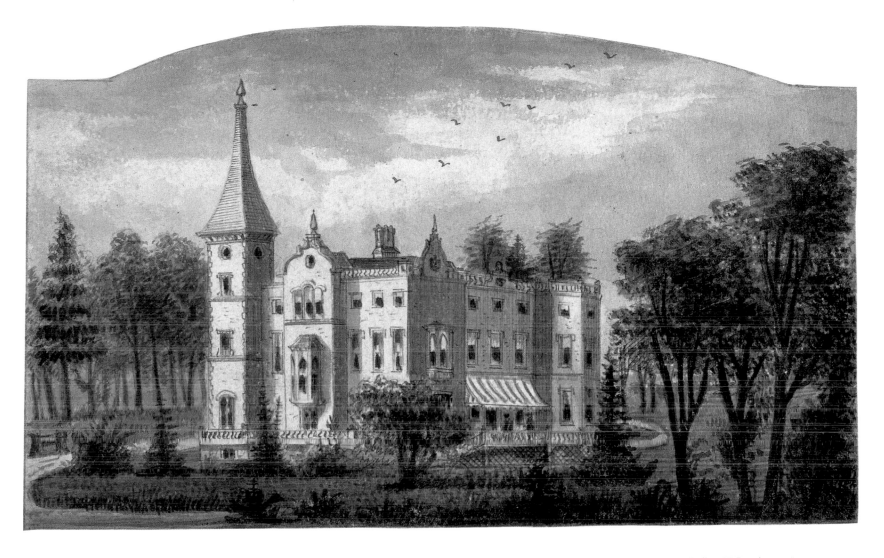

September 1, 1862. "Generals Heintzelman, Birney, and every one of the old III Corps were in low spirits for the stunning facts were known of the death of General Phil Kearny at Chantilly. . . . All flags . . . were at half mast while the whole Army of the Potomac mourned inconsolably the tragic death. . . . The III Corps idolized him. . . . They removed Kearny to Washington. Thence to New York and to his mansion [Kearny was a millionaire] at Bellville near Newark. [He was] subsequently laid in state two days at the City Hall, New York, and was buried at Trinity Church Broadway."

Sneden may have copied a photograph or print, but he could easily have visited Bellville after the war, perhaps while living at what is now Fairview, New Jersey.

Bellgrove, Bellville, N.J. Residence of Major General Philip Kearny, U.S.A. This brick French chateau was built by General Phil Kearny in 1850.

Fortified church Confederate earthworks

We do not know how many images Sneden submitted to the editors of Century magazine, but about thirty of his drawings were redrawn, engraved, and published in the magazine, or subsequently in the four-volume Battles and Leaders of the Civil War. Other images he submitted were redrawn but went unpublished. From notations on the redrawn images (later acquired by American Heritage Publishing Company), it seems Century believed that all of Sneden's submissions were from his wartime experiences. Those from the Peninsula Campaign were, but others were not.

This Sneden image was published in Battles and Leaders as being "From a Sketch Made April 4, 1862," which matches the date on Sneden's original.

Confederate earthworks at Big Bethel, Va.

This engraving in Battles and Leaders, *volume 2: 257, was published as being "From a sketch made at the time," and indeed is based on a June 1862 eyewitness drawing Sneden called "Fortified House, Fair Oaks." Charles A. Vanderhoof of* Century *redrew it for the engraver.*

House near Fair Oaks, used after the battle as quarters for the officers of the 1st Minnesota.

This engraving from Battles and Leaders is based on a reworking of a Sneden drawing by artist Hughson Hawley (1850–1936). It was published as being "from a war-time sketch," yet Sneden is never known to have been at the site. During the battle of Winchester he was incarcerated in Georgia, yet the title written on his original watercolor is identical to the published title.

Spout's Spring Mill, Opequon Creek, Va., hospital of VI Army Corps during the battle of Winchester, September 18, 1864.

In the decades following the war, Sneden attempted to convert his personal reminiscence into a general illustrated history of the war, producing elevations and plans such as these of Fort Henry on the Tennessee River and Fort Donelson on the Cumberland River. Both forts were unconditionally surrendered in February 1862 to Ulysses S. Grant, whose initials gained him the sobriquet "Unconditional Surrender" Grant.

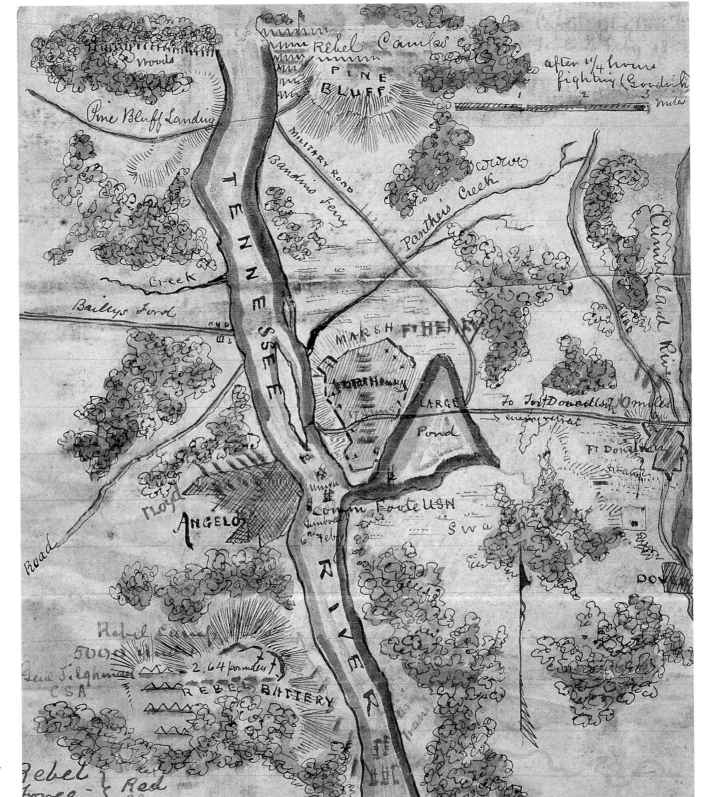

Plan of Fort Henry, Tenn.

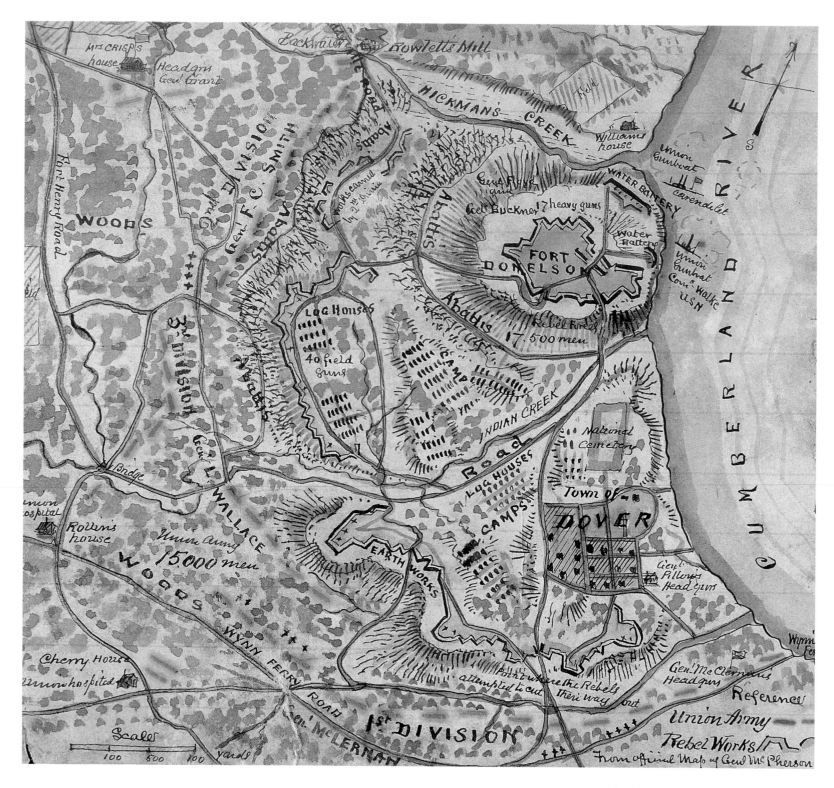

Plan of Fort Donelson, Tenn. From official map of General McPherson.

EDITORIAL METHOD

MANY OF THE CAPTIONS THAT ACCOMPANY the illustrations in this volume contain passages from Robert Sneden's memoir. Roughly half of them may be found in the text of *Eye of the Storm*. The other half are published here for the first time. Passages written by Sneden appear in roman type; the words in italics are our own. The identifying labels and picture legends underneath and beside the watercolors are Sneden's own words.

Because Sneden was able to base his memoir on diaries and notes created during the war as well as on his postwar recollections, he presented his account in the form of a diary, with entries for each day or a range of days. The period before his capture (just before dawn on November 26, 1863) tends to have entries for more individual days than does the period during which he was a prisoner of war. This difference reflects the disparity in the number of source materials he had to work with when he sat down to write the

memoir. His writing during the Andersonville period, for example, was based on the few scraps of notes and shorthand jottings in the margins of a bible that he was able to bring out of prison with him. During the earlier period, when he worked at the headquarters of various Union generals, he had the luxury of keeping a proper and voluminous diary.

The editorial method for transcribing Sneden's words in this volume is the same as in *Eye of the Storm*. That is, to quote from that book, "we modernized some of Sneden's text but still retained much of its original flavor and style." We have silently modernized erratic punctuation, abbreviations, capitalization, and confusing elements that are impossible to present in published form. Omitted text is indicated by ellipsis points. As we wrote earlier, readers interested in examining the Sneden collection may consult photocopies at the library of the Virginia Historical Society.

ACKNOWLEDGMENTS

As with *Eye of the Storm: A Civil War Odyssey*, this book was made possible by the contributions of many people. We will not name all of them here but refer the reader to the fuller acknowledgments pages of *Eye of the Storm*. We do wish to name a special few individuals who made it all possible. When Charles Ash walked through the front door of the Virginia Historical Society in 1993 bearing a suitcase filled with Sneden's scrapbooks, we had no idea we were on the threshold of an odyssey of our own. So we have him to thank all over again.

Then David Meschutt suggested that we look at Sneden's Landing, New York, after we had run out of ideas for tracking down the artist and his background. Later still, Alice Munro Haagensen, at the instigation of Albert Sneden, became our guardian angel when our first overture in Sneden's Landing seemed futile. If not for her, we never would have discovered the second Sneden collection, which we purchased from a descendant of the artist's brother. The two collections—scrapbooks of watercolors and multivolume illustrated memoir—are what made both books possible. The VHS board of trustees has expressed its gratitude to Mrs. Haagensen by voting her into the select company of honorary members of the Society.

We thank Floyd and Libby Gottwald once more for their foresight and generosity. If they had not stepped forward with the funds to purchase both Sneden collections, neither *Eye of the Storm* nor *Images from the Storm* would exist.

At the Virginia Historical Society, many staff members who helped with *Eye* pitched in again to make *Images* a reality in an even shorter span of time than it took to create the first book. In addition to all of those people, several others have helped in important ways. From experience with *Eye of the Storm*, we knew how

maddeningly difficult it was to keep the myriad bits of a collection accessible when it was at the same time being conserved, cataloged, photographed, and used by historians to produce a book. Two VHS volunteers, Cammy Bryan and Jackie Shopland, devoted many hours to sorting and cataloging Sneden's artwork. Their work greatly expedited ours. Robert Hardee, licensing sales associate in our museum shop, took charge of the transparencies of Sneden's art during the production of *Images*. We have him to thank for the smoothness of the process of dealing with the approximately three hundred images used in the book. In comparing Sneden's art to that of other soldier-artists, Ross Kimmel provided useful information about his great-grandfather, John Jacob Omenhausser. John Fox of the Putnam County Historical Society and Elizabeth G. Fuller of the Westchester County Historical Society, both in New York, were extremely helpful in providing information about the scenes reproduced on pages 244–246.

At the Free Press, we thank our editor, Bruce Nichols, once again. It was he who pushed the idea for a second Sneden book. Armed with the exceptional sales figures for *Eye of the Storm* generated in part by publicity in the *New York Times*, the *Washington Post*, and other national media, he convinced his company to approve the concept for *Images from the Storm*. Of course, Bruce wanted the book far sooner than we thought humanly possible, but in the end he proved right. The book's designer, Kim Llewellyn of Kim Llewellyn Design, worked her magic on the art and lay-

out as she had done with *Eye of the Storm*. The copyediting supervisor, Loretta Denner, again brought together the copy editor, proofreader, and indexer of the previous book to bestow their expertise on this one. Iris Cohen—this time in collaboration with Jim Thiel—supervised the production of the book, with the same meticulous care as before. Among others at the Free Press who found themselves in the company of the Civil War artist once more, we would like to thank Dan Freedberg and Jill Rosen. Carolyn Dean of Rice Dean Graphics designed the splendid map showing Sneden's travels. Our agent Carolyn Krupp of IMG Literary guided us with sure feet through the contract process, as did our attorney, Nina Graybill. We thank them for their excitement about the project as well as for their expert advice.

Lastly, we thank the VHS board of trustees, who have supported our work on Robert Knox Sneden with enthusiasm from the beginning. When we gave a lecture last November at the New-York Historical Society to launch the traveling Sneden exhibit, our trustees showed their true colors: nearly all of them attended the New York event. Sneden himself might have had second thoughts about seeing his life's work residing at a southern institution, but we like to think he would have approved of the New York opening.

Charles F. Bryan, Jr.
James C. Kelly
Nelson D. Lankford
October 2001

INDEX

African Americans
 contraband camp near Arlington House,
 138
 cooking for Union soldiers, 117
 Lee's former slaves, 136
 in McClellan's retreat from the Penin-
 sula, 113
 Slave pen at Alexandria, 134
"Albemarle" (Confederate ram), 207
alcohol consumption
 enlisted men going on sprees, 12
 whiskey ration, 10
Aldie (Va.), 178
Alexander's Bridge (Chickahominy River),
 78
Alexandria (Va.)
 Christ Church, 22
 Fort Lyon, 12, 13, 17, 18, 135
 Heintzelman's headquarters at, 120, 134
 Marshall house, 134
 McClellan's army returns to, 120
 McClellan's headquarters near, 136
 Mosby's men in, 120
 slave pen, 134
 soldiers on leave in, 12

Allen's farmhouse (near Fair Oaks, Va.),
 79
Andersonville
 barber shops, 206
 bloodhound hut, 213
 changing the guard, 202
 cookhouse, 208
 dead line, 209
 interior panorama of, 218–19
 general panorama of, 210–11
 ovens, 206
 plan of, 216
 Plymouth, N.C., prisoners to, 207
 Raiders hanged, 213, 214–15
 route from Richmond to, 201
 shanties and shelters, 204, 205
 Sneden prisoner of war at, ix–x,
 197–219
 Sneden's published view of, xiii
 Sneden's shanty, 203, 205
 south gate, 202
 statistics on prisoners at, 216
 sutlers, 212
 view from Wirz's headquarters, 217
 watchmaker's shanty, 212

 Wirz, xiii, xxi, 209, 212, 213
Annapolis (Md.), x, 240
Antietam (Sharpsburg), battle of, 142–44
 Burnside's Bridge, 143
 damage from Union shelling during, 144
 Dunker Church, 142
 old Lutheran Church, 144
 Rebel flags captured at, 146
Appomattox Court House (Va.), xvi
Arlington House (Va.)
 contraband camp near, 138
 Heintzelman's headquarters at, 136
 Washington family pedigree at, 137
artillery
 Confederate defenses at Charleston,
 232, 233
 Hazlett's battery at Gettysburg, 163
 on Jamestown Island, 109
 Quaker guns, 130
 Rebel batteries on the Potomac, 19, 20
 Weeden's battery at Malvern Hill, 97
 at Yorktown, 51
 See also water batteries
Atlas of New York and Vicinity (Beers), xxi,
 241, 244–46

Auburn (Va.), 171
Averell, William, 70, 71

Bailey's Cross Roads (Va.), 9
Ballenger house (Fort Lyon, Va.), 17, 135
balloons, 41, 46
Baltimore Cross Roads (Va.), 70, 71
Barhamsville (Va.), 66, 67
Battles and Leaders of the Civil War, xi, xiii,
 xv, xvi–xvii, xxi, 241, 248–50
Bealton Station (Va.), 173
Beaver Dam Creek (Mechanicsville), battle
 of, 80, 81
Beers, F. W., xxi, 241, 244–46
Belle Island (Richmond, Va.), 190, 193
Bellgrove (Bellville, N.J.), 247
Berdan's sharpshooters, 95
Big Bethel (Va.)
 advance of Army of the Potomac to,
 34
 burial of Union soldiers after battle of,
 35
 Confederate earthworks at, 248
 Union and Rebel positions, April 1,
 1862, 33
Big Round Top (Gettysburg, Pa.), 161
Billings, J. D., xv
Birney, David B., xx, 167, 168, 174, 175,
 180
Blackburn's Ford (Bull Run, Va.), 25
blacks. *See* African Americans
Botts, John Minor, 179, 186
Brandy Station (Va.)
 Meade's headquarters near, 182
 Military Telegraph Corps camp at, 187
 Miller's house near, 188, 189
 post office at, 179
 U.S. Sanitary Commission quarters at,
 187
 view of, 186
bridges
 Burnside's Bridge, 143
 Howard's Bridge, 38
 pontoon bridges at Hampton, Va., 30,
 31
 Turkey Creek Bridge, 95, 99, 101
 See also railroad bridges
Bristoe Station, battle of, 121
Budd's Ferry (Va.), 19
Buel, Clarence, xvi

Bull Run (Va.)
 Blackburn's Ford, 25
 running waters of, 125
 Union Mills on, 172
 See also second battle of Bull Run (Man-
 assas)
Burnside, Ambrose, 143, 148, 150
Burnside's Bridge (Sharpsburg, Md.), 143
Butler, Benjamin, 32, 116
Byrd, William, 104

Camp Lawton (Millen, Ga.), 223–29
 ovens, 227
 panorama of, 224–25
 plan of, 228
 Sneden's "office," 228
 view from inside the gate, 224–25
 view from Winder's headquarters, 226
Camp Parole (Annapolis, Md.), x, 240
Camp Wood (Yonkers, N.Y.), 3
Castine (Me.), 242
Castle Pinckney (Charleston, S.C.), xvi,
 232
Castle Thunder (Richmond, Va.), 194, 195,
 196
Cemetery Hill (Gettysburg, Pa.), 160
Centreville (Va.)
 Grigsby house, 129
 Heintzelman's headquarters, 129
 new defenses at, 169
 Quaker guns at, 130
 Union army falling back to, 130
Century (magazine), xi, xvi, xvii, 241, 248
Chamberlain, Joshua, 161
Chancellorsville, battle of, 152–58
 Hooker's headquarters, 153, 154, 155
 plan of, 152
 positions on morning of May 3, 1863,
 156
 Salem Church, 157
 Sickle's covering retreat from, 158
 Todd's Tavern, 155
Chantilly, battle of, 129
 Kearny killed at, 129, 130
 panorama of, 130–31
 plan of, 132
Chapman, Conrad Wise, xv
Charles City Court House (Va.), 113, 114
Charleston (S.C.), 231–34
 Castle Pinckney, xvi, 232

Confederate artillery at, 232
Confederate harbor defenses at, 233
Fort Sumter, 232
jail and workhouse at, 234
mass prisoner exchange at, 238
St. Michael's Church, 234
Sneden exchanged at, 236–39
view from roof of Roper hospital, 237
West Point Mills, 231
Christ Church (Alexandria, Va.), 22
"Cimerone" (gunboat), 110
City Point (Va.), 112
Clarke's house (near Yorktown, Va.), 50
Cockpit Point (Va.), 19, 20, 26
Cold Harbor (Va.), 83
Cole house (opposite Harrison's Landing,
 Va.), 110, 111
Conrad's Ferry (Potomac River), 11
contraband camp, 138
Cooney, John M., 12
Crew and Pemberton Prison (Richmond,
 Va.), ix, xx, 195
Culpeper Court House (Va.), 183

DeKay, Drake, 139
Devil's Den (Gettysburg, Pa.), 163, 164
draft, 140
Drew, Daniel, 244
Drew, William H., 244
Dunker Church (Sharpsburg, Md.), 142

Early, Jubal, 142, 160
earthworks
 at Big Bethel, 248
 at Howard's Bridge, 38
 on Little Round Top at Gettysburg, 161
 on Morrel's Hill, 37
 at Myer's house at Seven Pines, 76
 around officers' quarters near Fair Oaks,
 77
 at Rawlin's mill at Harrison's Landing,
 109
 on Willis Hill at Fredericksburg, xvii, 151
 See also redoubts; rifle pits
Eckert, Thomas, 187
Edwards, Harry, xvi
Egan, Thomas W., xx
Ellerson's Mill (Mechanicsville, Va.), 81
Ellsworth, Elmer, 134
entrenchments. *See* earthworks

Episcopal Seminary (near Alexandria, Va.), 136
Evansport (Va.), 19, 26

Fairfax Court House (Va.), 11
Fair Oaks (Seven Pines), battle of, 74, 249
Falls Church (Va.), 22
Faulkner house (near Catlett's Station, Va.), 174
flags, Rebel, 146
Florence (S.C.)
 gate of prison at, 235
 Sneden prisoner of war at, 234–36
 statistics on prisoners at, 235
 view of prison at, 236
 Winder's headquarters at, 235
Floyd, John B., 139
Forbes, Edwin, xvii
Forney house (Upton's Hill, Va.), 23
Forrest, French, 8
Fort Donelson (Tenn.), 251, 252
Fort Ellsworth (Va.), 12
Fort Henry (Tenn.), 251
40th New York Volunteers. See Mozart Regiment
fortifications. See earthworks
Fort Lyon (Alexandria, Va.), 12, 13, 17, 18, 135
Fort Magruder (near Williamsburg, Va.), 60, 61, 63, 118
Fort Monroe (Va.), 28, 33
Fort Ramsey (Upton's Hill, Va.), 23
Fort Schuyler (Bronx, N.Y.), 243
Fort Stevens (Washington, D.C.), 142
Fort Sumter (Charleston, S.C.), 232
Fort Washington (opposite Mt. Vernon, Va.), 25
Frank Leslie's Illustrated Newspaper, xi, xiii, xxi
Franklin, William B., 84, 148
Fredericksburg, battle of, 148–51
 Burnside's headquarters in Falmouth, 150
 the city after the battle, 151
 Marye's Heights, 148, 150
 plan of, 148
 Rebel works on Willis Hill, xvii, 151
 stone wall and sunken road, 150
 Todd's Tavern, 155
 view of city from across river, 149

French, William H., xx, 167, 183, 188

Gaines Mill, battle of, 82, 83
"Galena" (gunboat), 95, 99
"Galvanized Yanks," 223, 235
Gardner, Alexander, 144, 150
Gaston (N.C.), 199
Gaul, Gilbert, xv
Gee, John H., 200
Germanna Ford (Va.), 181
Gettysburg, battle of, 159–66
 Big Round Top, 161
 Cemetery Hill, 160
 Devil's Den, 163, 164
 Meade's headquarters at, 165
 Seminary Ridge, 166
 view of town from Emmitsburg Road, 159
 See also Little Round Top
Glendale (Nelson's Farm), battle of, 91–93
 Heintzelman's headquarters during, 91
 plan of, 93
 Willis Methodist Church, 92, 94
Glenerie Falls (near Saugerties, N.Y.), x
Gloucester Point (Va.), 41, 43, 47
Gotleb, Henry E., xxii
Grahamsville (Honey Hill), battle of, 230
Grant, Ulysses S., 177, 243, 251
Gregory House (Lake Mahopac, N.Y.), 246
Grigsby house (Centreville, Va.), 129
gunboats
 "Cimerone," 110
 "Galena," 95, 99
 "Mahaska," 99

Halstead house (Bedford, N.Y.), 244
Hampton (Va.)
 advance of Army of the Potomac from, 34
 Heintzelman's headquarters at, 29
 ruins of, 30
 St. John's Episcopal Church, 32
Hanover Court House (Va.), 73
Hardtack and Coffee (Billings), xv
Harrison's Landing (Va.), 101–11
 Byrd family cemetery at, 106, 107
 Cole house attacked, 110, 111
 map of, 103
 McClellan's headquarters at, 102, 108
 Rawlin's mill, 109

III Army Corps's position at, 108
Westover mansion, 104
Hart, O. H., 181
Hawley, Hughson, xvi, 250
Heintzelman, Samuel P.
 as commander of military district of Washington, 133–42
 at Fair Oaks (Seven Pines), 74
 headquarters of: at Alexandria, 120, 134; at Arlington House, 136; at Baltimore Cross Roads, 71; at Centreville, 129; on the Chickahominy, 74; near Fort Lyon, 13, 17, 135; at Glendale (Nelson's farm), 91; at Haggerty house in Barhamsville, 67; at Hampton, 29; at Howe's Sawmill, 40, 49; at Jones Bridge, 115; at Linden Farm, 75; at Malvern Hill, 95, 99, 100; at New Kent Court House, 69, 70; at Savage's Station, 85; at Slatersville, 68; at Taylor house in Barhamsville, 66; at Warrenton Junction, 120; at Washington, D.C., 139, 140; at William house in Barhamsville, 67; at Williamsburg, 65, 117; near Yorktown, 119
 headquarters teams at second Bull Run, 125
 in retreat from Harrison's Landing, 114
 at Savage's Station, 84
 shelling of headquarters at Williamsburg, 64
 Sneden as mapmaker for, viii–ix, xix, 17
Henry, Edward Lamson, xv
"Hero" (bloodhound), 196
Hill, A. P., 143
Holmes, Theophilus, 19
Homer, Winslow, xv, xvii
Honey Hill (Grahamsville), battle of, 230
Hood, John, 164
Hooker, Joseph
 at Antietam, 142
 at Bristoe Station, 121
 at Fredericksburg, 148
 headquarters at Chancellorsville, 153, 154, 155
 headquarters at Fair Oaks Station, 75
 retreat from Chancellorsville, 158
 shelling Rebel batteries across the Potomac, 19, 20

Hope, James, 143
hospitals
 at Allen's farmhouse, 79
 at Fair Oaks, 76
 at Linden Farm on Peninsula, 75
 at Malvern Hill, 95
 for officers at Clarke's house near York-
 town, 50
 at Savage's Station, 85
 at Willis Methodist Church during bat-
 tle of Glendale, 92
 at Wormsley Creek, 43
Howard's Bridge (Va.)
 advance of Army of the Potomac to, 34,
 37
 map of route to sawmill from, 36
 Rebel works at, 38
Howe's Sawmill (near Yorktown, Va.), 40,
 49

illustrated newspapers, xiii

Jackson, Thomas Jonathan (Stonewall),
 111, 122, 123, 142, 155, 158
Jamestown Island (Va.), 109
Jericho Mills (Va.), 178
Jersey City (N.J.), 241
Johnston, Joseph E., 27, 50, 56, 127

Kearny, Philip, 129, 130, 247
Kelly's Ford (Va.), 177, 180
Kelly's Mill (Kelly's Ford, Va.), 176

Lake Mahopac (N.Y.), 246
Lawrenceville (Va.), 198
Lee, Robert E.
 Arlington House, 136, 137
 at Chantilly, 129
 entrenching at Mine Run, 181
 at Fredericksburg, 148
 at Gettysburg, 166
 Meade attempting to outflank, 167, 177
 in Peninsula Campaign, 78, 79, 101
 recrossing Potomac after Antietam, 145
 at Salem Church, 157
 in second Bull Run campaign, 111
 White House Landing property of, 72
Lee's Mill (Va.), 45
Lewis house (near Bull Run, Va.), 127
Libby, James S., 245

Libby Prison (Richmond, Va.), 194, 195,
 196
Lincoln, Abraham, 111
Linden Farm (Va.), 75
Little Bethel (Va.), 35
Little Round Top (Gettysburg, Pa.)
 Chamberlain holds, 161
 Hazlett's battery on, xvi, 163
 Union breastworks on, xvi, 161
 view of battlefield from, 162
Longstreet, James, 150, 161
Lossing, Benson J., xv
Lowe, Thaddeus S. C., 41
Lutheran Church, old (Sharpsburg, Md.),
 144
Lutheran Seminary (Gettysburg, Pa.), 166

Magruder, John, 27, 30, 56, 97, 98
"Mahaska" (gunboat), 99
Maine regiments
 3rd, 6, 12, 108
 4th, 6
 20th, 161
Maltby stone house (near Bull Run, Va.),
 126
Malvern Hill, battle of, 94–100
 battlefield of, 95
 "grand scene" to Sneden, 100
 Heintzelman's headquarters, 95, 99, 100
 Magruder charging Weeden's battery,
 97
 map of, 98
 Porter's headquarters, 96
 Wyatt (Malvern) house, 94, 96
Malvern (Wyatt) house (Malvern Hill,
 Va.), 94, 96
Manassas Junction (Va.)
 Rebels destroy railroad cars at, 123
 Rebel withdrawal from, 24
 See also second battle of Bull Run (Ma-
 nassas)
Marshall house (Alexandria, Va.), 134
Marye's Heights (Fredericksburg, Va.),
 148, 150
McClellan, George B.
 failing to pursue Lee after Antietam,
 145
 headquarters of: at Episcopal Seminary
 near Alexandria, 136; at Harrison's
 Landing, 102, 108; at Little Bethel,

35; at Morrel's Hill, 37; at Savage's
 Station, 88; in Yorktown, 53, 59; dur-
 ing Yorktown siege, 48, 50
 Lee's attack on, 78
 ordered to join Pope, 111, 119
 Peninsula campaign, ix, xiii, 24, 27
 and Potomac blockade, 19
 retreating to Harrison's Landing, 101
 in Seven Days' battles, 79
 splitting his army on the Peninsula, 74
 to White House Landing, 72
McCormack house (Auburn, Va.), 170
Meade, George Gordon
 at Gettysburg, 165
 headquarters near Brandy Station, 182
 headquarters near Culpeper Court
 House, 183
 maneuvering in autumn of 1863, 167,
 177, 181
 Mine Run Campaign, 184
Meade, William, 147
Mechanicsville (Beaver Dam Creek), battle
 of, 80, 81
Meeker, Edwin J., xvi, 16
Michigan regiments, 21
Military Telegraph Corps, 187
Millen Prison. See Camp Lawton
Miller's house (near Brandy Station, Va.),
 188, 189
Mine Run Campaign, 167, 181, 184
Minnesota regiments, 77
"Monitor" (ship), 112
monitor fleet, 239
Moore house (Yorktown, Va.), 54, 55
Morrel's Mill (Poquoson, Va.), 37
Mosby, John Singleton
 in Aldie area, 178
 Alexandria raided by, 120
 Sneden captured by, ix, xx, 167, 189
Mount Vernon (Va.), 14, 15
Mozart Regiment (40th New York Volun-
 teers)
 barracks at Yonkers, N.Y., 1, 2
 in brigade theater orchestra, 12
 encampment at Yonkers, N.Y., 3
 encampment on Leesburg Turnpike, Va.,
 5
 at Harrison's Landing, 108
 picket post at Forrest residence, 8
 picket post at Olivet Chapel, Va., 14

picket post at Scott house, 13
picket post at Stout's Farm, 8
redoubts at Mount Everton, Va., 10
Sneden joins, viii, x, xvi, xix, 1
Munson's Hill (Va.), 9
Myer's house (Seven Pines, Va.), 76

Nelson house (Yorktown, Va.), 53, 56, 59
Nelson's Farm, battle of. *See* Glendale
(Nelson's Farm), battle of
New Kent Court House (Va.)
Averell's headquarters, 71
Heintzelman's headquarters, 69, 70
jail burned by the Rebels, 71
Rebels evacuate, 70
St. Peter's Church, 68
New York Illustrated News, xiii
New York regiments
38th, 6, 10, 12, 14
See also Mozart Regiment (40th New
York Volunteers)

Octagon House (Va.), 6
officers
earthworks around officers' quarters
near Fair Oaks, 77
hospital at Clarke's house, 50
on leave in Washington, D.C., 12
on picket duty, 17
uniforms of Pope's staff, 120
Old Capitol Prison (Washington, D.C.),
140, 141
Old Potomac Church (near Fredericks-
burg, Va.), 147
Olivet Church (Va.), 14
Olmsted, William B., x, xxi
Omenhausser, John Jacob, xv
Orange Court House (Va.), 181

passes, 139
Peninsula Campaign, 27–119
map of country between Yorktown and
Williamsburg, 62
map of lower Peninsula, 39
McClellan leaves to join Pope, 111
McClellan's plan for, 24
retreat to Harrison's Landing, 101
roads, 37, 39
Sneden's narrative missing for, xiii, 60
Sneden taking part in, ix

See also Harrison's Landing; Seven Days'
battles; Williamsburg; Yorktown
Perkins, Lieutenant, 48
Peterson, Harold, xvii
Pfeiffer, Carl, xxi
Philipsburg Manor (North Tarrytown,
N.Y.), 242
Phillips house (Falmouth, Va.), 150
picket duty, 17
Pickett's Charge, 166
Pictorial History of the Civil War (Lossing),
xv
Plymouth (N.C.), 207
Pohick Church (Fairfax County, Va.), 21
Pohick Road (Va.), 17
pontoon bridges at Hampton, Va., 30, 31
Pope, John
at Chantilly, 129
headquarters at Grigsby's house, 129
headquarters at Warrenton Junction,
122
McClellan ordered to join, 111, 119
retreating at second Bull Run, 129
Porter, Fitz-John
encampment on York River, 41, 50
at Hanover Court House, 73
headquarters at Harrison's Landing, 104
Potomac River
Cockpit Point, 20, 26
Conrad's Ferry, 11
Fort Washington, 25
Quantico Creek, 26
Rebel batteries on, 19, 20
Shippen Point, 20
prisons
Belle Island, Richmond, Va., 190, 193
Castle Thunder, Richmond, Va., 194,
195, 196
Crew and Pemberton Prison, Rich-
mond, Va., ix, xx, 195
at Florence, S.C., 234–36
Libby Prison, Richmond, Va., 194, 195,
196
in Richmond, 191, 192
at Salisbury, N.C., 200
at Savannah, 217, 220–22
Scott's Prison, Richmond, Va., xx, 197
See also Andersonville; Camp Lawton

Quaker guns, 130

Quantico Creek (Va.), 26

Raiders, 213, 214–15
railroad bridges
at Gaston, N.C., 199
at Rappahannock Station, 175
in Richmond, 197
Rappahannock Station (Va.)
engagement at, 177
railroad bridge at, 175
Rebel redoubts and rifle pits at, 177
Rawlin's Mill (Harrison's Landing, Va.),
109
Rebel flags, 146
Rebel prisons. *See* prisons
redoubts
at Fort Magruder, 61
at Rappahannock Station, 177
of 40th New York Volunteers at Mount
Everton, Va., 10
Reed, Charles W., xv
Richmond (Va.)
Belle Island, 190, 193
Castle Thunder, 194, 195, 196
Crew and Pemberton Prison, ix, xx, 195
Libby Prison, 194, 195, 196
old St. John's Church, 190
Rebel prisons in, 191, 192
Richmond & Petersburg Railroad
Bridge, 197
Scott's Prison, xx, 197
Tredegar Iron Works, 193, 197
rifle pits
at Fort Magruder, 61
on Morrel's Hill, 37
at Rappahannock Station, 177
of 40th New York Volunteers at Mount
Everton, Va., 10
roads on the Virginia Peninsula, 37, 39
Robinson house (near Bull Run, Va.), 126

St. John's Church, old (Richmond, Va.), 190
St. John's Episcopal Church (Hampton,
Va.), 32
St. Michael's Church (Charleston, S.C.),
234
St. Peter's Church (New Kent Court
House, Va.), 68
Salem Church (Salem Heights), battle of,
157

Salisbury (N.C.), 200
Sanderson, James M., 197
Savage's Station, battle of, 84–89
 McClellan's headquarters, 88
 plan of, showing scale of miles, 84
 plan of, with key to fighting forces, 87
 Rebel charge during, 89
 Rebel ironclad railroad car in, 86
Savannah (Ga.)
 panorama of prison at, 220–21
 plan of prison at, 222
 Rebel defenses at, 229
 Sneden a prisoner of war at, 217,
 220–22, 229–30
Scott, Julian, xv, xvii
Scott house (Va.), 13
Scott's Prison (Richmond, Va.), xx, 197
second battle of Bull Run (Manassas),
 124–29
 Heintzelman's headquarters teams at,
 125
 Lewis house, 127
 Maltby stone house, 126
 plan of, 124
 Pope's headquarters at Grigsby's house,
 129
 Robinson house, 126
 Sneden present at, ix, 119
 Warrenton Junction, 122
Sedgwick, John, 6, 16, 84, 157
Seminary Ridge (Gettysburg, Pa.), 166
Seven Days' battles, 79–100
 Gaines Mill, 82, 83
 Mechanicsville (Beaver Dam Creek), 80,
 81
 Sneden present at, ix, 79
 See also Glendale (Nelson's Farm), battle
 of; Malvern Hill, battle of; Savage's
 Station, battle of
Seven Pines (Fair Oaks), battle of, 74, 249
Sharpsburg, battle of. See Antietam
 (Sharpsburg), battle of
Shaw, James Thome, xxi
Shepardstown (Va.), 145
Sheppard, William Ludwell, xv
Shippen Point (Potomac River), 20
Sickles, Daniel E., 19, 140, 158, 161, 162
siege by approaches, 44
Slatersville (Va.), 68
Slave Pen (Alexandria, Va.), 134

Smith, Xanthus, xv
"Smithfield" (steamship), 207
Sneden, Ann Knox, xix, xxii
Sneden, John Anthony, xix, xxi
Sneden, Robert Knox
 chronology of, xix–xxii
 life after Civil War, x–xiii, 241–52;
 death of, xii, xxii; disability pension
 sought by, xi–xii, xxi; returns to New
 York City, x, 240; at Soldiers' and
 Sailors' Home, Bath, N.Y., xii, xxii;
 working for Olmsted architectural
 firm, x–xi, xxi, 241
 life before Civil War, vii
 as mapmaker: for Birney and French, xx,
 167; for Heintzelman, viii–ix, xix, 17
 in Mozart Regiment (40th New York
 Volunteers), viii, x, xvi, xix, 1–16
 in Peninsula Campaign, 27–119
 photographs of: xi; in 1911, xii
 as prisoner of war, 190–239; at Ander-
 sonville, ix–x, 197–219; attempted
 escape in Richmond, xx; at Camp
 Lawton, Millen, Ga., 223–29; capture
 of, xx, 167, 189; in Charleston,
 231–34; at Crew and Pemberton
 Prison, Richmond, ix, xx, 190–97;
 exchange of, x, 236–39; in Florence,
 S.C., 234–36; at Savannah, 217,
 220–22, 229–30; at Scott's Prison,
 Richmond, xx
 in second Manassas Campaign, 120–29
 as theatergoer, ix, 133
 wartime odyssey of, xviii
 in Washington, D.C, with Heintzelman,
 133–42
 works of: in Battles and Leaders of the
 Civil War, xi, xvi–xvii, xxi, 241,
 248–50; in Beers's Atlas of New York
 and Vicinity, xxi, 241, 244–46; cate-
 gories of Civil War art of, xiii; com-
 parison to other soldier artists, xv,
 xvii; diary/memoir, vii, viii, xi, xiii,
 xvii, xxii, 4; inaccuracies in, xv; "Map
 of Jersey City, New Jersey," 241;
 methods of, xiii; originals discarded,
 xiii; rediscovery of, xvii; war record
 of, xiv; watercolors of country
 estates, xi, 243–47
Sneden's Landing (N.Y.), viii, ix, xix

"special artists," xiii, xvii
Sprout's Spring Mill (Oppequon River,
 Va.), xvi, 250
Stevens, Isaac, 129
Stoneman, George, 68, 90
Stout's farm (Va.), 8
Stuart, J. E. B., 122, 155
Sumner, Edwin V., 79, 84, 148
sutlers, 212

Taber, I. Walton, xvi
Taylor, James, 243
telegraph operators, 46
Todd's Tavern (near Chancellorsville, Va.),
 155
Tredegar Iron Works (Richmond, Va.),
 193, 197
Turkey Creek Bridge (Va.), 95, 99, 101
"Twin Houses" (Fair Oaks Station, Va.),
 75

uniforms, 120
Union and Rebel positions in northeast
 Virginia, September 1861, 7
Union Mills (Va.), 172
Upton's Hill (Va.), 23
U.S. Sanitary Commission, 187, 192

Vanderhoof, Charles A., xvi, 23, 249
"Varuna" (steamship), 239

Ward, J. H., 174
Warrenton Junction (Va.)
 map of, 168
 Pope and Heintzelman's headquarters at,
 122
 view of Orange & Alexandria Railroad,
 175
Washington, D.C.
 encampments and fortifications around, 4
 forts surrounding, 142
 Heintzelman commands military district
 of, 133–42
 Heintzelman's headquarters in, 139, 140
 officers on leave in, 12
 Old Capitol Prison, 140, 141
water batteries
 at Gloucester Point, 43
 at Yorktown, 59
Waud, Alfred, xvii

Westover Church (Westover Landing, Va.), 105
Westover Mansion (Harrison's Landing, Va.), 104
West Point Mills (Charleston, S.C.), 231
whiskey ration, 10
White, Isaiah, 223, 229, 232, 234, 235
White House Landing (Va.), 72, 90
Whittaker's Mill (near Williamsburg, Va.), 64
William and Mary College (Williamsburg, Va.), 115, 116, 117
Williamsburg (Va.)
 battlefield at, 60
 Fort Magruder, 60, 61, 63, 118
 Heintzelman's headquarters, 65, 117
 McClellan retreating through, 115–17
 shelling of Heintzelman's headquarters, 64

III Corps marching on, 60
 Whittaker's Mill near, 64
 William and Mary College, 115, 116, 117
Willis Hill (Fredericksburg, Va.), xvii, 151
Willis Methodist Church (near Glendale, Va.), 92, 94
Winchester, battle of, 250
Winder, John H., 235
Winder, William S., 226
winter camp, 21
Wirz, Henry, xiii, xxi, 209, 212, 213
Wormsley Creek (Va.), 43
Wyatt (Malvern) house (Malvern Hill, Va.), 94, 96

Yorktown (Va.)
 balloon observation of, 41, 46
 Cornwallis cave in bluff near, 58
 Gloucester Point on opposite shore of, 47

Heintzelman's headquarters near, 119
map of siege of, 42
McClellan embarks for Alexandria from, 119
McClellan's headquarters during siege of, 48, 50
McClellan's headquarters in, 53, 59
military uses of buildings in, 57
Moore house used as signal corps station in, 54, 55
Nelson house, 53, 56, 59
 after Rebel evacuation, 59
Rebels evacuate, 50
siege by approaches, 44
Sneden drawing scenes of siege of, ix
Union batteries before, 51
Union troops enter, 52
view from rear of Howe's Sawmill, 40